The Year's Work at the **ZOMBIE** *Research Center*

THE YEAR'S WORK:
STUDIES IN FAN CULTURE AND CULTURAL THEORY

Edward P. Comentale and Aaron Jaffe, editors

The Year's Work at the

ZOMBIE

Research Center

Edited by

EDWARD P. COMENTALE
& AARON JAFFE

Indiana University Press Bloomington & Indianapolis

This book is a publication of

Indiana University Press
Office of Scholarly Publishing
Herman B Wells Library 350
1320 East 10th Street
Bloomington, Indiana 47405 USA

iupress.indiana.edu

Telephone 800-842-6796
Fax 812-855-7931

MANUFACTURED IN THE UNITED
STATES OF AMERICA

Library of Congress
Cataloging-in-Publication Data

The year's work at the Zombie
Research Center / edited by Edward P.
Comentale and Aaron Jaffe.
 pages cm — (The year's work: studies
in fan culture and cultural theory)
 Most of the essays were first
presented at a symposium held at the
University of Louisville in 2012.
 Includes index.
 ISBN 978-0-253-01387-3 (pb : alk.
paper) — ISBN 978-0-253-01382-8 (cl : alk.
paper) — ISBN 978-0-253-01392-7 (eb)
 1. Zombies—Congresses. I. Comentale,
Edward P., editor. II. Jaffe, Aaron, editor.
 GR581.Y43 2014
 398.21—dc23

 2014007386

1 2 3 4 5 19 18 17 16 15 14

To those who watched them with us and those who wouldn't

By heaven and hell, and all the fools between them,
I will not die, nor sleep, nor wink my eyes,
But think myself into a god; old Death
Shall dream he has slain me, and I'll creep behind him,
Thrust off the bony tyrant from his throne
And beat him into dust. Or I will burst
Damnation's iron egg, my tomb, and come
Half damned, ere they make lightning of my soul,
And creep into thy carcase as thou sleepest
Between two crimson fevers. I'll dethrone
The empty skeleton, and be thy death,
A death of grinding madness.—Fear me now;
I am a devil, not a human soul—

THOMAS LOVELL BEDDOES, "Hard Dying"

Contents

Acknowledgments

We're grateful to our editor Raina Polivka, Jenna Whittaker, and Nancy Lightfoot and the other professionals at Indiana University Press. We also owe thanks to Jill R. Hughes and the anonymous readers selected by the press, whose input made this a stronger book. We'd like to acknowledge the sustaining support of our colleagues at the University of Louisville and Indiana University. Our students deserve special mention—in particular, the University of Louisville honors students in English 402 (Brains! Literature, Culture, and Zombies) and the Indiana University freshmen in C103 (Zombies and the Cultures of Fear). Most of the work in this volume was first presented at a symposium held at the University of Louisville in 2012, supported by the generosity of our chairs and our departments as well as the Commonwealth Center for the Humanities at the University of Louisville, led by Tom Byers. We're grateful to the many colleagues and friends who attended and participated, including Tom Byers, Jennifer Stephens, Amy Clukey, Lucy Swanson, Nicole Seymour, Steven Pokornowski, Ben Creech, Justy Engle, Andrew Cooper, Dennis Allen, Guy Dove, Lee Cole, Rodrigo Paula, Glynis Ridley, Sarah Hopfer, Jesse Molesworth, Andrew Rabin, Karen Hadley, Cynthia Burkhead, Michael Miller, Hannah Harrison, Caleb Magyar, Daniel Conrad, and Tracy Heightchew. We are most thankful for the continued support of our two families; this volume would not be possible without their steady patience and generosity.

We thank the publisher for permission to reprint "Talking in Bed" from *The Complete Poems of Philip Larkin,* by Philip Larkin, edited by Archie Burnett. Copyright © 2012 by The Estate of Philip Larkin. Introduction copyright © 2012 by Archie Burnett. Reprinted by permission of Farrar, Straus, and Giroux, LLC, and Faber and Faber Ltd.

The Year's Work at the **ZOMBIE** *Research Center*

Introduction: The Zombie Research Center FAQ

EDWARD P. COMENTALE & AARON JAFFE

We're sure you've noticed that zombies are everywhere these days. Why else would you be reading this book? As it says in the stairwell: THE END IS EXTREMELY FUCKING NIGH. [#zombies.] In the bunker, out on the rooftop, inside and out back, stalking the horizon, zombies pose significant threats to both human identity and human civilization. *Who are they? What do they want? How do they "think"? What do they mean?* The recent explosion of zombies in film, literature, graphic novels, video games, and fan culture is inescapable. Even sociology, philosophy, and literary theory have gotten into the zombie act, elaborating core concepts around borrowings from this undead corner of pop culture. But who has time to read a book—let alone a tome as hefty as *The Year's Work at the Zombie Research Center*—during a zombie apocalypse? Perhaps you're curious about your world. (*A little late, no?*) Perhaps you need a few tips. In this book we'll look at zombie cult classics; historical documents from America, Europe, and the Caribbean; and some "zombie theory" by philosophers, sociologists, and literary theorists. We'll also consult some of the more recent hits from the ever growing zombie corpus in order to explore the contemporary meanings of the zombie and the zombie world. At the Zombie Research Center we've grown desensitized to the groans and eye rolls that names like Freud, Derrida, or Lacan sometimes elicit. *You should never feel stupid for ordering brains.* As you'll find, though, zombie culture today is as shapeless and mutable

1

as an actual zombie horde—and often just as violent. Since any total theory of this field seems impossible, we're here to provide not so much the "answer to infection" (as the broadcast in *28 Days Later* says), but a few suggestions for brain work, tactical maneuvering, and sufficient day-to-day survival.

Why are we obsessed with zombies?

Obsession is a good word, but we like *zombie fixation* even better. Zombies are clearly the pop-cultural fixation of the moment; more than anything else, we seem to be under siege by an endless stream of zombie commodities (zombie-themed mugs, doormats, onesies, bumper stickers, etc.). Because people know we at the Zombie Research Center are keenly interested in the topic, sometimes we hear refrains like "zombies are so over" or "zombies are so dead." It's not hard for us to agree, but isn't that the point? Zombies are dead, but they're not. The zombie fad is perfect, because it's autoimmunized from the kind of obligatory boredom dooming other fads. The zombie is "born" exhausted. It can't die, because you can't kill what's not alive. "I'm so sick of zombies" doesn't work either, because you're *supposed* to be sick of zombies.

Psychoanalysis—in its examination of undying ideas and imperishable drives—provides one avenue for understanding zombie fixation. About the prefix *un-*: Freud gives us the definition of *uncanny* as "that species of the frightening that goes back to what was once well known and had long been familiar" (*Uncanny* 124). The buried past returns, but in strange, distorted form, as in a dream, something at once desired and feared. The shock of the survivor in the face of the zombie is the shock of no longer knowing what's on the other end of the gun: mother or other, father or fiend. Or the prefix *ab-*: in her feminist revision of Freud, titled *Powers of Horror: An Essay on Objection,* Julia Kristeva flags the abject as

Edward P. Comentale & Aaron Jaffe

0.1. Sean Bieri, "Ordering Brains" (2008).

the decrepit thing that transgresses the boundary between subject and object. It occurs in four forms—disgust of (1) food, (2) bodily waste, (3) dead bodies, and (4) the mother's body—which, taken together, harken back to the forbidden pleasures of infancy (which, not incidentally, supplies the grotesque fourfold in Peter Jackson's *Dead Alive* [aka *Braindead*; 1992]).

Where Freud sees the castrating threat of the father, Kristeva detects the smothering power of the mother; where the uncanny signals psychological anxiety, the abject produces physical disgust. Faced with abjection, the survivor experiences not so much the immobility of

shock, but a sort of convulsion—an instantaneous attraction/repulsion toward that which threatens pleasurable destruction: to smell the sour milk, to play with the shits, to kiss the corpse. Thus, the survivor as lusty wanderer, manic territorialist, sniffs out the sweet-smelling corpses in order to kiss/kill them: "A deviser of territories, languages, works, the deject never stops demarcating his universe whose fluid confines—for they are constituted of non-object, the abject—constantly question his solidity and impel him to start afresh. A tireless builder, the deject is in short a stray. He is on a journey, during the night, the end of which keeps receding" (Kristeva 8). (For more on the uncanny and the abject in the zombie tradition, see Stephen Watt's report in chapter 1.)

And yet we hardly need to think about zombie fixation in human terms at all. Ozone holes, AIDS, Y2K, computer viruses, mad cow disease, SARS, MRSA, terrorist attacks, unending wars, miscellaneous hazmat, environmental degradation, climate change, self-replicating Ponzi schemes—panic culture grows around us, one unmanageable crisis after another, pushing our fascination with the zombie into the realm of hard science. In fact, given the state of emergency in which we currently conduct our lives, one can only chuckle at the quaint postmodernism of the "panic" concept as first outlined in the *Panic Encyclopedia* of 1989: "Panic is the key psychological mood of postmodern culture . . . as a floating reality, with the actual as a dream world, where we live on the edge of ecstasy and dread" (Kroker et al. 13–14). The *Panic Encyclopedia* locates its titular crisis in an imaginary collusion of science and culture (with postmodern physics affirming the hyperrealism of postmodern culture), but today's panic culture seems to have leaped beyond anything like sociological critique. The zombie infection module has us thinking beyond all human perspectives and institutions, thinking through the organism rather than the person, thinking corporately

0.2. *Plague Inc.,* Ndemic Creations (2012).

instead of nationally, leaping anxiously between the microscopic and the macroscopic.

As seen in the recent outbreak of outbreak films and the viral success of viral smartphone apps such as *Plague Inc.,* zombie fixation flows everywhere through a mass-mediated virophilia. Derived from *virus,* a Latin word meaning a poisonous sap ("I tried to take a blood sample and instead extracted only brown, viscous matter" [Brooks, *World War Z,* 7]), and the Greek *-phile,* meaning, of course, one who loves, virophilia = infection + affection. The word speaks to (1) our fascination with both real and hypothetical contagions, plagues, viruses, and other agents of noxious transmission and (2) our obsessive etiological tracking of ideas, trends, and parasitic social malfunction back to its presumed origin, whether a batch of toxic sap, a polluted patient zero, a bite-marked child, rabid critter, microbe, prion, or spilled barrel of radioactive matter.[1] In a way, virophilia points toward a much larger attempt to police cultural boundaries that have been delegitimized by the fluidity of multinational capital, the decentered power networks of transnational terrorism, and the rampant effects of pollution and ecological degradation. Susan Sontag nailed it years ago in *Illness as Metaphor and AIDS and Its Metaphors.* To represent disease as an "alien invasion" allows society to mobilize not just its more conservative emotions and desires, but also the necessary funds, resources, and power to preserve them. Thinking microscopically and macroscopically about infection frees us from the ethical considerations that marked prior treatment of other humans in our midst; science colludes with power to confront, paranoically, what is always couched as a "domestic disturbance" in an otherwise "pluralistic world" (105–106).

There's no need to squabble about the precise nature of the outbreak. The film *28 Days Later* (2002) stages it in a secret government lab

at a university, a setting that speaks as much to widespread ambivalence about scientific research as it does to the failure of both liberal humanism and militarist nationalism to staunch the imperium in decline. They know not what they do, sayeth the chimp, moral animal-rights activists/campus protesters, and venal university-military-industrial praetorians alike. Nothing in the film, however, seems so scary—or so poignant—as the drop of infected blood that falls from a crow's foot into the eye of loving father Frank, one castrating drop that immediately sets him into a spastic, zomboid rage and draws out a fatal rain of suppression gunfire from the military. But for virophilia-as-

"I'm so sick of zombies" doesn't work . . . because you're supposed to be sick of zombies.

technophilia nothing beats *[•REC]* (2007), the Spanish zombie classic that locks a bubbly late-night television reporter inside a quarantine building infected with a virus that is as much biological as it is demonic. *[•REC]* is notable for the way it stages Angela's degradation as spectator and spectacle; as the reporter confronts the stages of female life as a process of bodily corruption (culminating in the horrific sunken-breasted image of the "Medieros Girl"), so the audience is forced to confront its own desirous relation to gendered violence and decay. Here, though, the camera proves the best mediator of zombie fixation. "We have to tape everything," Angela lustily shouts at Pablo, her cameraman, shifting her role from spectacle to spectator. The recording device serves to manage an OCD-like relation to abjection, containing as well as copying (inoculating and incubating) the disease that threatens bodily integrity. (For gender and feminism in the zombie tradition, see Andrea Ruthven's analysis in chapter 10; for zombie technology and media, see Erik Bohman's research in chapter 4.)

Are today's zombies different from earlier ones?

We're living in times of "peak zombie," but some of the things that make zombies uncanny now have always been part of the zombie mix: their vacant robotic quality, their being neither alive nor dead, their association with rot and contamination, their underclass demography, and so on. The earlier varieties—both the Afro-Caribbean kind and the schlocky space vampire kind—seem quaint compared to the ravenous postapocalyptic schlock-fest on the loose today, but the changes have more to do with quantity rather than quality, speed over significance. Part of the reason for so much zombie stuff today is simply an issue of numbers. Zombies are contagious; thus, the horde can only grow in size, a fact that seems to speak to a culture that increasingly defines its hopes and fears in terms of statistics and demographics.

And nothing seems to die anymore. Everything thought or said exists in a virtual half-life, literally, in the massive digital crypt of the Internet, and experientially, in a world haunted, morally, philosophically, by its own pasts. Zombie philosophy, zombie economics, zombie computers, zombie genes—are these really any different from the zombie bikers, zombie nuns, zombie baseball players that first stalked the frames of George A. Romero's films, generic doubles of their original, vital selves? Today's zombies emerge with the pop culture of the '50s and '60s and thrive in the reduplications and redundancies of the culture industry; they are the dark shadows haunting the tragic margins of Andy Warhol's repetitive pop art, the shadows that explicitly marked Warhol's own death series, and they persist in the genre schlock of mainstream cinema and the memes of the Internet. Indeed, zombie killing has become as banal as deleting four hundred emails on a Monday morning, as Chuck Klosterman claims, but that doesn't negate the fact that they must be killed or that the killing is not without its pleasures. In fact, today's

0.3. *The Three Living and the Three Dead.* Collotype after the Master of the Housebook (1488–1505).

zombies—as numerous as they are virtual—cannot be conceived apart from the recent rise of video games, especially first-person shooters, such as *Resident Evil, Left 4 Dead, Dead Island,* for which zombies are the perfect foil because they can be destroyed without the same moral hazard as killing other baddies.

But "today's zombie" is a contradiction in more ways than one. Wherever there's been culture (and *culture* might really be another word for *germ,* for the organization of life and death), there have been zombies. The pastoral tradition, one of the earliest forms of Western literature, is also essentially a zombie tradition. The shepherd is always essentially a shepherd-survivor. In Virgil's *Eclogues,* for example, the shepherd's life exists precariously, barely, between nature and civilization both; his flocks are threatened by disease, infection, and mis-breeding;

his land and livelihood are subject to the violent whims of political and economic force. Everywhere, in the midst of sylvan reverie, there are shadows—dark "umbrae"—intimations of powerlessness and death. "Look where strife has led Rome's wretched citizens," cries the dispossessed Meliboeus. "We have sown fields for these" (35). Again and again, as much here as on Hershel's farm or the prison camp or the streets of Mayberry in *The Walking Dead*, the law exposes its own lawlessness and thus opens the way for apocalypse: the oceans leave their fish on the shore, stags feed in the sky, mares mate with griffins, and, in Eclogue VIII the dead rise from their "deepest graves" to haunt the crops (91).

In the medieval legend of "The Three Living and the Three Dead," too, the representatives of the civilized world—a duke, a count, a prince—encounter their own undead doubles at the fringes of civilization. The country jaunt always seems to imply a massacre, urging all witnesses to repent: "Such as I was you are, and such as I am you will be. Wealth, honor and power are of no value at the hour of your death." Similarly, consider two pastoral paintings from the early 1600s, both titled *Et in Arcadia Ego*. In the work by Guercino from 1618 to 1622, the shepherds are startled by a grinning skull, here being picked over by a field mouse and a fly, well-known symbols for temporal decay and infectious disease, respectively. In Poussin's version, from 1637 to 1638, the treatment is far subtler, more melancholic, and yet the shadow on the tomb suggests that here too death escapes its own monument. As Paul Alpers claims, pastoral depictions of landscape have little to say about actual nature. They are designed to address human strategies for living in the face of power—they give expression, in Alpers's terms, to "human strength relative to world" (44). Remember, too, Romero's first film, *Night of the Living Dead* (1968), opens with a weekend ride out to the country. Johnny and Barbra are planning to visit their father's grave,

0.4. Guercino, *Et in Arcadia Ego* (1618–22).

but Johnny goes down in the graveyard and Barbra loses it behind the poorly boarded walls of a farmhouse. (On the topic of survival and the spaces of country and city, see Dan Hassler-Forest's report in chapter 3.)

Zombies are as timeless as the genres in which they are ceaselessly revived. If the pastoral opens onto power and violence, then it is through convention—the deathliness of form itself—that death is confronted and honored. According to Alpers, the shepherd-survivor marks his relation to death via song. He sings his distress, his vulnerability and weakness, and thereby makes himself "representative" and

0.5. Nicolas Poussin, *Et in Arcadia Ego* (1637–38).

gives his world "pleasing aesthetic form" (58–59). In this, genre proves
the death of death. *Night of the Living Dead, Dawn of the Dead, Day of
the Dead,* and so on: representation—as re-presentation—becomes a
form of survival and habitation, a way of maintaining order and balance.
In fact, the shepherd-survivor usually sings of the death of an earlier
shepherd. He sings both in honor of some fallen shepherd and in place
of that shepherd and thus resurrects that shepherd in his song. In this
the shepherd-survivor is always a genre artist, playing cover songs, us-
ing the undead forms of the past to confront the present, using the very
deathliness of form to ward off death itself. Virgil takes up Theocritus as
Danny Boyle covers George A. Romero as, in Eclogue V, Mopsus covers

Edward P. Comentale & Aaron Jaffe

Daphnis—so one shepherd answers another, using the forms of the past to create not just a tradition, or lineage, in time, but a space, a community, in the present. Hence, *Et in Arcadia Ego,* the inscription—as undead refrain—speaks of and for the deathliness of form and in its very repetition proves its ability to be repeated, a source of sustenance and survival. As inscription, as monumental refrain, these words themselves mark a space, a convention; as utterance they make of their speakers both mortal and immortal, present in their absence, rich in their barrenness. (For more on zombie genre and literary invention, see Jonathan P. Eburne's report in chapter 12.)

What makes zombies so symbolically flexible?

Zombies come to light in some surprising areas of culture and cultural discourse—not just in Marxist manifestos and senate filibusters but also in themed weddings and kids' movies. They're not the branded monsters of the Universal Studios lot (even though there are "Romero" zombies, *R-zombies,* Romero fittingly never asserted his "moral right" of ownership on the idea), but are common, generic, allegorical.[2] They're low-rent by design—DIY, punkish, populist—anyone with some cheap makeup and fake blood can work up a decent, half-disgusting zombie. They (usually) don't speak for themselves, so it's easy to project all kinds of meanings onto them—dress them up in all kinds of costumes. "Ugh, I drank so much beer last night," moans the student in the back row, "I feel like a zombie." "I'm dying for a cup of coffee," growls the office worker. "This meeting's turning me into a zombie." (On popular zombie performance, see Atia Sattar's report in chapter 7.)

But even though zombies come across as (over)ripe for metaphorization, they themselves are not metaphors. If anything, they seem—in

their quick violence and slow decay—to eat through the logic of metaphor. *Is the biker zombie really an interpretation of the biker? Does the tap dancer zombie or the nun zombie offer a theory of the tap dancer or the nun?* Like other signs, zombies tend to repeat themselves, but their jerky repetition is not animated by any apparent sense or meaning. Yes, they are remarkably formal—insofar as, in their death, they continue to mark out some formal coherence—but their decaying, discombobulated state tends to expose the arbitrariness of all such forms. The zombie's status as undead—immortal in its mortality—exists in its being as sign, but only as it wreaks havoc on signification. Its weird temporality—the ideality of its repeatable form at odds with its corrupt moment-to-moment becoming—mirrors as it mocks the sign as such. As Jacques Derrida notes, "I am immortal" is an impossible proposition, because it contradicts the relation to death (my own disappearance, my own mortality) that marks the ideality of linguistic form. And yet this is precisely what the zombie says with every groan and growl—"I am immortal"—even as such "expressions" reflect back on our own impending demise (*Speech and Phenomena* 54).

No one wants his or her son to be remembered as a zombie.

Something of this formal repetition and its relation to time informs the very first scene of the very first film of the contemporary zombie era. *Night of the Living Dead* opens on a conversation about daylight savings time; Barbra and Johnny, visiting their father's grave, argue about the long drive and the effects of the time switch. Johnny, in particular, grouses about the missing hour, suggesting that they've been pushed (or "dragged") across time. This temporal slippage is doubled a moment later when Johnny, recalling his youth, chases his sister across the graveyard, pretending to be a monster. Oddly, he mocks a creature he has not

yet encountered in the film, referring, ironically, to his own later doom. "They're coming to get you, Barbra," he moans, as he is already coming to get her, making himself both a figure of her past and her future. In fact, he mocks a zombie that is now literally behind his own back, an only slightly paler man comically stumbling through the graveyard behind him, one whom he will later join as part of a larger zombie horde. In this, oddly, the zombie attack seems already past and always impending, always—like the zombie itself—behind and in front of you, marking an expansive temporal horizon of violence and terror. As Kanye West puts it down on his track "Monster," *"Everybody know I'm a motherfucking monster . . . / I'm living the future so the present is my past. / My presence is a present, so kiss my ass."*

There's something about these temporal lapses and repetitions that challenges the two most common interpretations of the genre: (1) that the zombie refers to some earlier trauma and thus figures as a form of collective psychosis, and (2) that it serves as a metaphor for a future revolutionary break and thus as a historical parable. All such theories assume the presence of repressed material as well as the possibility of its representation. But the zombie has no corporeal integrity; with its rotting flesh and exposed layers of muscle, bone, and organ, it has no depth, no repressed wish to be revealed or decoded. In a way the zombie body is not a sign, but rather a sticky surface that signs cling to and fall off of again—baseball caps, ball gowns, ties, watches. The zombie horde is the groundless ground against which the individual zombie rises and falls as a formal limit rather than an expression; it is like a refrigerator covered in poetry magnets, exposing the temporal decay or drift of all sign systems, their slow rot and ultimate arbitrariness. In turn, the zombie apocalypse becomes the moment of denegation, the negation of negation, when all signs lose their naturalness, when the figural becomes unbearably literal, splattered with blood and brains.

0.6. Jack Laughner, *The Triumph of Death over Man* (KEEP CALM AND CARRY ON) (2011).

In other words, if the zombie eats through the expressive fantasies of cultural analysis, he exposes the activity of indication. For Derrida, *expression* involves a pleasing doubling of self within self, the moment when an intention—once it takes shape in language—reflects upon the intending mind. *Indication,* however, refers to the gestural dimension of language, its terrifying tendency to point elsewhere; indication makes language an external or exteriorizing phenomenon, forever faced outward; it brings the entire mortal world into play—"the living present"—if only as dark potential. In other words, indication, insofar as it exposes us to mortal space and time, figures as a mode of "orientation," a way of placing ourselves in relation to mortal hazard (*Speech and Phenomenon* 37, 94). "Indication," Derrida writes, "enters speech whenever a reference to the subject's situation is not reducible, wherever this subject's situation is designated by a personal pronoun, such as *here, there, above, below, now, yesterday, tomorrow, before, after,* etc." (94; italics in original). Suddenly, speech exposes the speaker in space and time and thus sets the stage for the necessary work of orientation. The zombie as sign, behind you, over your shoulder, to the side, behind the door, in each instance, with each repetition, locates you within an unstable horizon of time and space. Linear time, epochal time, gives way to peristaltic convulsion, formal dilation, and contraction across an open field of intensities. (The word *monster,* we note here, derives from the Latin *monstrum,* meaning "omen, portent, sign," as in *de-monstration.*)

So we read zombie films not just for metaphors (of, say, consumer culture or Vietnam or AIDS) but for the explosion of sign systems that litter their frames—the blown newspapers, floating bills, illegible graffiti, unheard loudspeakers. As in Jack Laughner's zombie-world masterpiece, *The Triumph of Death over Man,* the debris signals not just the terror of infrastructural collapse but also a giddy release from the discursive

foundations of the law. Romero's zombies are never so comically clueless as when they trip over the bright advertisements and parking signs that no longer signify anything in their defunct suburban "mallscape." In fact, something of this linguistic subversion lies at the heart of all subcultural subversion; as in the Cramps' "Zombie Dance," the death of the signifier proves the life of the party (no squares allowed):

> At the Zombie Dance
> Here's Ben and Betty
> They tap their toes
> But they don't get sweaty
> They don't give a damn
> They're done dead already
>
> At the Zombie Dance
> Nobody moves
> They tap their toes
> Yeah, wiggle their ears to get in the groove, yeah
>
> They do "The Boogaloo"
> At the Zombie Hall
> They write "born to lose"
> On zombie restroom wall
> The kinda life they choose
> Ain't life at all.

"No Future" is scrawled across the gates of Resurrection Cemetery in *Return of the Living Dead* (1985). ("I like it," says Trash, "It's a statement.") "Who Cares?" is inscribed on the side of Suicide's car. ("You think this is a fuckin' costume?" he says. "This is a way of life.") *Et in Arcadia Ego. The End Is Extremely Fucking Nigh. Watch Your Head.* The

zombie is always its own situationist slogan, raising all kinds of indiscernible charges and demands.

What makes zombies such a "fun" tool to deal with heavy issues—mortality and civil rights, for instance?

This is how we know zombies are make-believe. And don't tell us any of the usual stuff about *Leuchochloridium paradoxum* (zombie snails) or *Ampulex compressa* (zombie roaches) or *Toxoplasma gondii* (zombie rats). We know that zombies are make-believe because they are "fun." If there really ever were a zombie apocalypse, then the "zombie walk"—where everyone dresses up as a zombie and stumbles through Main Street—is done (unless the idea is like the Bill Murray stratagem in *Zombieland* [2006], where you "zomb up" to sneak in a round of golf). Because zombies are already dead, they don't inspire the same ethical handwringing as other monsters, and they can be killed with impunity. Zombies are like cartoon characters: they always bounce back, and then they don't. In their dumb plasticity, they allow us to travesty death and other tabooed topics. In fact, a zombie might be nothing more than the butt of a joke. As Henri Bergson claimed, we laugh at a human behaving like a thing in order to relieve ourselves of our own thingliness. Laughter, like a good head shot, works to "soften down whatever the surface of the social body may retain of mechanical inelasticity." It dissolves the "rigidity of body, mind, and character that society would like to get rid of in order to obtain from its members the greatest possible degree of elasticity and sociability" (73–74). *The Evil*

We arm ourselves sufficiently—lightly, loosely, tactically—for academic survival.

Dead (1981), *Dead Alive* (1992), *Shaun of the Dead* (2004), *Zombieland*—zombie comedy, as *splatstick,* works a fine line between the laugh and the scream. "Horror, in some sense, oppresses; comedy liberates," writes Noël Carroll in his influential essay "Horror and Humor." "Horror turns the screw; comedy releases it. Comedy elates; horror simulates depression, paranoia, dread" (147). Cue Tallahassee and his banjo routine. Or, better, Bill Murray doing an impression of Bill Murray doing an impression of Zombie Bill Murray. The survivor becomes stand-up comedian, "killing it" night after night of the living dead.

And yet the thrill of such humor (as black humor, usually) no doubt derives from the very seriousness of its targets. We might as well argue that because zombies are *not* already dead, they *do* inspire ethical handwringing, and so they can *never* be killed with true impunity. Indeed, despite the popularity of first-person zombie shooters, the undead often have a special hold on our hearts. Their uncertain status—as alive or dead, sick or evil, misunderstood or hateful—often puts a halt to the killing spree. (See John Gibson's report on zombie ethics and philosophy in chapter 13.) While earlier zombies carried associations with slavery and the slave trade (associations that Romero sometimes references in his films),[3] more contemporary versions come across as misunderstood minorities. One encounters the inevitable sensitive zombie portrayal in romance novels such as S. G. Browne's *Breathers: A Zombie's Lament* and Isaac Marion's *Warm Bodies,* in which the zombie follows its vampire kinfolk into the generic trope where the revenant monster provides some lesson about the misprision of identitarian difference. Tellingly, these allegorical narratives feature zombies who [*sic*] lead richly subjectivized inner lives and thus come across as a little less zombie. In Marion's novel this quality is itself a side effect of brain consumption; the first-person-zombie narrator named R ingests memories and

experiences from the gray matter of his prey. Something similar occurs in *Warm Bodies*, a tweener retelling of *Romeo and Juliet*, but here rehumanization and social assimilation occur mostly through the warming passions of young love.

Better, Bruce LaBruce's films, especially *Otto; or, Up with Dead People* (2008), explores the links between zombies and queer sexual difference (the two groups are conceptually united in the film via their shared desire for "man-flesh"). As an ironic documentary of the "gay plague," the film smartly toys with the metaphorization of the zombie figure: each character wants to read Otto's zombification as an expression of something else: late capitalist accumulation, environmental collapse, heteronormative power, and so on. "Now raise your hand up out of the grave," shouts the director, Medea Yarn (who is obviously a Marcuse fan). "Raise it as a protest against all the injustices perpetrated against your kind. Raise it in solidarity with the weak and the lonely and the dispossessed of the earth, for the misfits and the sissies and the plague-ridden faggots who are buried and forgotten by the heartless, merciless, heteronormative majority. Rise! Rise!" The film, though, cuts through such clatter to focus on the emotional intensity of queer desire and the necessity of care in the face of hate. In the end, Otto accepts zombie performance as a potential form of social critique, but, while preserving something of his critical coldness, he nonetheless goes off down the road seeking others of his kind.

Matthew Shepherd and Roy Boney Jr.'s *Dead Eyes Open*—a graphic novel about civil rights for zombies—makes being dead the only functional difference between zombies and non-zombies (they can talk, they have feelings, they think, they're not ravenous for fresh human flesh), and it also tries not to trivialize it. When it comes out that a doctor, who just happens to be a zombie, is secretly experimenting on

himself—cutting open his abdomen to undertake covert medical forensic research on his strange condition—his non-zombie colleagues are disgusted by this development, though they follow good form by concealing their revulsion from him and vomiting around the corner. In this case, zombiehood becomes a cipher for illness and stigma, and the lesson is mitigating against aversion to the suffering human other, gruesome or otherwise. The questions raised by all such texts, however, concern less the ins and outs of zombie physiology than the relation of identity and its social performance. They do not necessarily ask "What is a zombie?" but rather "What does it mean when I say 'you are a zombie' or you say 'I am a zombie?'" And "What kinds of treatment and rights can be expected from one who is called a zombie?" (See Stephen Shapiro's report on zombie health care in chapter 5.)

It's hard out there for survivors, though, too. At its most theoretical, the zombie narrative asserts a "state of nature" paradigm in which, with the breakdown of sanctioned law and the rational public sphere, each survivor is forced to revisit his or her ethical principles. In fact, with its emphasis on the "extreme case," the zombie genre has risen in recent years to provide something like a vernacular forum for the study of ethical deliberation. No zombie text demonstrates this better than *The Walking Dead,* which seems with each entry more and more like an Aristotelian proving ground for the testing of moral virtue in the face of extreme passion and violence. The series—both the graphic novel and the television show—originally proved notable for showing that the basic zombie genre could be extended beyond the scope of immediate apocalypse. Splicing the DNA of both the soap opera and the horse opera into a postapocalyptic framework, writer Robert Kirkman and his collaborators turned what has always been little more than a ninety-minute countdown to death into a multiyear epic with both character

development and intergenerational conflict. And yet the series remains urgent today insofar as the circumstances of its world continue to press its characters to assess their ethical investments in the old world and its institutions: marriage, family, friendship, the law, religion, work, and so on. While examples abound, we only need point here to Dale, the bucket-hatted octogenarian and ex–car salesman. Dale's undying liberal heart comes to the fore as he makes his impassioned speech near the end of season two of the TV version, urging his fellow survivors to spare the life of a prisoner locked in their barn:

> Killing him, right? I mean why bother to even take a vote? It's clear which way the wind's blowing. . . . So the answer is to kill him for a crime he didn't even attempt? If we do this, we're saying there's no hope. Rule of law is dead. There is no civilization. . . . This is a young man's life, and it is worth more than a five-minute conversation. Is this what it's come to? We kill someone because we can't decide what else to do with him? You saved him, and now look at him. He's been tortured. He's gonna be executed. How are we any better than those people that we're so afraid of? . . . Not speaking out or killing him yourself, there's no difference. . . . You once said that we don't kill the living. . . . Don't you see if we do this, the people that we were, the world that we knew is dead. And this new world is ugly, it's harsh, it's survival of the fittest. And that's a world that I don't want to live in. And I don't believe that any of you do. I can't. Please. Let's just do what's right. ("Judge, Jury, Executioner")

"What's right" is precisely what comes into question as soon as the laws and institutions that enforce its meanings start to crumble. Yet it takes nothing less than an apocalypse to make us aware of this point, an apocalypse in which both the efficacy of these values and the man who proclaims them meet, by episode's end, an ignoble end.

Are there any famous—even celebrity—zombies?

How could there not be zombie all-stars—or, what we like to call *S-zombies* (special- or star-zombies)? Living death is such an anomalous condition. Until recently, the few exemplars who walked around after death were unfailingly sources of notoriety and controversy, and in that alone they have well-remembered names. Among the "special" zombies for an all S-zombie team, in addition to Johnny, Bub, Big Daddy, Tarman, Otto, Fido from *Fido* (2006), Eddie the Head (the mascot of the metal band Iron Maiden), and Ed from *Shaun of the Dead,* we might include Samuel and Lazarus from the Bible; Felicia Felix-Mentor and Clairvius Narcisse, two real-life Haitian zombies; Jeffrey Dahmer and Rudy Eugene, killers whose deeds have been associated with zombies; and Zombie Boy, a real person who has tattooed himself to look like a zombie.[4] For obvious reasons there are more zombie fans—deadheads, metalheads, phishheads, and so on—than there are zombie celebrities. In most cases, fictional or otherwise, names just don't stick with decaying corpses after death. Like Johnny from *Night of the Living Dead,* zombies won't answer to their former names. *Remember, Barbra, Johnny isn't Johnny anymore; he's just a zombie that wears driver's gloves.* Sometimes the living tag the dead with new nicknames, pet names—Bub, Tarman, Fido—but these don't so much designate inward as indicate outward, pointing to something terrific on the screen or something horrific up the path (see discussion of "indication" above).

And yet Western culture provides more than its share of proto-zombies, figures that, in contrast to their slaving Afro-Caribbean counterparts (which we'll turn to below), serve mostly to test the boundaries of life and death, the fragility of genealogy, and the power of creation. Among the first S-zombies is the Hebrew prophet Samuel. Samuel's strange return—through the exertions of the Witch of Endor

as requested by King Saul—provides an early version of the unhappy, abominable dead: "Why hast thou disquieted me, to bring me up?" asks the undead Samuel before prophesying Saul's downfall (1 Samuel 28:15). Bracketing all controversies about the zombie character of Jesus, the notable instance of living death in the New Testament is, of course, Lazarus—a name significantly intertwined with zombie discourse. The raising of Lazarus after four days in the tomb, stinking of death, provides an object lesson of Jesus's divine powers (John 11:38–44). The "undeath" of Lazarus—whether he remains a "dead man" after death or a "man that was dead"—gives the episode its nagging zomboid quality. "Lazarus, come out!" sayeth the zombie master (John 11:43). But why doesn't Lazarus speak? Why no proof viva voce? Is seating the undead Lazarus at the dinner table in the next chapter a normal occurrence? Does all the business about costly ointments also have something to do with masking away the stink of death away from the Seder (John 12:3–7)?

John Connolly's excellent short story "The New Lazarus" picks up on these themes. The Deadman from Bethany returns as bare life, a filthy abomination, cursed, infested with "small things burrowing in his flesh," "bloated with gas and fluids":

> His sisters are kissing him and speaking his name.
> "Lazarus! Lazarus!"
> Yes, that is his name.
> No, that is not his name.
> It was once, but Lazarus is no more, or should
> be no more. Yet Lazarus is here. (1)

Connolly's story puts a bright line under a certain embarrassment about the dead (and the more illustrious resurrection narrative it prefigures). What happens to Lazarus after all the hoopla dies out?[5] There were no

0.7. Vincent van Gogh, *The Raising of Lazarus (After Rembrandt)* (1890).

doubt furtive whispers, anxiously considered RSVPs, sudden changes in plans. But the episode also emphasizes the perennial aesthetic power of displaying the corpse, at once horrible and terrific—another decisively Western trope. The terrible beauty of Lazarus is made clear in paintings such as Caravaggio's *The Raising of Lazarus* (c. 1609), Rembrandt's *The Raising of Lazarus* (1630–31), and Vincent van Gogh's masterly copy of Rembrandt's version, which cuts Jesus out of the frame and focuses on the horrific astonishment of the onlookers (1890). (On zombies as "bare life," see Seth Morton's work in chapter 9.)

Turning from biblical zombie sources to literary ones, it's curious to find that Mary Shelley doesn't name Lazarus at all in her 1818 novel *Frankenstein; or, The Modern Prometheus.* If popular reception factored into subtitle selection, "The Modern Lazarus" might be a better choice. In the original 1931 uncensored film version, for instance, Dr. Frankenstein clearly has Lazarus on his mind when, after the more familiar exclamations, he says, "Oh, in the name of God! Now I know what it feels like to be God!" But the emphasis of the subtitle, a reference to the doctor and not the monster, speaks to a larger issue concerning naming and identity. Anyone who's read Shelley's novel knows that a perplexing mirroring of creature and creator organizes its plot. The erosion of the self's boundaries, in the creative act, defines the book's uncanny horror, from the very moment of the monster's awakening:

> It was on a dreary night of November that I beheld the accomplishment of my toils. With an anxiety that almost amounted to agony, I collected the instruments of life around me, that I might infuse a spark of being into the lifeless thing that lay at my feet. It was already one in the morning; the rain pattered dismally against the panes, and my candle was nearly burnt out, when, by the glimmer of the half-extinguished light, I saw the dull yellow eye of the creature open; it breathed hard, and a convulsive motion agitated its limbs.
>
> How can I describe my emotions at this catastrophe, or how delineate the wretch whom with such infinite pains and care I had endeavoured to form? His limbs were in proportion, and I had selected his features as beautiful. Beautiful!—Great God! His yellow skin scarcely covered the work of muscles and arteries beneath; his hair was of a lustrous black, and flowing; his teeth of a pearly whiteness; but these luxuriances only formed a more horrid contrast with his watery eyes, that seemed almost of the same colour as the dun-white sockets in which they were set, his shrivelled complexion, and straight black lips.

> The different accidents of life are not so changeable as the feelings of human nature. I had worked hard for nearly two years, for the sole purpose of infusing life into an inanimate body. For this I had deprived myself of rest and health. I had desired it with an ardour that far exceeded moderation; but now that I had finished, the beauty of the dream vanished, and breathless horror and disgust filled my heart. (35–36)

The perennial confusions between the world-famous, nameless living-corpse catastrophe and the indifferently remembered corpse reviver (was it Victor? Henry? Frederick?) is telling. It's a puzzle that cuts to the heart of the romantic ideology on which *Frankenstein* depends, a patronymic breakdown that codes the present as botched paternity for the past—or vice versa. Indeed, from Lazarus on down, the S-zombie—as miscarriage or stillbirth—seems to vex the family line, a fact most clearly reflected in its inability to maintain a proper name (the name as the name of the father). Arguably, every zombie is in search of a father—the deadbeat zombie master (aka, the *bokor*), scientist, government official who abandoned him at birth in the dumpster behind the lab. Or, better, in *Pontypool* (2009), every zombie is in search of a lost mother, not so much looking to consume human flesh, but to gnaw and burrow its way back into the womb. This family plot becomes a running joke in Mel Brooks's *Young Frankenstein* (1974), doubly marking the hilarious reunion of scientist and monster:

> DR. FREDERICK FRANKENSTEIN: Hello, handsome. You're a good-looking fellow, do you know that? People laugh at you. People hate you, but why do they hate you? Because they . . . are . . . jealous. Look at that boyish face. Look at that sweet smile. Do you wanna talk about physical strength? Do you want to talk about sheer muscle? Do you want to talk about the Olympian ideal? You are a god. And listen

to me, you are not evil. You . . . are . . . good! This is a nice boy. This
is a good boy. This is a mother's angel. And I want the world to know
once and for all, and without any shame, that we . . . love . . . him! I'm
going to teach you. I'm going to show you how to walk, how to speak,
how to move, how to think. Together, you and I are going to make
the greatest single contribution to science since the creation of fire.

INGA: Dr. Fronkensteen! Are you all right?!

DR. FRANKENSTEIN: My name . . . is Frankenstein!

Conversely, in the Wachowski siblings' *Doc Frankenstein* comic, the un-
dead creature decides to adopt his creator's moniker as a celebrity-style
brand, and with it goes on to earn PhDs; assist the causes of Abraham
Lincoln, Clarence Darrow, and abortion rights; and become a multipur-
pose liberal übermensch/secular messiah. "My name is hermeneutic,"
he says. "It has become a meaning, a symbol, a tale." Here, the instabil-
ity of the name becomes the power of self-creation, the first principle of
literary fantasy. (On zombie speech and language, see Tatjana Soldat-
Jaffe's report in chapter 11.)

Yet Frankenstein's hermeneutic universe is weirdly rich precisely
because he is as sympathetic to us as his non-name is semiotically over-
loaded. In Shelley's novel the monster speaks, reads literature, feels
things, experiences qualia, yet he's still loathsome and ultimately inas-
similable. In all this, though, *Frankenstein* isn't really a representative
zombie text. Most of the time what's scary about zombies is their blank
inhumanity and the fact that there's usually more than one. The monster
in *Frankenstein* no doubt leaves a trail of corpses behind him, but this
proliferation of death can be understood only as a product of his creator's
unnatural transgressions. If anything, the novel's influence on the zom-
bie tradition concerns the abuses of science and broken taboos about
death and the corpse, themes that are most clearly revisited in Romero's
Day of the Dead in Dr. Logan's research lab and the comic pathos that

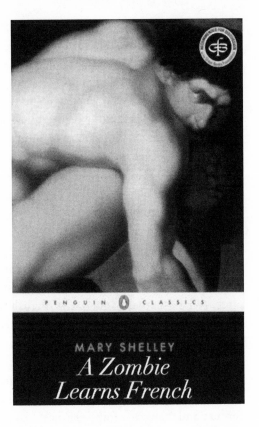

0.8. *A Zombie Learns French,*
betterbooktitles.com.

surrounds the gentle Bub's efforts to shave, read, and use a telephone. (For more zombie science, see Jack Raglin's research in chapter 6.)

What about those real-life zombies?

Paradoxically, so-called real-life zombies may have more to tell us about fictional zombies than any retrofitted genealogy of S-zombies' atavistic forerunners (golem, *draugr*, ghoul, pod people, etc.). Because real-life

zombies are not zombies (*you know this, right?*), they are more conspicuously sensationalized and thus expose the excesses of the idiom. When it comes to real-life zombies, three sorts of claimants come to mind: (1) historical-ethnographic representatives such as Felicia Felix-Mentor and Clairvius Narcisse, studied to instantiate the Haitian/West African folkloric roots of the zombie concept; (2) heinous killers such as Jeffrey Dahmer or the Bath-Salts Zombie, humans who did terrible, ultraviolent things to other humans, attackers for whom the word *zombie* has become a kind of shorthand for journalists unraveling their stratagems; and (3) Zombie Boy, a (real, living, non-zombie) person who is a passionate fan of zombies (an *F-zombie*), who has altered his physical appearance to seem more zombielike.

Beyond anything else, these supposed real-life zombies bring to the fore the colonizing powers of *zombie* as a word and a phenomenon. Unlike other pop culture monsters—ghosts, ghouls, werewolves, vampires—whose names came to the English language through European folklore, *zombie* comes into the lexicon from non-European sources, carrying an etymology, according to the *OED*, "of W. African origin; compare Kongo *nzambi* god, *zumbi* fetish." The *OED*, in fact, gives several instances of the word used as "the name of a snake-deity in voodoo cults of or deriving from West Africa and Haiti" from the nineteenth century and then cites, for the earliest instance of the word used to mean "a soulless corpse," William Seabrook's hit, sensationalist account of Haiti, *The Magic Island,* published in 1929.[6] "At this very moment, in the moonlight," Seabrook intoned, creeping out his American readers, "there are *zombies* working on this island, less than two hours' ride from my own habitation" (94; italics in original).

A decade later, in *Tell My Horse: Voodoo and Life in Haiti and Jamaica,* Zora Neale Hurston published an ethnography that, in its consideration

of this same theme, attempts to avoid Seabrook's sensationalism, or at least counters it with her own. Hurston had applied for a Guggenheim fellowship and traveled to Haiti to conduct research and interviews. Focused on a series of local zombie tales and one startling photograph, her account frames the Haitian-zombie, or historical-zombie (*H-zombie*), within the legacy of slavery. Folklore, in her account, no matter how outlandish, serves as a negotiation of material history, with the zombie stalking the colonial horizon as the dehumanized refuse of imperial capital. Despite her documentary claims, though, Hurston's text is most notable for its own folkloric bent and subtle play with voice and narration, features that complicate the startling photograph of Felicia Felix-Mentor that centers her presentation. "What is the whole truth and nothing else but the truth about zombies?" Hurston writes. "I do not know, but I know that I saw the broken remnant, relic, or refuse of Felicia Felix-Mentor in a hospital yard" (179).

Marina Warner objects to Hurston's lack of sympathy for her subject, complaining that the photographic image of Felix-Mentor in *Tell My Horse* reenacts the kind of soul theft that Warner posits is the essence of zombie-ism: "Felicia looms into the lens, her body tilting, her arms lifted, her gaze blind, her face blurred in shadow. . . . [The image] only allows its subject a desolate and tormented vacancy" (*Fantastic Metamorphoses* 131). Yet the actual photograph—also printed in *Life* magazine—gives the episode a strangely ruined Sebaldian flavor in the context of Hurston's research project. Hurston calls it elsewhere the first and last photograph of its kind, suggesting that photographic documentation might rescue a zombified person from oblivion by providing a kind of restitution of identity. In 1945 one Louis P. Mars, MD, published another account of Felix-Mentor in *Man: A Record of Anthropological Science,* making a related case:

> Her occasional outbursts of laughter were devoid of emotion, and very
> frequently she spoke of herself in either the first or the third person
> without any sense of discrimination. She had lost all sense of time and
> was quite indifferent to the world of things around her.

Felix-Mentor is not a container emptied of its content, a lifeless husk. Rather, she is refugee, homeless, displaced, dispossessed—a victim of colonial possession (a variant of voodoo possession) as dispossession. In fact, the photograph is nothing without its accompanying narrative. Hurston presents Felix-Mentor as a victim of patriarchy and colonialism both; her book merges folklore and ethnography to craft a sympathetic tale of a woman abandoned and betrayed by cowardly male exploiters. (For issues related to zombies and race, see Edward P. Comentale's findings in chapter 8.)

Later in the twentieth century, H-zombies abandon their masters (and their dullness) and become free-range roamers. Some early Caribbean tales ended in anarchy, but only because H-zombies, after tasting the master's salt, wanted to return to their graves.[7] Their true revolutionary fervor would erupt only later, on American soil, in the work of Richard Matheson and then Romero, in the context of suburban boredom, the Cold War, and civil rights (see below).[8] But because H-zombies depend on a notion of the remaindered human—remnant, relic, refuse, enduring ruin, unworried by signs of interiority—they remain today redolent with folk philosophical, psychological, and anthropological import. For example, the elaborate thought experiment about philosophical-zombies, or *P-zombies,* by analytical philosophers depends on the H-zombie puzzle that there's no way to tell the difference between someone who has a "mind" (or "consciousness," or "qualia," or "understanding") inside and someone who doesn't if their outward behavior is identical.[9] Most movie zombies are spotted the minute they loom onto

0.9. Felicia Felix-Mentor, "the broken remnant."

the screen, but some still test their audiences' power of discernment. From the Romero canon, Roger's turn in *Dawn of the Dead,* for example, may best illustrate the P-zombie point. The precise moment his lights turn out is inscrutable; it happens under a sheet, as it were; we only know Roger is not Roger when he's green.

Nearly four decades after the photographing of Felix-Mentor, Wade Davis, working on his Harvard doctoral dissertation in anthropology

0.10. Clairvius Narcisse, "marked for all time."

and ethnobotany, traveled to Haiti to search for local H-zombie informants as well as "zombi powder," the potent mixture of chemical compounds, poisons, beliefs, and practices that he hypothesized might, in the right proportions, cause actual physiological zombification. Beware all fugu! From a "straight" pharmacological perspective, we now know, "The composition of the powders varied widely: each one was a witch's brew of strange ingredients, including toads, tree frogs, snakes, lizards,

centipedes, and sea worms. However, three classes of ingredients were common to all the preparations: (1) charred and ground bones and other human remains, (2) plants with urticating hairs, spines, toxic resins, or calcium oxalate crystals, and (3) puffer fish."[10] (On the relation between zombies and another kind of evil potion, see Stephen Schneider's report on zombie cocktails in chapter 14.)

Davis always insisted that the potion produced a state of suspended animation that only *imitated* death, but he never denied the culture of terror that informed the zombification ritual. In Haiti he tracked down another H-zombie, Clairvius Narcisse, whose case supplied him with much of the evidence for his PhD. Zombified by a malicious relative in 1962 over a land dispute, Narcisse "died," was entombed, exhumed, reanimated, and then impressed into forced labor for a period of time, from which he eventually escaped. Decades later some of Narcisse's relatives (more sympathetic ones, we gather) stumbled upon their "dead" kin shambling around and reinstated him into their community. In this, for Davis, H-zombie-ism proved to be an ethno-chemically enhanced ostracism, "a form of social and spiritual death, and so someone who's been made a zombie is marked for all time. No one wants them."[11] Like Hurston, Davis associates the H-zombie with a folkloric legacy of slavery that naturally asserts that some forms of labor are worse than death. As Davis puts it (echoing Seabrook, if only incidentally), the menace of H-zombies turns on "not of being harmed by zombis, but rather of becoming one" (*Serpent* 139).

**Ok, then, H-zombies sound kinda tame.
What about the real-life killers?**

In a sense, *zombie* means much the same in the context of Davis's research as it meant during the trial of Jeffrey Dahmer, which began on

January 30, 1992. Dahmer's deranged objective in his grisly killings of seventeen victims, according to his defense team, was to create zombies, docile slaves to his (sexual) bidding.[12] In this he followed the H-zombie blueprint, imagining himself as a malevolent zombie master. The idea that he was trying to create zombies wasn't merely a feature of his legal defense or a handy framework supplied by media coverage; it also played a prominent role in his own obscene efforts to divulge his motivations in subsequent television interviews.[13] As media spectacle, Dahmer speaks of feeling "so hopelessly evil and perverted." He wanted to "possess [his victims] permanently," to "control them." Saving skulls, skeletons, and body parts, eating hearts, and taking Polaroids were simply his attempt to commemorate their failed role in his work.[14]

And yet Dahmer is sometimes called the Milwaukee Cannibal, a moniker that shifts his role in the common trope. In a sense he exists at the uncomfortable intersection of two zombie definitions: the H-zombie, in which the zombie is a figuration of life-in-death (a human automaton worked by remote control by a malevolent zombie master), and the R-zombie, in which the zombie figures as an ultraviolent example of death-in-life, material evidence of the (increasingly) macabre inhumanity of real-life humans to other humans.

The latter definition of zombie—the R-zombie—remains the ruling hermeneutic when it comes to celebrity zombies today. Take the 2012 case of the so-called Bath-Salts Zombie, Rudy Eugene, who was allegedly tweaked out not on zombie powder or muriatic acid injected in his skull, but on bath salts, a slang-term for a type of designer amphetamine (a claim that subsequently turned out to be untrue; it was simply marijuana). Eugene made headlines for chewing the face off of Ronald Poppo, a homeless man. Let's bracket whatever brought him to this deed (and his death through lethal force by the police) and focus on what it means to identify him as a zombie. Not long ago it would

have been sufficient—sensationalist enough for headline writers, that is—to describe Eugene as a cannibal. There's no suggestion in any of the public accounts that Bath-Salts Zombie was actually undead, let alone controlled by an evil master, only that the undead zombie has, in effect, replaced the cannibal as a living category for understanding certain incomprehensibly violent acts.

That Eugene's attack involved chewing the *face* of the dispossessed seems evocative of the zomboid turn in Romero's work: an extreme failure of sympathy for the other that radically enacts the typical disregard that homelessness elicits. But this brutality no doubt cuts both ways. The public framing of such heinous figures as zombies or cannibals raises significant issues for the modern discourse of human rights and citizenship. Playing the "zombie card" here not only brings a primitivizing logic to bear on the case but also loosens both figures as well as their prosecutors from any humanist accountability. Moral culpability vanishes in a voodoo haze, removing such incidents and their aftermath from the moral grounding of the law. Eugene, in the extremity of his act, received no due process. Far from it, he was immediately dispatched, most likely by a shot to the head. (And, as of this writing, his victim remains blind and disfigured, a permanent resident at the Jackson Memorial Perdue Medical Center.)

One telling feature of this incident is that Bath-Salts Zombie's mother strongly objected to her son's designation in these terms:

> "He was a good kid. He gave me a nice card on Mother's Day. Everyone says he was a zombie. He was no zombie. That was my son," the mother, who asked that her name not be revealed, told CNN affiliate WFOR.[15]

No one wants his or her son to be remembered as a zombie, one would think. Ironically, though, the ruined fragments of moral economy in this last vignette is what makes the news item most typical of zombie

worlds: a chewed-off face, a Mother's Day card, a name not revealed. The credit of a card on Mother's Day doesn't offset the wholesale human debasement of this horror show, but it does supply a nugget of pathos for representing maternal loss amid ultraviolent wretchedness.

But people want to be zombies all the time. What about the F-zombie, the zombie fan?

Yes, it's true. Despite the claims of Eugene's mother, some people do want to be known or remembered as zombies. The punk movement of the 1970s—with its anarchic violence and "No Future" sloganeering—comes closest to embodying the negative ethos of the zombie apocalypse. The Sex Pistols and their hooligan fans performed negation upon negation, eating through the discourses of nation, capital, fashion, and ultimately rock itself, performing ugly, undead covers of songs they no longer loved. As anti-star, Johnny Rotten had perfected the blank zomboid stare ("pretty vacant," he'd chant), a catatonic pose broken only by bursts of ritual blood-shedding both on and across the stage. In fact, in describing the destructive pleasures of punk youth—squatting, stealing food, destroying furniture, gobbing—Rotten once remarked, "You remember *Dawn of the Dead,* where the zombies are in that huge department store. That's what it was like. A dream come true." He defined his bonked-out mindlessness as a "good pose." "The kids want misery and death," he claimed, "they want threatening noises, because that shakes you out of your apathy."[16] Like the zombie, punk can't die, because it's already dead. The movement mocks its own alienation, working the death of death in its very image—white face makeup, bloody lips, broken chains, straitjackets, and shit-kickers. For Dick Hebdige, punk—as an impossible mash-up of glam nihilism and reggae revolt—presents itself as "blank, expressionless, rootless," expressing in its emptiness,

0.11. Zombie Punks—"My God, they're eating each other."

its own self-mockery, "a condition of unmitigated exile, voluntarily assumed" (65–66). Similarly, Greil Marcus, in his book *Lipstick Traces,* follows the punk un-ethos to its apocalyptic end in order to find something vital on the other side: "negation is the act," he writes, "that would make it self-evident to everyone that the world is not as it seems—but only when the act is so implicitly complete it leaves open the possibility that the world may be nothing, that nihilism as well as creation may occupy the suddenly cleared ground" (9).

A more recent case is provided by Rick Genest, or Rico the Zombie, or Zombie Boy, if you will, a punk-rocker-cum-fashion-icon who plans to secure his own horror film franchise and whose image has

been co-opted by Lady Gaga for her "Little Monster" scene. Zombie Boy exemplifies the F-zombie insofar as he construes that the proper way to like zombies is to seem to become one—forever. Whereas most zombie mimicry can be removed with a tub of cold cream, Zombie Boy has tattooed a permanent lesson about zomboid anatomy on the surface of his body, a map that he describes as an "anarchistic transitive pictograph verbalization to the world." In the Frankenstein's monster tradition of the sensitive zombie, Zombie Boy provides an able reading of his motivations:

> The common thought of zombies [to] many represents a pervasive xenophobia. As in my life, I was often out-casted, hated or misunderstood for being so. The zombie concept is also often used as a metaphor for runaway consumerism. This is the idea that we live through the notions without reflecting, as a commercially programmed bio-organism. Rebelling from this notion is the very meaning of punk; defining the tenuous line between civilization and barbarism. Understanding that the first step to anarchy is defiance; the notion of being alive while dead, is defiance to the very laws of nature itself.[17]

Zombie Boy's speech brings together several interpretive strains of zombie-ism, but his zombie state, like some nonhuman Narcissus, unmanifests itself by turning the project of self-fashioning inside out. A fair conjecture is that Zombie Boy's skin suit makes him a magnet—or, better, a target—for all kinds of theories about zombies. One imagines zombie concepts stalking Zombie Boy as if he were the living avatar of a first-person shooter. *Hey, Zombie Boy, what do you think of the nonhuman condition in the era of advanced capitalism? Is your fame a statement on the emptiness of celebrity culture or the viral nature of contemporary pop culture?* Now, he's shirtless; now, dressed in zombie drag; now, with tattoos buried under concealer, he's subhuman and proud of it. Later,

0.12. Rico the Zombie Boy.

playing P-zombie, exhibiting mere surface without mind, he's scaring the punters with a frightening dumb show—aestheticizing mindlessness as punk, urban camouflage. Yet the concept of self that defines Zombie Boy's tattoo experiment, like identification with zombies more generally, is paradigmatically about an anamorphic transposition of insides and outsides. These theories make sense less as truth claims about the zombie condition than as efforts to map the social-historical body that make zombies possible.

While it's not advisable to follow any single F-zombie's fixation on what does or does not count as a zombie, we propose that collective fiat matters more than pedantic purism when mapping zombie worlds and what's worth knowing and thinking about them. By design, *The Year's*

Work at the Zombie Research Center follows Condorcet's jury theorem: what matters to us is what's recognizably zomboid in the context of zombie worlds. As fans and scholars, we like to think of zombies as fragments of genre conventions freed—or, better, unstuck—from any one particular ancestral medium and thus available for tattoo work. Above all, we read Zombie Boy as Zombie Queequeg, mapping his body with assorted undead cartographies, but unlike Melville's Polynesian harpooner, Zombie Boy can't make a coffin upon which to redraw this map of self and world. As the International Necronautical Society reminds us, Queequeg's tattoos

> represent the layout of the earth and heavens according to Queequeg's people's belief, and thus form "a mystical treatise on the art of attaining truth." Yet, as [the tattoos] cover his whole body, Queequeg cannot see them, and so needs to copy them—that is, himself—onto another surface, projecting space in the manner of a cartographer. (2)

Conceived and written by sympathetic F-zombies with advanced degrees, *The Year's Work at the Zombie Research Center* is designed, in effect, as that second surface for re-encryptions, a navigation handbook for a futurist-critical thinking about zombie worlds.

How do I spot a zombie?

Again, it's not entirely helpful to cling to purist criteria. A zombie by any other name would still smell as un-sweet and so forth. Some zombie fans run on pedantically about how to spell words like *zombie,* or whether zombies are allowed to run, or whether zombies must stick to a brains-only diet. "Did we just watch a 'zombie' movie?" we're asking, after watching *Invasion of the Body Snatchers* (1956) or *The Birds* (1963) or *Assault on Precinct 13* (1976) or *Zulu* (1964) or even Ionesco's

ZOMBIE BINGO

Zombie Attack!	Humans fight each other when they should be fighting zombies	Running from zombies	A zombie eats a former family member	A woman is scared
One human betrays another	A man is angry	There's a news report about zombies	**People arguing about how to fight zombies**	Zombies break in and grab people
Someone has a brilliant idea that ends badly	Zombies shamble around	☠ **FREE SPACE**	Boarding things up to keep out zombies	Explosion!
Zombies eating people	A character who's been "sick" the whole movie turns into a zombie	People shoot at zombies	People gather weapons for fighting zombies	People talk about how they escaped the zombies
Several people are angry	Someone screams	Zombies cause a car accident	**A body that's been eaten by zombies is discovered**	FIRE!

Fun Fact: ZOMBIE BINGO works for pretty much every zombie movie. Try it at home!

0.13. Zombie Bingo.

play *Rhinoceros* (1959). "Are those 'zombies' just sick?" we wonder while watching *28 Days Later*. Do walking skeletons count, à la *Army of Darkness* (1992)? What about *The Mummy* (1932)? Are S-zombies, H-zombies, R-zombies, P-zombies, and F-zombies really distinct from one another? Don't they always ultimately eat through their own classificatory schema? When it comes right down to it, to the level of bullets and bloods, shouldn't we speak only of *Z-zombies*? Otherwise, this kind of exercise quickly becomes a kind of zombie movie bingo.

Something may be zombie, if it (1) is named *zombie* (or, some equivalent word; i.e., *thing, walker, roamer, geek, biter, lurker, flesh-eating ghoul, shuffler, biter, creeper, deadite, infected, skel, draugr, crazie, zed, zeke, zack, asshole, a-hole, z-hole*, etc.; (2) looks like an animated corpse; has an abject/repulsive body; seems actually composed of a corpse or someone who is now dead; (3) preys on the living ("cannibalism"); attacks by biting, scratching, and grasping ("infection"); (4) is relentless, hostile to the living; (5) exhibits mindlessness, weak-mindedness, automatism; (6) assembles by hording, swarming, massing; and (7) can be killed with moral impunity; will kill and "die" by ultraviolent means. Zombie texts may include one, some, or all of the following zomboid ingredients: the above-mentioned BINGO categories; fast zombies; slow zombies; naked zombies; zombies in suits; zombie dogs; (mad) scientists; professors; voodoo; transmissions of the Emergency Broadcast System; people in hazmat suits; faceless military; garden implements, including chainsaws; canned goods; zombies using tools; using zombies as tools; BRAINS!; toilet humor; enumerations of rules; commodity hording; boards nailed to windows and doors; corpse cannibalism; a basement; an attic; a graveyard; fumbling with keys; projectile blood vomiting; a roof scene; a helipad and a helicopter; infections; an arsenal; child zombies; a pop-out red herring; viscera; talking zombies; zombie sex; etc., etc., etc. We think the best way to engage the problem

of zombie research in cultural theory is to consider each zombie world as a self-organizing ecology, each fulsome with sticky and sufficient, but not necessary (or wholly arbitrary), conditions. In other words, it's less important, we submit, that a zombie text has actual zombies in it than that it situates us in a zombie world. (On the inconsistent consistency of zombies and zombie worlds, see Aaron Jaffe's report in chapter 2.)

Step back from zombies—always advisable with things that bite or scratch, at the zoo, for instance, or wading among sea urchins—and take a look at the larger horde. Conceptually, you'll find yourself immediately confronted with the category of *the undead*. On the one hand, *the undead* is allegedly a more general set—a greater whole that includes any number of other popular or folkloric monsters, ghosts, and vampires, most prominently. On the other, *the undead* is just another word for zombies, infecting all such creeps and ghouls with its significance. *Undead* is both a limiting synonym and an expansive umbrella term. Several universal horror monsters rate as undead, of course, including, most obviously, Boris Karloff's Frankenstein monster. The undead S-zombie, who learned French, becomes way more R-zombie on screen when he's deprived of speech. Bela Lugosi's Dracula—the undead sexual predator on a liquid diet—provides another bridge to R-zombie. In the 1930s Lugosi starred as a wicked H-zombie controller in *White Zombie* (1932), its plot loosely derived from Seabrook's lurid accounts of H-zombies working in the cane fields, but it's mostly a cheap rip-off of *Dracula* (1931) set in Haiti, filmed on the very Hollywood sets that were cinematically transposed from Transylvania. Lugosi is a corporeal bridge between H-zombies and R-zombies, not only for his work in the 1930s but also for his involvement in a host of schlocky 1950s horror properties that involved space vampires, space zombies, and radioactively reanimated corpses, notably, in the camp classic *Plan 9 from Outer Space* (1959). "Unstoppable horrors from outer space paralyze the living

and resurrect the dead" is how the poster puts it, in an idiom obviously zomboid today, but fifty years ago it could only be described in terms of an outbreak of space vampires.

Several years before this, in 1954, Richard Matheson's *I Am Legend* extended the conceptual overloading of the undead by bridging vampire and zombie in a less campy vein, folding potent postwar fears about scientific disaster, monstrous demography, and out-of-control contagion into the H-zombie conceptual terrain. In effect, zombies in this period provide the generic clearinghouse and switching station for the undead as such—submerging the literary inheritances of the gothic and the ghost inside other kinds of fringe monstrosities, co-opting legally unprotected pulpy things from beyond, from outside, from underground—including the H-zombies from the Caribbean and West Africa, as well as aliens, other autonomous things from outer space, and mutated walking cadavers from the underground pulps. This point isn't so much one of literary-cultural philology—influence mugging, filiations, derivations, genealogies, and so forth. Instead, the sum of the work in *The Year's Work at the Zombie Research Center* demonstrates that *zombie* is a loose, incomplete conceptual morpheme, a kind of obscenely detached cultural-semiotic prefix or suffix, that stalks around a number of weird worlds with its entrails dragging in tatters behind it. In fact, there is no such thing as a zombie unbound, a "compleat" zombie; it only exists as meaning (grammatically, even) in its sloppy, negative relation to other meanings. Zombies are, in effect, synonymous with the *un-* part of the word *undead,* and only thus, in their negativity, attain their much greater size and weight in terms of semantics, culture, and politics.

In other words, the potent conceptual work of the zombie depends decisively on its in-sufficiency, or, rather, un-sufficiency; it inspires us to think precisely in its aversion and hostility to all thought. To be as

inclusive—catholic, eclectic—as possible about zombie research, then, we would highlight no more than two particular conditions focusing on the *un-*: first, the rapacious death drive centered on and emerging from the deathliness of the crypt, as it were; and, second, feelings of confusion and anomie toward ruined figures within a ruined horizon, aggressive ontology without metaphysics. In other words, it is our belief that a sufficient scholarship on zombies entails thinking through insufficiency—or, again, un-sufficiency—the un-sufficiency of our current knowledge, our working methods, our inherited theories, our own results. The chapters in this research manual all lead with the *un-*, with death and suspicion, *un*-grounding and *un*-doing the terms and claims of our own field and research, of dead scholarship in the sciences and humanities, in order to make them walk once more.

Wait, what exactly does the *un-* in *undead* do?

The prefix *un-* indicates negation, as everyone knows. And *dead* also designates a negative fact—the negation of life. *Undead,* strictly speaking, means lack of death, lack of non-life, but the double negative doesn't convey a simple reversal, for the un-dead are no longer (not) alive. The word carries weird pleonastic powers; it packs in the superfluous meanings. *Undead,* as if *dead* were not enough, works something like *overkill* through *underkill,* as in the expression "I couldn't care less," for instance. The minimal degree of care here seems to announce something else. Not just reversal (a certain kind of caring), but redundancy, perhaps, or excess. The R-zombie double tap from *Zombieland* is a case in point, as is the pink pile of Sno Balls that tumbles out of the Hostess truck; both are simply an expression of the empty excess, the bingeing—binge eating, binge dying, binge gore, binge theory—that marks the tradition at

large. To be undead is just to continue with more ending, as Dr. Logan theorizes: undead means more. The *un-* weirdly turns subtraction into addition.

In this light, compare a word that's related—if not precisely synonymous: *immortal. Im-* (or *in-*) is the Latin prefix equivalent of *un-,* and *mortalis* means *death.* "All men are mortal," so the syllogism goes. Although the constituent parts of both words seem to mean the same (*im-mortal* literally meaning *un-dead*), the Latinate version carries more obvious associations with the divine, the sacred, the metaphysical, than does the vulgar Anglo-Saxon one. Hence, vampires tend to fancy themselves as "immortals" rather than "undead." Mortality implies being unto death, which immortals lack, and for this reason they are grandly impossible beings (as stated above, "I am immortal" is an impossible proposition). Again, though, double negations abound. Immortals, unlike the dead, have special bodily integrity, invulnerability, invincibility. Zombie bodies, on the other hand, are decidedly vincible and vulnerable. The negations of invincible and invulnerable are clear, whereas vincible means something like subject to overcoming, but thus raises its own weird absolutism, its strange primacy or integrity. *How much undoing can it stand? How much of the body can be lost before it becomes a nobody? Two limbs? Four limbs? A head?* Unlike the words *invincible* and *invulnerable,* the root of *integrity* is troublesome. *Integrity* and *integer* have the same root. The whole is not a fraction, but a thing complete in itself, from the Latin, "intact, whole," from *in-,* "expressing negation," and *tangere,* "to touch." The zombie's unwholesome body can't be touched without hazard, and *un-* (as "zombie-") marks that; the touch (signaled by the prefix) defiles the wholeness for the survivor. But the zombie can touch all bodies in turn, incorporating (*un-*corporating) them into its own (rotten) integrity. Again, less is more. Not surprisingly, research

into zombie fixation takes us from prefixes like *un-* or *sub-* or *in-* or *ab-* to the ubiquitous need for suffixes that suggest entire zombie worlds: *-human* and *-oid* and *-abilities* and *-strophe* and *-ocaust* and *-ageddon* and *-pocalypse.*

What does the *un-* do in zombie worlds if not give us a suitable zombie injunction—namely, "get used to living with less"? Get used to deprivations: "There is no army, no government, no hospitals, no police, it's all gone. . . . No phones. No computers," Rick tells the prisoners (*Walking Dead*, "Sick"). Un-deading the dead won't make them live again, and yet they live again. *Un-* unleashes death from its hiding places and visits it on the living in the open as if deadness is the new normal. Philip Larkin's poem "Talking in Bed" captures the vortex of negation behind the zombie fixation in zombie worlds, even if its zombie characters cling more to the P- than the S- (or R- or H- or F-) formula:

> Talking in bed ought to be easiest,
> Lying together there goes back so far,
> An emblem of two people being honest.
>
> Yet more and more time passes silently.
> Outside, the wind's incomplete unrest
> Builds and disperses clouds about the sky,
>
> And dark towns heap up on the horizon.
> None of this cares for us. Nothing shows why
> At this unique distance from isolation
> It becomes still more difficult to find
>
> Words at once true and kind,
> Or not untrue and not unkind.
> (*Whitsun Weddings* 27)

There's no reason why war or apocalypse should lead to anything like the true or kind. The zombie attack seems both to carry us toward presence even as it steals it away again. We see something of this experience—at once affective and critical—in nearly every scene of *The Walking Dead,* in the bewildering melancholy that defines the new normal in its carefully staged zombie world. Most poignantly, it marks the final living exchange on the prison bridge between an estranged Rick and Lori—faraway, so close! After all the small talk, a bit of postapocalyptic housekeeping—"We'll start cleaning tomorrow. . . . For the record, I don't think you're a bad mother. . . . We got food. Hershel's alive. Today was a good day"—Lori finally says what needs to be un-said: "Maybe you come out here to talk about us. Maybe there's nothing to talk about anymore" ("Sick").

It is in this catastrophic undoing of the said and the unsaid, in the uncanny gap between dead and undead, presence and absence, more and less—the new normal—that *The Year's Work at the Zombie Research Center* presents something like a scholarship of sufficiency. Indications over expressions, orientations over metaphors, ecologies over epistemologies: we arm ourselves sufficiently—lightly, loosely, tactically—for academic survival, measuring again and again, as scholar-shepherd-survivors, "strength relative to world."

Be specific. What can professors tell us about zombies today?

About two-thirds through *Night of the Living Dead,* Ben and Tom find a television set, prop it on two dining room chairs, and plug it in. Barbra sits vacantly on the couch. Judy is in the basement tending Karen, the ailing, slowly zombifying Cooper daughter. Helen Cooper is taking a drag on a cigarette while Harry Cooper paces around, being as patronizing as ever: "You better watch this and try to understand what's going

0.14. This Is Only a Test.

on," he barks at Barbra. Ben reminds him who's in charge: "I don't want to hear any more from you, mister! If you stay up here, you take orders from me! And that includes leaving the girl alone!" This isn't a democracy anymore, Rick Grimes would say, as if it ever was. Never the voice of reason, Harry Cooper makes a bit of sense for once—nothing should stop us from trying to understand what's going on—even if, in truth, there's little hope for the likes of men who talk back to the television.

Finally, Tom gets a signal on the TV and suddenly everyone hushes up: "It's on! It's on!" As the squabbling survivors fiddle with the rabbit ears, tuning in to catch a bit of the evening news broadcast, it becomes clear that the group of people holed up in the abandoned house are really just fighting about what's on the TV. Tuning in, more than ever, means differentiating signals from static, gleaning bits of information from all that noise. When the program finally comes on, they turn up

the volume and listen desperately for updates, knowledge: "Don't hide inside behind locked doors in abandoned rural houses. Make your way to the emergency rescue stations. Please stand by."

The following is a test of the Emergency Broadcast System. This is only a test.

The zombie is passing through our ruined zeitgeist. It's the perfect anti–spirit totem for a world that feels wholly deprived of spirit and time, in which commercial belonging, imagined community, and pre-fabricated care are the only communal thing really on offer, a world in which the prevailing affective dispositions seem to run either to panicky terror or feverish lust. All plans hatched by the living—alternatives, occupy movements, green agendas, radical maneuvers of art—get curb-stomped by a death-and-money cult that seems to run automatically, endlessly devouring everything, incorporating everything, assimilating everything.[18] KEEP CALM AND CARRY ON?!! How's that, when it's *into* everything? When everyone is already infected? That's the secret of Dr. Jenner, the last man standing at the CDC, by the way. The zombie-world zeitgeist is a pathology that punks even the most punk of all punks, Zombie Boy. Its rules of endless growth, endless acquisition, find perfect cultural expression in the Z-word: ubiquitous insecurity and relentless drive are the very qualities that organize zombie zeitgeist.

But professors also play their part in zombie worlds. H. P. Love-craft's protagonists are often professors, demented tenured radicals at Miskatonic U. Victor Frankenstein and Herbert West are also professors, their research distinguished only insofar as it dispenses with the human-consent paperwork. Zombie research is a major theme of the third film of Romero's saga; Dr. Logan tries his version of social behavioral psychology on his zombie test subject: "Civil behavior is what

distinguishes us from the lower forms. It's what enables us to communicate. To go about things in an orderly fashion, without attacking each other like beasts. Civility must be rewarded. . . . If it isn't rewarded, there's no use for it." The third season of *The Walking Dead* charts a similar course with Milton Mamet, an adjunct professor somewhere with outstanding student loans before the fall, perhaps. Milton still wants to ask research questions: "Do you think they remember anything? The person they once were?" ("Walk with Me").

Back in the living room in *Night of the Living Dead,* the emergency rescue stations scroll by on the bottom of the screen, and the program cuts to the newsman interviewing three experts emerging from a high-level meeting in a government building: the public official, the general, and the professor. As Merle puts it, "this ole world gets smaller towards the end" ("Sick"). Where the bureaucrat offers empty reassurances in the face of the crisis ("We're doing everything we can") and the soldier dissembles ("I'm not sure that that's certain at all. . . . I don't think that's been irrefutably proved"), it falls to the professor to profess some ideas in the face of cynical reason and indiscriminate nihilism, to keep posing questions, to try to winnow some information from all the rampant chatter.

What sort of "pure" knowledge remains? On *The Walking Dead* the governor expresses familiar frustration with Milton's attempt to "impose logic onto chaos": "What does it buy us?" he complains, "More questions, more theories, but no answers?!" ("Walk with Me"). There are massive numbers of superficial and ignorant a-holes in academia who are in "too much of a hurry to go deeply into the subject"—managers, administrators, bureaucrats, massive open online course (MOOC) techno-Benthamites, shoddy journalists, sub-mediocre students, deep-pocketed speculative investors—all of whom are saying precisely as much as they conspire in their zomboid efforts to vocationalize and

financialize the delivery of higher learning (Bady). The discourse is everywhere straight zombie world:

> If you don't get on the MOOC bandwagon, yesterday, you'll have already been left behind. The world has already changed. To stop and question that fact is to be already belated, behind the times. (Bady)

But take down this note from Aaron Bady: "[W]e need to slow things down and figure out what the heck we're talking about." There is still time to think—even, or, perhaps especially—with no instrumental gain or end in sight.

"Do you feel there's a connection," the professor is asked, in the footage on TV, in *Night of the Living Dead*, "between this and that?" "Yes," says the professor, "there is . . . there is a definite connection." There's an unusual amount of *this* in connection with *that . . . enough to cause mutations in certain circumstances.* We at the Zombie Research Center support this conclusion: there are definite connections and some possible connections. We leave causation and correlation to the hard and soft scientists, respectively, and, as a group of humans—humanists mostly, we should say, from before Z-day, that is—we still focus on connections, sufficient connections between ceaselessly changing and truly dangerous conditions: a very high degree of radiation regarding the zombie phenomenon is causing all kinds of mutations.

That's all the information we have at this time. This was only a test. We need more tests.

So what should we do if we see an actual zombie?

Well, there's no problem. If you have a gun, shoot 'em in the head. That's a sure way to kill 'em. If you don't, get yourself a club or a torch. Beat 'em or burn 'em. They go up pretty easy.

Notes

1. See Radiolab, *Patient Zero.*
2. See McGurl, "Zombie Renaissance."
3. See Jean and John Comaroff, "Alien-Nation."
4. On second thought, there is certain to be a zombie version of any given celebrity, made to order, ready to be called forthwith from the Internet with the right search terms; see http://wilwheaton.typepad.com/wwdnbackup/is-this-the-end-of-zombie-wil.jpg. Furthermore, celebrities have particular undead abilities as earners beyond death; see, for instance, Top Earning Dead Celebrities, http://information2share.files.wordpress.com/2011/09/top-earning-dead-celebrities-of-the-decade.jpg.
5. See here Nick Cave's album *Dig, Lazarus, Dig!!!* Commenting about the album on his website, Cave writes:

> Ever since I can remember hearing the Lazarus story, when I was a kid, you know, back in church, I was disturbed and worried by it. Traumatised, actually. We are all, of course, in awe of the greatest of Christ's miracles—raising a man from the dead—but I couldn't help but wonder how Lazarus felt about it. As a child it gave me the creeps, to be honest. I've taken Lazarus and stuck him in New York City, in order to give the song [the title track], a hip, contemporary feel. I was also thinking about Harry Houdini, who spent a lot of his life trying to debunk the spiritualists who were cashing in on the bereaved. He believed there was nothing going on beyond the grave. He was the second greatest escapologist, Harry was, Lazarus, of course, being the greatest. I wanted to create a kind of vehicle, a medium, for Houdini to speak to us if he so desires, you know, from beyond the grave. (http://www.nickcave.com)

6. Recognizing the fraught history of pop cultural appropriations of Haitian religious practices, our practice is nonetheless to follow more conventional English usage (*voodoo*)—except when referencing actual religious practices (*vodou*). In most cases, we're suspicious of the impulse to invoke more accurate or authentic naming practices concerning zombie folk.
7. See Hutter, "Salt is not for Slaves."
8. In a February 14, 2008, interview with Mariana McConnell for the website Cinema Blend, George A. Romero said: "I ripped off the idea for [*Night of the Living Dead*] from a Matheson novel called *I Am Legend*. . . . I thought *I Am Legend* was about revolution. . . . [His book has] one man left; everybody in the world has become a vampire. I said we got to start at the beginning and tweak it up a little bit."

9. See Chalmers, *The Conscious Mind,* and Dennett, "Unimagined Preposterousness."

10. See Hahn, "Dead Man Walking."

11. Qtd. in Toohey, "American Story."

12. See Lea, "Modern Zombie Makers."

13. "Jeffrey Dahmer Stone Phillips Interview," http://www.youtube.com/watch?v=vPMBfX7D4WU (accessed May 1, 2013).

14. "Jeffrey Dahmer 2 of 2 Inside Edition Interview," http://www.youtube.com/watch?v=COKYJdoUV2w (accessed May 1, 2013).

15. Qtd. in Martinez, "Tests in Cannibalism Case."

16. Qtd. in Savage, *England's Dreaming,* 119, 121–22.

17. Qtd. in Gladwin, "Interview."

18. We're thinking here of not only of Jack Laughner's drawing but also Tim Etchells's comments on opening night as the new artistic director of the Hebbel am Ufer theater in Berlin; see www.hebbel-am-ufer.de/videobotschaft-etchells.

STEPHEN WATT

I wasn't a sex symbol, I was a sex zombie.

Veronica Lake

Two scenes in Ruben Fleisher's *Zombieland* (2009) emblematize key psychical and affective dimensions of much zombie culture, dimensions that are often subordinated in critical discussions to such terms as *terror* or *horror* or neglected altogether. At first glance the earlier of these scenes seems almost silly—so much fodder for gifted actors to exploit—and irrelevant both to the film's narrative and to the larger psychical and affective issues inherent to such recent films as *28 Days Later* (2002), *Shaun of the Dead* (2004), *Pontypool* (2009), and others. After Tallahassee (Woody Harrelson), zombie exterminator extraordinaire and one of the film's two protagonists, makes his brash entrance and confronts Columbus (Jesse Eisenberg) on a highway littered with wrecked vehicles, debris, and even the broken fuselage of a downed jet, the pair join forces and make their way down a more rural, uncluttered road. Shortly thereafter, as Columbus recounts in his voice-over narration, Tallahassee reveals his one "weakness" when they stop at a breach in a twisted metal barrier on the roadside, gazing down into a grassy ravine where a Hostess Bakeries truck has veered off the road.

Tallahassee announces that he could "use a Twinkie" and begins his descent to the truck, prompting Columbus to recommend a regimen of light calisthenics and stretching as dictated by his self-imposed Rule #18: "Limber up." Tallahassee rejects the suggestion, reminding his companion that lions don't "limber up" before taking down a gazelle. When they arrive at the truck, Fleisher trains close-ups on the Hostess name and strands of red hearts that comprise the company's logo on the side and back of the trailer, which Tallahassee opens excitedly, expecting to find a Twinkie. Instead, a cascade of Hostess Sno Balls falls at his feet. Feverishly searching for a Twinkie, he is both enraged and repulsed by the Sno Balls, shouting, casting them irreverently aside, and stomping them into pulp. By contrast, Columbus opens a package and enjoys eating one, promoting the freshness of its distinctive coconut flavor, which, in turn, motivates Tallahassee's retort: "I hate coconut—it's not the taste, it's the consistency." The scene ends with Tallahassee vowing to continue his quest for a Twinkie, which he does later when the duo enters Blaine's Supermarket, and where, after the requisite dispatching of zombies, they meet and are conned by Wichita (Emma Stone) and her sister Little Rock (Abigail Breslin).

The second of these scenes occurs in a flashback in *Zombieland* when Columbus recalls his "insanely hot" neighbor (Amber Heard), known only as 406 after her apartment number, banging frantically on his door. At home alone for the third consecutive Friday night, drinking Mountain Dew Code Red and playing video games, Columbus is amazed that this beautiful young woman has entered his apartment and actually thrown her arms around him. As his narration explains, all he ever wanted was to find a girl to take home to his emotionally distant parents and, with her, form a "cool, functional family." On this Friday night (which takes place before a mutant strain of mad cow disease in a mere two months has reduced America to a wasteland), his neighbor

1.1. Sno Balls in Hell, *Zombieland* (2006).

is terrified and seeks comfort from a harrowing assault by what she believed to be a homeless and "sick" man who attempted to bite her. Exhausted by the encounter, she lowers her head on Columbus's shoulder to close her eyes for a moment, prompting him to gush that he is now "living the dream"—that is, he may actually be able to fulfill his fantasy of gently brushing a girl's long hair behind her ear. After a brief temporal ellipsis, however, his fantasizing is shattered by the girl's horrific transformation, a process marked almost immediately by her vomiting of a bilious liquid. Now one of the undead, she lunges at him and he recoils; he apologizes for hurting her while defending himself, and soon she is splayed on top of him in the bathroom. Columbus attempts to ward her off, directs a spray can at her face, and then wraps her in a nearly transparent shower curtain, upon which the outline of her mouth is impressed and through which blood and other assorted gunk explode. The attack ends with his smashing her head with the porcelain top of his toilet's water reservoir, not once but twice, a repetition that serves as the origin of one of his most insistent rules: whether wielding a shotgun, baseball bat, or piece of a toilet, always administer a "double tap,"

1.2. "Living the Dream," *Zombieland* (2006).

particularly to a zombie's head. Otherwise, you might just become a human Happy Meal.

Albeit quite different, these two scenes not only further motifs that inform *Zombieland* but also gesture to the psychoanalytic and affective dimensions of many contemporary films featuring the undead. The latter scene with 406, for example, advances two motifs established almost from the film's first frames: bloody mouths and relentless orality on the one hand, toilets and human offal on the other. The former motif is hardly surprising, as zombie films frequently train close-ups on bloody mouths oozing partially masticated flesh; in this regard, the contemporary undead, unlike their predecessors in such films as Victor Halperin's *White Zombie* (1932) and Jacques Tourneur's *I Walked with a Zombie* (1943), are figures of manducation, things that bite and cannibalize with indiscriminate abandon. So when Fred Botting characterizes zombies as "not machine, not animal, not inert matter" but as "residually human at the level of appearance and thoroughly in-human," he gestures toward a fundamental question about exactly how such creatures might be understood (187). Cinematic privileging of the mouth in representations

of the undead, a privilege achieved in *Zombieland* by numerous close-ups of zombies ripping through flesh, belching, or regurgitating blood, recalls Georges Bataille's meditation on the beginnings of the human body and his juxtaposition of humans and animals. Discussing this relationship, Roland Barthes invokes Bataille's notion that the mouth is "the beginning or, if one prefers, the *prow* of animals," a commencement that man—by sharp contrast—lacks ("Outcomes" 241). If animals begin with their mouths, then the undead might be regarded as closer to animals than humans. *Zombieland* at times reinforces this analogy, with the undead in one segment feeding on roadkill (humans) until Tallahassee speeds onto the scene, blasts the predator with a strategically opened car door, and brings the grisly meal to an abrupt halt.

But the matter of zombie identity is usually more nuanced, more psychically resonant, than this equation expresses, as the undead are seldom mistaken for or identified with animal predators, so many lions stalking gazelle. And when they are—a reporter in *Pontypool,* unsure of exactly what he is witnessing, describes a gathering mob of the undead as a "herd," another compares them to dogs or a school of piranha—this analogy is soon proven to be inadequate. Equally important, their human antagonists seldom regard them as animals, whose treatment is typically delimited by a kind of moral foundation or ethical obligation predicated, at least in part, on our "sense of the mortality and vulnerability" that we share with nonhuman others (Wolfe, *Philosophy and Animal Life* 11).[1] What transpires in Columbus's apartment exceeds any such ethics, as we watch the transformation of an object of desire into one of both fear and revulsion—a Twinkie surrounded by hearts turned into a malevolent Sno Ball, as it were—a process intimated in an early montage in *Zombieland* when a topless zombie stripper, dollar bills adorning her G-string, pursues her customers into the parking lot of a club, vomiting dark blood as she runs. That is to say, the attack

in Columbus's apartment might be contextualized with a meaningful comparison in Freudian psychoanalysis—namely, the analogy between sexual need and biological hunger, both of which exert psychical pressure to be satisfied. Indeed, Freud's *Three Essays on the Theory of Sexuality* (1905), described by Peter Gay as one of the two "pillars" of psychoanalysis, begins with this very analogy (*Freud Reader* 239):

> The fact of the existence of sexual needs in human beings and animals is expressed in biology by the assumption of a "sexual instinct," on the analogy of the instinct of nutrition, that is, of hunger. Everyday language possesses no counterpart to the word "hunger," but science makes use of the word "libido" for that purpose. (240)[2]

This comparison, however, barely scratches the surface of the attack in Columbus's apartment, for 406's rapacity and persistence surpass any notions of mere hunger (as does Tallahassee's pursuit of Twinkies, a point to which I shall return). How are we to understand this paradigm in *Zombieland:* the relationship between the desire of the protagonists, in Columbus's case an unexceptional longing for a girlfriend, and the representation of the undead, including their unrelenting demand for human flesh?

Further complicating the issues of both the nature of the undead and our responses to their slaughter, as Maria Warner describes in *Phantasmagoria: Spirit Visions, Metaphors, and Media into the Twenty-First Century,* the zombie "has been robbed of all the qualities that make up personhood—feelings, sentience, reflexivity, memory—but survives under a sentence of immortality (like a vampire)" (359). Well, not exactly—zombies are hardly immortal. Still, unlike the moral response Cary Wolfe outlines in which humans recognize the vulnerability and mortality they share with animals, this excavation of personhood

produces in zombies an ontological difference we cannot share. Is this what enables us not only to countenance but also to enjoy the slaughter of zombies in films like *Zombieland*? The question itself marks a recent development in representations of the undead, for both history and earlier cinema are replete with instances of a subject peoples' domination by a superior power and a diminution of personhood that can hardly be celebrated. In the postcolonial Haiti of *White Zombie,* for instance, zombies labor in their master's sugarcane plantation, "plodding like brutes, like automatons."[3] When one worker stumbles into the blades of a machine processing cane, no one notices or seems to care; production continues in all of its inexorability, implying that the zombie workers are of less value than animals and certainly as mortal. Equally important, while we deplore the brutal domination of such workers, the film does not create sufficient emotional engagement for us to be moved by their passing. These nameless workers, much like the *Muselmänner* Giorgio Agamben describes in *Remnants of Auschwitz* (1999), function as "mummy men" or the "living dead," expressionless beings regarded by most guards and fellow prisoners with profound indifference, and about whom Primo Levi in *Survival in Auschwitz* (1986) observed, "One hesitates to call them living: one hesitates to call their death death."[4] Here, Fred Botting's observation again seems relevant: the undead are "residually human" yet, at the same time, decidedly "in-human."

Through a series of visual and narrative motifs, *Zombieland* addresses the questions implicit in the example above from *White Zombie* and the intellectual framing provided by Bataille, Botting, Warner, and others: What are the undead, and how should we respond to them? Are they innocent victims, animals, or machines, or something much less (or more)? More specifically, the shocking transformation of an object of desire—or of sensual, if not sexual, fantasy—into a zombie in

Columbus's apartment bears more scrutiny, as do Columbus's initial apologies for fracturing 406's ankle with his bedroom door as she attacks him. In this flashback his beautiful neighbor becomes a figure of the uncanniness of all zombies: embodiments of the familiar rendered profoundly unfamiliar, terrifying, and even repulsive. His eventual killing of her with part of a toilet, as I shall explain, furthers a larger motif in *Zombieland* associating the undead with excrement, the "not me" that is routinely flushed away from our lives. Similarly, through its burlesque of desire and repulsion, its degradation of objects symbolized by hearts into figures of abjection, Tallahassee's response to Sno Balls gestures toward the same feeling as desire is transformed into its opposite: disgust. In such scenes, questions of affect, emotional intensity, and viscerality are foregrounded, joining the elements ably summarized by Kyle Bishop in his explanation of the increased prominence of zombie films since September 11, 2001. For Bishop, the "protocols" of this genre include the "imminent threat of violent death," a "postapocalyptic backdrop," the "collapse of societal infrastructures," the "indulgence of survivalist fantasies, and the fear of other surviving humans" ("Dead Man" 20). To these *narrative* conventions, I want to add three additional *psychological and affective* dimensions of many zombie films—drive, desire, and disgust—all theorized within what has now become a conspicuous turn in contemporary culture to the Freudian uncanny.

For however cogent postcolonial or late capitalist explanations of the current zombie phenomenon might be,[5] zombie films traffic in both psychical complexity and what might be called, after Sianne Ngai's influential book, "ugly feelings" that demand further investigation. One such feeling in *Zombieland,* a high-intensity one not cataloged by Ngai, is potentially as complex as the nature of the undead—namely, the obvious pleasure Tallahassee takes in killing the undead, at times in

extravagantly violent ways. And, as I have posed earlier, why is it similarly pleasurable, even funny, to watch this spectacle? In asking this question and asserting the immediacy of affective readings of zombie culture, I do not mean to suggest that psychoanalytic valences never inform more self-consciously politicized zombie texts or political readings of them; nor do I mean to refute Melissa Gregg's assertion that "passion, emotion and affect" constitute "the new frontier for politics" (105).[6] In his unpacking of the allegorical dimensions of George A. Romero's *Land of the Dead* (2005), for example, Adam Lowenstein makes a powerful case for the modern horror film's allegorical tethering to "specific national contexts" and "historical trauma," in this instance the war in Iraq. Freud's concept of *Nachträglichkeit,* or deferred action, helps Lowenstein decode Romero's re-transcription of the traumatic memory of a war fought by a working class (zombies) on behalf of powerful industrialists represented in the film by Kaufman (Dennis Hopper). So when the leader of the zombies, the former gas station operator known only as Big Daddy, entraps Kaufman in his limousine and shatters its windshield with the nozzle of a gas pump, Lowenstein detects traces of the antiwar slogan "No blood for oil" and an allusion to the precipitous rise in gasoline prices caused by the Iraq War, a rise felt most keenly by the very families whose sons and daughters were fighting the war. More important for my purposes, through his depiction of Big Daddy as a problem solver and strategic leader, Romero, in Lowenstein's view, achieves the rare feat of manipulating his audience to empathize with a zombie (114). In this way Big Daddy can be seen to reside at the opposite end of an affective spectrum from the one occupied by the undead in *Zombieland,* who demonstrate no strategic intelligence and evince no resistant politics—or any politics, for that matter—and, more important, fail to elicit even a scintilla of empathy from the spectator.

This chapter concerns such issues, the psychoanalytic and affective dimensions of representations of the undead. For, like vampires, zombies have never been, first and foremost, mere figures of political or economic allegory. Their appeal, such as it is, is much more visceral and psychical, even sexual, as I attempt to outline here.

Uncanny Vampires, Uncanny Zombies: Desire and Drive

"It is only rarely that a psycho-analyst feels impelled to investigate the subject of aesthetics, even when aesthetics is understood to mean not merely the theory of beauty but the theory of the qualities of feeling. He works in other strata of mental life and has little to do with the subdued emotional impulses." Thus Freud begins his 1919 essay "The 'Uncanny,'" and within the space of his opening paragraphs he identifies the motives of his argument: first, to "distinguish as 'uncanny' certain things within the boundaries of what is 'fearful'," and, second, to counter those discourses in aesthetics that "in general prefer to concern themselves with what is beautiful, attractive and sublime—that is, with feelings of a positive nature—and with the circumstances and objects that call them forth, rather than with the opposite feelings of repulsion and distress" (17: 219). The contemporary zombie film typically cultivates the latter "opposite feelings"—anxiety, fear, disgust—as it refashions the *heimlich* (the familiar) into the *unheimlich* (the unfamiliar), which for Freud defines the uncanny. Narratives of what Freud's former colleague Otto Rank termed the "double" or *doppelgänger*—think here of Edgar Allan Poe's "William Wilson" or Dostoevsky's novella *The Double*—provide examples of the uncanny existence of two characters with the same name and appearance but with diametrically opposing projects that inevitably lead them to conflict.[7] But more than eerie resemblance

is at issue here; as Freud adds, "We can also speak of a living person as uncanny . . . when we ascribe evil intentions to him. But that is not all; in addition to this we must feel that his intentions to harm us are going to be carried out with the help of special powers" (17: 243). Predictably enough, this premise leads Freud to fairy and folk tales, where inanimate objects might come to life, characters display "special powers," and, more pertinent to our concerns, the dead are reanimated. In addition, albeit according to Freud less frequent an occurrence in "real" life, the "uncanny" may proceed from "repressed infantile complexes" or once-abandoned primitive beliefs confirmed by contemporary events (17: 248). Texts in which vampires and zombies predominate are therefore well described by the uncanny, yet at the same time, key differences obtain between these undead that might help us understand more fully how the transformation of the familiar into the unfamiliar produces "unpleasantness and repulsion."

An illustrative example of both the uncanny and the affects to which Freud alludes occurs in Bram Stoker's novel *Dracula* (1897), commonly misidentified as the origin of the vampire tradition (numerous Victorian stories and plays featured the undead well before Stoker's novel was published). It is important to remember, I think, that when zombies emerged in the American cinema of the 1930s and '40s their relationship to vampires was often muddled. *White Zombie,* for example, starred Bela Lugosi, whose career was launched by his appearances in both the 1927 Broadway and 1931 screen adaptations of Stoker's novel. Made in eleven days for a reported fifty thousand dollars, *White Zombie,* an ultimately unsuccessful attempt to ride the vampiric wave that Tod Browning's film *Dracula* helped create, was advertised by a salacious poster featuring a scantily clad young woman trumpeted as "performing [Lugosi's] every desire." As I shall describe later, a subgenre of such recent zombie

films as *Deadgirl* (2008) and *Zombie Strippers* (2008) has revived this fantasy of zombified women as potential sex slaves eager to gratify a man's "every desire" (one desire in particular).

Vampires, however, are more commonly represented as figures of desire. Several scenes in *Dracula* confirm this representational calculus, none more so than when Professor Abraham Van Helsing and his compatriots confront Lucy Westenra as she begins to ravage a helpless child. As reported in Dr. John Seward's diary, when he, Van Helsing, Quincy Morris, and Lucy's husband, Arthur, arrive at a gloomy churchyard, they are aghast at the results of Lucy's resurrection from her tomb: her "sweetness was turned to adamantine . . . and the purity to voluptuous wantonness." The phrasing is as revealing as it is almost pleonastic, especially the notion of a pure woman becoming as voluptuous as she is wanton. Now one of the undead, Lucy displays a "voluptuous smile" and later a "wanton smile"; and, functioning as a kind of perverse Eros, as she advances toward her husband with "a languorous, voluptuous grace," Lucy attempts to seduce Arthur to fall into her "hungry" arms. Even as Lucy's mouth is stained with blood, however, it is still "lovely"; her voice, "diabolically sweet" (188); even as her appearance constitutes a frightening spectacle, it evokes sexual frisson and sensual excess. By stark contrast, the blood-smeared mouths of most contemporary zombies can hardly be described as "lovely" or seductive. Think here of the zombies in *Zombieland,* or of Shaun's buddy Ed (Nick Frost) in *Shaun of the Dead* (the quintessence of slovenliness even before being infected), or of the attractive assistant radio producer Laurel-Ann Drummond (Georgina Reilly) in *Pontypool,* whose mouth grows increasingly befouled until she splatters a disc jockey's glass-enclosed sound booth with a stream of blood in what is a fatal regurgitation.

The language of Stoker's scene also connotes defilement and, as Paul Ricoeur explains, an "indissoluble complicity between sexuality

and defilement seems to have been formed from time immemorial" (28). So, for example, Lucy's eyes appear "unclean and full of hell-fire, instead of the pure, gentle orbs" the men once knew (Stoker 188); and the wanton Lucy in the crypt appears as a "devilish mockery of Lucy's sweet purity" (190). Rites of purification—Van Helsing's wielding of a golden crucifix, his recital of prayers for the dead as the stake is driven through Lucy's heart, her decapitation, and the stuffing of her mouth with garlic—are more than attempts to vanquish a figure of powerful evil; rather, they are performed with the intent of reversing a defilement of which the vampire's abhorrent sexuality is symptomatic. This notion of enlargement or excess is consistent with Van Helsing's later description of Dracula himself, in whom "all the forces of nature that are occult and deep and strong must have worked together in some wondrous way ... In him some vital principle have [sic] in strange way found their utmost" (278). Vampires, in this famous depiction, however unclean and demonic, are not only possessive of a lust for life and a sexual excess, but they also exhibit an innate superiority that enables them to exploit the special powers Freud finds inherent to the uncanny.

By contrast, zombies in the contemporary cinema seldom bear resemblance to such superior figures, though several exceptions might be noted. In *Against the Dark* (2009), which is little more than a vehicle for Steven Seagal to dispatch zombies ninja-style with a samurai sword, the undead seek shelter from the sun at daybreak and exude a kind of patrician hauteur that recalls Stoker's vampiric aristocrat. One zombie disdainfully tells a potential victim, "We think. We talk. We plan. . . . We've evolved. You people are just cattle to us." As if to confirm this zombie worldview, a deranged father butchers and hangs human bodies in an improvised abattoir as if they were so many sides of beef for his undead daughter—the "next step in evolution"—to consume. This sense of zombie superiority is afforded its most articulate précis near the

end of *Against the Dark* by Amelia (Emma Catherwood), once a generous character before emerging as a pale yet oddly attractive member of the undead legion, when she harangues her former human friends: "It's not what we thought. . . . I feel more alive than I ever did. . . . You're all fools. You hunt us down like we're vermin, when it's you who don't belong anymore." In this way *Against the Dark* recalls the muddling of distinctions between vampires and zombies in earlier films, as does the evocation of Christianity and demonic possession in perhaps one of the most terrifying of contemporary zombie films, *[•REC]* (2007). The final scene of *[•REC]* reveals that the penthouse of a contaminated and bloody apartment building once housed an agent of the Vatican sent to Spain to investigate a virus causing demonic possession. As the hand-held camera pans across crucifixes, portraits of the Virgin Mary, and other religious iconology, an emaciated figure appears from the shadows, attacking everything in her path. Unfortunately for the characters involved, there is no Van Helsing to help them, no rite of purification to perform.

But these representations of the undead as a more highly evolved species or the products of demoniacal possession are unusual, even anomalous, as most contemporary zombies embody an entirely secular devolution. They lack selfhood, as Warner describes, and their restricted communication skills include only primitive grunts or enraged howls. Moreover, they lack an attractive sensuousness and seldom connote wanton sexuality—quite to the contrary. In short, the zombies in *Zombieland, Pontypool, 28 Days Later,* and most contemporary films are neither objects nor figures of desire or a wanton luxuriance; instead, as Slavoj Žižek observes in another context, zombies, like Arnold Schwarzenegger's Terminator, embody the psychical *drive* "devoid of desire." They are frightening, as the "Governator" was, precisely because no matter how diminished or inhuman, zombies "persist" automatically in

their quests, pursuing victims "with no trace of compromise or hesitation" (*Looking Awry* 21–22). Žižek regards the return of the living dead as constituting the "fundamental fantasy of contemporary mass culture," a fantasy underlying not only zombie films but also such horror franchises as *Halloween* and *Friday the Thirteenth,* to name just two. But most zombies are as far removed from the Michael Myers and Jasons of slasher movies as they are from Dracula. Nor do we have any sense that, like slashers wearing hockey masks or vampires like Stoker's Lucy, zombies represent a "disturbance in the symbolic rite" of burial (*Looking Awry* 23). "Proper burial" is simply not an issue in *Zombieland* or *28 Days Later,* though it was in *Hamlet* and in Sophocles's *Antigone,* as Žižek explains, and could be in *White Zombie,* as immediately after "Murder" Legendre, the zombie puppet master, is rendered unconscious, his enslaved posse in lemming-like fashion leaps off a cliff seemingly in search of a proper death in the dark waters below.[8] In other words, contemporary zombies merely *are,* which is to say they are speechless aggressors in a singular and mechanical pursuit of flesh.

Žižek makes these observations in his book *Looking Awry* (1991) in a chapter titled "The Real and Its Vicissitudes," here echoing the title of one of Freud's most powerful statements on the drive, "Instincts and Their Vicissitudes" (1915), and recalling a vexing question in his psychoanalysis—namely, the relationship between "instinct" and "stimulus," which will lead later commentators, ultimately, to a discussion of instinct and drive.[9] Before troubling this latter distinction, we might recall that in the earlier *Three Essays on the Theory of Sexuality,* Freud alluded to a common analogy between "sexual instinct" and "hunger." Žižek refers to a drive as "devoid of desire," as an unhesitating, even automatic impulse *toward* an object, and Freud describes a similar impetus in his essay: "In the first place, an instinctual stimulus does not arise from the external world but from within the organism itself." Further, an instinct

"never operates as a force giving a *momentary* impact but always as a *constant* one"; instincts constitute a "need" demanding "satisfaction," and no "actions of flight can avail against them" (14: 118, italics in original). An instinct, in short, is an unrelenting force exerting pressure that impels the organism to seek satisfaction, which is usually found in an object not "originally connected with it." In "Instincts and Their Vicissitudes," Freud identifies two groups of such instincts—"the *ego, or self-preservative,* instincts and the *sexual* instincts"—a grouping that will be expanded in *Beyond the Pleasure Principle* (1920) to include one of the thorniest of all Freudian concepts, the "death drive" or instinct to restore an "*old* state of things, an initial state from which the living entity has at one time or other departed and to which it is striving to return by the circuitous path along which its development leads" (18: 38, italics in original).

While some Freudian commentators, Peter Gay, for instance, quite deliberately employ "drive" and "instinct" synonymously,[10] there is no universal agreement on this point. Jean Laplanche concedes that *Trieb,* the German term for *drive,* derives from a word that means "to push," as does *Instinkt,* which also means to incite or push. But Laplanche goes on to explain that for Freud "instinct" represents a "preformed behavioral pattern, whose arrangement is determined hereditarily," from which drives are derived (9–10). Drives are comprised of an impetus, aim, object, and source, this last of which for Freud resides outside the "scope" of psychology. For our purposes the first three components are the most relevant: the impetus exercises pressure, a "demand for work"; the aim is the "act to which the drive is driven," the final aspect of which is always satisfaction or "the appeasing of a certain tension"; and, importantly, the object, as Laplanche emphasizes, is highly contingent. That is to say, its specificity or "individuality" is "of minimal concern" to the drive itself (12). Reading Freud with even more stricture, Jacques Lacan

emphasizes that *"As far as the object in the drive is concerned, let it be clear that it is, strictly speaking, of no importance. It is a matter of total indifference"* (168; italics in original). Laplanche adds that the object possesses traits "which trigger the satisfying action," yet, perhaps most importantly, no object of any need "can satisfy the drive" (11–13).

Much more complicated is the object of sexual aims, the basis of which, for Laplanche, is strongly registered in Freud's third of the *Three Essays on the Theory of Sexuality:* "There are thus good reasons why a child sucking at his mother's breast has become the prototype of every relation of love. The finding of an object is in fact a re-finding of it" (19). If this is accurate, Laplanche reasons, the object of sexual love must be at least partially phantasmic insofar as the aim of the suckling child is satisfied by milk; it is the object of the drive, not the breast, that is a partial object representing the mother. The aim in this example is ingestion or incorporation as well, not sexual union or the larger unity it represents; so, however close "drive" and "instinct" might be, desire for a love object represents a different phenomenon with different aims, including a meaningful "re-finding." The love object is, at minimum, irreducible to the contingent or totally unimportant object targeted by the unrelenting pressure of the drive; indeed, as Laplanche notes, "the prevalence of narcissism" is detectable "if not in every libidinal relation at least in every *love* relation." Hence, "at the very moment in which man—and Freud—would yield to 'objectality,' he shifts dialectically into another form of narcissism" (78; italics in original). There exists, in short, a profound relationship between self and other in the love relation that does not define the object of a drive, which is contingent, lacks individuality, and merely exists for its presumed potential to satisfy an aim. *Desire* thus differs from *drive* in several crucial respects, and one of these pertains to the object receiving the pulsion, or psychical force, of desire. As Lacan describes, the object of desire is both an "interpretation" and "either a

phantasy that is in reality the *support* of desire, or a lure" (186; italics in original). So, for example, recall Columbus's fantasy in *Zombieland* of finding a girl, brushing her hair back gently over her ear, and with her forming a "cool functional family." This project is starkly different from that of the zombies in *Pontypool* as described by reporter Ken Loney, who witnesses a frenzied, ravenous mob not merely eating people but frenetically trying to "climb inside them" as if returning to the womb.

Many contemporary zombie films underscore this distinction between drive and desire. *Shaun of the Dead, Zombieland,* and more recently *Warm Bodies* (2013) are, among other things, romantic comedies that foreground the most important trajectory of such traditionally heterosexual narratives: boy meets girl, forces emerge (some of them internal to the characters themselves—being a zombie, for instance, in *Warm Bodies*) that jeopardize their relationship, but eventually the pair is united. The multiple marriages and celebrations of nuptials common to the Shakespearean comic formula are not always possible in such films, but the movement of the films' action points in such a direction. *28 Days Later* creates a more complicated version of this plot, as a growing affection between Jim (Cillian Murphy) and Selena (Naomi Harris) is threatened not only by zombies but also by a rogue troop of British soldiers who send out radio transmissions presumed to be offers of help to humans who have escaped the RAGE virus. As the soldiers' commanding officer later explains, however, the transmissions were made solely to attract women into sexual slavery, juxtaposing the sexual drive of soldiers to rape *any woman* (or young girl) with the equally insidious drives of the undead they intend to starve and kill by any means necessary.

The hearts decorating the abandoned Hostess Bakery truck in *Zombieland* find graphic parallels with the Valentine's Day hearts and Cupids displayed at the CLSY radio station in *Pontypool,* and the infection

inherent in the English language that strikes the remote Ontario community of Pontypool interrupts the exchange of holiday cards. The contamination originates in English, in verbal understanding, and particularly in terms of endearment like "sweetheart" and "honey" so often employed in the saccharine discourse of commercial greeting cards. To escape the contagion, language needs to be reinvented, understanding short-circuited. For this reason, after Sydney Briar (Lisa Houle) has killed an attacking zombie child and appears to be succumbing to the word *kill*, Grant Mazzy (Stephen McHattie) "disinfects" her by insisting, "Kill isn't kill. . . . Kill is loving. . . . Kill is beautiful. . . . Kill is kiss. Kill is kiss." Sydney asks Grant to kill her, and he obliges by kissing her passionately, which both acts as a curative and leads them back to the radio microphone to share their potentially lifesaving findings with listeners as the military begins a countdown to "sterilize" the area. After the film's credits conclude, Sydney and Grant make a brief cameo appearance, suggesting that they have not only survived the military's threatened devastation of the community but also—in the tradition of the romantic comedy—are together and happy. Their previous relationship, a prickly and decidedly *unromantic* one, intimated by Sydney's last name (Briar), has apparently been altered by the contingency Sara Ahmed argues is intrinsic to the etymology of happiness, which includes the Middle English word *hap*, meaning "chance" ("Happy Objects" 30).

By contrast, as embodiments of a naked drive, a psychical pulsion, zombies are generally incapable of such relationships or of responding effectively to the irruptions of chance; instead, the undead, like Laurel-Ann in *Pontypool*, who rams herself into the sound booth repeatedly, know only one direction. Their unrelenting and indiscriminate drive to consume, especially when juxtaposed to romantic object choice and its dialectic of underlying desire, defines the horror movies in which the undead are featured. But there is also one more distinction to be

made, and that's the difference between a monster that is fearful and a thing that functions as an object of disgust. In *Zombieland* in particular, revulsion and disgust are much on display, yet they serve a key purpose in the narrative in allowing us to become so distanced from the undead that their deaths are not only events we can countenance but also occasions for a very different kind of pleasure both for us and the film's protagonists.

Disgusting Behavior; or, Do Zombies Really Belch?

The destruction of contemporary Britain in *28 Days Later* is paralleled by the similar devastation of America in *Zombieland,* as a virus reduces both countries to rubble and collapses the social order into chaos. The opening moments of *Zombieland* make this devolution clear: a minuscule American flag flutters in front of an upside-down capitol while a cacophonous, Jimi Hendrix–like rendition of "The Star Spangled Banner" blasts loudly in the soundtrack. America is gone. But that's not all, as a zombie leaps over a toppled car with a conspicuous governmental seal on its door, stares straight into the camera, and does things most zombies don't do: in a tight close-up emphasizing his grotesqueness, he picks flesh from his teeth and belches with an almost knowing audacity. Words, rational argument, expressions of desire—characteristics of the human—don't emanate from a zombie's mouth in *Zombieland,* only blood and amorphous gunk, often in close-ups like this one that project the mess right into the spectator's face. And it is disgusting.

If the Freudian uncanny theorizes "feelings of unpleasantness and repulsion," then few things can be more unpleasant than masticating, barfing zombies in the early sequences of *Zombieland.* To seal the representational deal, as it were, they are also associated with excrement, with shit, in the film's early scenes. That is to say, to return to perhaps

the most revolting visual trope in the film, Fleisher's zombies continually and uncontrollably emit blood and other organic matter from their mouths—and this organic matter is all too familiar. "It's amazing," Columbus tells us, "how fast things can go from bad to a total shit storm," connecting zombies from the start to feces. As Harry G. Frankfurt hypothesizes in his brilliant book *On Bullshit* (2005), shit is by its very nature unrefined; it is "not designed or crafted at all; it is merely emitted or dumped. It may have a more or less coherent shape, or it may not, but it is in any case certainly not *wrought*" (21–22). Zombies—unlike vampires, who might pass in Victorian society as well-groomed, well-spoken, and thus exceptionally well-wrought aristocrats—are almost always the most *unwrought* of characters: they don't dress well, their hair is a mess, and their oral hygiene is obviously suspect. What's worse, and strengthening zombies' association with the excremental, human victims are at a distinct disadvantage in *Zombieland* when perched on toilets with their pants dangling around their ankles. For this very reason, one of Columbus's most emphatic rules is "Beware of bathrooms," which early in *Zombieland* are both settings for zombie attacks and scenes of anxiety for a narrator with irritable bowel syndrome just looking for a safe place to "go number two." Zombies, in short, hang around toilets and attack humans while they defecate; "they can just smell it," Columbus wryly remarks, and in one scene he is pursued by a zombie with toilet paper wrapped around his leg—a walking turd, as it were. And if the mouths of zombies, through their spontaneous evacuations of organic matter, resemble excretory organs, anuses in particular, we should not be surprised that from the outset of the film they are associated with shit. Killing them is thus no more momentous than flushing the toilet.

These associations of zombies with excrement, vomited blood, belching, and so on situate them within the boundaries of abjection and the disgusting as theorized by Julia Kristeva, Sianne Ngai, and Sara

Ahmed, whose work might illuminate one of the questions with which this chapter began: Why is the slaughter of zombies in *Zombieland* not only ethically acceptable but at times even pleasurable? Kristeva begins her influential unpacking of abjection with a salient observation: "The abject has only one quality of the object—that of being opposed to the *I*." Like 406's sudden attack in the scene in Columbus's apartment, the abject triggers a "massive and sudden emergence of uncanniness, which, familiar as it might have been in an opaque and forgotten life, now harries me as radically separate, loathsome. Not me. Not that" (1–2). Recalling the narcissistic element in object choice, we might regard Kristeva's abject as an annulment of desire, a trope from which one wants only distance, not proximity. In this regard the abject inheres with particular tenacity to conceptions of disgust, an affective connection Ahmed traces to its etymological origins in bad taste or distaste (*gustus* means taste in Latin). Disgust operates on several levels, one of which is its intensification of contact between bodies and a concomitant dread of contamination. For Ahmed, disgust works on the borders between things; it is sticky and revolting, in part because it is frequently in contact with other disgusting and sickening things (*Cultural Politics* 87–88), a process reinforced in *Zombieland* when zombies crawl under stalls in public toilets and when they feed on roadkill.

One obvious result of this process is that abject and disgusting things seem "lower" than or "below the subject, even beneath the subject," and eventually this lowness "becomes associated with lower regions of the body" (89). We don't want disgusting things near us, a feeling that at times might explain unnecessary and unnecessarily elaborate assaults on the undead in *Zombieland* and, on occasion, in other films. In one scene in *28 Days Later,* for example, the four survivors stop to siphon gasoline from a tank truck. Wandering away from the group, Jim notices a dilapidated shop advertising cheeseburgers and decides, baseball bat

in hand, to take a look inside, even though they have just stuffed their vehicle with goods from a supermarket and even after Selena reminds him that they have more than ample supplies. Undeterred and walking inside, he is attacked by a small boy, and after a brief struggle, Jim glowers down at him with his boot planted firmly on the child's throat. Moments later he exits the building, wiping blood from his bat with a rag, apparently having satisfied an internal demand to rid the world of one more object of disgust.

Disgust, as in this example, inevitably obtains in relationships of power; we are above the disgusting, which is slimy, excremental, revolting. For Sianne Ngai, whose interest in negative emotions includes their often ambiguous political work, the disgusting is "always that which is insistent and intolerable"; thus, contrary to Ahmed's emphasis on our desire to avoid the sticky surfaces of the disgusting, our intolerance, like Jim's and Tallahassee's, might motivate us to seek out the disgusting and eradicate it, even when it doesn't threaten us (333). Unlike desire, Ngai posits, which at times can seem vague or "amorphous," or attraction, the parameters of which can be "notoriously difficult to determine and fix," disgust and its "kernel" of repulsion are always urgent and specific (335). In other words, I may not be able to tell you why I could use a Twinkie, and perhaps later would be a better time for acquiring one, but I can certainly explain why Sno Balls are repulsive: it's the consistency of the shredded coconut inside them, not the taste, and I can't stand it.

It is also the case that desire and disgust are often juxtaposed in films like *Zombieland*. In this regard, one of the film's most evocative scenes occurs in Blaine's Supermarket, where once again there is not a single Twinkie to be had, but where the questing twosome of Columbus and Tallahassee meet the con artist sisters who will eventually form their impromptu family, the family that both male characters have lost as a result of the viral catastrophe. Before entering the store, Tallahassee

arms himself with a strange array of weapons that includes a baseball bat, hedge clippers, and a banjo. Inside the store his first weapon is the banjo, and he wields it by playing the familiar refrain from the song "Dueling Banjos," which has the desired effect of drawing out a zombie who rushes toward him. Before blasting him in the head, Tallahassee tells him, "You got a pretty mouth," echoing a line from the film in which "Dueling Banjos" was first heard, John Boorman's 1972 film *Deliverance*, in which four Atlanta businessmen venture into backwoods Georgia and suffer abuse at the hands of savage hillbillies. (The facts that zombies in the scene are overweight and wear bib overalls or flannel shirts support this reference.) In Boorman's film a backwoodsman sodomizes one of the men while his friend is forced to watch. In *Deliverance*, "You've got a pretty mouth" is thus uttered as a prelude to sodomy and its resultant emasculation, whereas in *Zombieland* it accompanies Tallahassee's recognition of a talent he never knew he possessed: killing zombies. Equally important and unlike Boorman's unfortunate businessmen, Tallahassee reconfirms his masculinity in Blaine's Supermarket. After all, as they enter the market he tells Columbus, "It's time to nut up or shut up"—and this is what he does, recovering his masculinity as he dispatches disgusting hillbilly zombies.[11]

The pleasure of killing zombies in *Zombieland* therefore is associated not only with disgust but also with both wish fulfillment and a renewed masculinity. By killing zombies, Columbus finally "gets to first base" with a beautiful girl, a project thwarted earlier when his "insanely hot" neighbor, the object of his lust, is turned into a zombie, and Tallahassee achieves his absurd goal of devouring a Twinkie. More important, as I have mentioned, both characters and the two young women they save at the amusement park are able to recreate a family and forge a familial bond based on trust and affection, something both men have lost.

Post-Credit Postscript

Obviously I cannot end just yet, as the previous paragraph moves from ugly feelings to more positive ones, seemingly undermining the last part of my argument on zombies and "ugly feelings." Moviegoers are growing accustomed to this kind of coda, as a number of the films discussed here develop additional narrative material—sometimes surprising or enigmatic content, as in the case of *Pontypool*—while the closing credits are running or after they have been completed. (For quite different purposes, film comedies have employed this convention for some time, as in *The Hangover* franchise, for instance.) So here's my version of a post-credit postscript, intended to broaden, even challenge, the reading I have just offered.

It begins with *Zombieland* and the film's rich intertextual network, suggesting the contemporary zombie film's investment in popular, some might even say "trashy," culture. By "intertextual" I mean simply the array of texts referenced or quoted in the film, the majority of which are mass-cultural phenomena. These include not only *Deliverance,* mentioned earlier, but also *National Lampoon's Vacation, Ghostbusters,* and *Saturday Night Live;* the Southern "good old boy" subculture represented by Tallahassee's cowboy boots and his reverence for the late NASCAR driver Dale Earnhardt demonstrated by his painting the number 3 on the cars he steals; and by the characters' gleeful ransacking of the Kemo Sabe roadside store. The destroyed store acts as a microcosm of a destroyed America, a piece of Americana rendered superfluous in a place that is no longer a nation. That is, heroes like the Lone Ranger—a staple of American mass culture since the Great Depression, known by his loyal Indian sidekick, Tonto, as Kemo Sabe—will no longer save us in the nick of time. Only survivors can do that. Even Bill Murray, an actor Tallahassee idolizes, must go (the large initials "BM" on the gate of

his mansion presage his, uh, elimination). Thus, as the main characters move purposefully toward the Pacific Playland amusement park, they invert or destroy familiar icons along the way. They rewrite the social order in an admittedly odd but familiar comic way, and they do so with a libidinal energy and an almost refulgent joy that counters the ugly feelings stirred by zombies in all their excremental abjection.

Shaun of the Dead might be viewed in similar ways and be understood to provide an especially clear response to Robin Wood's thesis (after Freud) that film monsters embody the return of the repressed. As Wood catalogs in *Hollywood from Vietnam to Reagan . . . and Beyond* (2003), "all that our civilization represses or oppresses" is embodied in that filmic "other" known as the monster who emerges in the movies right from our worst nightmares (68). Such nightmares can be collective, as Wood implies when, during the Cold War, films like *Them!* (1954) depict mankind being overwhelmed both by a perverted Nature it has contaminated with radiation and a "subterranean army" of giant ants suggestive of communists who lurk under our streets or in dark alleys poised to strike. "Others" also often represent a threat to the heterosexual family, thus suggesting the psychical logic of the closing scenes of *Shaun of the Dead,* in which zombies become either domesticated servants or, in the case of Shaun's buddy Ed, a playmate who no longer disrupts the romance between Shaun (Simon Pegg) and Liz (Kate Ashfield). Before he was transformed into a zombie, Ed posed the greatest obstacle to the lovers' union; his obsession with video games infected Shaun, as did his predilection for drinking in a nearby pub. This strong homosocial attachment, evocative or not of homosexual desire, intrudes into Shaun's relationship with Liz and threatens it, but after becoming a zombie Ed can finally be afforded a place in Shaun's life without disturbing the nascent family. Chained in a backyard shed to play video

games a safe distance away, Ed and homosociality have been displaced sufficiently, and the happy male pair can indulge in all the gaming they want without jeopardizing the new nuclear family of Sean and Liz. The repressed has been managed.

And then there are shackles of a different kind—the straps that constrain a naked zombie to a hospital gurney in *Deadgirl* and the invisible chains of capital that impel women into exotic dancing in *Zombie Strippers*. Both films seem to explore quite explicitly the possibility of zombies functioning as figures of desire. Both concern men—disaffected high school boys in *Deadgirl* and the pathetic habitués of a strip club in *Zombie Strippers*—gazing at and then committing sexual acts with infected women who eventually do what zombies typically do: attack them. In *Zombie Strippers* a governmentally contrived virus maintains its potency and purity when transferred from women to other women; Kat (adult film star Jenna Jameson) contracts the virus, which leads both to her greater success at an underground strip club and, in turn, the envy of her co-workers, several of whom allow themselves to be infected so as to earn more money from the supercharged effects of the virus. For their part, the male customers grow increasingly mesmerized by the higher-octane pole-dancing and even more suggestive strip show enabled by the infection, showering the zombies with dollar bills. More important, after being turned into zombies the women aggressively select men to take to back rooms for "lap dances," and once they arrive there, before any more money changes hands or any negotiations take place, they throw themselves on their victims, quickly making their way to their zippers and to fellatio. Aroused and expecting the ultimate sexual experience, the men are quickly and predictably separated from their genitals, their desire for sexually voracious women eager to gratify them overwhelmed by the zombie strippers' drive for lunch. So, like the

disgusting orality of zombies in *Zombieland* captured in scenes in bathrooms and on highways complete with bloody roadkill, *Zombie Strippers* has more than its share of women snacking on a kind of Twinkie that Hostess Bakeries never produced.

The play of desire and drive is more complicated in *Deadgirl*. Several disaffected and horny teenagers enjoy repeated episodes of sexual intercourse with Deadgirl (Jenny Spain), who is tied down and unable to resist. Not surprisingly, analogous to the fantasy of strippers wanting to have sex with customers more than the customers do, one of the teenagers promotes the experience to his classmates as something Deadgirl really wants. This importantly includes oral sex, which turns out rather badly for one unsuspecting football player, because it is clear almost from the beginning that, if freed, she possesses the power and drive to destroy everything with which she comes in contact. At the same time, the sensitive Rickie (played by Shiloh Fernandez) refuses to exploit Deadgirl and even attempts to free her. Rickie is also infatuated with his beautiful classmate Joann (Candice Accola), and in several scenes he watches her longingly from a distance as she flirts with her popular football-playing boyfriend. Like the zombie strippers, Joann is thus the object of the male gaze, and, through a series of horrific accidents and plot convolutions, Rickie is finally able to close the distance between them by tying her to Deadgirl's gurney and creating a far more romantic atmosphere than obtained previously with Deadgirl. Like the back room of a strip club, then, the remote basement of an abandoned hospital becomes a site where the distant and inaccessible object of desire can be brought close enough to gratify Rickie's "every desire." We see, too, in this juxtaposition a distinction between the Lacanian drive, the object of which is "of no importance"—one zombie stripper is more or less like another—and the object of obsession or teenage infatuation, as Rickie has no interest in intimacy with Deadgirl, only in developing

a closeness with Joann. In this regard the crassness and perversity of his high school buddies reduce them to kinds of zombies who, driven by libido, would violate almost anyone or anything. And it is disgusting.

My contention, then, is that however flexible the convention of the zombie genre might be—however great the affective distance between wish-fulfilling reveries like *Zombieland* and nightmares like *[•REC]*—psychoanalytic theory and recent developments in the study of affect are well-situated to explain their attractions. Desire, demand, and disgust represent only three possibilities and therefore might be three potentially useful additions to our zombie survival guide.

Notes

1. Here, Wolfe is discussing philosopher Cora Diamond's views of our ethical obligations to nonhuman others from her 2001 essay "Injustice and Animals."

2. All subsequent references to Freud's work come from *The Standard Edition* and will be followed in the text by volume and page numbers. Here, to include Peter Gay's characterization, I have used *The Freud Reader.*

3. Seabrook, *Magic Island,* 101. Seabrook's work is used to great effect in Bishop, "The Sub-Altern Monster." In such a postcolonial and Caribbean context, as Bishop notes, a zombie is a "new monster for a New World" (145).

4. Qtd. in Agamben, *Remnants of Auschwitz,* 44. Importantly, these "undead" in Levi's account, like the zombies in *Zombieland,* are connected with excrement, thereby rationalizing the excessive brutalization of their captors.

5. See, for example, Bishop, "The Sub-Altern Monster," and Harper, "Zombies, Malls, and the Consumerism Debate."

6. Here, Gregg is describing one of the many implications of Lawrence Grossberg's work for cultural studies.

7. See Rank, *The Double.* Of course, much more is involved in the concept of doubles, the splitting of an ego, for instance, into opposing halves and the projection of these antithetical motives onto two characters. Rank wrote his essay in 1914 and returned to the topic in *Beyond Psychology* completed in 1939, the year of his death, and published in 1941. By this time he had expanded his thinking in both cultural and spiritual directions and outlines these in a chapter titled "The Double as Immortal Self."

8. The grave of Madeline Parker (Madge Bellamy), a victim of Murder Legendre in the film, is violated as Madeline is removed and returned to the home of the man responsible for her victimization. In this way, too, *White Zombie* resembles *Dracula* and its emphasis on a "proper Christian" burial, one that allows a character like Lucy to access eternal peace.

9. Freud, *Standard Edition,* 14: 118. Here Freud asks directly about the relationship between "instinct" and "stimulus," quickly adding: "But we immediately set on our guard against *equating* instinct and mental stimulus" (italics in original).

10. In his notes to "Instincts and Their Vicissitudes" in *The Freud Reader,* Gay notes that throughout the volume "instinct" and "drive" should be "treated as synonyms" (564).

11. It may be that this is also one of the most politically incorrect readings of my chapter on a variety of levels. The film makes a particular point of identifying overweight humans as easy prey for zombies, and in this scene the zombies themselves are both obese and dressed as mountain or rural residents. More important, the allusions to oral sex and anal rape in *Deliverance* also recall Freud's observations in *Three Essays on the Theory of Sexuality* that those who condemn oral sexual gratification "are giving way to an unmistakable feeling of disgust," and "Where the anus is concerned it becomes clearer that it is disgust which stamps that sexual aim as perversion" (*Freud Reader* 248).

AARON JAFFE

listen: there's a hell / of a good universe next door; let's go.

e. e. cummings, "pity this busy monster, manunkind"

Three Zombie Horizons

The first is marked by a silhouetted human form, shambling along the interface between earth and sky; a head flops to one side. In a word: zombie! A corpse that doesn't know it's dead, as George A. Romero defined the concept, a concept he still refuses to name out loud. "A Zombie being a corpse that won't give in and admit it," reads the communiqué in *Pacific Islands Monthly* from the outermost rim, even earlier, arriving right after V-J Day (49). The uplink from Zombieville reports that "the sea is flat, an opaque disc of green-blue . . . without as much as a ripple to mar its mirrored surface" (49). The second horizon is more familiar: the churchyard at dusk, after the three-hour drive, where Johnny spots a "huddled figure in the distance up on the mounded hill walking among the graves."

> JOHN: They're coming for you, Barbra.
> BARBRA: Johnee! Stop it . . . You're ignorant . . .

John: They're coming out of their graves . . . After
you . . . They're coming after you . . .
 The shadowy figure moving among the graves, stops,
stands for a moment. Barbra glances toward the figure and
momentarily her anxiety turns to embarrassment.
(Romero, *Night of the Living Dead*, Draft Script 8)

Barbra's embarrassment is the embarrassing hangover of social meaning during a state of emergency.[1] Zombies let embarrassing things be done to human beings.

The third horizon, again black and white, happens in the morning. The rain has just stopped, and a man, woman, and child crawl out of their hiding place. The man points "to a distant chain of human forms on a ridge against a dark, retreating sky, with summer lightning glittering over the horizon like needles." Here, turning to the screenplay for Ingmar Bergman's *Seventh Seal*:

> I see them! I see them! Over there . . . They are all there [. . .] and
> Death, the severe master, with his scythe and hourglass, invites them
> to dance. He tells them to hold each other's hands and then they must
> tread the dance in a long row. . . . They dance away from the dawn and
> it's a solemn dance towards the dark lands, while the rain washes their
> faces and cleans the salt of the tears from their cheeks.

Death's props are the temporal instruments of human lives, timepieces, harvests, chronos. "Love, birth, death, marriage, labor, food and drink, stages of growth," as M. M. Bakhtin writes of the chronotope (225–26). Zombies don't have such things—idylls, tools, social geographies—but they do play games: zombie chess, zombie dice, zombie outbreak simulation, zombie Jeopardy. One of the ironies of Bergman's film is that the knight Antonius Block and his entourage (and not Death) are corpses

2.1. Original movie poster for *Dawn of the Dead* (1978).

and don't know they're dead. The game is played along the limit, as *homo sacer* (the sacred man) becomes *homo ludens* (the playing man).

In this light the minimalist poster for Romero's *Dawn of the Dead* is iconic. The BLAST of the zombie canon: a monstrously pink sky

punctuated by an ersatz sun that's—wait for it—a stylized head missing skin, with infected eyes, lurking behind the curvature of the earth, indicated by a black field and red foreshortened title card: "When there's no more room in HELL the dead will walk the EARTH.... First there was 'NIGHT OF THE LIVING DEAD.' Now GEORGE A. ROMERO'S DAWN OF THE DEAD." Kilroy was here ... but is now undead. Ω is a z-gram: The Omega Man. The meaning of this image is the last sunrise, the sunrise seen at the end of history. The death of the sun is the death of death (Lyotard 8–11).

The horizon works differently in zombie texts. As a concept and a phenomenon, the line that limits, the conventional horizon is open, designating future tense, spatial possibilities out there, experiential and interpretive frontiers, and so on. This distance will be shortened; unknowns will become information as they come into view. One moves toward horizons, or, more properly, as Hans-Georg Gadamer writes, one moves against them, for "[a] horizon is not a rigid boundary but something that moves with one and invites one to advance further" (238). In zombified texts, horizons are closed and foreclosed, fortifications are fortified. Over the horizon, there is no life-world. The zombies, the conventional shamblers, are massing. One runs away from the horizon toward the center, holes up in the middle, boards up claustrophobic space, bars the cellar door. Containment. What does it mean to say horizons are ruined by zombies? In effect, it means the horizon itself—the very conceptual frame of a cultural situation—is ruined.

Z-Grams

I'm skeptical about the existence of real zombies. When they turn up in conversations, so-called *real* zombies are unfailingly banal: remote-controlled ants, forgotten relatives, and so forth. Spare me all the

Time-Life Books knowledge about zombies. I feel more confident about the existence of zombies as *words*. These "zombies" exist: I can confirm them, using my instruments. Google's Ngram Viewer was developed at Harvard's Cultural Observatory. It's one of the linchpins of a new form of administration we're supposed to call *culturomics* ("Culturomics"). What the Ngram Viewer does is count a given word in a given corpus of texts. In this case the corpus is a tremendous mass of information, the entire pile of scanned print materials available through Google Books. Big data. From the earliest stuff they have to the present, the data collection consists of 15 million documents, and the ambition is to increase this number by a factor of ten ("Google Books").

Let's run an Ngram for "zombie" growth, controlling for a few factors: a time span of 1800 to the present and the English language. Y is the percentage of "zombie" in the corpus; X is time. Two hundred years ago there were no zombies; around 1900 there's a slight murmur; a bit more commotion in the mid-twenties, a stirring of interest in Haitian-zombies, stoked by Hearne, Seabrook, and Hurston; and then Hollywood takes over and thereafter zombie business is booming. Fitting the curve, then, means exponential growth. The first principle of population dynamics for the word "zombies" is $Y = 2^X$.

"Ghouls" make for a nice point of comparison. They're like zombies in several ways. They are living corpses. They hang out in graveyards; zombies do also. So let's compare (see fig. 2.2[2]). Ghouls fare better than zombies for a very long time ("Zombie vs. Ghoul"). They peak in the mid-twenties, right about the same time as the first zombie "boomlet." Then something happens on or about 1970—Romero—and thereafter I recommend investing in zombies. At first Romero doesn't mention zombies at all. He calls "his guys" ghouls and doesn't change lexical horses until *Dawn of the Dead* in 1978.

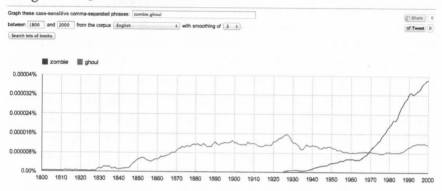

2.2. Zombie vs. Ghoul Ngram. Source: Google Books Ngram Viewer.

But somebody was calling these things *zombies* in 1970 already. A pulpy zombie matrix sets this in motion far earlier in the century. The matrix is configured by cheap adolescent entertainment material. First, *Weird Tales* and *Amazing Stories* and, later, horror comic titles like *Tales from the Crypt, The Vault of Horror, The Haunt of Fear,* and *Menace* provide a dating service for the cannibal, the zombie, the ghoul, the robot, the tell-tale heart, the swamp thing, the spaceman.

As Romero notes, it is

> mostly comics, and [now] most influentially, video games that have made this creature popular. Everybody knows the rules. . . . The point is, it's become this new sort of monster, and it's idiomatic. I expect a zombie to show up on Sesame Street soon, teaching kids to count. And you can sorta glue onto it anything you want to talk about. . . . It's all just sort of action. Whack 'em, sack 'em . . . more like video games. The Dawn remake was more like a videogame to me, much more than anything I ever made.[3]

2.3. *Menace* #5 (July 1953).
Cover art by Bill Everett.

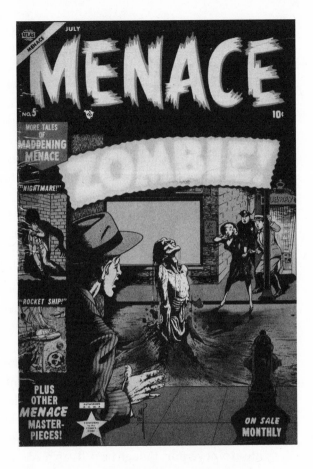

Pulp auteur H. P. Lovecraft's contribution to this matrix may not seem at all obvious to the uninitiated, but his influence on the zombie "rule book" is second only to Romero's. The idea of an animated, upright revenant intent on settling grievances with the living is long-standing literary bread and butter, of course. And the zombie's historical provenance

is more familiarly traced to folkloric sources in the Caribbean and West Africa. The generalized discourse about labor, race, and slavery in zombie texts is one legacy of this background, but other aspects of the cane-field zombie go away.[4] The zombie master basically helicopters out with his collection of potions, poisons, and supernatural incantations, for instance, leaving uncertainty about control as a sovereign issue of zombie cybernetics.[5] One innovation to the new zombie gestalt that we can drop squarely on Lovecraft's doorstep is the idea that the chief monstrosity of the ruinous and zombified form of humanity rests in uncountability.

Mary Shelley's creature certainly has naming problems but he's singular, and a large part of his unhappiness follows from that singularity. The solitary zombie plays a role in several Lovecraft tales from the 1920s and 1930s—"Herbert West: Reanimator," "In the Vault," "Cool Air," "Pickman's Model," and "The Thing on the Doorstep"—but it is seldom a lonely zombie. One exception is "The Outsider," a first-person account of a zombie's coming to awareness of being dead. With no memories, the dead being is thrown into a claustrophobic, ruined environment that is "infinitely old and infinitely horrible; full of dark passages and having high ceilings where the eye could find only cobwebs and shadows" (*Tales* 8). The place is defined as much by "piled-up corpses of dead generations" as "maddening rows of antique books," where the outsider can take no measure of time and—with a Beckettian twist—can recall no life except vermin, though he still can read somehow (8). From this situation, surrounded by ruined people and things, he deduces that other "beings" must have once cared for his needs, yet with no mirrors there's no way for corpse Caliban to see his own face (8). Eventually he climbs a mysterious tower and gate-crashes an unsuspecting party of the living. As the attendees flee in horror, he comes to the inexorable truth before a mirror: that he is

all that is unclean, uncanny, unwelcome, abnormal, and detestable . . .
the ghoulish shade of decay, antiquity, and desolation; the putrid, drip-
ping eidolon of unwholesome revelation; the awful baring of that which
the merciful earth should always hide. . . . To my horror I saw in [the]
eaten-away and bone-revealing outlines [of this face a] leering, abhor-
rent travesty on the human shape. (13)

Because this is Lovecraft, the scene speaks at once of "cosmic nightmar-
ishness and hellish accident" (13). Nietzsche's Last Man stumbles up the
stairs at the end of history and finds himself ready to party, auditioning
for *Return of the Living Dead* avant la lettre.

Lovecraft's first zombie tale is a manifesto of sorts for Lovecraf-
tian poetics—a poetics of misanthropy conjoined with exanthropy.
Fittingly, the promise of Lovecraft's version of "I, Zombie" ends with
the joys of pure zombie multiplicity, the single corpse joining the un-
countable, multitudinous corpses who occupy the western lands over
the horizon:

[Now I] ride with the mocking and friendly ghouls on the night-wind.
. . . I know that light is not for me, save that of the moon over the rock
tombs . . . ; yet in my new wildness and freedom I almost welcome the
bitterness of alienage. . . . I know always that I am an outsider; a stranger
in this century and among those who are still men. (14)

Part of the interest here is, why are zombies so hateful? Why can't they
just chill like most inert things? Why must exanthropy entail misan-
thropy? If Graham Harman is to be believed, the Lovecraftian zombie
world is exemplary for its strict materialism, but if alienage is bitter,
why must it be welcomed? In "Herbert West: Reanimator," the good
researcher is a strict materialist in all things and presumes to probe be-
yond good and evil. Herbert West, Lovecraft writes, was "materialist,
believing in no soul and attributing all the working of consciousness to

bodily phenomena; consequently he looked for no revelation of hideous secrets from gulfs and caverns beyond death's barrier" (43). In effect, West denies an ontological difference between life and death—between shit and non-shit—and is presented in the tale as "a fastidious Baudelaire of physical experiment" (46). West's research project aims at, in his formulation, "restoring rational and articulate life to the dead," but the dead are not especially pleased about it: "Help! Keep off, you cursed little tow-head fiend!" one corpse says pointedly (44).[6]

The hostility of the dead suggests something more than a twisted point of view. Because West's "research work required a prodigious supply of freshly slaughtered human flesh" (47), he gleefully embraces the opportunity to further his experiments amid the trench horrors of World War I—and here we find another commonplace: a zombie parable about the risks of unintended consequence.

> Terror stalked [West] when he reflected on his partial failures; nameless things resulting from imperfect solutions or from bodies insufficiently fresh. A certain number of these failures had remained alive—one was in an asylum while others had vanished—and as he thought of . . . eventualities he often shivered beneath his usual stolidity. (46)

What's beneath this surface is ooze—the Lovecraftian inhuman necroplasm—and the point about this stuff is that it isn't wholly human from the start. Nerd stuff par excellence, ooze consists of specially cultivated "reptile embryo tissue," claimed to be "better than human material for maintaining life in organless fragments."

> In a dark corner of the laboratory, over a queer incubating burner, [was] kept a large covered vat full of this reptilian cell-matter; which multiplied and grew puffily and hideously . . . with hideous reptilian abnormalities sprouting, bubbling, and baking over a winking bluish-green spectre of dim flame in a far corner of black shadows. (47)

In effect, the uncountable zombie horde as we now know it emerges from this stuff, intent on doing "cannibal things" to the hapless living survivors (50). Just as the zombie goo multiplies "puffily and hideously," so do the tomb legions, commanded by a zombie colonel who has stolen West's techniques. These "creatures," Lovecraft writes, "acted less like men than like unthinkable automata. . . . Their outlines were human, semi-human, fractionally human, and not human at all. [Above all else] the horde was grotesquely heterogeneous" (54).

In effect, Romero's *Night of the Living Dead* taps into the pulpy mass of weird adolescent reading materials. The act doesn't just release grotesquely heterogeneous stuff upon the cinema; it urges the ghouls to emigrate from the graveyard. This was the first innovation of the film's opening sequence: the ghoul leaves the crypt, no longer content to restrict its diet to dead stuff; the living-dead crypt keeper departs the cemetery gates and follows the fresh meat up the road. "Zombies"— formerly soulless labor, remote-control operated by some accountable, absent master—get press-ganged into the service of a new concept for which the transmitter is uncannily absent. When Peter gives his mall balcony soliloquy—"When hell is full, the dead shall walk the earth"— he is as much spinning eschatology after the death of God as he is pointing to the would-be demographic commonplace that more people are living now than have ever walked the earth. By this measure we could amend Peter's line: when the graveyard cupboard is bare, the ghouls walk around looking for more dinner.

Let me put the living-dead factoid the way I first heard it: most people who have lived are still alive. A factoid is, of course, a kind of zombie, too. No matter how many times it gets refuted, it just continues to exist. It turns out that by a very conservative estimate all the people who have ever lived far outnumber those currently living. The international Population Reference Bureau devoted some resources to

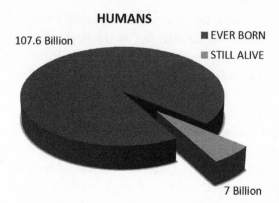

HUMANS

107.6 Billion

■ EVER BORN
■ STILL ALIVE

7 Billion

2.4. Number of Humans. Source: Population Reference Bureau.

tackling and debunking the pseudo-fact a few years back. To be brief, human beings have been around a very long time. If one takes the first *Homo sapiens* as the starting point, fifty thousand years ago, and projects forward, the total number of people who have ever been born is some 108 billion—100 billion more than are alive now. So the people living now comprise about 6.5 percent of the number who have ever lived (see fig. 2.4).

This percentage turns out to be a massive number but nowhere near the majority. Certainly it's not as bad as conditions in the zombie apocalypse imply, when the living are outnumbered by a factor of 400,000—according to the guesstimates in *Day of the Dead,* at least. This cozy catastrophe puts the world population at 15,000, back to levels not seen since well before the advent of agriculture. Even if we consider the total number of people alive at some point in the twentieth century as a benchmark, 11.4 billion, the number is 10 percent of the people who ever lived (see fig. 2.5).[7]

It's telling that this particular meme about population overload—about numerical imbalances between the living and dead—shuffles

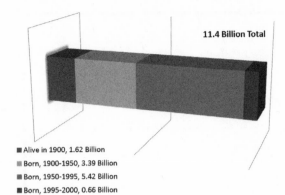

11.4 Billion Total

■ Alive in 1900, 1.62 Billion
▨ Born, 1900-1950, 3.39 Billion
■ Born, 1950-1995, 5.42 Billion
■ Born, 1995-2000, 0.66 Billion

2.5. Humans in the Twentieth Century.

along haplessly notwithstanding its status as a pseudo-fact. Oddly enough, our age of total information seems also to be a high-water mark for bad information: the day the Factoids walked the Earth. It isn't hard to guess why this living-dead factoid continues to exist or why it plays such a prominent role in zombie texts. We can multiply examples from the zombie canon—Colson Whitehead's *Zone One,* Max Brooks's *World War Z,* and others. On the one hand, the response mobilizes older, Malthusian notions about exponential population growth, rising birthrates, and scarce resources. On the other, it gives form to newer, more uncanny ideas about the risks hidden in falling death rates.[8] Should it not be a good thing if fewer people die? The folk psychological figuration of modernity figures any "out-of-control" growth as a sin against a mystical double-column accounts book, the celestial cash register, as James Joyce puts it.

The curve for long-term population growth increases exponentially (see fig. 2.6).[9] Significantly, 1968, the year of Romero's *Night of the Living Dead,* was also the year of the demographer Paul Ehrlich's best seller *The Population Bomb.* Its graphs of out-of-control population growth

2.6. Long-Term Population History, 1800–present. Source: Wolfram|Alpha.

are overdetermined by concomitant fearmongering about human death rates. Ehrlich's jeremiad warns that "too many people" in an overpopulated future will usher in "astronomically" out-of-control appetites, mass migration, starvation, and wars, pandemic catastrophes, and other unspeakable new brutalities (71). In so many words, Ehrlich foretold the zombie apocalypse without the zombies: exploding numbers of the living foretold exploding numbers of the dead.

Let me state my thesis as plainly as possible: zombies are monsters of demography. They are abstractions of demography given monstrous, fictionalized shape. I hasten to add that I am not arguing the usual thing about zombies being free-floating metaphors for society's fears. I think zombies are stickier signifiers than this; the relation with demography I'm after is straight analogy, based on formal similarities of ratio. That

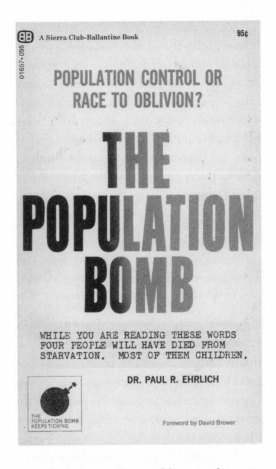

curve for long-term human population growth resembles—in the sense that it fits the curve—the zombies Ngram. Why is this? Because massive population growth in modernity also includes massive growth in rates of transmission of words about many undead things, and some of those things are zombies.

It's no great mystery that zombies owe something to migrants and pilgrims, the crowd, the mob, the mass, the ruinous multitude: *"One hundred million angels singin' / Multitudes are marchin' to the big kettle-drum,"* as Johnny Cash puts it ("Man Comes Around"). The award-winning title sequence to Zack Snyder's *Dawn of the Dead* (2004) remake, which is scored to Cash's version of the Second Coming, does the bridge work by mashing together documentary footage of actual demographic risks and the fictive imagining of a zombie outbreak. Think here of the famous point Raymond Williams reaches in the conclusion of *Culture and Society:*

> Masses = majority cannot be glibly equated with masses = mob. . . . I
> do not think of my relatives, friends, neighbours, colleagues, acquain-
> tances, as masses. . . . Yet now, in our kind of society, we see those others
> regularly, in their myriad variations, stand, physically, beside them. . . .
> To the other people, we also are masses. Masses are other people. (299)

Yet, isn't it precisely this equation that animates the zombie apocalypse? When *bios* = *zoe,* there is no difference between a majority and a blood-thirsty ruinous multitude. Humans are countable in zombie texts. Zombies are not. They are so numerous their numbers can only be estimated; depending on the text, zombie populations serve as known unknowns or, more often, unknown unknowns: a hundred million massing over the horizon is implied.

The point for zombie texts is that this massive explosion designates nothing less than a "corpsed" audience structure, a ruined horizon of re-ceivers. As Samuel Weber notes, Walter Benjamin's essay "The Work of Art in the Age of Mechanical Reproduction" puts a fine point on using the radio term *receivers* for the shifting means of cultural transmission driven by new media technologies. Forget aura; as transmission takes place in an efflorescence of receivers, it takes on a massive, waste-like

character devoid of obvious organizing, unique singularity (83). Forget consumption; zombies eat only to transmit malfeasance—"multiplying exchanges at lesser cost," to borrow from Michel Serres[10]—without properly digesting anything they consume (72). It's axiomatic that—save perhaps for periods of distraction and contraction through war, famine, plague, and so on—cultural material expands exponentially over time, and that this curve accelerates vertiginously during the twentieth century. The zombie gesture par excellence is broadcast transmission, appropriation through pollution.[11]

Noël Carroll argues that a monster is a necessary condition for horror texts, which paradigmatically elicits something he calls toxification, a response that

> *What does it mean to say horizons are ruined by zombies? In effect, it means that the horizon itself—the very conceptual frame of a cultural situation—is ruined.*

depends on their being hazardously dirty or filthy ("Nature of Horror"). To Carroll's proposition we can apply this zombie corollary: zombies are monsters that toxify through uncountability. Certainly, zombies are fecal–shit bags par excellence, to borrow the term of art from Captain Rhodes in *Day of the Dead*—a shit you don't want to take, and zombies are so filthy that even zombies won't eat them (*Day of the Dead*). The response approximates my response to the plentitude of Golden Corral. Think here also about the connection between zombies and toilets—shit meant something important to them once. I wonder if the horror that zombies elicit has less to do with their impurities than with the difficulties they bring as candidates for counting. How many zombies are in the house? How many are in the yard? How many are over that hill? Is there one in the backseat? Is there one under that pile of pink Sno Balls? Are zombies less or more? Is waste something less or more? These

diminished, ruined people are monstrous because they are uncountable. At the same time, the zombie outbreak demands that survivors devote the majority of their energies to reducing the zombie horde with impunity and extreme prejudice.

Zombie Research Plan

About *your* zombie research plan, first things first: determine some rules. The first thing to ask: Are there really zombies on the premises? Do you feel seriously endangered? Maybe you're thinking about zombie evacuation plans and survival strategies as you're reading this. Is it best to make a break for it or head to the cellar? Should you be the boss of the upstairs or the boss of the crypt? "Get a Kit, Make a Plan, Be Prepared," the Centers for Disease Control and Prevention gamely advises (Khan). If you hope to see your loved ones again, that is, "You should pick two meeting places, one close to your home and one farther away" (Khan). The mailbox is one idea. Or the doorway. Should we rendezvous on the roof or at the mall? What about that old limestone mine over by the zoo? An island in the tropics? What about equipment? That's another story: the tools and supplies that the CDC endorses—a utility knife, duct tape, battery-powered radio, household bleach, soap, towels—all seem rather nonthreatening goods, but then again they're not the NRA and really can't be mock-coaching the public in the manufacture of sawed-off shotguns, groovy chainsaws, and tricked-out lawnmowers.

You're going to need more than a toothbrush, a safety razor, and an iPod. "If zombies did start roaming the streets," according to the CDC's public service announcement,

> [the agency] would conduct an investigation much like any other disease outbreak. CDC would provide technical assistance to cities,

states, or international partners dealing with a zombie infestation. This assistance might include consultation, lab testing and analysis, patient management and care, tracking of contacts, and infection control (including isolation and quarantine). It's likely that an investigation of this scenario would seek to accomplish several goals: determine the cause of the illness, the source of the infection/virus/toxin, learn how it is transmitted and how readily it is spread, how to break the cycle of transmission and thus prevent further cases, and how patients can best be treated. Not only would scientists be working to identify the cause and cure of the zombie outbreak, but CDC and other federal agencies would send medical teams and first responders to help those in affected areas. (Khan)

Looking for signs of postapocalyptic stress disorder doesn't help with the kind of zombie research plan that matters, though, the kind that will tell us what zombies mean.

Do you even know that zombies are fictional? If you don't, it's likely that you exist captive to some kind of zombie make-believe—a zombie movie, probably, zombie CDC propaganda, bunked down with zombie intertextuality. The problem here is that you typically don't have access to other zombie texts, including the CDC's "fun new way of teaching about emergency preparedness" (Khan). In zombie texts three basic kinds of zombie research plans rule, three epistemological stances: two applied forms of knowledge and one given to pure research. The first two have a survivalist bent; the third is exposed as a decadent luxury, "like shampoo and affection," as Colson Whitehead puts it, rendered in the machinery of a *skel*-world cautionary tale (21).

The first research question concerns zombie realty: where to go? Upstairs, with an exit, an elevator shaft, a helicopter? Or downstairs, *à huis clos,* in the death trap? Later I relate this matter—upstairs/downstairs—to the persistent philosophical quarrel between zombie

physicalism and zombie metaphysics. Question number two: what do you need? Zombie logistics: equip yourself with goods. In other words, the ever popular smash and grab, guns and looting. Question number three—here the CDC recommends the intercession of the scientific method: what's up with zombies? Usually this means zombie epidemiology and pathology. These three research dispositions more or less shape the contours of Romero's zombie trilogy, *Night, Dawn,* and *Day.* Such is the status of knowledge within zombie make-believe. No time for literary criticism; inside this intertextual leviathan the non-zombies are not as knowledgeable about zombies as we are. This point, in fact, may be the best rule of thumb for determining whether or not you're truly facing a zombie apocalypse. In *fictional* zombie worlds—which is to say, in zombie worlds—knowledge about the undead is harder to come by than in non-zombie worlds, which is to say *worlds.* A big part of in-universe zombie research plans involves ascertaining how many zombies are nearby and counting off rules about them; undead *literary* reflexivity, reading, interpretation—meta–zombie knowledge—is another story.

Meta–zombie knowledge does provide a ready source of zombie comedy, though. Bub thumbing through Stephen King's *Salem's Lot* mirrors the efforts of Shelley's creature to digest Milton. Who knew there was pleasure to be had in literary and cinematic meta-culture beyond the death drive? *From Dusk till Dawn* (1996)—not a zombie movie per se—has a telling scene organized by this uncanny archival matrix, the charnel house of undead genres. Moving with the dead from night to day—from dusk till dawn, here it's not zombies but vampires: "yellow-eyed, razor-fanged, drool-dripping VAMPIRES," as the screenplay puts it (Tarantino). The screen presence of Romero effects wizards Tom Savini, playing Sex Machine with his crotch gun, and Gregory Nicotero signals something of the meta-generic continuity:

JACOB: Does anybody here know what's going on here?

SETH: I know what's going on. We got a bunch of fuckin' vampires out there trying to get in here and suck our fuckin' blood! And, that's it, plain and simple. And I don't wanna hear anything about "I don't believe in vampires" because I don't fuckin' believe in vampires either. But I do believe in my own two fuckin' eyes, and with my two eyes I saw fuckin' vampires! Now, does everybody agree we're dealin' with vampires. [Everybody agrees.] Now that we agree we're dealing with vampires, what do we know about vampires? Crosses hurt vampires. Do we have a cross?

. . .

SCOTT: We got crosses all over the place. All you gotta do is put two sticks together and you got a cross.

SEX MACHINE: He's right. Peter Cushing does that all the time.

SETH: Okay, I'll buy that. So we got crosses covered, moving right along, what else?

FROST: Wooden stakes in the heart been workin' pretty good so far.

SEX MACHINE: Garlic, sunlight, holy water . . . I'm not sure, doesn't silver have something to do with vampires?

SCOTT: That's werewolves.

SEX MACHINE: I know silver bullets are werewolves. But I'm pretty sure silver has something to do with vampires.

KATE: Does anybody have any silver?

ALL: No.

KATE: Then who cares?

JACOB: Has anybody here read a real book about vampires, or are we just remembering what a movie said? I mean a real book.

SEX MACHINE: You mean like a Time-Life book?

Step one: believe what your eyes see. Step two: compile undead literary and cinematic genre information. "Yeah, he's right. Peter Cushing does

that all time." On the one hand, only a Time-Life production can be represented as a "real" book, and yet it doesn't count; on the other hand, remembering what some movie said does not even rate as knowledge. What we know can only be the limited case—*these* vampires—based on the vampire evidence in this movie.

Then there's the scene in *Return of the Living Dead* (1985), during the first act, in the medical supply warehouse:

> FRANK: Kid, I've seen weird things come and I've seen weird things go. The weirdest thing I ever saw, just had to cap it all. . . . Let me ask you a question, kid, did you see that movie, *Night of the Living Dead*?
>
> FREDDY: Yeah, yeah, yeah, that's the one where the corpses start eating the people, right? Sure, what about it?
>
> FRANK: Do you know that movie was based on a true case?
>
> FREDDY: C'mon, you're shitting me, right? That's not possible. They showed zombies taking over the world.
>
> FRANK: They changed it all around, what really happened was: back in 1969, in Pittsburgh, at the VA hospital, there was a chemical spill, and all that stuff, kind of leaked down into the morgue—and made all the dead bodies kind of jump around as though it was alive.
>
> FREDDY: What chemical?
>
> FRANK: 2-4-5-trioxin. It was to spray on marijuana or something. Darrow Chemical was trying to develop it for the army. They told the guy who made the movie, that if he told the true story, they'd just sue his ass off, so he changed all the facts around.

Of course, it's not much of a claim to say it, but zombie texts are always based on true cases with the facts all changed all around. As pseudo-things, zombie facts are "all messed up," as the hick sheriff who heads the posse in *Night of the Living Dead* puts it. They are facts without horizons. The banal point is, perhaps, that this resembles the situation of literary modernity without literary history. What Karl Rove said a few

years back about the American imperium—its power to command what counts as facts—holds about the status of knowledge in zombie worlds:

> We're an empire now, and when we act, we create our own reality. And while you're studying that reality—judiciously, as you will—we'll act again, creating other new realities, which you can study too, and that's how things will sort out. We're history's actors . . . and you, all of you, will be left to just study what we do. (Suskind)

The upstairs boss pulls the ladder up. In Beckett's *Endgame,* before Clov looks out at a "corpsed" horizon he turns the telescope on the auditorium and sees not a sea of gadgets but an impossible audience structure: "a multitude . . . in transports . . . of joy."

> HAMM: And the horizon? Nothing on the horizon?
> CLOV (lowering the telescope, turning towards Hamm, exasper-
> ated): What in God's name could there be on the horizon?
> (Pause.) (107)

Beckett is clearly borrowing cold comfort and a sponge from Nietzsche's madman.

> Who gave us the sponge to wipe away the entire horizon? What did we do when we unchained this earth from its sun? Whither is it moving now? Whither are we moving now? Away from all suns? Are we not plunging continually? Backward, sideward, forward, in all directions? Is there any up or down left? Are we not straying as through an infinite nothing? Do we not feel the breath of empty space? Has it not become colder? Is not night and more night coming on all the while? (*Gay Science* 120)

It may not be Beckett, but *Return of the Living Dead* is a film with much to recommend it, despite protestations from *Walking Dead* creator

Robert Kirkman about its shortcomings as "dramatic," "thought pro-voking" filmmaking: 2-4-5-Trioxin, chemical spills, army conspiracies betray much more epistemological certitude than Romero's films (Kirk-man and Moore, *Walking Dead*, Vol. 1). The army *is* experimenting with risky herbicides; nihilistic punks *are* subhuman Paraquat; zombies *are* after your brains. In *Return of the Living Dead* one zombie gets strapped to a gurney—eyes and voice still operational, unlike the vivisected specimen in *Day of the Dead*. Viva voce, she explains, quite reasonably, that zombies eat brains because being dead is painful and living brains have analgesic properties: "How does [eating brains] make you feel?—It makes the pain go away." It's all really quite reasonable. A no-brainer for the ontological other.

There's no more nature now, as Beckett observes, only humans overwhelmed by waste. Even the so-called man-made cause, 2-4-5-Tri-oxin, designates a new temporal disposition: a present situation com-promised by an inexorably inhuman future. There's no metaphor here, no allegory about otherness. Quite straightforwardly, the problem of indestructible waste has ruined the horizon of humanity and human-ism. Romero is less clear about his zombie etiology, but his zombies still give us the rule of risk epistemology, where human survival depends on managing hazards hidden over the horizon, as it were (Beck 162).[12] It's what we think we know about the invisible, uncountable unknown that counts. As numerous commentators have observed, the films grow progressively and increasingly indifferent to the causal explanation broadcast on TV in the first film, radiation from space, hitchhiking on the Venus satellite. To the initiated, the transmission nods subtly to *Plan 9 from Outer Space* (1956), Ed Wood's zombie camp, Venus entering the constellation of Libra.

Sometimes commentators see later Romero taking a crypto-reli-gious turn—hell being full, we're all already fallen, and all that—but the

films seem to be working toward a more explicitly Beckettian/Nietzschean end, a future-overburdened present. In later films, with communication, transmission, and reception ever more fitful, the telepathology of the zombie ur-cause is repeatedly marked as a known unknown. The message from space is an inhuman end. Savini's 1990 remake of *Night of the Living Dead*—sanctioned by Romero—makes this point another way: multiple zombie etiologies are permissible. It's both/and: both inside and outside, both down in the crypt and up in the sky, both chemical weapons and a hole in the ozone layer.

One last point: there's a near obligatory tendency in the zombie research plans hatched outside zombie texts to propose zombies as free-floating metaphors of the zeitgeist. Zombie research can't resist posing the single question to which the answer is already known: how is the logic of zombies tethered to its subtext? My conclusion is that zombies don't depend on the logic of the metaphor, transferring something into something else, but analogy, similarity, proportion. It's the failure of difference that matters—that's fascinating and macabre: *"We're them, and they're us"* (*Night of the Living Dead* 1990). The game is played on the limit. When it comes to zombie culture, category confusions abound, but these are just embarrassments of minimal difference. If the first premise of a zombie research plan is that zombies don't exist, that they're not real, the embarrassing truth is that the critic can't help but being a mercy killer—a murderer, even—of zombie concepts. All the evidence points to the zombie as the last metaphysical conceit, or the last one standing on a ruined horizon, yoking the most heterogeneous ideas of our times together by violence. The misery from which this zombie ought to be released is our own.

Notes

1. Barbra's embarrassment underscores, in effect, the ruined horizon of sociality. With the zombie apocalypse—some while beforehand, perhaps—forms of social affiliation (filial piety, remembrance for the dead, etc.) become voided. Here I have in mind Ulrich Beck's idea of the zombie concept, lingering and totalizing social residue, that is nevertheless functionally dead. Even though Beck uses "zombie" as sociological metaphor, its power as a tool of thought can be turned back on the wellspring of pulpy zombie corpus and help us understand the zombie's explosive possibilities for composing social and political allegory in terms of a surfeit of decayed and superfluous bodies. See Beck, *Risk Society.*

2. Google Books Ngram Viewer, http://books.google.com/ngrams. On the development of the Ngram, its methodology, and possibilities for research, see Jean-Baptiste Michel et al., "Quantitative Analysis of Culture Using Millions of Digitized Books."

3. Murray, "Interview with George Romero." It's significant that the zombie auteur himself makes this observation. Beginning in the 1920s, narrative pulps were printing weird tales by Lovecraft, Poe, and others of animated dead alongside H-zombie stories, and this recipe continued through the horror comics of the 1950s—the trinity *Tales from the Crypt, Haunt of Fear,* and *Vault of Horror,* in particular, which Romero, born in 1940, is certain to have encountered on newsstands.

4. Much of my understanding of the H-zombie comes from Zora Neale Hurston and, more specifically, *Tell My Horse.* In an interview, she says about the zombie that he or she "is supposed to be the living dead. People who are resurrected but without their souls. They can take orders. And, they're supposed never to be tired and to do what the master says. . . . I do not believe they were actually dead. I believe it was suspended animation. Case where people are found months later actually alive but without their minds" (McBride, Interview with Zora Neale Hurston). Hurston's mix of ethnography and historical research details how the H-zombie prefigures the revolutionary potential of the zombie horde; apparently the Haitian revolution was supported with the aid of zombie soldiers, and many Haitian zombie stories end in anarchy and the tearing down of the master's house.

5. For one investigation of the complex legacies of the H-zombie for race, labor, and control in the context of popular music and dance genres, see Edward Comentale's chapter in this volume.

6. The angry zombie trope echoes the return of the undead Samuel (1 Samuel 28:15): "Why hast thou disquieted me, to bring me up?"

7. Of course it is unclear how to create a census after the zombie apocalypse anyway, when everyone living, dead, or somehow both just continues to exist.

8. If the factoid were fact, writes the head demographer at the Population Reference Bureau, it would imply that "births in the 20th century [would massively outnumber] those in the past or that there were an extraordinary number of extremely old people living" (Haub).

9. "Long-term Population History," www.wolframalpha.com.

10. Massing readers is a game of numbers and probability, not individual responses: massively consumed texts are always better rated by their receivers than more "literary" texts by theirs, because more consumers are less likely to have more books with which to compare them.

11. Of course, in addition to the zombie's syncretic synthesis of hazards like social depredation, environmental degradation, and corporeal decrepitude, the zombie, without much disguise, is also an avatar of nasty pandemic catastrophe (especially in films like *28 Days Later* or video games like *Urban Dead,* "A Massively Multi-Player Web-Based Zombie Apocalypse." In this regard, Daniel Defoe's *A Journal of the Plague Year* (1722) is as much a prototype for the physicalist, physiological R-zombie as Matheson's *I Am Legend* (1954).

12. Beck's risk epistemology is not exclusively ecological—it's also economic and terroristic—but the ruined horizon of future ecological catastrophe may be understood as its governing theme.

3 Zombie Spaces

DAN HASSLER-FOREST

> New York City in death was very much like New York City in life. It was still hard to get a cab, for example. The main difference was that there were fewer people.
>
> **Colson Whitehead, *Zone One***

Over the past decade the zombie has been transformed from a movie monster that appeared primarily in American underground cinema and Italian horror films to a ubiquitous trope in popular culture. Instantly recognizable to general global audiences, yet flexible enough to serve both as a legitimate monster and as the punch line to a bad joke, the figure of the mindless undead has clearly found resonance in late capitalist culture and has been connected to a wide range of concepts and ideas. In the same way that Marx and Engels related the system of industrial capitalism to the figure of the vampire, many critics have pointed out that our postindustrial obsession with zombies is no coincidence: "the nineteenth century, with its classic régime of industrial capitalism, was the age of the vampire, but the network society of the late twentieth and twenty-first centuries is rather characterized by a plague of zombies" (Shaviro 282).

The rise of the zombie as what Gilles Deleuze and Félix Guattari have described as our culture's "only modern myth" (*Anti-Oedipus* 368) has been accompanied by a simultaneous and insistent foregrounding of

urban life as the strongest single unifying concept in capitalist societies. With close to half the world's population now residing in various forms of urban geographies, cities have now come, in Edward W. Soja's words, to "emanate a generative force that is the primary cause of economic development, technological innovation, and cultural creativity" ("Beyond *Postmetropolis*" 452). Cities can therefore no longer be regarded merely as the most visible products of capitalism, industrialism, and modernity, but should instead be recognized as the primary forces that constitute and shape modern ways of seeing and thinking.

One of many forms in which the dominance of this urban framework has expressed itself culturally is the proliferation of spatiality as a mode of discourse and expression. The teleological framework of early modernity, with its emphasis on Enlightenment concepts such as linear progress and causal development, has given way to the cluttered maze of the cityscape and its more appropriate forms of network theory. Contemporary narrative media are no longer dominated primarily by the classical cause-and-effect chain of narrative, but instead engage in an increasingly complex intertextual web that extends not only beyond any single individual text but across many different media as well. This postmodern shift in popular media reflects the complex, networked structure of urban experience that dominates contemporary consciousness.

The zombie genre is one of the clearest embodiments of this spatial shift and its effects on traditional narrative media. In many ways the zombie genre even represents a form of antinarrative that relies much more strongly on the continuous establishment of spatial coordinates than it does on the causal chain of classical narrative. The situational paradigm of the zombie genre maps out an environment in which a group of individual survivors must navigate an urban space where "simplistic renderings of inside as familiar/safe and outside as unknown/ dangerous are disrupted by the creation of bodies with new identities"

(May 293). The object of the narrative is only very rarely the successful resolution and containment of the crisis, or even the establishment of a rational explanation of its key events; instead, it is primarily organized around the individual's survival of a series of encounters that challenge and disrupt the traditional uses of urban space.

In this chapter I offer a wide-ranging analysis of the fundamental relationship that exists between the postwar zombie and the postmodern city. Unlike the occult Caribbean *zombi*, which was an articulation of colonial imperialist anxieties, particularly in relation to discourses of race and slavery (Russell 15), modern zombie films present the zombie as an internal threat, building on its colonialist origins to become the archetypal embodiment of the breakdown of binary distinctions: "simultaneously living and dead, subject and object, slave and slave rebellion, the zombie presents a posthuman specter informed by the (negative) dialectic of power relations rather than gender" (Lauro 91). My argument is that even as our experience of contemporary urban life finds expression in the framework of the zombie figure, the zombie genre simultaneously helps us to understand and articulate both the problems and opportunities of urban life under global capitalism.

Since the zombie is no longer a figure we can associate with any single medium, I draw on examples from popular cinema, comic books, television drama, video games, and smartphone apps that together make up a complex zombie paratext. Not only does this archive serve to underscore the part of my argument that relates to the total ubiquity of the zombie figure in our media landscape, but it also shows how systematically certain grounding concepts and structural frameworks continue to tie these multiple iterations of the zombie trope together.

Besides the conceptual threads that connect the cross-media figure of the zombie across many diverse texts, I draw on two key works that help solidify my argument. First I turn repeatedly to Raymond

Williams's classic work *The Country and the City*, in which he famously describes the complex sets of discourses that have defined our understanding of the urban as a sociocultural form. Williams's concepts help me articulate the way we conceive of the urban as an inherently dialectical concept, not only existing as counterpart to its pastoral "other" but also containing its internal sets of contradictions as well. Second, I foreground Richard Matheson's novel *I Am Legend* (1954), which functions as a foundational text for the contemporary zombie genre and both grounds and prefigures many of the existing connections between the zombie and the city.

Zombies and Urban Space

One of the easiest mistakes to make in any critical reading of the zombie is to impart certain fundamental qualities to the figure of the undead. Although it lends itself "almost too easily as a metaphor about our current economic predicament" (Paik 7), the postmodern zombie is not grounded in its meaning by any single center. As a figure that literalizes the contradictions inherent in dialectical thinking, it can be put to any number of allegorical uses: the zombie has stood for mindless consumerism (*Dawn of the Dead*), viral contagion (*28 Days Later*), the civil rights struggle (*Night of the Living Dead*), and even the theoretical anxieties of poststructuralism and the linguistic turn (*Pontypool*). By now the zombie figure has reached a point of cultural saturation where one can no longer speak of the zombie signifier standing for any single signified: zombies can be used for romantic comedy, for pastiches of literary classics, for flash mobs, and for video games in any genre.

One structural aspect, however, does unite the zombie figure across these multiple platforms: the modern zombie is always connected to anxieties about enclosed spaces as well as the collapse of boundaries

between interior and exterior in the context of modern urbanization. The zombie therefore functions not so much as a metaphorical signifier, but instead as "a conceptual tool that sensationalizes the bodily ambiguity of both bodies and cities in addition to rematerializing them" (May 288). In every permutation of the zombie trope, the primary thematic concern has been the reestablishment of clear enclosures, the safeguarding of private property, and the raising of barriers that unambiguously resolve economic and social tensions.

In the "carceral archipelago" of the neoliberal city (Soja, "Six Discourses" 190), it can come as no surprise that this paradigm has become the dominant model of organizing entertainment in such a wide variety of media and genres. The appeal of the zombie trope hinges on its articulation of dialectical processes on two different levels. First, it suggests the desire to transform urban space into gated communities that shelter "us" from "them," the spatial organization of urban life reflecting the socioeconomic contradictions between separate classes of citizens. At the same time, the zombie genre's perpetual rupturing of these multiple boundaries articulates the unsustainability of this separation, expressing both the inescapable dread that such boundaries cannot be maintained while paradoxically playing on our desire to see the system break down.

I Am Legend: The Postwar Zombie Ur-Text

I will take as the modern zombie trope's foundational text the Richard Matheson novel *I Am Legend,* which served as the source not only of three direct film adaptations (*The Last Man on Earth* [1958], *The Omega Man* [1971], and *I Am Legend* [2007]) but also as a key reference for *Invasion of the Body Snatchers* (1956) and an acknowledged inspiration for George A. Romero in his breakthrough zombie film *Night of the Living*

3.1. Vincent Price in *The Last Man on Earth* (1964).

Dead (1968). While neither *I Am Legend* nor *Night of the Living Dead* takes place in an urban center, both films illustrate clearly how the urbanization of postwar America has challenged the distinction between country and city, transforming the landscape into a claustrophobic environment with no exterior space of refuge: neither the suburban landscape of Matheson's book nor the Pennsylvania countryside of Romero's film offers safety from the rampaging hordes associated with the urban mob.

Trapped in a suburban home that must continuously be fortified and patrolled, protagonist Robert Neville divides his time between sending the undead to a more definitive grave and conducting scientific experiments that may help him find a cure for the virus that has caused the apocalyptic outbreak. Playfully bringing the Gothic vampire myth

into the modern era of scientific discourse and postwar urban decay, Matheson's book effectively introduces the trope of the zombie as the victim of a viral infection that transforms the living into the voracious walking dead.[1]

But perhaps even more potently, Matheson's pulp narrative moves the site of its undead invasion from the exotic Caribbean settings of earlier zombie narratives to the psycho-geographical space of the sprawling American city.[2] Rather than playing on the clearly defined geopolitical distinction between the nation's supposedly safe interior space versus the malevolent "other" that exists outside it, the zombie threat has now been fully internalized, creating a first rupture in the traditional distinction between "us" and "them." *I Am Legend* then crucially builds its narrative tension around the "spatial opposition that visually orients the zombie genre as a whole, between the domestic interior . . . and the wilds of the outside" (E. Williams 82). This opposition between the embattled domestic inside versus the outside as "an 'other'-space, blank space, empty except for the pregnant fear of the unknown" (May 293) emerges during the historical moment in which suburbanization was rapidly remapping the postwar American landscape.[3]

The rapid development of American suburbia from the 1950s onward not only heralded the age of consumer culture but simultaneously represented a breakdown of the traditional distinction between country and city. If the postwar wave of suburbanization was informed to a large degree by a fantasy of a return to a more traditional form of "country living," the wave of horror films from *Invasion of the Body Snatchers* to *Night of the Living Dead* serves as a vivid illustration of the social and cultural contradictions that have accompanied this flight from the cities. David Harvey explains that the rising tide of paranoia, social and political conformism, and materialism altered our perception of the relationship between the country and the city, because it happened "at

the cost of hollowing out the central cities and leaving them bereft of sustainable economic basis, thus producing the so-called 'urban crisis' of the 1960s" (*Rebel Cities* 9).

The suburban conception of one's residence as one's individual castle, a domestic fortress divorced from either urban or rural forms of social totalities, has gained both prominence and relevance in the neoliberal age of rampant privatization and gated communities. The horror fiction of the 1950s and 1960s has been interpreted by many as an indication of the extent to which capitalism had become the only framework from which to understand reality: "the overt doubleness of American culture in the 1950s can . . . be taken as a reflection of the increasing hegemony of capitalism in the decade, as the last remnants of agrarian alternatives to capitalism were swept from the American scene once and for all" (Booker 4). The traumatic absence of these agrarian alternatives, traditionally symbolizing spaces of refuge from the "unnatural" urban environments, is acted out spatially throughout the zombie canon. From *I Am Legend* onward, zombie narratives thus developed as a structural form that no longer relied on the difference between the Western nation-state and its colonial "other," but hinged instead on the increasingly ambiguous distinction between the urban and the rural, the country and the city.

Zombie Dialectics: The Country and the City

In order to map out the correspondence between the zombie and the city, I employ Marx's appropriation of Hegelian dialectics, which Harvey describes succinctly as a "process in which the Cartesian separations between mind and matter, between thought and action, between consciousness and materiality, between theory and practice have no purchase" (*Justice* 48). This way of thinking, which "emphasizes the

understanding of processes, flows, fluxes, and relations over the analysis of elements, things, structures, and organized systems" (49), makes it possible to address the many internal contradictions of both the zombie and the city without attempting to simultaneously resolve them. For in both cases it is exactly the tension inherent in the coexistence of incommensurable opposites that creates their unique attraction as well as their critical potential.

The dialectical tension that exists within Western and, perhaps more specifically, Anglo-American discourses of city versus country living not only has become one of the key cultural concerns in postmodernity but also provides the zombie figure with one of its structuring concepts. From the nineteenth century onward, the structure of feeling that informs our cultural understanding of the country and the city, most notably in narrative fiction, has portrayed the individual as "the person who must escape, or try to escape, from this repulsive and degrading mass" that is explicitly associated with modern urban life (R. Williams, *Country* 222). In this sense the zombie genre operates most frequently as a structuring fantasy that allows the individual protagonist not only the promise of escape from the squalor and decadence of (post-)industrial urban life, but also one that sets back the clock to an older age of supposedly natural innocence and purity. As Williams famously stated in *The Country and the City*, "It is difficult to overestimate the importance of this myth" in which "the transition from a rural to an industrial society is seen as a kind of fall, the true cause and origin or our social suffering and disorder" (96). From this perspective, the zombie apocalypse, while obviously traumatic, fulfills the nostalgic desire to break free from the decadent unreality of modern urban life.

For an uncannily precise illustration of this idea, consider the text that adorns the back cover of every issue of the popular comic book *The Walking Dead:*

How many hours are in a day when you don't spend half of them watching television? When is the last time any of us REALLY worked to get something we wanted? How long has it been since any of us really NEEDED something that we WANTED?

The world we knew is gone.

The world of commerce and frivolous necessity has been replaced by a world of survival and responsibility.

An epidemic of apocalyptic proportions has swept the globe causing the dead to rise and feed on the living. In a matter of months society has crumbled—no government, no grocery stores, no mail delivery, no cable TV.

In a world ruled by the dead, we are forced to finally start living.

Clearly, the structure of feeling that this genre fantasy provides includes not only the fear of an apocalyptic event that will bring about the end of human history but also a libidinal investment in just such an event: a delight taken in the removal of all "unnecessary" and "unnatural" modern preoccupations, thereby allowing the individual subject to reengage with "a world of survival and responsibility." In every version of this dynamic, the prelapsarian world we seek to return to is associated with the pastoral imagery of the country, while the "world of commerce and frivolous necessity" is represented by city life. Besides articulating our anxiety about urban alienation, these narratives thus allow us to indulge in a fantasy of an escape to a world that is more dangerous, more exciting, and—crucially—more "real."

Many theoretical approaches to the horror genre foreground this contradictory desire to access the Real. Zombie narratives strive to create an affective response described by Noël Carroll as "art-horror," but they do so in a profoundly dialectical way. Primarily, they stage a confrontation with one or more monsters that are not merely frightening, but the threat of which is "compounded by revulsion, nausea, and

disgust" ("Nature of Horror" 54). The nature of this threat is always redoubled in the uncanny effect of contradictoriness embodied by the monster that simultaneously represents our own mirror image: "audiences taking in a monster story aren't horrified by the creature's otherness, but by its uncanny resemblance to ourselves" (Newitz 2). The horror genre, perhaps more than any other type of popular mythology, thus provides a relatively safe environment in which viewers can navigate the tension between fear and prohibited desire, charting the gap between the Lacanian realms of the Symbolic and the Real.

This is where Robin Wood's psychoanalytical description of the horror genre as the archetypal mode of expression of repressed fears and desires is helpful. The dialectical structure of the horror narrative requires the reader to continuously navigate between two opposite positions, moving back and forth between the nominal (human) protagonist and the monstrous "other" that embodies the threat to our "natural" order: "central to the effect and fascination of horror films is their fulfillment of our nightmare wish to smash the norms that oppress us and which our moral conditioning teaches us to revere" (Wood, "Introduction" 177). The appeal of the horror narrative and its complex structure of feeling thus lies to a large extent in its ambiguous negotiation of prohibitions and its staging of scenarios that are simultaneously terrifying and deeply pleasurable.[4] The lack of ultimate resolution that typifies the horror genre as a narrative mode aligns it with Marxist dialectics, its ongoing tension between incommensurable points of identification infinitely deferring a final point of closure.

Raymond Williams uses the same kind of dialectical method to map out the relationship between the country and the city, which should not be understood as the clear opposition between one set of terms (*rural, archaic, undeveloped, natural, innocent*) and another (*urban, modern, sophisticated, artificial, decadent*). Instead, they should be viewed as two

complementary sets of discourses grounded in complex local, national, and global histories. This dichotomy is primarily discursive in nature, for, as Harvey has explained, "The distinction between built environments of cities and the humanly modified environments of rural and even remote regions appears arbitrary except as a particular manifestation of a rather long-standing ideological distinction between the country and the city" (*Justice* 119). Like the zombie, neither the country nor the city therefore has a true center that defines its meaning independently of other categories; instead, they exist only in relation to each other in a complex process of mutual and internal contradiction. For those discursive formations of country and city exist not as transcendent and internally coherent objects in and of themselves: they are both defined and contradicted by their counterpart, functioning dialectically as a "union of two or more internally related processes that are simultaneously supporting and undermining each other" (Ollman 49). In this way the country and the city are both "self" and "other," both feared and desired, both dream and nightmare.

Returning then to the postwar zombie's ur-text *I Am Legend,* we find that this kind of dialectical reading opens up the text to a much more productive interpretation than its superficial man-versus-monsters plot might suggest. The surface meaning seems to relate directly to the sense of sociocultural alienation that has isolated the American upper middle class in the post–World War II years of suburbanization. From this perspective Robert Neville occupies the sympathetic position of the traditional "scientist-hero" whose task it becomes to defend our cultural values from the barbaric onslaught of postmodern philistinism. Thus, Neville spends his time listening to classical music and undertaking scientific experiments, which together make him the ideal post-Enlightenment humanist: rational, methodical, independent, and cultured.

This aspect of the narrative mobilizes the individualist fantasy of self-improvement through isolation, as exemplified by *Robinson Crusoe*.[5] Like Crusoe, Robert Neville is a resourceful, inquisitive, and very practical-minded protagonist who is thrown back entirely upon his individual abilities. While the catastrophe that moors Crusoe on a remote island, surrounded by dangerous savages, initially makes him morose and depressed, his adventure results not only in large financial rewards through colonial practices but also in the personal improvement of his own character as a religious and morally grounded human being. Crusoe's triumphalist trajectory therefore represents the individual's successful navigation of the opposition between the city (represented by the modern, rational world of civilization and culture) and the country (the unexplored, savage wilderness of the New World).

Robert Neville is similarly isolated in *I Am Legend*. The barbaric hordes that surround him may not be native islanders but vampiric zombies, which we should understand first and foremost as "completely realized colonial subjects" operating under a "colonial gaze" that is all but identical to that of Defoe's early modern mercantilism (Canavan 437). The way zombies are represented in fiction as objectified and dehumanized bodies is all but identical to the way colonial subjects were conceived of in imperialist literature: as disposable, distinctly monstrous shapes that occupied an ambiguous space between human and animal. In other words, the viral infection that has changed the citizens of suburban Los Angeles into ghouls has transformed the urban landscape into a new frontier that Neville must occupy and civilize with purifying violence.

But unlike the triumphalist capitalist worldview embodied by Crusoe, Matheson's tale includes a twist that illustrates the horror genre's dialectical nature: rather than offering a narrative that reaffirms the

ideological concepts that are fundamental to capitalism and its grounding myth of the transcendent individual subject, Matheson's zombie narrative lays bare the frightening contradictions and ambiguities inherent in these very ideas. The story begins with Neville incrementally "colonizing" the urban space that surrounds him by working his way systematically through his urban surroundings, driving stakes through the hearts of the ghouls that prowl the streets at night. He later discovers that many of those he executed were cognizant members of a new society, for which Neville had become the monstrous invader. Thus, the title *I Am Legend* ultimately becomes a deeply ambiguous statement, indicating the moment when Neville realizes that he himself has been the dreaded monster to a new social totality that had been literally invisible to him. While *I Am Legend* therefore brings the corpse of colonialist imperialism back to shambling life in the contemporary context of postwar urbanism, its narrative ultimately hinges on the destabilization of the ideological concepts on which it was built.

Although most zombie narratives follow a similarly cynical trajectory, the two Hollywood adaptations of *I Am Legend* reject the novel's ironic reversal, focusing instead on the elements of the text that support the masochist fantasy of existing as a sole colonial presence in a postmodern urban environment overrun by bloodthirsty savages. Both *The Omega Man* and *I Am Legend* start off with spectacular opening scenes in which their respective protagonists (Charlton Heston and Will Smith) skillfully commandeer expensive sports cars through the abandoned avenues of a major metropolis. These lengthy sequences invite the viewer to engage in a fantasy of mastery via the hero's command of urban space through his phallic automobile.

I Am Legend in particular transforms New York City into a literal urban jungle via a spectacular combination of digital effects work and

expensive location shooting as Neville uses his sports car and high-powered rifle to hunt for deer on a "naturalized" Times Square overgrown with high weeds. Occupying an expensive inner-city mansion, Neville adopts the customs and demeanor of an aristocratic country lord, dividing his time between recreational hunting, rounds of afternoon golf, and scientific experimentation in his personal laboratory. Both the film's visuals and its promotional materials strongly emphasize this spectacle of a major city emptied of life and overseen by a proto-colonialist male authority figure. Much of the film's value as a visual spectacle is thus defined by its transformation of what Raymond Williams calls the "human landscape" of the archetypal modern city into a "natural" environment that is there for the individual to oversee and master.

Zombies and the Spatialization of Narrative

The Crusoe-esque structure of the traditional "hero's journey" encountered in both *The Omega Man* and *I Am Legend* is typical of Hollywood narratives but is more unusual in the genre of exploitation cinema where the modern zombie film has its roots. As defined by the oft-repeated narrative framework of *Night of the Living Dead,* zombie films more frequently foreground a breakdown of traditional narrative structures and may even be considered a form of antinarrative in several important ways. The European zombie films of the 1970s and 1980s are especially notable for consisting of little more than a series of intense and violent zombie attacks, strung together by a tenuous narrative chain. In lieu of causality, these texts foreground concepts and categories that are spatial rather than logical or temporal: zombie films are about how space is reorganized, boundaries are reestablished, and characters follow new trajectories across a deeply unstable geography.

The primary way this spatial logic is organized remains the country-city dialectic, which can be productively employed in either direction: the zombie attack is presented as emanating from the overcrowded and corrupt city as often as it is used to express the primitive dangers of provincial backwaters or underdeveloped remote islands. The most basic spatial distinction holds either way: "in these films, a man's house—or any house secure enough to hole up in—is indeed a castle, and a castle exists for protection and siege, for shoring up the splintered remnants of the distinction between private and public spaces, between zones for family bickering and zones for all-out war" (E. Williams 82). In either case, the core separation is that which comes to exist between the individual and *any* form of social totality and in which the outside world is unremittingly hostile.

But although the zombie threat can appear in any environment, from the urban to the rural, the type of subjectivity the zombie represents is fundamentally postmodern and therefore defined by a type of consciousness that destabilizes the urban/rural distinction. The vampire, as the zombie's frequently cited generic counterpart, is most commonly associated with a highly individualized aristocracy, "the epitome of licensed unnatural acquisitiveness" (Auerbach 32). Zombies, on the other hand, have often been described as the horrific embodiments of the *Lumpenproletariat:* the mindless mass of industrial urban laborers who crucially lack both individuality and subjectivity. While the vampire is therefore easily recognized as a figure that represents a form of nostalgia for earlier forms of capitalism, "the zombie, as a creature that engages in a form of low-level, mechanistic consumption divorced from any kind of productive activity, reflects the fears of a stagnant or contracting economy which has become incapable of the expansion necessary to support widespread prosperity and a social safety net" (Paik 7).

While both figures are thus immanent to capitalist social and economic relations, the zombie comes much closer to a representation of our current late capitalist condition.

But the lack of consciousness displayed by all but a very few zombie characters goes much further than a straightforward satirical depiction of late capitalist consumerism. The mindless, slouching form of the undead ghoul, moving in crowds down city streets or across rural pastures, is also the uncanny embodiment of the city dweller as described by Georg Simmel in 1903. In his essay "The Metropolis and Mental Life," he writes that "the reaction of the metropolitan person . . . is moved to a sphere of mental activity which is least sensitive and which is furthest removed from the depths of the personality" (12). This leads to a general metropolitan attitude he describes as "blasé-ness," which he defines as follows:

> The essence of the blasé attitude is an indifference toward the distinctions between things. Not in the sense that they are not perceived, as is the case of mental dullness, but rather that the meaning and the value of the distinctions between things, and therewith of the things themselves, are experienced as meaningless. They appear to the blasé person in a homogeneous, flat and grey colour with no one of them worthy of being preferred to another. (14)

This thoroughgoing sense of indifference in the metropolitan subject is part of a mode of writing on the city and its effects that is typical of early twentieth-century discourse on the country and the city. Its relation to the dialectical figure of the zombie is, again, double: obviously, the shuffling crowd of undead functions as the parodic embodiment of the city dweller's indifference. Conditioned only to consume, the zombie is the condensed expression of the kind of person who experiences his surroundings as completely meaningless, as "the ambivalence

of many city-dwellers is written on to the body of the zombie" (May 289). Since the explicit identification of the mall-obsessed zombies of Romero's *Dawn of the Dead* as satirical embodiments of consumerism, many classic zombie texts have played up the notion that the undead are the blasé urban subject's uncanny double: recent zombie films such as *Shaun of the Dead* (2004) and *The Revenant* (2009) have played up a general inability to distinguish zombies from "normal" city residents as one of their central jokes.

But at the same time, the emergence of the zombie epidemic is also the catalyst that forces these texts' human survivors to break out of their own blasé-ness and engage with a more urgent reality. The zombie film's audience is thus invited to indulge in a fantasy that functions as an "extended thought experiment about the reconstitution of community life under conditions of severe privation and perpetual danger" (Paik 7–8). This momentary escape allows us to imagine for the duration of the text what it would be like to be forcibly removed from the many comforts of affluent consumer society, even as most such fictions tend to withhold any viable alternatives: "the zombii's dystopic promise is that it can only assure the destruction of a corrupt system without imagining a replacement—for the zombii can offer no resolution" (Lauro 96).

This fantasy clearly depends on a basic difference that still existed in early capitalism between life in the city and life outside it. But in the late capitalist age of globalization and zombie fiction, there no longer seems to be any outside. Harvey has noted that the "fading of the urban-rural divide" correctly predicted by Henri Lefebvre has led to a situation in which "the mass of humanity is thus increasingly being absorbed within the ferments and cross-currents of urban life" (*Rebel Cities* xv). With nearly half the world's population now living in cities, and those living outside them having adopted a suburban framework that relies just as heavily on a quintessentially urban mind-set, spaces of refuge no longer

seem to be available to the Western subject. As Soja writes, "In an almost oxymoronic turnaround, suburbia is being increasingly urbanized as the monocentric modern metropolis morphs into a polycentric regional city encompassing a broadly cast network of agglomerations of various sizes—a new urban geography" ("Beyond *Postmetropolis*" 460).

The rise of the zombie as . . . our culture's "only modern myth" has been accompanied by a simultaneous and insistent foregrounding of urban life as the strongest single unifying concept in capitalist societies.

This claustrophobic urban geography is illustrated all too frequently in the most popular zombie texts. It finds its strongest expression in the early sequence from Romero's *Dawn of the Dead* in which the SWAT team enters an urban minority housing project that has become infested by the undead epidemic.[6] But while the stultifying conditions within the apartment building seem to be a natural breeding ground for poverty, disease, racial miscegenation, and any number of other social anxieties, the scenes directly after show that the countryside has become equally tainted by the zombie apocalypse. The kind of metropolitan subjectivity first described by Simmel, therefore, has increasingly become the only available mode of existence, while the crumbling of rural traditions and belief systems has left the individual mired in a social reality that has become as decentered as the complex form of regional urbanization that has proliferated since the 1970s.

As a figure that exists in a state of perpetual contradiction, the zombie appears as both the symptom of and the remedy for this modern urban disease: while the zombie can be read as the parodic incarnation of the urban subject's total indifference to the distinction between things, the apocalyptic zombie plague also forces the human protagonists to

abandon this frivolous blasé-ness and emerge Robinson Crusoe–like as survivalists. And since survival in the zombie genre is primarily a question of establishing safe spaces of refuge, the emphasis in recent zombie fiction has come to lie firmly on home security and the militarization of urban space.

Zombie Survivalism: Home Security and DIY Handbooks

Most zombie texts begin with the unexpected invasion of supposedly safe or even sanctified spaces. The opening scenes of many classic zombie films are marked by the sudden appearance of the undead within a familiar enclosed space: the graveyard in *Night of the Living Dead;* the suburban bedroom in the 2004 remake of *Dawn of the Dead;* the pastoral farmhouse in *28 Weeks Later;* the backyard in *Shaun of the Dead;* and so on. Like the dialectical relationship that structures Raymond Williams's description of country and city, this should, again, not be misunderstood as the invasion of rural tradition by monstrous urbanites. Instead, it demonstrates a more general worldview in which the very existence of difference has been eradicated: "in a world homogenized by the commodity-form, and by money and information as universal equivalents, 'the Other no longer has a place of refuge'" (Shaviro 284).

The response to this existential threat is all too often the creation of a fortress-like safe house in which the protagonists attempt to withdraw: the shopping mall in both versions of *Dawn of the Dead,* the luxurious high-rises of *Land of the Dead,* London's heavily militarized Docklands in *28 Weeks Later,* a prison building in *The Walking Dead* comic books, or the abandoned pub in *Shaun of the Dead.* This use of the home defense motif is also most frequently what defines computer games and smartphone apps in which the zombie has become a strikingly ubiquitous figure. One of the most telling examples is the popular cross-platform

3.2. *Plants vs. Zombies,* PopCap Games (2009).

game *Plants vs. Zombies,* in which the object is to defend one's suburban home from an onslaught of zombies making their way through the garden toward the front porch. However, unlike most other video games, from the long-running *Resident Evil* franchise to the popular smartphone shooter *Zombie Gunship,* this undead epidemic does not serve as an excuse to indulge in an overdose of firepower.

The more playful, family-friendly *Plants vs. Zombies* instead relies on the player's virtual gardening skills to maintain a line of defense against each new wave of attacking ghouls. A selection of plants with various defensive abilities, ranging from pea-shooting daisies to

exploding mushrooms, must constantly be acquired and planted at strategic (and aesthetically pleasing) positions around the front yard. For the purchase of this arsenal of biological weapons, the player must continuously "harvest" sunshine, which is immediately transformed into credits that allow for the investment in further decorative weaponry. Like most other resource-management strategy games, *Plants vs. Zombies* thus implicitly articulates the basic processes of capitalist value production while cheekily transforming suburban bourgeois recreation into a life-or-death scenario.

As undeniably cute and cleverly conceived as this casual strategy game might be,[7] at the same time *Plants vs. Zombies* is an unusually potent indication of the connection between the zombie genre and discourses of property rights. The game reproduces an ideologically charged environment in which one's home is under constant attack by forces as mindless as they are relentless and which requires constant reinvestment in a unique hybrid of decorative gardening and home security systems. Natural resources are not only our allies in this endless battle, but they also embody "a highly instrumental view of nature as consisting of capital assets—as resources—available for human exploitation" (Harvey, *Justice* 124). Such games thus tend to naturalize the capitalist view of land and other natural resources as commodities that can be individually owned, create surplus value, and require both securitization and perpetual reinvestment.

And now that commodification, consumerism, and privatization have become de facto modes of existence that define our social and political totality, the local distinction between country and city is experienced primarily as a nostalgic fantasy. Neoliberal capitalism has displaced the traditional distinction between the two from the national to the global level: "thus one of the last models of 'city and country' is the system we now know as imperialism" (R. Williams, *Country* 279).

For postindustrial nations, the idea of the country as supplier of cheap labor, food, and raw materials for the city has been transposed to the difference between poor, "developing" nations and rich, "metropolitan" countries or regions.

From this perspective the zombie genre clearly has a reactionary element that provides a fantasy of returning to a more authentic way of living. The liberating aspect of the zombie apocalypse is its puncturing of our Baudrillardian "hyperreality," as we are moved back from a world of simulations and simulacra into one of raw necessity with life-and-death stakes. One of the problematic fantasies the zombie genre therefore invests in most heavily is that of necessity that excuses socially unacceptable behavior.

> Here we find the darkest, and simultaneously most joyous, heart of the zombie film: the consummate bad faith of the savagery you've wanted to inflict all along. It is bad faith because it veils the real desire under the sign of necessity: *I had to kill her, she was going to "turn."* It is the misanthropy of everyday life, the common urge to just stop talking things through, to stop biting your tongue, to unload on your friends, neighbors, siblings, and parents. And even more, on the stranger, the human body we don't know. (E. Williams 83)

This attraction runs through many of the classic zombie texts, which repeatedly assemble groups in which only those who are physically fit, practically minded, and ethically flexible will ultimately survive. And again, *I Am Legend*'s protagonist, Robert Neville, continuously boasting of his scientific knowledge as well as his survival skills, may be the archetypal figure in this regard.

Max Brooks's popular book *The Zombie Survival Guide* is a more contemporary example of this kind of pragmatic attitude that simultaneously rids the zombie of much of its critical potential. The guide

is formatted as a practical handbook on how to survive zombie attacks of incremental sizes, cataloged in categories from a class 1 "low-level outbreak" to the class 4 "living in a zombie world" apocalypse. In the tradition of Matheson's detailed scientific explanation for the virus that causes the undead epidemic, Brooks provides a faux medical description of the fictitious "Solanum virus" and its zombifying effects. The rest of the book is then devoted to exhaustive (and, frankly, exhausting) lists of methods and tools for staying alive in a zombie-infested world, accompanied by illustrations that are as rudimentary as they are pointless.

Unlike the more traditional types of zombie fiction, *The Zombie Survival Guide* eliminates all questions of morality and ethics, focusing instead on the purely instrumental and utilitarian aspects of survival. Throughout the text are constant reminders of the notion that the only consideration in the zombie world must be the use value of every object, location, and decision. The attraction of this type of conceptual framework, which invites us to imagine that we are operating in a world of absolute pragmatic instrumentality, is that we can at least imagine a point of escape from the hegemonic presence of late capitalism, "where exchange value has been generalized to the point at which the very memory of use value is effaced" (Jameson, *Postmodernism* 18). If one of the specters that continues to haunt us as metropolitan Western subjects is the absence of any true sense of the "real," then Brooks's DIY handbook offers an imagined reprieve from this type of safe, passive existence.

The book's reactionary survivalist posture is evident as well in its supposedly pragmatic disdain for the city, which it describes in strictly negative terms. Aligning itself with the dominant representation of cities in zombie fiction, any city environment is a nightmare vision of urban decay that is beyond repair and should be "avoided at all costs" (Brooks, *Zombie Survival* 114). This wholesale rejection of urban life is

typical of the way major cities have been articulated in certain major trends of American cinema, most notably from the early 1970s onward. In exploitation cinema especially, the city was all too often portrayed as a den of despair where "soaring crime, social crises, and countless municipal strikes were causing a precipitous decline in the quality of life" (Sanders 371). This representation of the inner city as a hell on earth connected with a social reality of soaring unemployment and homelessness as deindustrialization swiftly transformed the industrial heartland of America into a destitute "Rust Belt."

The zombie film genre has offered some of the most extreme examples of this particular form of discourse surrounding the contemporary city, which further exaggerate and intensify older urban visions that "identified the crowding of cities as a source of social danger: from the loss of customary human feelings to the building up of a massive, irrational, explosive force" (R. Williams, *Country* 217). All too often this new and unstable force was associated directly with the growth of the industrial proletariat and fears of a revolution that might topple the capitalist order. But in the postindustrial age of the zombie, the proletariat has all but disappeared from sight, as "capitalism has fortuitously taken a path . . . towards the elimination of the militant particularisms that have traditionally grounded socialist politics—the mines have closed, the assembly lines cut back or shut down, the ship-yards turned silent" (Harvey, *Justice* 41).

In the neoliberal, postindustrial world we now inhabit, labor has disappeared from sight: "production has literally become invisible; it can only be imagined as an occult force" (Shaviro 289). If early twentieth-century urban anxieties concerned the danger of unchecked proletarian masses in our cities, the late twentieth-century zombie has often been interpreted as the uncanny resurrection of now-invisible

labor. The zombie figure of the Romero films is the most obvious example, appearing as an ambiguous monster that opens up a space for social and ideological critique. But just as neoliberal discourse has managed to seal off the specter of disposable labor and neocolonialism, *The Zombie Survival Guide* moves away from

The zombie attack is presented as emanating from the overcrowded and corrupt city as often as it is used to express the primitive dangers of provincial backwaters or underdeveloped remote islands.

the ironic ambiguity that has dominated the genre from *I Am Legend* onward, concentrating instead on the pragmatic individual's successful navigation of this new world of the undead. With its faux-scientific approach and nineteenth-century literal-mindedness, the book continuously reestablishes absolute distinctions between "us" and "them," subject and object, human and zombie, and this trend has been picked up by many other forms of zombie fiction. Instead of dwelling on the critical opportunities opened up by the zombie figure, these texts have focused instead on detailed technical celebrations of zombie warfare, post-zombie survivalism, and the Robinson Crusoe myth.

One remarkable example of this trend has been the Zombie Safe House Competition, organized annually since 2010 for architectural projects specifically designed for survival in a zombie world. Sponsored by Max Brooks, Architects Southwest, and the ZomBcon International fan convention, the competition awards submissions that combine feasibility and ingenuity with clearly elaborated architectural designs, giving extra credit for projects that demonstrate "thinking outside the box" (*Zombie Safe House*). Rather than expressing anxieties about the fundamental inability to successfully suppress the monstrous "other" of

late capitalism, these zombie survival guides, design competitions, and comedies like *Zombieland* (2009) celebrate the unambiguous triumph of human ingenuity and individualist survivalism.

But at the same time, countermovements are attempting to reclaim the zombie as the ambiguous figure that challenges the Cartesian boundaries between consciousness and materiality. If, as Lefebvre insisted, our task is "to imagine and reconstitute a totally different kind of city out of the disgusting mess of a globalizing, urbanizing capital run amok" (Harvey, *Rebel Cities* xvi), then the zombie may still provide productive ways of conceptualizing our urban sphere. For by challenging the boundaries that separate private from public in our neoliberal urban environments, zombie fiction has the possibility to indicate "liminal social spaces of possibility where 'something different' is not only possible, but foundational for the defining of revolutionary trajectories" (xvii).

Zombies and the Right to the City

If Marx and Engels's oft-cited metaphor of capital as a vampiric force remains intact, we might continue to perceive the zombie as the embodiment of dead labor, but only as long as we take the phrase literally and emphasize the notion that labor in the postindustrial world is indeed dead and gone. For the zombie figure's ubiquitous appeal to Western consumers makes more sense if we interpret it as the phantasmic resurrection of what has been disenfranchised, ignored, and cast aside in consumer society: the legions of the unemployed, homeless, and destitute that have become the horrific by-product of neoliberal globalization. "In contrast to the inhumanity of vampire-capital, zombies present the 'human face' of capitalist monstrosity. This is precisely because they are the dregs of humanity: the zombie is all that remains of 'human nature,'

or even simply of a human scale, in the immense and unimaginably complex network economy" (Shaviro 288).

This conception of the zombie as the posthuman residue of globalized neoliberalism also corresponds with the genre's obsession with private property and domestic security. The postmodern city has been transformed in recent years into an increasingly privatized and militarized carceral archipelago held together by "technologies of violence and social control, fostered by capital and the state" (Soja, "Six Discourses" 194). Beginning with the Western urban centers of concentrated capital, but swiftly spreading to major cities worldwide, this development has now resulted in the dramatic gap between the increasingly isolated ghettos, shantytowns, and favelas of the poor existing side by side with the spectacular and rigidly guarded gated communities of the rich. The securitization and even militarization of affluent real estate has therefore become one of the most recognizable characteristics of urban and suburban lifestyles in the late twentieth and early twenty-first centuries.

While many zombie films dramatize this overriding concern with domestic security in various consistent ways, *Land of the Dead* (2005) makes the development of the neoliberal city its overriding thematic concern. This fourth installment in Romero's ongoing *"Dead"* film cycle is the first to abandon the usual motif of having a small group attempting to survive a zombie epidemic in a remote and relatively isolated location.[8] Instead, *Land of the Dead* attempts to sketch out a postapocalyptic social and political order that reflects the growing distinction between rich and poor in the neoliberal metropolis. The resulting narrative depicts an environment that comes across as an only slightly distorted depiction of the neoliberal metropolis. In the film the inner city has been fenced in to keep its inhabitants safe from the undead roaming the suburbs and the countryside. In the skyscrapers of Fiddler's Green,

the rich continue to live in opulent luxury while ordinary citizens are reduced to the barest levels of subsistence. A new class of armed free agents ventures outside the city limits in search of food and other materials, the bulk of which is claimed by the wealthy capitalists.

The undead, usually depicted as soulless, mindless ghouls lacking both purpose and reason, are transformed in this film into something new when early scenes show them being ruthlessly and sadistically taunted and butchered by the corporate-sponsored raiders. Observing the violence inflicted for no apparent reason on the bodies of other zombies, the zombified gas station attendant Big Daddy develops a first inkling of consciousness and becomes the leader of a massive "suburban to urban zombie migration" (May 295). Unlike his more feeble-minded brethren, Big Daddy is able to recognize a weakness in the city's security system and leads a mass of the living dead into the heart of the city, where the immoral capitalists finally receive their just rewards at the hands of their own disposable workforce.

What sets this film apart not only from the other Romero films but from most zombie films as well is its development of an obviously allegorical class system: the rich occupants of Fiddler's Green represent the capitalist minority, the impoverished inhabitants of the city are what is left of a disenfranchised middle class, and the zombies outside the city's nested series of gated communities represent the haunting specter of unwanted labor. Amid this fairly ham-fisted representation of class conflict, the entrepreneurial raiders represent a separate class that mediates between these different worlds, carrying information and commodities back and forth as they attempt to profit from the various injustices of the status quo. While this small group of mercenaries includes the film's main protagonists, and although they are superficially guided by good intentions, they have been alienated from their own class by the endemic greed and corruption that defines the system of which they are

a reluctant part: "as Karl Marx and other philosophers have explained, there is a particular kind of social alienation attached to labor in free market capitalism.... Alienation is what it feels like to be someone else's commodity, to be subject to a boss who 'owns' you for a certain amount of time" (Newitz 6).

This layered structure of separate classes of characters, none of which is able to break free of the cycle of exploitation that is fundamentally embedded in this system, makes *Land of the Dead* one of the most ambitious attempts to use a zombie film for anticapitalist critique. Moving beyond the effective but simple-minded zombie consumers of *Dawn of the Dead,* this film shows how neoliberal capitalism would not only survive a zombie epidemic but would also seemingly thrive in this apocalyptic environment. As the hordes of living dead finally bear down on the elite capitalists of Fiddler's Green, their revolutionary force has become the most appealing element in the film: the zombie is transformed "from villain into vengeful anti-hero" as we see "capitalist ideology annihilated by the racialized working-class anti-hero" (May 292).

As the nominal protagonists retreat to the wilderness of Canada in their armored truck, conceding the city to Big Daddy and his zombie legions, *Land of the Dead* reverses the traditional dynamic of the zombie genre. Remarkably, the living dead are no longer represented as the monstrous threat of a postindustrial, post-ideological, even posthuman world; they are instead shown as the sympathetic victims of a ruthless economic system that offers immense privilege to a small and underserved minority while all other classes are transformed into disposable units that are alienated, disenfranchised, and dehumanized. The conflict between what remains of the middle class and disposable zombie labor is articulated in the film as an illusory threat that is maintained as a distraction from the basic injustice of the socioeconomic system. Meanwhile, the effects of this slightly exaggerated version of neoliberal

capitalism are depicted emphatically in terms of the militarization, privatization, and segregation of urban space.

This recent reversal of the zombie-human dynamic, in which the audience is explicitly encouraged to cheer on the living dead as they invade the private mansions of capital, connects to recent social movements and the increasingly lively anticapitalist struggle. As in the thematically similar *28 Weeks Later*, zombies in the neoliberal age can just as easily be portrayed as the victims of a totalizing framework that systematically alienates and destroys every form of human community. Combining this recent trend of zombie rehabilitation with the traditional anti-consumerism of earlier zombie classics, factions of the Occupy Wall Street movement have taken to dressing up as zombies while reclaiming the city streets as a form of political and social commons.

The Occupy movement developed in multiple forms and locations around the world shortly after the mortgage crisis of 2008. The movement in its many incarnations aims to draw attention to the injustices of globalization and neoliberal capitalism by symbolically reclaiming urban space as a site for free political debate.

> The "street" in Wall Street is being occupied—oh horror upon horrors—by others! Spreading from city to city, the tactics of Occupy Wall Street are to take a central public space, a park or a square, close to where many of the levers of power are centered, and, by putting human bodies in that place, to convert public space into a political commons— a place for open discussion and debate over what that power is doing and how best to oppose its reach. (Harvey, *Rebel Cities* 161)

Inspired by the Egyptian popular uprising on Tahrir Square and the other urban protests that made up the Arab Spring, the Occupy movement mobilized a substantial international group of activists, students,

and cross-demographic participants in a shared attempt to alter political perceptions by visibly transforming urban space.

This "emergence of an international protest movement without a coherent program" reflects "a deeper crisis, one without an obvious solution" (Žižek, "Occupy Wall Street"). The movement's call for change without any clear conception of a preferred alternative is indicative of our post-ideological framework in which individuals have been reduced to instrumentalized passivity. This clarifies as well the connection with zombie discourse demonstrated by the carnivalesque dress-up of Occupy protesters in the guise of undead ghouls: the shared desire is one of far-reaching change, but the inability to articulate what should be changed—and how—keeps one mired in a perpetual present, very much like a living corpse. The zombie parades are therefore not only appropriate for the Occupy movement's attempt to draw attention to the organization of urban space and its basis in neoliberal capitalism, but they also offer a perhaps unintentional reflection of the absence of any discernible postcapitalist alternative.

Conclusion

If there are indeed any clear conclusions to be drawn from this investigation of the relationship between the internally contradictory figure of the zombie and the equally uncontainable field of urban theory, it is first and foremost that the zombie genre provides us with a suitably decentered perspective on the modern city. As first sketched out in the influential foundational text *I Am Legend,* the zombie trope has tended to emphasize the securitization of domestic space, the alienation of the individual in the urban environment, and the spatialization of narrative as some of its central motifs. While each of these themes has been

articulated in many different ways across the diverse cross-media zombie paratext, they do crucially align themselves with the complex discursive formations between the country and the city, as described by Raymond Williams.

In our contemporary context of globalized neoliberalism, the ubiquity of the commodified zombie narrative seems to be yet another demonstration of "the widespread sense that not only is capitalism the only viable political and economic system, but also that it is now impossible even to *imagine* a coherent alternative to it" (Fisher 2; italics in original). But while the DIY survivalist ethos that dominates the books of Max Brooks and many other snarkily postmodern zombie texts clearly supports this position, the zombie can also still be employed productively to challenge, critique, and even disrupt the organization of privatized urban space. From films like *Land of the Dead* and *28 Weeks Later* to the zombie costumes of Occupy Wall Street protesters, the fundamental ambiguity of the walking dead may yet prove resilient enough to survive its own commodification and allow it to rise again as the destabilizing force that brings to light the most urgent contradictions facing us today.

Notes

1. Although the ghouls in Matheson's book are nominally vampires, they not only function as "nonconscious consuming machines" (Lauro 99), but they also prefigure the contemporary concept of zombies as carriers of a viral infection.

2. *White Zombie* (1932) and *I Walked with a Zombie* (1943) are two of the most influential examples of the zombie as embodiment of colonial imperialist anxieties.

3. As the visuals of all three film adaptations attest, one of the primary motifs in *I Am Legend* involves the uncanny spectacle of the modern city emptied out of all life: the specter of postwar urban decay and social unrest dramatically exaggerated from within the "safe" context of genre fiction.

4. This mirrors Fredric Jameson's pithy observation on the dialectical nature of capitalism, in the sense that it is "at one and the same time the best thing that has ever happened to the human race, and the worst" (*Postmodernism* 47).

5. Defoe's novel provides the quintessential narrative of entrepreneurial capitalism, and is not only the model for innumerable popular fictions but also the embodiment of the ideological values that have organized and sustained capitalist economies.

6. Similarly claustrophobic urban environments provide the basic spatial coordinates for many other key zombie texts, including [*REC] (2007), *La Horde* (2009), and *Land of the Dead* (2005).

7. The zombie characters in the game often reference iconic zombified characters, like, for instance, a zombie who dresses and moves like Michael Jackson in the "Thriller" music video.

8. *Land of the Dead* is also the only one of Romero's zombie films thus far to be financed and distributed by a major Hollywood studio.

4 *Zombie Media*

ERIK BOHMAN

We are the hostages of news coverage, but we acquiesce secretly in this hostage-taking.

Jean Baudrillard, *Virtuality and Events*

The news is always horseshit.

Tony, *Diary of the Dead*

Taken as a whole, George A. Romero's body of work has most often been thought to mark shifts in cultural anxieties—anxieties around the Vietnam War and the civil rights era, the rise of a consumer economy, the relation of science and the military during the Cold War, the war in Iraq, and the irruptive spectacle of terrorism—anxieties that his films not only embody but also critically respond to, and all of which have been well documented. Yet, by regarding these films as markers of cultural anxieties or repressions, such readings either implicitly or explicitly tend to use psychological models, often ones that have been transposed to a cultural level.[1] Such frameworks, while certainly useful, also tend to domesticate the zombie.[2] Under such models, the zombie becomes safe and familiar, immanently legible as political allegory and cultural construct. In the end, it all comes back to us humans.

But I would like to take seriously the notions that a zombie world poses new problems and demands new frameworks for understanding it and that in order to make sense of this world we need models that are less bound to a strictly humanist discourse. Thinking through zombie media can perhaps give us some of these models. With the help of some key figures of media theory, figures who prove to be strangely unwitting articulators of this zombie world, we can use Romero's work to track our culture's changing relations to particular media, whether print, radio, television, or digital, and especially to the news media as it becomes crystallized in these various forms. Tracing the zombie event and media coverage of it over Romero's career unearths a fraught nexus—one that brings together our relations to history, social institutions, ethics, and our present mediated state.

The arc of Romero's work . . . reveals media as inherently zombifying—media makes everything the same, destroys distinctions, and obliterates our sense of history and the real.

What's stranger, though, is how Romero's work drives toward a sense of media as itself zombifying, but not in the obvious, we're-all-fatties-on-our-couches-not-thinking-or-feeling kind of critique. This isn't the contemporary-consumer-as-already-a-mindless-zombie trope that *Shaun of the Dead* features so prominently and through which *Dawn of the Dead* has certainly been read (and which might also be about the least interesting thing one could say about either film), but something much more insidious. The arc of Romero's work, and 2008's *Diary of the Dead* in particular, reveals media as inherently zombifying—that media makes everything the same, destroys distinctions, and obliterates our sense of history and the real. Romero's work suggests that our growing mediation makes our relation to our cultural past become something

like that of the zombie's: we return to our old shuffling grounds and reenact old practices, but without a sense of it meaning much, without knowing why, without it being real. It's an emptied-out gesture. We see in Romero's films how media coverage increasingly comes to stand in for the thing itself—how a proliferation of voices, interpretation, commentary, and information actually occludes truth, whatever that may be.

As a way of making sense of this phenomenon, it's perhaps fitting that I reanimate a few corpses as well—in particular those of Marshall McLuhan and Jean Baudrillard, two figures who, like all good zombies, created hordes of their own. They both inspired an indistinguishable mass of adherents and prompted a visceral revulsion from their contemporaries. Their ideas swept over their disciplines like a kind of contagion, demanding to be dealt with, even if only to ensure inoculation. And when the fever passed, they were left for dead among the piles of human fodder routinely deposited by the dictates of academic fashion.

But one of the nice things about zombie theory and its reanimated, ideational corpses: they never return quite as you remember them. Yes, that's Zombie Baudrillard—another Johnny—at the boarded-up window with his dark, speculative eyebrows and cigarette stains between his fingers, but there's something different about him. To read these media theorists as articulating a kind of zombie theory, to take up zombie as a critical mode, renders these figures and their work uncanny. They become alive again, unsettling, even dangerous (Who reads Baudrillard anymore? Hadn't we already dispatched these guys?). Zombie McLuhan and Zombie Baudrillard don't speak of "hot and cold media" or "simulacra"; their visceral groans recall "implosion" and "ruptural events." Their well-worn and immediately recognizable conceptual vestments now adorn bodies of work that appear much stranger, more

(un)timely, and more monstrous. Not only that, but Zombie McLuhan and Zombie Baudrillard become unfamiliar even to themselves. While their work has a preternatural ability to articulate a zombie world, that zombie-ness also turns against them, devouring and deforming whatever humanist bits may have been left in their respective corpuses.

So in the arc of Romero's oeuvre we can not only see the shifts in our relations to media, but we can also track changes in media theory: its concerns, revisions, and assumptions. Zombies and the zombie event put pressure on these theories, and the zombie apocalypse becomes a strange test case. On the one hand, the theories themselves often prove surprisingly useful for making sense of zombie world, and on the other, the act of considering these theories in such terms also renders them strange and unfamiliar. Like so many unlucky members of a supporting cast, the theories "turn" as well. Such an unholy matrimony forces us to look afresh upon ourselves, and that view is deeply *unheimlich,* ever unsettled and unsettling.

Media Coverage and the Zombie Event

The relationship between the zombie event and the news media's coverage of it, and how this relationship evolves and is rearticulated over Romero's career, ultimately crystallizes and brings to the fore our changing relations to media. So what is the zombie event? In his discussion of virtuality and events in *The Intelligence of Evil,* Baudrillard offers us an almost disarmingly apt description of it.

For Baudrillard, an event, like the figure of the zombie itself, is characterized "by its uncanniness." An event has both a "troubling strangeness—it is the irruption of something improbable and impossible—and ... [a] troubling familiarity: from the outset it seems totally

self-explanatory, as though predestined, as though it could not but take place." The zombie event "breaks the continuity of things and, at the same time, makes its entry into the real with stupefying ease." It is *something that happens without having been possible*" (130; italics in original). Thus, the event has its own strange temporality at odds with our usual sense of cause and effect: "[Normally] things first have to be possible and can only actualize themselves afterwards. This is the logical, chronological order." In contrast, however, events "first take place, *ex nihilo* as it were, as something unpredictable. Only then can they be conceived as possible." "This is the temporal paradox, the reversed temporality that designates the event as such." This temporality is one that "relates to living events, to a living temporality, to a depth of time that no longer exists at all in real time" (131).

"Real time," for Baudrillard, is the time of "information," of the news media, of the nonevent. "The non-event is not when nothing happens. It is, rather, the realm of perpetual change, of a ceaseless updating, of an incessant succession in real time, which produces this general equivalence, this indifference, this banality" within our present world. This perpetual change "gives rise to a culture of difference that puts an end to any historical continuity. Instead of unfolding as part of a history, things have begun to succeed each other in the void." We face a "profusion of language and images before which we are defenceless" (122). In this state, "everything merely follows everything else and cancels it out, to the point of re-creating total immobilism: the impression, amid the whirl of current events, that nothing changes" (128).

This sense of overriding immobilism in the face of constant change is one that McLuhan addresses as well, one that he sees as emerging out of the form of the newspaper itself: "The press had created the image of the community as a series of on-going actions unified by datelines. Apart

from the vernacular used, the dateline is the only organizing principle of the newspaper image of the community. Take off the dateline, and one day's paper is the same as the next. Yet to read a week-old newspaper without noticing that it is not today's is a disconcerting experience" (190). It's disconcerting because such an experience yokes together these two very different impressions: the sense that we are aware of and caught up in the very real changes that happen in the world each day, and that these changes can also seemingly amount to nothing, hardly epiphenomena, ever and ultimately fungible with regard to one another.

Yet what's striking about McLuhan's contention is that this experience derives from the medium of the press itself. McLuhan asserts, "The press is a group confessional form that provides communal participation"; it presents "corporate images of society in action" (183). But this corporate social body—a kind of horde whose members and particular activities may differ from day to day, but which nevertheless remains a horde, the same horde, an unchanging horde—at least according to McLuhan, is actually produced by media technology. The medium not only enables the community to conceive of itself in this way, it demands it. A medium is influential precisely in its ability to determine the ground over which any particular content might be laid. Thus, according to McLuhan, the explicit stories of a newspaper matter far less in determining the community's sense of itself than the newspaper's formal structure. Moreover, once the press begins to recognize its constitutive function, it takes on a more active role in determining the explicit content as well: "The press began to sense that news was not only to be reported but also gathered, and, indeed, to be made. What went *into* the press was news. The rest was not news" (189; italics in original).

In the everyday world of nonevents, the news media can readily narrativize and make sense of what happens; indeed its ability to do so

is the prerequisite for there to be news in the first place. But then comes the event: the massive occurrence that defies such explanation, that happens without having first been possible, and that leaves the news media struggling to fit it into a familiar story line. They must transform it into something else, into something they already know and understand. Hence, the zombie apocalypse as event. In Romero's films the zombie event becomes the ground upon which our relations to media (and where our cultural fears and the monstrosity of our social systems) are articulated, and it's this relation we'll be tracking as we see it crystallized in the representation and function of the news media in his films, in those films' strange resonance with historically contemporaneous media theory, and how the figure of the zombie and its zombie world both embody and challenge such theories, ultimately giving us a rather troubling look at ourselves as mediated beings.

Mass Publics and Mediated Man: Zombie McLuhan and *Night of the Living Dead*

Four years before *Night of the Living Dead* unsettled audiences as what would be a seminal film in the birth of the modern horror genre, Marshall McLuhan published his equally unsettling and equally seminal study *Understanding Media: The Extensions of Man* in the nascent field of media theory. McLuhan offered up a view of human beings as essentially mediated, as using various media technologies to extend perceptions and capacities, with each technology reorienting what one can do and perceive. McLuhan's work offers us a contemporaneous and unwittingly resonant articulation of the modern zombie figure and its world as they emerge at this moment; it also allows us to make sense of how ubiquitous electric media seem to dictate characters' orientations and actions within the film.

On the surface McLuhan's account of media seems like a paragon of technological determinism. His definition of media, for which he has often (and rightly) been criticized,[3] is astonishingly broad. A medium is "any extension of ourselves," he contends (23). Along with those media technologies that first come to mind—the telephone, radio, television, film, the computer—he would also include clothing, games, money, and virtually every other human technology. According to McLuhan, we have a finite perceptual sensorium, which means a given medium will extend and give greater weight to certain senses while limiting others. A medium reconfigures our "sense ratios" (54). What is important about any medium, then, is how it creates an environment, how it structures that within which we operate, and not any particular, explicit content. It's not about the particular TV show you're watching; it's how the television creates in you a particular kind of sensorial engagement. "For the 'message' of any medium or technology is the change of scale or pace or pattern that it introduces into human affairs" (24). Moreover, it does this work without resistance.[4] The model McLuhan offers, which characterized most accounts of communication in early media theory, is an intrinsically passive and linear one, wherein the broadcaster sends some message through a given medium, which is then received. What was unusual about McLuhan, of course, was his assertion that the explicit content of that message is insignificant because what matters is the medium itself and its ability to determine the perceptual limits and engagement of the receiver in a particular way.

Yet that technological determinism belies how McLuhan's model requires a humanist core. His account needs a universal concept of the human, and it still privileges and operates fundamentally at the level of individual human beings, even if the rationality inherent in this model belongs to the system rather than the person. Like many models in early media theory, McLuhan's assumes a solitary, abstract, and fungible

individual receiver who is part of an abstract mass public. So even if the particular proportions of our sense ratios may vary from culture to culture, it's assumed that those ratios will be influenced in predictable and uniform ways by a given medium. There's no sense of significant variation in reception among a public. The communication model implicit here, even if McLuhan is ostensibly unconcerned with explicit content, ultimately goes hand in hand with an account of broadcasting that likewise imagines a uniform, rational public. Such an account maintains an implicit trust in the machinery and institutions of communication (a trust that, as we'll see, *Night of the Living Dead* seems to share, at least initially, but that *Dawn of the Dead* will radically challenge), such that officially sanctioned facts or information can be transmitted and received uniformly, passively, and equally, to then be taken up and rationally acted upon by the survivors in the film.

According to McLuhan, the historical moment of *Understanding Media,* and of *Night of the Living Dead* as well, is a unique one in which the advent of electric media is in the middle of producing a profound shift in Western man, a shift for which the zombies of Romero's film ultimately provide a powerful and troublesome articulation. McLuhan argues that for centuries our various media have followed a kind of trajectory: that mechanization and its attendant mode of operation[5]—a mode defined by causation, classification, and infinite expansion— have produced an ever increasing specialization. Such specialization, McLuhan warns, produced increasingly shallow, automaton-like individuals—in short, zombies. But according to McLuhan, this trajectory has been supplanted, thanks to electric media, by a new (or, rather, old) mythic engagement with the world. This mythic engagement is a kind of "implosion," a global networking that reduces what was far-flung into a "global village," removes time, and as a result turns our former obsession with "data collection" into a concern for "pattern recognition" (vii).

According to McLuhan, this mythic engagement foments a kind of tribalism, which *Night of the Living Dead* will ultimately play out in rather monstrous forms. For McLuhan, as soon as "sequence yields to the simultaneous, one is in the world of the structure and of configuration" where "specialized segments of attention have shifted to total field, and we can now say 'The medium is the message' quite naturally" (28). By recalling this mode of mythic engagement with the world, electric media, he thinks, also allow us to be aware of the work of media as such.[6] It provides meta-insight into our essentially mediated state.[7] Thus, McLuhan's work actually performs the very anxious and conflicted cultural transition that he describes: it uses the analytic tools of a mechanically rationalist Enlightenment world to articulate the supplanting of that world by one of total field awareness and pattern recognition, the kind of awareness that McLuhan's description is ultimately an instance of. *Night of the Living Dead,* as we'll see, performs a similar operation: it turns the rationalism and skepticism implicit in the theoretical account of broadcast media discussed above against those technological and institutional structures themselves in order to achieve its own kind of meta-insight and total field awareness, but the pattern that it recognizes is perhaps far more terrifying.

When the zombies first begin to gather in *Night of the Living Dead,* they do so as a mass. The film begins with a solitary zombie figure, but the latter soon becomes only one of many and virtually indistinguishable from the others. This shift is actually a profound one, for the zombie is never important by itself. There's never just one. Their power and logic operate at the level of the horde, and Romero's film is cognizant of this. As the zombies start to accrue around the farmhouse, the film doesn't make it easy to differentiate between particular zombies. They're often shown in long shot, partially shadowed, and with fairly nondescript clothing. The only two zombies that do stand out are the male zombie

from the start of the film and the naked female zombie who seems fresh out of the shower, but in each case they're individuated not because they are coded in some way, such as by profession, lifestyle, class, or subcultural group,[8] but because of either the narrative attention given to them or, well, the absence of clothes. The rest of the zombies are neither particularly memorable nor recognizable.[9]

The logic of the modern mass public, which undergirds this representation of the zombie, stands behind the film's representations of broadcast news media as well. The film, at least initially, operates with a model of news media as concerned with the dissemination of official, sanctioned information for an imagined mass public, where both stand in good stead. The radio announces that "hundreds of stations" are "pooling [their] resources," engaging in a solemn cooperative effort to keep the public "informed" and be responsive to a changing understanding of the situation. "These are the facts as we know them," the announcer proclaims. Within this model and the functions it assumes, the news media actually gets it right: they display an evolving understanding as they struggle to make sense of the seemingly inexplicable event that confronts them.[10]

As the newsman takes pains to tell us, these escalating reports have been met by a careful, considered skepticism: "So this incredible story becomes more ghastly with each report. It's difficult to imagine such a thing actually happening, but these are the reports we've been receiving and passing on to you. Reports that have been verified as completely as is possible in this confused situation. It *is* happening." And later: "It's hard for us here to believe what we're reporting to you, but it does seem to be a fact." Here, when confronted with an event—with a situation that does not fit an already known narrative—the news media seem to adapt to it slowly, but the adaptation is still at least possible. As we'll see, in future films, however, the news media seem to have less and less

of a hold on some accurate account of what's happening, and instead multiple and conflicting accounts emerge, where the "facts" and their criteria are no longer clear nor agreed upon.

What's notable about the news media in *Night of the Living Dead* is that they are addressing not an audience, but a public. The ubiquity of broadcast media and the implicit trust seemingly granted to it in this film reinforce the communicative and institutional models described earlier. Each of the main characters, except Barbra, seems to have found out about the outbreak via the radio: Ben jumps into a truck near Beakman's Diner to listen to radio reports; Tom and Judy first hear about it in their car while out to go swimming; and Barbra would have heard about it had she and her brother arrived at the cemetery a minute later. There's also an implicit trust in the news media and the quality and authority of its accounts of the action. As Mrs. Cooper says to her husband (she had initially humored his decision to stay in the cellar, until, that is, she found out there was a radio upstairs), "That radio is at least some kind of communication. If the authorities know what's happening, they'll send people for us and tell us what to do. How are we going to know what's going on if we lock ourselves in this dungeon?" The radio is a source of knowledge and seems to be integral for determining how to orient oneself to the world. It's a primary way of knowing what's happening and what to do, hence the stakes of the news media's account of the zombie event.[11]

The implicit trust afforded the news media and government authorities, however, becomes more problematic as the film nears its climax. There's no sense of a government or media cover-up, no intentional misdirection or visible malfeasance; instead the film seems, at least at this point, to accept that both institutions are striving to provide responsible information to the public at large.[12] Yet some lingering uncertainties creep in. As the group has decided to act on the television's instructions

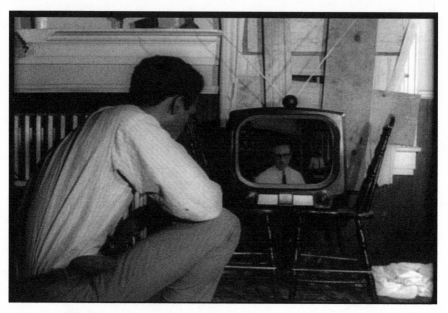

4.1. Makeshift authority in *Night of the Living Dead* (1968).

to evacuate to the nearest rescue station and devised what turns out to be an ill-fated plan to fill up the truck with gasoline while diverting the zombies with Molotov cocktails, the film reframes the shot of the television. After having moved close in for most of the broadcast footage, such that only the immediate border of the television set is visible around the screen, the film shows us once again the staging of the television itself: the group has propped it up on two rickety chairs, and looming behind it is a partially covered window open to the apocalypse just outside. We realize that the group has deferred to this makeshift authority, an authority precariously positioned and less stable than the group is willing to recognize. What follows, though by no means as a direct result of the advisement given by the news media, has certainly been prompted

by it. After all, before the television tells the public that they should be making their way, if possible, to a local rescue station, our survivors had no serious plan or desire to escape the house.

After the failed escape attempt, Ben and the others wait, despondent and anxious, for the next broadcast, an image the film intercuts with scenes that linger on the zombies eating the corpses of Tom and Judy. When the broadcast returns, the survivors see footage of a local posse engaging in some zombie cleanup (the same posse that will find Ben in the film's famous conclusion), and the film's presentation of this news coverage once again reveals something problematic underlying the public trust in such coverage. First, the film has the news media use language steeped in association with the Vietnam War.[13] Second, the film's techniques produce an even more general and unsettling sense of the news media and its limitations. The voice of the newscaster describes how "all law enforcement agencies and the military have been organized to search out and destroy the marauding ghouls," but the news footage that the film presents us with doesn't quite correspond. Yes, there are some cop cars, but instead of uniformed law enforcement personnel or soldiers, we have images of civilian men, clearly coded as "good old boys," moving together as a posse and armed with their own rifles. Though near the end of the footage we see some actual police officers, by and large there's a disconnection between the news media's description of what's happening and what the viewer is actually seeing. This sense of some unsettling fissures between the event and the news media's accounts of it will become much more pointed by the film's end.[14]

But it is precisely when the news cameras turn off—when the film shows us the news reporter deciding to go elsewhere because things here seem "under control" and for the first time the film gives us a view of the posse not seen through news footage—that the disturbing nature

of this control becomes all too apparent. The posse dispatches zombies with ease, picking them off across fields and safe distances, and as a result the zombies no longer seem an immediate threat. They become toothless, easy kills. Meanwhile, the nonchalance of the posse as they go about their work turns cold, even disturbing. When the posse passes the burnt-out truck and whatever remains of the charred corpses of Tom and Judy—two characters to whom the audience had grown attached and whose deaths the film makes startling and upsetting—the chief says casually, "Somebody had a cookout here, Vin." Seconds later, Ben is summarily shot without the posse bothering to verify whether the figure they see moving in the farmhouse was actually a zombie. The shooter is complimented on his marksmanship.

All of this goes undocumented by the media. When the news media does reemerge, this time in the form of a set of grainy photographs that depict the "protectors" removing Ben's body from the house with a meat hook and tossing it onto a pyre to be burned with other zombie bodies, Ben has been reduced to just another exterminable and exterminated figure in the eyes of the "official" record. These newspaper photos stand in for an official record; they become the accepted account of what really happened. And any evidence to the contrary goes up in the flames of the final bonfire. Thus the film suggests that the real—the cold, ugly truth of the situation—lies beyond the official record, in an account that doesn't actually exist. The film is a chronicle of a history that is not only untold but inaccessible, fictional. Yet it should be noted that some sense of "the real" still exists, particularly with respect to the ethically freighted, historically resonant violence of the film's final act. For the film's first viewers, this violence was profoundly disturbing.[15] *Night of the Living Dead* externalizes and foregrounds systemic violence—the "objective" violence that according to Slavoj Žižek maintains our supposedly nonviolent norm (*Violence* 1–2). In doing so, the film builds into

its structure a moment of implosive insight; it has achieved a kind of total field awareness that brings to the fore the monstrosity and violence of our social bodies, the shadow of inhumanity following us wherever we go.

Encoding/Decoding Zombie Media in *Dawn of the Dead*

Romero's *Dawn of the Dead* (1978) begins at a television station. Rather than presenting its audience with the end products of these institutional forces—the television newscast, the coverage of the posse and its accomplishments—its first twenty minutes instead take us inside the institutional operations. We see the television studio; we are brought along on a police raid of housing projects. Romero's shift in this film corresponds to a shift in media theory as well. This conceptual shift, led by Stuart Hall among others, resulted in a move from theory in which "the process of communication [is conceptualized] in terms of a circulation or loop," and which "has been criticized for its linearity—sender/message/receiver," to a theory that conceptualizes "this process in terms of a structure produced and sustained through the articulation of linked but distinctive moments—production, circulation, distribution/consumption, reproduction" (128). Hall argues that this new model is "homologous to that which forms the skeleton of commodity production offered in Marx's *Grundrisse* and in *Capital*" and also "highlights the specificity of the forms in which the product of the process 'appears' in each moment, and thus what distinguishes discursive 'production' from other types of production in our society and in modern media systems" (128). Ultimately, we'll see, such a model has built into it the possibility, if not the inevitability, of a multilevel series of encodings and decodings between distinct moments, which produces "systematically distorted communication" (136).[16]

The zombies in *Dawn of the Dead* are at once recognizable and a bit off from their predecessors, and not just because of their brilliant color. In a way, they function as a model for Hall's cultural encoding and decoding, given that many, in fact, appear as more ostensibly coded: the nun, the baseball player, the handyman, the Hare Krishna zombie, for instance. *Night of the Living Dead* presents a few standout zombies through narrative attention or some singular features, but these figures are *not* coded like those in *Dawn of the Dead*. The zombies of the earlier film aren't wearing strongly coded uniforms of particular professions, lifestyles, or identities. They are a slowly building mass, and what we notice is their increasing number, the growing size of the horde as a horde, and not individuals. *Dawn of the Dead* seems to foreground the operation of codes, presenting the zombie as an unwitting carrier of codes, the zombie body as inscripted vessel. But the zombie body as medium here seems particularly troubling for media theory. In one of the film's funnier moments, as Roger and Peter pull the body of a "businessman" zombie behind the counter at J. C. Penney's, a sign above the glass doors reads, "Of course you can exchange." The film suggests an inherent fungibility to the zombie, one that extends to the codes that mark it; for all of the distinctions and meanings such codes seemingly secure, they simultaneously accrue to and are sloughed off by the zombie body.

Such doubling extends to the film's representation of news media as well. In the film the fractured, multilevel structure of discursive production that Hall describes, as well as the various contested relations to the multiple encodings and decodings that are part of such production, are reproduced in the programming itself. The fractures within the production base—the various dissenting views and underlying motives regarding the content being placed over the air—are doubled at the level of the program. The newscaster Mr. Berman challenges his guest, a scientist

and official expert, and when Berman contends, "I'm not so sure what to believe. All we get is what you people tell us," the expert responds, "You're not running a talk show, Mr. Berman. You can forget pitching an audience the moral bullshit they want to hear." In this scene we have on display both a creeping skepticism regarding the government—a skepticism that was unsettling because of its marginality and radicality in Romero's first film becoming more commonplace within the news media itself—and, as we'll see, the growing proliferation of speculation, commentary, and interpretation that will increasingly subsume news coverage.[17]

According to Hall, this struggle to narrativize the event and interpret what's happening shouldn't be surprising: "A 'raw' historical event cannot, *in that form,* be transmitted by, say, a television newscast. Events can only be signified within the aural-visual forms of the televisual discourse. In the moment when an historical event passes under the sign of discourse, it is subject to all the complex formal 'rules' by which language signifies. To put it paradoxically, the event must become a 'story' before it can become a *communicative event*" (129; italics in original). Undergirding this account is a model of discourse that Hall makes explicit: "Reality exists outside language, but it is constantly mediated by and through language: and what we can know and say has to be produced in and through discourse. Discursive 'knowledge' is the product not of the transparent representation of the 'real' in language but of the articulation of language on real relations and conditions. Thus there is no intelligible discourse without the operation of a code" (131). As a result:

> New, problematic or troubling events, which breach our expectancies and run counter to our "common-sense constructs," to our

> "taken-for-granted" knowledge of social structures, must be assigned
> to their discursive domains before they can be said to "make sense."
> The most common way of "mapping" them is to assign the new to some
> domain or other of the existing "maps of problematic social reality." We
> say *dominant,* not "determined," because it is always possible to order,
> classify, assign and decode an event within more than one "mapping."
> But we say "dominant" because there exists a pattern of "preferred read-
> ings"; and these both have the institutional/political/ideological order
> imprinted in them and have themselves become institutionalized. (134;
> italics in original)

The film foregrounds this interpretive process and the work it de-
mands.[18] Rather than display a gradual reassessment of the situation
according to shared criteria, the film draws our attention to the disso-
nance and debate in the coding of the event. The function of the news
media no longer seems to be the dissemination of "facts" but, rather,
self-conscious and inherently contentious narration.

As it plays out in one remarkable sequence within the film, we are
able to see a bearded, eye-patched scientist speaking with our favorite
host, Mr. Berman, in an increasingly dilapidated set and with shaky
camera work. As the film shows us footage of zombies attacking and
wandering about, our scientist says (in voice-over), "These creatures
cannot be considered human. They prey on humans. They do not prey
on each other. That's the difference. They attack and they feed only
on warm flesh. Intelligence? Seemingly little or no reasoning power."
Meanwhile, the film cuts to zombies on ice trying to play hockey and
zombies pushing mannequins over second-story mall railings. "What
basic skills remain are more remembered behaviors from normal life,"
says the scientist. "There are reports of these creatures using tools, but
even these actions are the most primitive, the use of external articles
as bludgeons and so forth. I might point out to you that even animals

will adopt the basic use of tools in this manner." We then see zombie tool-use without mastery, clear purpose, or focus. "These creatures are nothing but pure, motorized instinct." The film finally gives us a shot of the scientist on the television. "We must not be lulled by the concept that these are our family members or our friends. They are not. They will not respond to such emotions." But then we start to hear the audience/crew audibly disagreeing with him, and the scientist gets louder. "They must be destroyed on sight!" he bellows. As the problematic relation between the scientist's description and the images we see is reinforced by the crew's dissent, we understand the scientist's assessment not as some kind of objective truth, but as a kind of coding and narrativizing of the zombies that allows for certain otherwise reprehensible actions to be justified. It's a useful narrative: don't think of them as your friends or family; that way you can kill them more easily. The code thus becomes a tool to clothe the naked power always yearning to be exercised, a code that exists in direct opposition to the mere "moral bullshit" that threatens to disintegrate it.

As the film foregrounds the potential bad faith of the media's codes through these set pieces, this bad faith is borne out by the actions and experiences of the survivors almost from the very beginning. Fran and Stephen, along with many others, abandon the television station ("Our responsibility is finished") and steal the station's helicopter, ultimately acknowledging, if not embracing, their identities as outlaws.[19] Peter and Roger likewise abandon their roles as protectors of public safety in order to save themselves. Within the mall, they use the in-house media to distract the zombies and, later, for their own entertainment. Beyond such manipulation there seems to be a deep ambivalence in their relationships to the broadcast media. Even after working so hard to secure a radio and television, the survivors are almost always doing other things when these devices are on: playing cards, talking to one another,

making plans. Gone is the intense focus of the survivors on these technologies—unlike the survivors in *Night of the Living Dead*, they aren't huddled around the television screen hanging on every word, desirous of "the facts," and waiting to be told what to do.

No doubt these media maintain an incredible ubiquity and necessity throughout the film. During their first escape in the helicopter, Fran bemoans, "We don't have food. We don't have water. We don't even have a radio." That the radio should be afforded a spot in such a list of necessities, and that the "even" that precedes it indicates that this media technology should at once be somehow more basic and prolific than either food or water, testifies to the characters' profound and continuing reliance upon such technology. As in *Night of the Living Dead*, the media still seem to provide a fundamental means of understanding and acting properly within their situation or environment.[20] Yet the survivors and the film itself appear skeptical of the explicit content of those transmissions; the actual "information" of these broadcasts is always subject to the problematic coding and bad faith already described. We need the media, it seems, for our sense of reality—but we can't and don't trust it.

Of Records: After the Zombie Event in *Day of the Dead* and *Land of the Dead*

As the narrative arc begun in *Night of the Living Dead* reaches 1985's *Day of the Dead*, we're far enough into the postapocalypse that news media and its coverage of the event ceases to exist, let alone be an issue. Meanwhile, under the assumption that nothing radically new can now happen after the zombie event, that we've reached an end of history years before Francis Fukuyama would prematurely declare it so, what takes the place of narrative interpretation is a concern with records: records

of a now inaccessible past and an inscrutable, interminable present. As our theorist of such a state, Zombie Baudrillard will make his return.

Day of the Dead opens with Sarah staring across an empty, gray room at a solitary calendar on the wall. All the days of October have been crossed out, and when Sarah approaches and touches the calendar, the arms of the dead burst through the cinder block wall to grab her. But the arms don't penetrate in a cloud of dust and rubble; instead, those arms emerge like they've breached a thin film that has resealed around them, as if the dead lie waiting in the wall itself. This image proves potent—the dead are not just kept in this military bunker, but the place itself seems to produce them. It seems to produce and allow only an interminable, deathly existence, which we'll see detailed shortly. Sarah then wakes suddenly—it was all a dream—and she's on a helicopter scouring the coast of Florida in a fruitless search for other survivors. The now famous shots of the abandoned city—trash everywhere; the silent, unpeopled streets; dollar bills blowing across the sidewalk—point to how far we've entered into the postapocalypse.[21] The once omnipresent media infrastructure has been reduced to a broadcast of and to nothing: our survivors are broadcasting over "dead air," and there's "nobody" out there, "or at least nobody with a radio." With no luck on the radio, the survivors land the helicopter and try calling out over a bullhorn, an attempt that elicits a response only from the zombie residents.

In *Day of the Dead* there's no longer a news media to report on and fashion an account of the zombie event and its aftermath. But, as we learn from one character, there are records. Lots and lots of records:

> Hey, you know what all they keep down here in this cave? Man, they got the books and the records of the top 500 companies. They got the defense department budget down here. And they got the negatives of all

your favorite movies. They got microfilm with tax returns and newspaper stories. They got immigration records and census records, and they got official accounts of all the wars and plane crashes and volcano eruptions and earthquakes and fires and floods and all the other disasters interrupting the flow of things in the good old U. S. of A. Now, what does it matter, Sarah darling, all this filing and record keeping? Are we ever going to give a shit? Are we even going to get a chance to see it all? This is a great big fourteen-mile tombstone with an epitaph on it that nobody gonna bother to read. Now here you come, here you come, with a whole new set of charts and graphs and records. What you gonna do? Bury them down here with all the other relics of what once was? Let me tell you what else, I'll tell you what else. You ain't never gonna figure it out.
. . . It ain't mankind's job to figure that stuff out. So what you're doing is a waste of time, Sarah. And time is all we got left, you know.

Sarah responds with the begrudging fatalism of one present after the end of history: "What I'm doing, it's all there's left to do." Sarah and the other scientists are producing only more material, more data, which has yet to prove "useful" or to "mean something" to the rest of the survivors. There's a sense that in this bunker one can only amass more information, generate further records, without any of it having a clear value or the ability to lead the survivors to something new. This feeling that radical historical change is no longer possible—that rather than taking new or drastic actions, we can only document this interminable nonevent, producing more interpretations, more records, and more data—this is a state that Zombie Baudrillard articulates well:

> The policing of events is carried out by information itself. Information represents the most effective machinery for de-realizing history. Just as political economy is a gigantic machinery for producing value, for producing signs of wealth, but not wealth itself, so the whole system of

> information is an immense machine for producing the event as sign, as
> an exchangeable value on the universal market of ideology, of spectacle,
> of catastrophe, etc.—in short, for producing a non-event. (121–22)

That the caverns of *Day of the Dead* are filled with the "official accounts" of other disasters, other events that now stand as just another pile of unusable data, should be of little surprise.[22]

While the anxiety about this state—where in its changeless inter-minability the aftermath of the zombie event bears an uncanny resemblance to the everyday world of nonevents—seems to overwhelm both Sarah and, at times, the film itself, a couple of characters maintain the possibility and availability of some other kind of life. John replies to Sarah's fatalism, "Shame on you. There's plenty to do, plenty to do. So long as there's me and you and maybe some other people we could start over, start fresh. Get some babies, and teach 'em, Sarah, teach 'em never to come over here and dig these records out." The fact that the only concrete description of this supposedly new life is the explicit refusal or repudiation of the old one, that it can be imagined only through a relation to these same records, is perhaps a sign of just how vexed such a fresh start may be. Nevertheless, there's still a kind of tempered hope here—that there remain unforeseen possibilities, that there can still be a break.

Such a break seems to occur at the film's end. In the film's final sequence, the survivors' attempted escape seems to be a failure when Sarah opens the door of the helicopter and zombie arms grab her, but her scream and the cut to a black screen is followed by Sarah waking suddenly from a nightmare. She's on a tropical beach, and in the background John is fishing and Phillip is lounging on the sand. She's somewhere else, somewhere new—the opposite of the dark, militarized caverns they've been living in. But as the fact that Sarah is stricken with

nightmares already suggests, she hasn't left that record hall/tombstone behind. She hasn't really escaped it. In a moment that recalls the dream sequence at the start of the film, she pulls out of her pack a notepad on which she's already made the boxed rows for a calendar. It says November, and the first four boxes have been numbered and crossed off. The rest of the boxes are empty, even of numbers for the day of the month. The record keeping continues.

If the ending of *Day of the Dead* holds out some qualified potential for a new beginning, by 2005's *Land of the Dead* that hope has been appreciably subverted. In *Land* the apocalypse hasn't produced a meaningful historical break or a radically new society; instead, the same set of racial, class, and capitalist structures have re-formed, but they are starker and more explicit. In the film the wealthy live in a secure, carefully manicured high-rise, where they are served and provided for by a poverty-stricken underclass that polices the fences, waits on the wealthy, and searches out needed supplies. Even when the character Cholo (John Leguizamo) does enough dirty work to amass enough wealth to buy a place in the towers, the board of directors refuses. The racial and class divisions have become impermeable, such that what little mobility the pre-apocalyptic system maintained by stark improbability, the postapocalyptic one renders impossible.

Even the zombies of *Land of the Dead* seem trapped in these old social forms. In the film's brilliant opening sequence, the camera descends on a bucolic small town where zombies slowly shuffle about performing bucolic small-town activities: high-school-sweetheart zombies take a stroll around the town square, where a zombie band plays in the square's gazebo. Big Daddy, an African American zombie who owns a gas station and auto shop, is poised to help a customer when the bell rings. In a form more exaggerated and explicit than the dead consumers returning to the mall in *Dawn of the Dead, Land* shows us zombies endlessly

reenacting old practices and relations. There is no radically new social body, just as there is no radically new human society either. In fact, an armored vehicle full of humans setting out to pillage supplies soon guns down these idyllic zombies. While this violence appears to galvanize a new kind of zombie sociality—Big Daddy, having recognized the tactics of the humans (their use of fireworks as distractions) and spurred by a righteous anger and sense of injustice, leads the other zombies on a long march to the human city—it is decidedly recognizable.

Even when the zombie/underclass revolution seems finally to come in the film's climax, the film displays a deep skepticism of its potential to establish anything new. For all the sympathy we might feel for Big Daddy, the zombies' assault on the high-rise and its denizens is bloody and merciless, as they devour not only the wealthy but the poor as well. Meanwhile, those human underclass figures who come to lord over the city's ruins at the film's end have no explicit plan for how a different society might be established. That the film's protagonist refuses to join this effort is perhaps a sign of its looming problems, but the film is skeptical of even that protagonist's choice to abdicate and head to Canada. Retreating to a solitary existence in the Great White North hardly constitutes any more of a viable future for humanity.

With *Land* we see what Baudrillard will soon help us articulate: that the zombie event as it is increasingly imagined by Romero is a peculiarly contemporary kind of event. It isn't an event that introduces radical historical change—in fact, such change seems no longer capable of being imagined—but instead is a kind of absolute disorder. The proliferation of records, of information and its reproduction, creates a troubling sense of irreality while making the real seem accessible only through this media. The various strands we've been tracking thus far and the strange logic that undergirds them come together in 2008's *Diary of the Dead,* a film in which Romero attempts to take these issues head-on.

A Suitable Failure: *Diary of the Dead* as the Problematic Apotheosis of Zombie Media

Most audiences and critics have categorized George A. Romero's *Diary of the Dead* as a well-intentioned failure. The film follows a group of student filmmakers as they record themselves attempting to survive the first days of the zombie apocalypse. It presents itself as a play on the "found footage" horror film (such as *The Blair Witch Project* or *Cloverfield*), but it's one in which the footage has been self-consciously edited and uploaded by one of the central characters, Debra. Deb reluctantly provides the voice-over and the final edit to her boyfriend Jason's guerilla documentary (it was Jason's dying wish that she continue filming). Structurally, *Diary* is episodic in nature: it follows the students as they are interrupted by the zombie apocalypse while out filming Jason's senior project—a mummy movie—and then as they cram into a Winnebago and attempt to make their way along the back roads of Pennsylvania to their various homes.

One of the key features of the film is that the episodes of this road trip are broken up by Deb's musings. These musings appear over collections of footage that the group has either downloaded, found in abandoned video cameras, filmed via cell phone, or nabbed from security camera systems. Much of this footage was made by Romero for the film. However, intercut with sequences of zombie attacks is archival footage of real events and real disasters—from the 1992 Los Angeles riots, Hurricane Katrina, and a number of others. (I'll say a bit more about this repurposing of actual news footage later.) Throughout *Diary* the students are quite self-conscious about their attempts to make sense of the event and the need to document it in some way—to make it somehow more "real," to show what is "really happening" so that the vague

4.2. Zombie target practice in *Diary of the Dead* (2007).

audience (those worldwide viewers, who apparently are still taking the time to surf the Internet while facing their own local zombie outbreaks) can "know what's going on."

What strikes me as particularly interesting about *Diary of the Dead* is how the film, apparently unironically, thematizes its own failure: how it seems to imagine and call attention to its own ineffectuality. Deb bemoans the fact that the proliferation of unofficial voices and guerilla attempts to document these events don't lead to some greater sense of their "truth," something that their "raw" and unofficial status should ostensibly supply. Instead, we're overwhelmed with "noise," and whatever "truth" that is imagined to be out there seems to disappear in all of the attempts to attain it. While this raw coverage is supposed to bring insight to its content, the coverage itself, both for the students and the

film, *becomes* the content. The film thus seems to become this noise while it simultaneously (and earnestly) tries to articulate the "truth" underlying its events—which it then fails, rather spectacularly, at doing.

The film seems to be both aware of this emptying out and unable to get beyond it, and this failure is nowhere more apparent than in the film's final scene. Debra here provides a moralizing voice-over to found Internet footage of some "Hometown Joes" tying up a zombie woman by her hair and using her for target practice. The scene is something that both the students and the film *want* you to find disturbing but that becomes a kind of sickening farce. A bloody "tear" rolls down the zombie woman's half head after she's been blasted with a shotgun, and encapsulated in that scene we have both the reminder of ethical import that *should* be there and a keen sense of its absence. The ethical "truth" that the film wants to reveal—that perhaps we as human beings don't *deserve* to survive this apocalypse—lacks the unsettling punch that the scene was tailor-made to deliver.

In its form and affective nullity, *Diary of the Dead* embodies a problem that it can't quite articulate, let alone powerfully address. The film seems to circle and even inhabit this problem without ever getting clear about it. Moreover, this difficulty seems to plague Romero's own accounts of the film as well. In an interview with the *New York Times,* Romero warns, "It's scary out there, man. . . . There's just so much information, and it's absolutely uncontrolled. Half of it isn't even information. It's entertainment or opinion. I wanted to do something that would get at this octopus. It may be the darkest film I've done since 'Night of the Living Dead'" (Onstad). Romero's word choice here— "octopus"—is telling. He seems to be fighting his way through tentacles, unable to find the beast's head. In the director's commentary to the film (where he's joined by the director of photography and one of the film's editors), Romero laments that the promise of the Internet for fostering

unofficial voices has led not to more accurate information or greater "truth," but to increased militancy, the splintering of the audience, and even more extreme and entrenched worldviews. But as he gets going, he becomes increasingly unable to clarify just what disturbs him about this new media (there are a number of other things he laments in the course of the commentary), and so he finally declares, "Let's order some beers and talk about this shit." Again, he seems to be approaching something, feeling it out, without quite being able to get a handle on it.

Yet *Diary*, like its director, clings to a sense of truth. It, too, imagines a ground that once was there, waiting to be uncovered in its visceral, gut-gnawing immediacy. Just think of Ben being carried out on meat hooks in *Night of the Dead*. But such a ground is missing in *Diary*. We have only the affective nullity of the event and its attendant truth. We are treated only to a cipher.[23] But the ineffectuality of that supposed truth is what lingers, and it's here where Baudrillard proves most useful. He offers us an account of why the film *must* fail at this critical moment, along with greater insight into the heightened popularity in recent years of imagining the zombie apocalypse and the complex desire that the zombie event stokes.

Zombie filmmakers and audiences no longer need to get their hands dirty. They don't even expect to anymore.

The sense of "total immobilism" and interminability that Baudrillard says marks our present world and the experience of the nonevent is remarkable in that it's also a state described by the internal framing of the film (128). *Diary of the Dead* presents itself as Deb's finished version of Jason's project, and Jason has given that project a name that, once one gets past its initial silliness, is worth considering: "The Death of Death." It is the end of endings. But rather than opening for us some

transformative or evolutionary path, the title actually describes a closing down of possibilities. The zombie apocalypse threatens only to mirror the present state that Baudrillard describes: it, too, becomes interminable, unchanging, even boring, and all without the possibility of meaningful discontinuity.

So, for Baudrillard, the "violence of real time . . . is also the violence of information." Thus there's a "dilemma posed by all the images we receive: uncertainty regarding the truth of the event as soon as the news media are involved" (132). Hence, the casual skepticism of the characters in the film regarding the media: "The news is always horseshit," says one of the students. (What a contrast to the original *Night of the Living Dead,* in which the characters clung to news reports as their only source of information and followed their directions without question!) To some degree this skepticism is justified. For *Diary* begins with the "unedited" news footage of an initial zombie attack that the students downloaded off the Internet. It was, according to Deb's voice-over, "secretly uploaded by the cameraman who shot it. It was his way of trying to tell the truth about what was happening." However, later in the film, that footage reappears on a TV broadcast in an edited form so that it looks as if the zombies had never died and come back to attack the living. Deb says in another voice-over, "The media were lying to us. Or the government was lying to them. They were trying to make it seem like everything was going to be all right. Now I can understand why Jason was so anxious to upload his own footage." Yet if this were the central problematic of the film—the issue of an entrenched, corporatized, mainstream media that either could be easily manipulated or themselves manipulate the information they broadcasted so that the public wasn't getting the "truth"[24]—then, frankly, the film would be far less interesting. But Romero and, by extension, Deb are working their way toward a much stranger and unsettling set of phenomena.

To continue with Baudrillard: "As soon as they are both involved in and involved by the course of phenomena, it is the news media that are the event. It is the event of news coverage that substitutes itself for coverage of the event" (133). This, in a nutshell, is both the formal and explicit content of *Diary of the Dead*. In the face of the inexplicable, impossible event—one that is singularly resistant to explanation and befalls the characters from out of nowhere—the attention paid to acts of recording the event substitutes itself for actual coverage of the event. The survivors worry, argue, and wax philosophical about the act of documenting what's happening to them. They are distracted by it. It becomes an end in itself. And this, according to Baudrillard, should be utterly unsurprising.

"We are passing into a realm where events no longer truly take place," according to Baudrillard, "by dint of their very production and dissemination in 'real time'—where they become lost in the void of news and information" (122). In one scene we see Jason anxiously trying to upload footage he's just taped. He appears to be recording his own act of dissemination for future dissemination. Through his attention to this proliferation of documentation and recording, Baudrillard can offer us an explanation for Romero's complaint—for how "truth," whatever that may be, gets lost in the noise of information. "Disinformation," Baudrillard says, "comes from the very profusion of information, from its incantation, its looped repetition, which creates an empty perceptual field. . . . It's a space where everything is pre-neutralized . . . by the procession of images and commentaries." This noise, "after having emptied events of their substance," creates a kind of "artificial gravity" (122–23). In order to "pass through the non-event of news coverage (information)," we need "to detect what resists that coverage," and thus to see in the event what stands "against all the machinery of commentary and stage-management that merely neutralizes it" (133). This, strangely enough,

is the project that both the film and Debra seem to be taking up, and yet what both offer, instead of a sense of what resists such machinery, is precisely further commentary and stage management. The "truth" they ostensibly point to in the film's conclusion is itself overladen with commentary and highly stage-managed—as indeed is the majority of the film. The violence of the film's final scene is intended to unsettle us, to linger with us. But it doesn't.

Yet what's remarkable about the film is how both it and Deb also seem to be keenly aware of this possibility of ineffectuality. Earlier in the film, Deb says in a voice-over that accompanies one of her montages, "It's strange how looking at things, seeing things through a lens . . . you become immune. You're supposed to be affected, but you're not. I used to think it was just you out there, the viewers. But it's not. It's us as well, the shooters. We've become immune too, inoculated, so that whatever happens around us, no matter how horrible it is, we just wind up taking it all in stride." Her remarks become oddly prescient of the film's concluding scene. It's one of inoculated cruelty. Atrocity as only spectacle.

In the face of such inoculation it should be no surprise that we desire the event. According to Baudrillard, we desire events because they "[repair] this immense banalization of life by the information machine. We dream of senseless events that will free us from this tyranny of meaning and the constraint of causes" (133). An event, and especially a zombie event, thus inspires a kind of "[elation] for overthrowing the order of things, whatever it may be" (134–35). However, we simultaneously "also desire just as passionately that nothing should happen, that things should be in order and remain so, even at the cost of a disaffection with existence that is itself unbearable. Hence the sudden convulsions and contradictory affects that ensue from [an event]: jubilation or terror" (135–36). Such contradictory affects seem to plague the audience of any Romero zombie film. "We live in terror both of the excess of meaning

and of total meaninglessness" (134). Here we see the terror of the zombie film under Romero: that it always has an excess of meaning generated by an underdetermined allegorical register and simultaneously threatens us with meaninglessness through its fundamental inexplicability and often deeply nihilistic view of human existence.[25]

But the zombie event, as it is increasingly imagined by Romero over his career, appears as a curiously contemporary one: rather than being a "historical event," wherein "the event could be analyzed as the high point in a continuous unfolding and its discontinuity was itself part of an overall dialectic," it is instead what Baudrillard would call a "ruptural event" (125–26).[26]

> Ruptural events [are] . . . unclassifiable in terms of history, outside of historical reason. . . . [They] break the tedious sequence of current events as relayed by the media, but which are not, for all that, a reappearance of history or a Real irrupting in the heart of the Virtual. They do not constitute events *in* history, but *beyond* history, beyond its end: they constitute events in a system that has put an end to history. They are the internal convulsions of history. And, as a result, they . . . appear no longer the bearers of a constructive disorder, but of absolute disorder. (125–26; italics in original)

The ruptural event—the only species of event that seems possible anymore—is, in short, a zombie apocalypse.[27] What's important to note about this passage is that this kind of event will never give us history. It will never give us a Real. To see the zombie event as a ruptural event— to see it as producing elation and terror; as stoking the desire to both upset the order of things and fervently maintain that order; but, above all, to see it as offering no alternative ordering, no reintroduction of history, no Real—provides us with a way of reading some of the most prominent zombie texts. Films such as *28 Days Later,* or really any of

Romero's works, tend to reassert recognizable social orders—even, or especially, those that are monstrous in form—rather than offering us something new. For so many zombie texts the apocalypse doesn't offer a break with so much as a concentration of the bleak power dynamics already there in our social order. There is no meaningful discontinuity. So it's perhaps quite fitting, then, that *Diary*, as the film in Romero's canon that is most preoccupied with these issues of media and the act of recording, appears strangely history-less. If his first four films followed a kind of a historical sequence—in each one the zombie outbreak and apocalypse is further along, until 2005's *Land of the Dead*, in which years have passed and social orders have reformed and stabilized—*Diary* is remarkable for its return to the initial outbreak. It's as if the previous films had never happened, even while that history looms over and is even referenced by the film itself.[28]

Ironically, the final scene's failure is cemented by the very thing the film attempts to evoke and appeal to: its own history. The video clip of the zombie tied to a branch by her own hair and used as a target practice tries to evoke both lynchings and the power of *Night of the Dead*'s conclusion, but these play as empty historical gestures; they just point to the film's own ineffectuality. Why are viewers unaffected by this final scene? In large part it's because they haven't yet forgotten the previous ninety minutes. The self-referential noise that is the majority of *Diary of the Dead* makes the gesture at the end a horrendous spectacle. Moreover, the real events that the film repurposes—the lynchings, the footage of real looters and disasters, the radio broadcasts from 9/11—rather than adding gravitas to the film's imagined apocalypse, actually work against it. Such footage only emphasizes the film's lack of weight, its artificial gravity, while the hyper-mediated form of the film simultaneously de-realizes these images. It calls our attention to their status as images, unmoored from the events they were once supposed to be

giving us access to. Meanwhile, the events, those histories, and whatever truths they may hold, have retreated elsewhere. Ultimately, the film is undone by history: the shadow of the real events it repurposes, its own cinematic forefathers, and the memory of its audience.

But perhaps *Diary of the Dead* offers us one lasting critique: by thematizing and dramatizing its own failure, a suitable failure, the film unwittingly points to the necessity of its null center and inarticulate truth. It can remind us of history's cumbersome weight, of the real mass, now absent, whose gravity we once felt and whose meager substitute is perhaps the most unsettling horror of all—or at least more unsettling than a digitally produced bloody tear after a shotgun blast to the face.

Whither Zombie Media? Or, the Zombie in the Cloud

At the end of *Diary of the Dead,* the film's three remaining survivors—with cameras, booze, and a depleted sense of irony in tow—seal themselves inside a panic room while zombies amass outside. Deb will spend her remaining time editing their footage (and creating the film we've just seen) and then uploading it to the Internet. As the title of the film suggests, things don't look particularly bright for these three: this is, after all, a diary of the dead. But this diary enters the digital cloud, and these humans, or the record of these humans—their voices and images, their self-culled experiences and representations, their digitized remains—will continue on, bodiless and unmoored from any particular material infrastructure. The yellowing newspaper swirling about the city streets in *Day of the Dead* will last only as long as the paper it's printed on, but in the cloud the dead lie waiting to be revived, if only in an empty form. There lie the ones and zeros of human life rendered immanently transferable. These dead will say the same things and carry out the same motions—an endless reenactment, resurrection on repeat.

They are digital coding writ large. These dead aren't even bound to the pressed grooves of the record or the magnetic tape of the VHS; even the hard drive of your machine is not their grave. For the digital cloud subsumes not as yet another medium, but as a kind of meta-extension that enables other media. In its incredible capacity to store and disseminate, reproduce and archive, this nebulous non-space colonizes both our past and our future.[29] The physical caverns of *Day of the Dead,* that vast underground archive of documents and microfilm, at least promised the fantasy of escape. The film's tombstone of civilization is now everywhere and nowhere, and it certainly can't be left behind for some tropical beach.

Even the profound embodied-ness of the zombie—how as a monster it seems to demand a fierce reckoning with the body, its flesh and tissues, organs and fluids—which seems fundamentally to pose the threat and possibility of an extension-less, unmediated human, has become increasingly digitized.[30] Zombie filmmakers and audiences no longer need to get their hands dirty.[31] They don't even expect to anymore. The ghost in the machine has been consumed by the zombie in the cloud. The conscious-less bodies of both Descartes and Gilbert Ryle have become feast for Zombies McLuhan and Baudrillard, for a mediated existence where materiality and its other is, well, less material.

Romero's career presents media as that which we increasingly make our way *within* rather than *with.*[32] In both *Night* and *Dawn of the Dead* we see the emergence of the ubiquity and fundamentality of our media—its given-ness and necessity for orienting ourselves in the world, for getting a handle on what's "really" happening—as well as a creeping awareness of the problematic coding and institutional power that such orientation relies upon. The real of *Night*—a disclosure of the monstrous violence of our systems that enables our peaceful, ordered state—could at least

still be made visible by the zombie event, if only in the impossible, fictional form of the film itself. This real becomes imagined as something other than the news media's official record, something *outside* of it. Yet as Romero confronts the digital age, this *outside* becomes increasingly unable to be imagined, even as a fantasy. The postapocalyptic social orders of *Day* and *Land* ultimately offer nothing new; and *Diary,* in its proliferation of commentary and media forms, in its failed recuperation and re-catenation of its own history, renders the profoundly unsettling violence of *Night* as a hollow, ineffectual exercise. Even the zombie event as a ruptural event, the event after the end of history, has become rote.[33] Romero's recognition of how we live *in* media has made the fantasy of a "real" that is outside of and radically different from our presently mediated state seemingly less conceivable.

With its undead theorists in tow, our zombie media has returned as a digital cloud horde, and having already consumed our past and future, it amasses outside the window, ever hungry for more.

Notes

1. Robin Wood's influential readings of *Night of the Living Dead* and *Dawn of the Dead* in *Hollywood from Vietnam to Reagan . . . and Beyond* are perhaps the most famous examples, though one can also see it in more recent works, such as Adam Lowenstein's "Living Dead."

2. In effect, thinking of Freud's essay on the uncanny, domesticating the zombie makes its *unheimlich* character rather, well, *heimlich*. The zombie world, like the figure of the zombie itself or, as we'll see, the zombie event, is indeed uncanny; however, I use this term not as a throughway to a Freudian explanatory mechanism writ large on the social body, but as a phenomenal description that keeps alive the fundamentally unsettled and unsettling nature of the zombie world.

3. See, for instance, the discussion of McLuhan in Debray's *Media Manifestos.*

4. McLuhan writes, "The effects of technology do not occur at the level of opinions or concepts, but alter sense ratios or patterns of perception steadily and without

resistance" (33). So, "To listen to radio or to read the printed page is to accept these extensions of ourselves into our personal system and to undergo the 'closure' or displacement of perception that follows automatically" (55).

5. This operation, according to McLuhan, "is achieved by fragmentation of any process and by putting the fragmented parts in a series" (27).

6. So while we may still be thinking in an older, mechanized way, we're living mythically. "For myth," McLuhan says, "*is* the instant vision of a complex process that ordinarily extends over a long period. Myth is contraction or implosion of any process, and the instant speed of electricity confers the mythic dimension on ordinary industrial and social action today. We *live* mythically but continue to think fragmentarily and on single planes" (38–39; italics in original). McLuhan predicts that this mythic engagement should produce a kind of tribalism, wherein different mythic, total-field accounts will be at odds (which, strangely enough, becomes visible in the arc of Romero's films as well). "The stepping-up of speed from the mechanical to the instant electric form reverses explosion to implosion" (47). "Obsession with the older patterns of mechanical, one-way expansion from centers to margins is no longer relevant to our electric world. Electricity does not centralize, but decentralizes" (47). It creates the sense of "instant, total field-awareness" (56), of "total interdependence" (59) rather than separation and distinction. "For the fragmented man creates the homogenized Western world, while oral societies are made up of people differentiated, not by their specialist skills or visible marks, but by their unique emotional mixes. The oral man's inner world is a tangle of complex emotions and feelings that the Western practical man has long ago eroded or suppressed within himself in the interest of efficiency and practicality" (59).

7. While the zombies might articulate the age's implosion at the hands of electric media and the anxiety that surrounds this change, they also threaten the very meta-insight into media that this change has supposedly enabled. After all, the zombie is the monstrous possibility of extension-less man. It is human being shorn of its technologies, of the shifts in scale such media produces; it is human being with its perceptual sense ratios not just realigned but dulled all around, its capacities delimited to just one: devouring other humans. The deep ambivalence that the zombie inspires—that complex combination of disgust and identification, of fear and sympathy—unsettles McLuhan's notion of man's mediation as essential. The zombie doesn't cease to be human, after all; the shudder of recognition reminds us of that.

8. Unlike the zombies in *Dawn of the Dead,* which I'll say more about in the following section.

9. With exceptions made, of course, for those zombies who were human characters earlier in the film, like Johnny or the Coopers' daughter.

10. The radio's first account of the zombie event is that an "epidemic of mass murder being committed by a virtual army of unidentified assassins" is sweeping the East Coast and Midwest. There is "no apparent pattern or reason for the slayings," and these acts are being committed by "ordinary-looking people" that some say look to be "in a kind of trance." Over the course of the film, the news media's account of the zombie event will evolve from this to one that includes "victims showing evidence of having been partially devoured by their murderers" and eventually to one wherein "persons who have recently died have been returning to life and committing acts of murder," until, by the end, those dead persons are officially "ghouls."

11. In the film the radio details what is known according to law enforcement and other government institutions, what the official responses have been, and which reports have been verified by multiple sources. When the announcer indicates that people should "seek shelter indoors," Ben says aloud to a mostly catatonic Barbra, "Hey, that's us. We're doing all right." When, later on, the television declares a shift in advice from officials about what the public should do—that instead of staying in their homes, people should be evacuating to local rescue stations if feasible to do so—the survivors begin to plan an escape.

12. As our survivors consider plans of action, the television shows an interview in Washington of military and scientific personnel as they leave a high-level cabinet meeting. The reporters persistently and forthrightly ask these men for information, especially regarding the possible link between this event and the return of a highly irradiated Venus probe. What's odd, and perhaps oddly comforting, about the exchange is the explicitness of the disagreement among the members, which reveals that though there are some speculative explanations for the zombie event, more proof is needed before any definitive cause can be announced. Of course, no full explanation is ever given in the film; even this gesture toward radiation as a possible cause was one later added by Romero after distributors were concerned about the utter inexplicability of the event.

13. We can see such references in the rhetoric that there was an ongoing "search and destroy mission" against the ghouls. Plenty of zombie-scholar ink has already been spilled drawing out the connections between this film and the war, and I have no desire to take a bite out of that critical corpus. It's been picked over too well.

14. Moreover, when the reporter interviews Chief McKellen, who is leading this local zombie cleanup, the reporter stages the questions in military terms—"Will we be able to *defeat* these things?" (italics added)—while operating with the assumption he's providing the public with value-neutral information. The reporter asks the chief what one should do if he finds himself alone and surrounded, whether the zombies are slow

moving, and how long until the situation is under control. The news media make no critical inquiries regarding just how this control is achieved.

15. The late film critic Roger Ebert had an especially vivid account of his first viewing of the film during a Saturday matinee filled with children whose delighted screams during the first part of the film gave way to utter, disturbed silence, save those who were actually sobbing (Ebert review).

16. This distortion isn't a matter of "selective perception" but "arise[s] precisely from the *lack of equivalence* between the two sides in the communicative exchange" (S. Hall 131; italics in original), thus engendering various relations to the coding process (for instance, Hall lays out three hypothetical positions: the dominant-hegemonic, the negotiated, and the oppositional) (136–38).

17. In such coverage "facts" become increasingly contested, and interpretation is grounded in Zombie McLuhan's kind of tribal identity—a mythic, total-field assertion that differs between groups rather than the assumed existence of an abstract mass public that shares the same assumptions.

18. Hall writes: "In speaking of *dominant meanings,* then, we are not talking about a one-sided process which governs how all events will be signified. It consists of the 'work' required to enforce, win plausibility for and command as legitimate a *decoding* of the event within the limit of dominant definitions in which it has been connotatively signified" (134–35; italics in original).

19. Fran does show some ethical qualms about their actions and even maintains a remainder of that sense of obligation to the public, but it's ultimately short-lived. For instance, when Fran's boss worries that without the list of (defunct) rescue stations running along the bottom of the screen, "people won't watch us . . . they'll tune out" (as if this, alas, is the greatest threat), Fran responds, "Are you willing to murder people by sending them out to stations that have closed down?" When Stephen wants Fran to leave with him at nine that night, she resists, saying, "We can't. We've got to stay." Stephen responds, "We've got to survive. Somebody's got to survive." When she seems unconvinced, the crewmember standing nearby reassures her: "Go ahead. We'll be off the air by midnight anyway. The emergency networks are taking over." A few choice words and she's on the stolen helicopter. A bit later Peter makes their position explicit once they've escaped in the helicopter and are looking for a safe place to land: "We're thieves and we're bad guys. That's exactly what we are."

20. For instance, as the survivors contemplate staying in the mall for a while, they figure they can "check out the radio, see what's happening." The synesthesia of this phrasing points to how the information that the radio provides seemingly will help them see or is necessary to seeing the situation at hand.

21. These are shots that Danny Boyle would masterfully crib for *28 Days Later.*

22. In *Day of the Dead* we see such records effectively police past events in retrospect and in ways that curtail the sense of present possibilities, but in the next section we'll see how in *Diary of the Dead,* such policing by information actually renders the event a nonevent *as it is happening.*

23. So why does the film fail in its attempt to eke out some truth? I argue that this failure does not stem from any of the likely culprits: it is *not* the result of a lack of inventiveness, nor the "tired . . . idiom of amateurism" (as Manohla Dargis describes in her review of the film in the *New York Times*), nor the heavy-handed speechifying, nor even a result of questionable acting, as if these were the things that spoil what would be an otherwise effective critique. No, I argue that the failure is far more deep-seated; in short, the film's failure isn't a failure of execution, or even a "failure," but a suitable failure. It is a failure prescribed by the very problematic the film tries to address. The film formulates an indictment of the information glut and hyper-mediation of our present times, that these things distract us from getting to what's real, or what's true, rather than helping us get there. And that indictment stands. Yet the film still holds out a belief in some "real," some "truth" that can still be gotten to. Not only that, but the film also seems to think it *has* gotten to it, and that in its climactic final scene that it confronts the viewer with this revelation.

24. Basically, this means if it were a problem that the work of guerilla journalists and the raw footage available on the Internet (in other words, the work of Jason and the TV cameraman) would ostensibly address.

25. This inexplicability is one of the remarkable features of Romero's films that separates them from earlier science fiction and horror cinema. As noted previously, the filmmaker only begrudgingly added lines in *Night of the Dead* that pointed to a cause (radiation from a returning Venus space probe), though even that cause is contested by the "experts" within the film.

26. In the past, according to Baudrillard, the event was a *historical* event, and "the French Revolution was its model" (125).

27. The framing that Baudrillard provides can perhaps help us make sense as well of the recent popularity of zombie films, and in particular the focus on how one would survive the apocalypse. Baudrillard's account describes why—if we are always desiring the event and its capacity to overturn our present order while at the same time always desiring that that order be maintained, whatever the cost—our fantasy, especially in the past decade, bears the form of a zombie apocalypse: it is an event that increasingly seems only able either to destroy *all* order or to intensify the monstrous social order we already have. Furthermore, against the fundamental inexplicability and ruin of the zombie apocalypse, the desire to map out a survival plan—to determine where one would go, with what supplies, what weapons, and what people—can

be seen as a manifestation of that coequal desire for order. So is the impulse to set the rules for zombies—rules that define what exactly they are, how they can be killed, and what capacities they have. We must have rules for the game. The zombie event is thus an occasion for the fantasy of upending our world and for testing our ability to master the inexplicable. We must make sense of even this impossible scenario.

28. For instance, *Diary* self-consciously uses some of the newscaster footage from *Night of the Living Dead*.

29. See Coley and Lockwood's *Cloud Time*.

30. See note 7 above for a brief discussion of the zombie figure's threat to McLuhan's account of human beings as essentially mediated.

31. Recent large studio films like *Zombieland* and the incredible number of straight-to-DVD and made-for-TV zombie films of the past ten years are notorious for relying almost exclusively on digital gore. The makeup might be real, but the actual violence of these films is increasingly a product of computer-generated imagery (CGI).

32. See Mark Deuze's *Media Life*, which takes this distinction—that we increasingly live our lives *in* rather than *with* media—as the ground for analysis of contemporary society.

33. To ask what one would do in the face of the zombie apocalypse is no longer an unusual or interesting question. Who doesn't have a survival plan, or at least some banal response? For what it's worth, mine involves a 7-iron, hiking boots, and a CamelBak filled with tequila.

STEPHEN SHAPIRO

Wouldn't it be kinder, more compassionate to just hold your loved ones and wait for the clock to run down?

Dr. Edwin Jenner in "TS-19," *The Walking Dead* (2010)

The Zombie Now

"Wildfire," the fifth episode of AMC's *The Walking Dead*'s first season, shows a crisis many Americans are currently facing.[1] In the aftermath of a zombie attack, the human survivors must prevent their killed loved ones from returning as zombies. One woman, Carol, refuses to let the group's men take responsibility for "decraniating" her prone life partner. "He's my husband," she says before splattering his gray matter onto the viewing lens. The scene cuts to another woman, Andrea, cradling her dead sister and waiting for the first sign of reanimation. Over a soundtrack of sentimentalized music, Andrea mournfully says, "Amy. Amy. I'm sorry. I'm sorry for not ever being there. I always thought that there'd be more time. I'm here now, Amy. I'm here. I love you." When Amy's groans indicate her undead return, the men move to dispatch her. But Andrea preempts this outsider intervention by shooting her own sister's brains out.

5.1. Andrea waiting for Amy's reanimation in "Wildfire," *The Walking Dead.*

This scene's emphasis rests less on the general horror of zombies than specifically on a family member's agony and response to a loved one's final life moments. It stages a problem about life and death that has become increasingly critical in Western societies. For a preeminent social tension in contemporary health care involves medical science's ability to keep the body's physical apparatus operating longer than an individual's self-defining intentional agency or cognitive consistency, as with the onset of senile dementia. Here, the American cultural preference for optimism, even in the face of challenging or absent pathways to physical recuperation, smashes against the reality of aging and an ill patient's declining quality of life, a reality that is simultaneously shaped by the force of acute costs for medical care. One especially painful threshold comes when a family member or health care proxy must work through a matrix of grief, guilt, and anger as they are called on to

make a legal choice involving the Do Not Resuscitate (DNR) protocol. This is the moment that feels like the time we decide to "kill" our family and loved ones. While some palliative care clinicians, those tasked with reducing a patient's pain but not forestalling her or his decease, prefer the term AND (Allow Natural Death) so as to downplay the emotional burden involving the decision to omit medical intervention, few of those asked to choose experience a transcendental, natural process of any kind within the blasted landscape of blood, excrement, and industrial waste that is the modern hospital.[2]

Exacerbating the emotional difficulties facing contemporary end-of-life considerations is the fact that these decisions are themselves relatively new, for the earlier state of medicine and life care meant that individuals died earlier and more suddenly than today. Tied to the moral quandaries resulting from the modern possibilities for technologically prolonging the last phase of human existence is the new burden of anti-institutional choice typified by the DNR protocol. While painful decisions could once be lodged with and distanced by medical professionals, the language of individual liberty that became increasingly dominant from the 1960s onward became tied with clinicians' fear of career-damaging malpractice suits. It resulted in shifting the weight of these choices onto individuals, who often have little expertise or an inadequate frame of reference to make irreversible life decisions.[3] Always shaping these supposedly uncoerced choices, though, are the financial pressures of increasingly privatized medical care, so that families and individuals are often forced to make medical decisions based on cost rather than emotional free will.

The complexities surrounding end-of-life considerations have become more difficult to navigate in a damaged political environment now routinely deranged by manipulative, bad-faith incitements, like Sarah Palin's screed against "death panels" during her 2008 presidential

campaign against Obama's health care plans, or the early 2000s orchestrated controversy that delayed the sober realization about Floridian Terri Schiavo's persistent vegetative state. Because Americans lack a functioning public sphere that can present a spectrum of debatable positions in neutral tones of reasoned and analytical inquiry, the zombie representations of the walking dead have recently become popular—particularly those that showcase the generic scene of characters having to kill the infected before they reanimate, or the sight of someone's loved ones now incoherent, incapable of emotive communication, and often wandering in a confused fashion—as a social medium for rehearsing decisions about the termination of life support and care for the elderly, cognitively challenged, and terminally ill.

As early as *Democracy in America* (1835 and 1840), Alexis de Tocqueville recognized that modern, individualizing societies leave their members restless and moody as they face the unpleasant awareness of being alone and unprotected before the greater massed power of an anonymous social crowd. For Tocqueville, the old regime of hierarchical castes ("estates" in French) was not to be idealized, but needed to be recognized as providing cushioning narratives to regulate life expectations. He argued that the need for social familiarities amid a democratizing world, which otherwise insistently seeks to remove prefabricated, knowable social relations, results in individuals either seeking surreptitiously to reestablish the older means of rule or turning to compensatory activities, which he saw primarily as explaining the rise of insatiable consumerism.

In *On Suicide* (1897) Emile Durkheim built on this claim as he proposed that the modern rise of mental distress and suicidal ideation was caused by *anomie,* the condition resulting when life-framing narratives vanish due to the breakdown of social institutions that produce stable codes of life expectations and satisfactions (the *nomos*). Already by the

late nineteenth century, Durkheim claimed, institutionalized religion (the Church), centralized nation-states, and extended family units were no longer capable of giving a legible shape to individuals about their life-pathway decisions. His suggested institutional replacement was the labor union, and its relations of class and workplace solidarity. Yet at the end of the twentieth century and onset of the twenty-first, unions and other forms of consensual and cohesive public institutions of government or political engagement have likewise splintered. Consequently, modern subjects look to find socially framing narratives elsewhere, such as in popular culture.

It is a truism that the last two decades have been a golden age for television serial narratives, especially on cable channels, such as HBO, Showtime, FX, and AMC. Yet the most celebrated examples of this new "quality" television have also been exemplified by their return to highly generic narrative forms—urban crime procedurals, espionage thrillers, fantasy swords-and-sandals costume drama, sentimentalized romance, and Gothic horror. These forms excavate and renew what not long ago had been consigned as obsolete and lacking any audience appeal, especially for the more economically secure and ostensibly culturally "sophisticated" consumer base required for subscription television. Perhaps the success of television that paradoxically combines high production and presentation values with otherwise predictable generic story lines indicates that genre television functions today as the ersatz *nomos*-making institution for Americans to find guidance within the problems of modern living (and dying) in an otherwise overly alienated world.

If the American middle class invests genre television with the social status and role previously enacted by other arrangements, then the field of popular cultural studies needs to be attentive to the figuration of zombies, not only because we want to be sensitive to the existential

trauma of bodily decline and the challenge of maintaining human dignity in the face of the mind's inability to control the body, but also because the sudden widespread popularity of zombies, as exemplified by the unexpectedly large audience for AMC's *The Walking Dead*, can tell us something larger about the current moment of social uncertainty, transformation, and need for different narrative-making institutions. If the purpose of cultural studies is fundamentally to explore the relationship between cultural products and the tensions within social experience, then it needs to take the new zombie surge seriously. But how?

How to Read a Zombie

Let me begin with a scandalous claim: there is no such thing as a televisual narrative zombie tradition. While there are certainly past instances of zombie representations, which offer a usable set of familiar images and events, it is not useful to read these within a framework of a linear development (a "tradition") that provides a homogeneous or coherent perspective. Each recurrence of zombies is less a *recitation* or adaptation of the already known than a more or less distinctive *repurposing* of generic, representational devices to consider a specific contemporary process that generates social uncertainty or crisis. There is no prerequisite continuity or commanding influence between one zombie cultural moment and another, because each new cluster of representations in discrete times and locations stands as a different "object of knowledge" or cultural artifact responding to its own pressing conditions. This historical difference is most clearly seen when generic themes or figures, like paranoid conspiracy tales or Sherlock Holmes–like figures, suddenly become popular again after a period of minimal presence or limited audience. The relative dormancy of these devices or story lines is precisely what allows them to be remade for different purposes, since no

guarding institution cares enough to police the installation of formerly used up but now reconstructed figures. A change in social purpose and pressure is most clearly indicated when a later use of residual figures changes basic elements or explained "truths" about its scenario, alters the narrative voice or directed identification with or against its characters, or motivates a different or massively enlarged audience for the reception of its themes.

The initial zombie cinema typified by *White Zombie* (1932) or *I Walked with a Zombie* (1943) seems fascinated by the possibility of American hemispheric imperialism as an enabling solution to the Depression era's failures. These movies seem to wonder if colonized, foreign workers, illustrated by the barely animate zombie, could provide the consumer goods that economic doldrums, wartime rationing, and mass, domestic unemployment were otherwise not allowing Americans to purchase. Later, George A. Romero's revitalization of zombies with *Night of the Living Dead* (1968) and his ensuing trail of sequels is conversely preoccupied with the breakdown of social consensus resulting from homeland disparities about unequal access to the consumer goods proliferating *through* the American postwar boom. Tensions about the uneven opportunities for equal consumption are most acutely experienced within Romero's cinema by the presence of local, social violence, which can no longer be kept out of the domestic environment by the graveyard fences that enclose racial or underclass ghettos, as well as by the expression of white petit bourgeois/working-class members' resentment at their declining socioeconomic status.

The substantive difference between these two social crises is registered by the latter's alteration of the former's ruling conventions. While the early zombie cinema still relied on Haitian folkloric elements and locales, with the zombie plantation's slavelike labor, Romero's zombies are liberated from any statelike centralized authority commanding

coerced production. His zombies roam autonomously and do anything they want, without any controlling master or ruling force, exemplifying the contradictions within America as a "free country." The radical shift from the earlier cinema's concerns about managing the reach of consumer expectations in an age of New Deal Keynesianism to those about internally generated disruptions within the unexpected return of market deregulation is signaled by Romero's transformation of the zombie code. He foregrounds the new and entirely un-foreshadowed element of zombie cannibalism as the most basic breakdown of physicalized boundaries. While the shambling zombies in the cinema of the 1930s and 1940s may have been aesthetically uncanny or disturbing, they rarely posed a viscerally disruptive threat to their observers. Romero's zombies, on the other hand, have an insatiable desire to consume, but,

[L]oved ones now incoherent, incapable of emotive communication, and often wandering in a confused fashion [become a] medium for rehearsing decisions about . . . care for the elderly, cognitively challenged, and terminally ill.

paradoxically, they never seem to decay or decline when the supply of carnal goods is blocked or delayed. For Romero, frustrating (or retarding) the expression of consumer demands won't diminish or resolve their force, since these wants, once disinterred from any controlling weight from above, will continually press onward until they find the opportunity for their enactment.

Even later basic changes in the narrative devices or form, such as with *28 Days Later* (2002) and its replacement of Romero's slow and sluggish zombies with fast and attack-oriented ones, or the innovation of AMC's *The Walking Dead* (2010–) concept that everyone who dies

will reanimate, regardless of whether or not their skin surface was broken by a zombie's bite or scratch, signals that zombies are being used less as a cultural heritage that predetermines their use by their past appearances and more as a means of articulating new problems of social life.

A long-standing challenge for cultural studies is how it can best respond to these changes and navigate among the different levels of social analysis listed by Marx: the universal, general, particular, and singular (*Grundrisse* 85–88). Leaving aside the universal as a realm for considering overarching ontological questions (e.g., the definition of humanness) or epistemological ones (e.g., the meaning of truth), Marx sought in his economic writings to establish the general laws of capitalist accumulation, often leaving particular period-specific analyses for his writings on history or politics. The singular level, often associated with "great men and dates" historiography, was usually not considered at all by Marx, being too unique and individualistic to make any overarching social conclusions. Marx's emphasis on the general, however, has long hobbled cultural studies, which often relies on "general" explanations to make interpretive claims that seem overly predetermined, repetitive, and lacking in consideration for how social subjects apprehend social relations in ways that allow them to respond variously to their own historical experiences. The challenge is to convincingly balance the general against the particular in ways that can illustrate how the classical arguments about capitalism are flexible enough to satisfyingly explain the particular features or prominent tensions at different times and places. This project's usefulness comes from the way that cultural phenomena usually register social experience in advance of political enactments or legal-administrative pronouncements. To illustrate one way of reading popular culture that intertwines the general and the particular, let me return to recent zombie representations and the matter of end-of-life health care.

The contemporary health care crisis emerging from the collision of scientific and technological advances against the inequality-producing effects of these advances exemplifies how people often face the realities of capitalism as a world system that depends on draining life for profit. Of course, we all routinely experience capitalism. No one needs to be educated about its pressures, but most manage this awareness in a muffled form as a result of the hegemony of everyday expectations and interactions. Extremely distressing events, like family illness and end-of-life emergencies, hurtle individuals across the threshold of recognition as these personal crises amplify the dull pain of existence within capitalism that is otherwise expected to be managed as normative background noise.

The particular rise of the DNR moment, which is often initially experienced as a lonely, singular decision rather than a collective social pressure, has such a possibility for the latter's revelation because contemporary life termination decisions within a clinical setting go beyond bioethical concerns about the abstract nature of life and death to now stand centrally as ones where the individual or family responsible is asked to determine relative value against an equivalent monetary standard. What, for example, is the value of arranging for the ill to have more lifetime against their diminished self-agency and appreciation of this time, especially when this decision is placed under the pinch of its cost? Is one more month of a grandparent's existence worth, let's say, the cost of a year's university tuition for the grandchild?

Consequently, DNR events focus attention on the known but inconvenient truth about the primacy of the money form in capitalist societies as the standard of value between two otherwise incommensurate commodities. The general inadequacy of using money's exchange value to enumerate different kinds of life use values is made particularly

salient as end-of-life considerations fall into the category of exceptional, irreversible decisions; many modern individuals, dissociated from life-ritual institutions, now have little experience or context within which to make those decisions. Additionally, many agonizingly sense that no matter what they decide, there will never be any means of retrospectively ascertaining the appropriateness of that decision. While individuals are pressured, due to the prohibitively high cost of the end-of-life clinical environment, to find the supply-demand equilibrium point that liberal economics insists is the rational location for choosing to sign the contract (or form that frees the medical professional or institution from liability), they also recognize that even if it's "finally all money," this grim revelation does little to prevent their continuing disempowerment, given their inability to state definitively when or where the choice over life determination should occur within the money system.

Since neither the marketplace nor the servicing institution wants to become implicated with the moral choice about life termination, modern subjects look for help elsewhere. This guidance has increasingly become the function of generic popular culture, often found on cable television with its greater tolerance for displays of emotional ambiguity. Genre functions today as a surrogate institution, because the institutions previously responsible for life maintenance have become obsolete or dysfunctional (more on this below). In the first instance, genre culture often repetitively stages scenes of hyperbolic emotion as an emotional laboratory for its consumers to experiment and model what their emotional response might, or ought to, be in extreme situations. Generic tales, with their repetition of "unoriginal" scenes and events, do a para-institutional "bridging" work. When traditional, expert-led institutions fail to provide guidance or leadership, genre texts go beyond simply thematizing a crisis, even while they often fall short of critically

theorizing its resolution. Genre novels, television, and film mediate between unsaid or undocumented experience and critical analysis, linking both, while also being different from either.

On one hand, sensational texts form a safe arena to test emotional response, wherein otherwise indicted or conventionally controlled emotions (anger, fear, ambivalence) can be expressed even while their nonrealistic scenarios allow for a cultural distance that allows the subject the plausibility of denying engagement with or entertainment by these maneuvers, as it's "only a television show." On the other hand, sensational genre also stages shocking scenes that give its viewers catalyzing conceptual material that allow them to push beyond the horizon of the everyday, a move especially useful for the larger segments of the civil population that do not routinely dedicate themselves, unlike university cohorts, by the display of and facility for abstract theories (of capitalism, for instance). For these reasons, generic tales function better and are in greater demand than "high culture" ones, since their seriality and repetitiveness make them a better and broader template than the unique quality of auteur-created tales. Consequently, when certain generic themes or figures swarm at particular moments so that the undead are everywhere, this marks the presence of a signal crisis, the moment when otherwise manageable tensions within a particular aspect of society generate contradictions that have become so amplified or widespread that they need a response.[4]

While an older form of popular cultural studies would emphasize the reading or viewing of generic works as ripe for ideological policing and a further instance of social control, this judgment seems less viable for the first phase of a genre's return, since how could its magnetic effect be predicted in advance? Rather than read the current zombie resurgence as a moment of representational control or, conversely, even one of representational rebellion, let me consider it as a transistor of still

indeterminate thinking about a particular social crisis, which may also convey a larger realization of a more general developmental one and possible directions in response to these crises.

Fans versus Newcomers

The possibility of a dual optic on a particular and more general developmental crisis suggests a substantive difference between the representation of zombies in the fan-world spheres (what used to be called subculture) and in commercial, capital-intensive broadcasts like AMC's *The Walking Dead*, which require a larger audience than the fan world can provide in order to be financially viable. The fan world's syntax functions as what Fredric Jameson calls a "strategy of containment," a maneuver that "allows what can be thought to seem internally coherent in its own terms, while repressing the unthinkable" (or what is presented as unthinkable) such as a socioeconomic explanation that "lies beyond its boundaries" (*Political Unconscious* 35). Fans' often nominalistic obsession with the serial recitation of what are taken as the unalterable, transhistorical figurative devices and plot rules that certify a text's inclusion within a pristine category functions to protect its consuming agents within a psychological green zone that too successfully dampens pain and the problem of living through a protective ritual of naming evidence. By confusing medium for message, fans act like the hoarder who mistakes the possession of objects like coins for the socially produced and consumed value that the coins were created to facilitate in the first instance. The fan world's need to display its certainties, often witnessed in the cave of spatially enclosed, quasi-privatized (costume replica) conventions, is a kind of semiotic essentialism and culture of non-exchange that insists that certain objects and acts are important because they *mean* something, but fans' tight control over their medium

limits its dynamic range and makes it hard to determine exactly what is the social purpose of this highly involuted meaning.

The fan world's obsession about correct details follows the logic of body cutting, where a subject creates a mainly self-seen incision, for two reasons.[5] First, the felt sharp pain answers the question, *Am I alive or dead?* as the unhappy subject desires to register any sensation, even pain, in order to prove that while she may be emotionally blank, she is not yet dead. Second, the cut acts like a protolanguage or pre-discursive act that allows trauma to be expressed, but only if distanced by being displaced onto an external source.

Thomas Szasz argues that individuals who cannot openly or safely express a "problem in living" (his replacement term for "mental illness") will use a somatic, nonlinguistic manifestation as a surrogate means of expression, either because they feel dominant forces would punish them for articulating the conflict in language or (less often) simply because they lack a self-reflexive language to decipher the cause of pain (107–21). He calls this "protolanguage" because it does not operate according to the familiar conventions of semiotic signification, since it performs a superficial basic command for action (*Help me!*) more than an explanation of what kind of action is necessary to qualify as a rescue. So rather than speak of sexual abuse or the unwelcomed pressures of parental expectations for career success in the market economy, the traumatized subject damages herself to produce a distant object, the torn skin, that can be labeled as the source of easily treatable pain. This externalization thus protects the subject from the risks of speaking about the nature of actual distress within her interpersonal and social relations. The cut is a strategy of containment that expresses affect while simultaneously blocking enunciation of the substantive emotional problem in living the subject faces, as the cut indicates a surrogate source of pain, the skin's wound, rather than the subject's life relations.

The tactic of the cut operates just as Marx describes the commodity fetish, which magnetizes human desire on what appears to be a self-making object that is, as Jameson says, "internally coherent in its own terms" (*Political Unconscious* 53), while also silencing the unfair labor relations linked to commodity's production and the network of social exchanges that put the commodity into motion. But when cultural values *do* circulate beyond the policed realm of the fan world's hoard and into a wider audience, including that of the mass, commercial televisual market, they become a different kind of object and provide a more widespread perspective on the present total set of social relations. Neither the fan world nor the mass market is any more correct or authentic than the other. Yet in a case of "winners lose," the fan world more effectively manages the problem of living through controlled reiterations and the exclusion of representational deviations, and in so doing also makes it more difficult, from a cultural studies perspective, to discern the social problem at stake.

Conversely, the elasticity of genre in the large-scale mass market better facilitates the expression of a crisis, because it more easily allows for the introduction of new elements that show where our focus ought to be directed. The move, though, from fan world to mass market often requires the presence of intercalated works that either parody or camp the prior narratives. Parodies dislodge generic elements from the protective control of the fan world so that generic conventions can be "taught" to new audiences who would otherwise abstain from any awareness of the materials. For zombie culture, the move from the self-selecting audiences of Romero's grindhouse films to the substantively larger and more heterogeneous ones viewing AMC's *The Walking Dead* requires films like *Shaun of the Dead* (2004) that use comedy's light tone to disseminate the older codes to audiences who might otherwise be averse to consuming them. Similarly, the aim of the new mash-up fiction like

Pride and Prejudice and Zombies (2009) is to mock not just canonical literature but also the titles that are particularly beloved by women, who might allow their own emotional investment in Jane Austen to allow for learning the sense and sensibility of zombie codes. Once a new, wider audience has been welcomed to the genre, tones of horror can be reinstated. But now the generic tales appear for entirely different purposes and social problems.

The indication of a new motivating purpose appears most clearly when a later adaptation (often occurring in the move from one medium to another) knowingly verges from the original by either reweighting elements or installing new ones. Hospitalization and end-of-life decisions do appear in Robert Kirkman's graphic novels of *The Walking Dead* (2003–). The police officer Rick Grimes "enters" the zombie apocalypse in medias res, which occurs while he is unconscious in a hospital bed recuperating from being shot in the line of duty. One possible implication of this temporal gap is that the entire ensuing sequence of events might only be Rick's semiconscious, interior fantasy sequence, much like the narrative explanation for U.K. time-and-place-jumping television series like *Life on Mars* (2006–10) or *The Singing Detective* (1986). When Rick joins a group of other survivors, none offers a detailed documentary account of the zombie apocalypse's first days, preferring to allude to it only elliptically as a time when things got crazy and so on. The absent testimony can suggest the presence of Rick's own desire to use the "cut" of the zombie apocalypse as a means of distancing any discussion of the emotional distress surrounding his injury (a marital dispute that might have distracted him during the line of duty). In this light we can read Rick's first premeditated response to the zombie apocalypse—his return to euthanize a horizontalized zombie girl, who cannot move due to missing legs—as an expression of his own longing for final release from his bed-ridden state and mental world of pain, but one that

5.2. Rick Grimes "awakes" in the hospital in "Days Gone Bye," *The Walking Dead.*

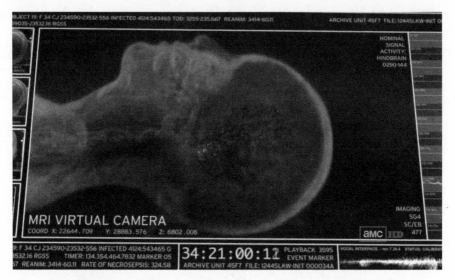

5.3. MRI display of zombie progression for "Test Subject 19" (the epidemiologist's own wife) in "TS-19," *The Walking Dead* (2010).

is externalized and objectified as the damaged zombie. Conversely, the farmer/veterinarian Hershel's care for zombies under the belief that they can be cured stands as a surrogate marker for what might be Rick's own life support in hopes of recovery.

Yet if these elements of medical care exist in the graphic novels of *The Walking Dead,* they are often marginalized to a greater fascination with repeated instances of bodily dismemberment among the living as a corporeal metonym for the fragility of civil society units (single-family house, extended-family farm, enclosed village, regional network). The graphic novels often seem to want to express a cultural pessimism by distressing the Enlightenment era's sociological claims about beneficial stages of human development from nomadic savages through pastoralized barbarians to conclude happily as the civilization enacted by

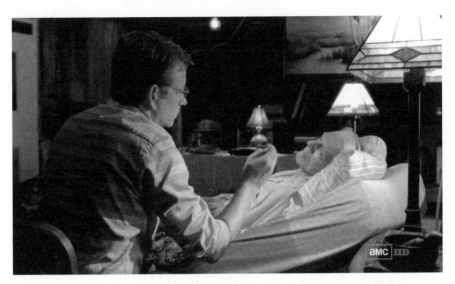

5.4. Milton tests his memory-retention hypothesis in "When the Dead Come Knocking," *The Walking Dead*.

market-trading moderns. The televised form of *The Walking Dead* shifts from the graphic novel's obsessions and devotes much greater emphasis and duration of focus on the illness bed, such as the greater length given to representing the child Carl's near-death shooting and recovery. More significantly, it introduces a raft of end-of-life scenes that are not present in the graphics, such as season one's concluding visit to the Centers for Disease Control and Prevention, with its video of the clinically observed death of a wife; Rick's wife Lori's caesarian birthing of and subsequent euthanization by her son, Carl; and the palliative-care laboratory at Woodbury, where a scientist tests his hypothesis about possible residual memory in zombies by installing them at the bedside of a soon-to-die elderly man. The experiment fails, forcing Andrea to repeat her prior shooting of her sister and the viewer to recall it. Season

three ends with Rick turning his sanctuary into a home for Woodbury's ill and elderly after having previously refused entry for more muscular and agile survivors.

The arrival of zombies in the television series often feels like merely an opportune mechanism for continually staging emotionally torrid scenes of individuals responding to the last stages of a family member's life and death and their reluctant decision to terminate the individual's existence in a less-than-human cognitive state, a scene made more common with the series' new narrative "fact" that all humans will turn to zombies when they die. The staging of end-of-life scenes will never fade from the show, since now every dying character must be carefully watched (by the characters and the viewing audience) for his last breath. These moments work to remind the viewers that all of us, not merely the unlucky few, will grow old and may have to face the unsteady state between our physical decline and ultimate demise.

But such a claim about AMC's zombies as enabling concerns about health care and end-of-life issues should not be seen as an allegorical reading, where Z is really Y, be it the proletariat, nonwhites, or any other social collective or abstract noun. For the allegorical explanation is an interpretive move from which popular cultural studies should distance itself.

Against Allegory

In *The Political Unconscious* Jameson stages a sophisticated defense of allegorical interpretations for historicized and political readings of cultural texts. He acknowledges the disrepute that allegorical readings have gained in cultural studies, where they often seem homogenizing, predetermined, and lacking in complexity. He proposes a dialectical work-around of the criticism that allegorical master narratives receive

by arguing they must remain "a persistent dimension" in our reading practices "precisely because they reflect a fundamental dimension for our collective thinking and our collective fantasies about history and reality" (34). Because cultural works *have* been produced using allegory, it would do substantive damage to deny entirely the legitimacy of allegory as a means of responding to texts. Yet Jameson also recognizes that allegory cannot simply be reinstated and has instead proposed a redefining return to

> the concept of *mediation:* that is, the relationship between the levels or instances, and the possibility of adopting analyses and findings from one level to another. Mediation is the classical dialectical term for the establishment of relationships between, say, the formal analysis of a work of art and its social grounds, or between the internal dynamics of the political state and its social ground, or between the internal dynamics of the political state and its economic base. (39)

A "more modern characterization" of mediation would be the concept of "*transcoding:* as the invention of a set of terms, strategic choice of a particular coded language, such that the same terminology can be used to analyze and articulate two quite distinct types of objects or 'texts,' or two very different structural sets of reality" (40).[6] Transcoding is also the means by which a cultural text can link individual acts of artistic creation to collective concerns and facilitate the expression of utopian longing for human betterment and liberation from the chains of necessity—whether they are natural resource scarcity, the limits of technological capability, oppressive political regimes, or exploitative economic ones—even while containing these yearnings by reifying them as isolated objects only accessible through a cultural commodity's sale.

Yet, posed in this way, transcoding simply mirrors the action of the money form, which yokes two distinct commodities for exchange in

ways that reify relations of production while also redirecting these energies toward the utopia of commodity consumption as a weirding of collective emancipatory desires. Marx reminds us, however, that while we can imagine commodities talking to each other, they do not really have anything to say in capitalist societies other than the same old story about their exponential growth as capital. In this sense they are like the zombie herd: relatively mute but accumulating all the time.

If the logic of capital is that everything different can become the same one thing, if the universe of different commodities always collapses into money's standardizing equivalent, if human differences transform into a common zombie uniformity, then is the term *allegory*, with its similar interpretive move of a condensing decoding, the most satisfying way of primarily understanding cultural communications? For to examine the flow of communications only from procedures that mimic the perspective of the money form's transcoding would simply be to see social relations exclusively from the capitalist point of view, by tracing the flow of a commodity's selling price rather than the values and confrontations motivating its creation.

Furthermore, in what sense is the recent zombie narrative's display of a family member's agony over the decision whether to prolong or terminate a sick one's life allegorical of the actual life decision to prolong or terminate life? Surely the former is weakly transcoded, if at all, and requires little or no hermeneutic labor or need for interpretation to see it for what it openly and actually displays. On the other hand, the supernatural Gothic setting and paraphernalia of the zombie apocalypse also discounts its tale from being purely mimetic, or a reflection of actual, everyday life. The paradox of these scenes being neither solely realistic nor requiring a depth interpretation suggests we need a third term that can capture the reenactment of recognizable scenes in otherwise exceptional, fantastic, or supra-rational locations or processes. One way

would be to characterize these as *herme-mimetic*. The neologism's echoing of the prior opposition between hermeneutic and mimetic reading options allows us to springboard beyond to recognize a different cultural expression that allows for a rehearsal of possible responses to a thematized signal crisis, the direction of which is not predetermined.

Unlike allegory, which implicitly always promises an end theory or solution, the herme-mimetic is less definitively conclusive. Allegory promises narrative closure. It inevitably suggests that once we discover and name the alluded-to master sources, the problem can be solved, since the riddle of encryption is highlighted more than the problem requiring encryption. The herme-mimetic does not, in the first instance, look to resolve an initial problem. The herme-mimetic differs from the allegorical, because it shows exactly its concerns; its thematic focus is clearly present, but neither is it entirely mimetic or asking for emulation, even though the viewer is encouraged to place himself within the realm of experience and mental action. In this case we are not encouraged to learn how to act in a zombie apocalypse, but rather how to respond emotionally to distressing scenes of decision about human loss. Yet, although it prepares us for response, the direction of that response is not guaranteed, even when a certain direction is suggested. Hence there is the need to rehearse the scene's range of possibilities by repeatedly staging its occurrence throughout the narrative.[7] Generic narratives are especially herme-mimetic in tendency, given their predisposition to repetition of scenario and action.

In this sense herme-mimetic tales often treat a relatively isolated signal crisis. A signal crisis registers a particular conflict that exists within one sphere of capitalism but does not necessarily become a larger developmental one that will catalyze a larger transformation. For cultural studies it is necessary to allow the particular to be considered in relative isolation without rushing to make it overly generalized as

indicative of capitalism overall. So the signal crisis does not have to be read as a *symptom* of underlying issues. On the other hand, a number of signal crises can converge to become a developmental one. And when a signal crisis becomes amplified by the convergence of several other signal crises, the herme-mimetic often moves beyond simply thematizing a problem and begins theorizing a more critical response to the implications of that problem.

A chief indication that the herme-mimetic is reaching beyond thematic placement and toward a more theorized approach of both a signal crisis and a larger developmental one is that in addition to the introduction of new formal devices (for zombies, aspects like cannibalism, accelerated tempo, etc.) there is also a change in narrative voice or perspective. For Raymond Williams the formal transformation of narrative voice was the chief signal of a new structure of feeling trying to express itself in the absence of self-defining cultural institutions; we can use Williams's insight to consider how and when a particular signal crisis might be expanded toward a more general one (*English Novel*). If a new rule locates a new social problem, a new kind of narrative voice indicates a broader horizon of outlook.

The New Zombie Normal

I have argued that AMC's *The Walking Dead*'s zombie representations are herme-mimetic because they allow their viewers to experience traumatic or uncertain conditions, especially those surrounding our response to a senior and aging population. The pressure of the end-of-life health care crisis is a signal crisis of this time because it is relatively self-coherent as a problem arising from medical technology advances within a decidedly capitalist environment. But something else is afoot, because other zombie tales contemporaneous with *The Walking Dead*

have introduced a change in narrative perspective that allows the theme of end-of-life to be congruent or enclosed within a larger general, sociohistorical problem about the demise of the American (Western) middle class in this moment of long-wave economic transition within capitalism.[8]

This transformation of perspective has occurred with the accelerating turn in zombie works toward a Janus-like form of representation, where the viewer's emotional alignment, her affective point of view, has become increasingly both *against* and *with* the zombie in ways suggesting that the impulse to be "versus" the zombie and splatter its stuffing is now joined with a longing to *be* the zombie, to walk *in,* rather than alongside, its shoes.

Just as zombie parodies helped to facilitate the move toward a larger audience, the incorporation of the zombie's perspective within the viewer's own could not automatically emerge without the presence of precursor works that would ease the ideal viewer into this dual position. First, the father of the modern zombie code, George A. Romero, began investigating the possibility of zombie sentience and qualified recomposition of the human in *Day of the Dead* (1985) as the zombie Bub recalls sonic patterns and his past gestures. In *Land of the Dead* (2005), the zombie Big Daddy continued this process and then consciously organized a collective zombie revolt. Building on the notion of the zombie becoming human again was the acceptance of the zombie as man's new best friend—see, for example, the companionate zombies in *Shaun of the Dead* (2004) and *Fido* (2006). An even greater human-zombie fusion occurs with the combination of romantic comedy and zombie films, the *romzomcom,* exemplified by *Warm Bodies* (book 2010, film 2013). Although not strictly a zombie tale, the ABC television series *Invasion* (2005–06) used the central figure of a sheriff, like Rick Grimes, to stage the turn from humans being initially paranoid about the presence of

those bitten and then reconstituted as alien to the season's finale, which sympathetically staged the community-members-turned-alien being herded for destruction in visual terms like the Holocaust outrage of European Jews pushed into the death camps' ovens. The Syfy channel's *Battlestar Galactica* (2004–09) similarly concluded that we need not worry about species contamination and inorganic Cylon infiltration, since this had already happened so long ago that to be human was always already to be Cylon.

From the memory-laden zombie to the socially interacting one, the next step was the dissolution of any negative barrier, so becoming a zombie was transformed from being a negative state to be avoided to now being one that is normal, if not even heroic. If *Colin* (2008) is considered to be the first movie made from a zombie's perspective, the graphic novel series *iZombie* (2010–12) celebrates the Eugene, Oregon, zombie Gwendolyn as an attractive post-Buffy young woman who has a hunger for brains, although this is kept under maintenance, much like any other figure-enhancing diet.

Colson Whitehead's *Zone One* (2011) not only marks the willingness of a "high fiction" writer to deploy pulp forms (a move previously allowed to be enacted only with the alibi of nostalgia, as with, for example, Michael Chabon's novels) but also uses a zombie tale as the contemporary fusion of the European bildungsroman, the tale of entry into bourgeois adulthood, and a *Great Gatsby*–like narrative of disaffection with American capitalist aspirations. In Whitehead's novel the narrator ultimately learns to reject the frisson of a former Manhattan banker's lifestyle of high-rise apartments, consumer tech toys, and trophy girlfriends, and to embrace the city as Zone One, overrun by the zombie horde. The novel ends with the narrator's conscious choice for zombiehood: "Fuck it, he thought. You have to learn how to swim sometime. He opened the door and walked into the sea of the dead" (322).

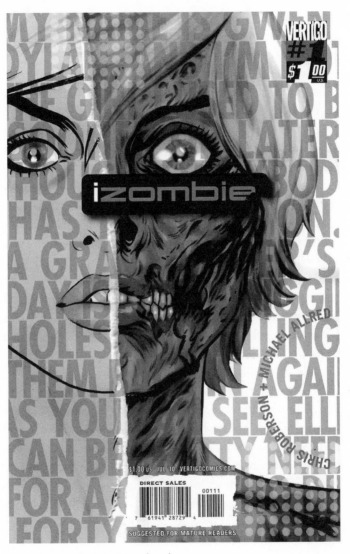

5.5. The cover for *iZombie* #1 (2010).

Developmental maturity is signaled as growth into a zombie identity, where the prospective next stage of life as an undead is calmly seen as necessarily consequential as the prior arrival of secondary sex characteristics marked the end of the pubescent body. Whitehead's chrysalis conclusion is a long way from the scenario of Richard Matheson's *I Am Legend* (1954), which similarly ends with an interior monologue reflection of the narrator gazing on a zombielike horde. Matheson's scene also ends with the narrator wading into the mass, but this gesture is one of nihilistic suicide, since the narrator acknowledges that as the last human, he is the abnormal: "Normalcy was a majority concept, the standard of many and not the standard of just one man" (159). Unlike Matheson, who echoes his contemporary Ayn Rand's celebration of the selfish individual in opposition to the Whitmanesque demotic crowd, Whitehead sees the horde as a *better* state (in both the uncapitalized and capitalized sense of the word) than the consumer capitalism that was previously dominant in post–Ground Zero Manhattan. The zombie state is nowhere better embraced than in the rise of popular zombie walks, with public spaces, rather than private convention halls, being occupied for marches in gore makeup.

The attraction of joining the zombie's bare life is clear. While a zombie may be imprisoned within the realm of necessity, with its need for flesh forcing restless movement, it also exists in the realm of freedom from the pain of human life, with its fear about inevitable bodily decline or damage, anxiety about unfulfilled sexual desire, and shame or humiliation about personal failure.[9] Zombies exist in groups, but without the pressures of community interaction: no zombie needs fear being bullied over its failure to wear the right clothes or to achieve an attractive body ideal or career goal. Given the hell of everyday life in late capitalism, such a condition has clear attractions.

But once certain works achieve the complex function of operating on both sides of the lens, looking at an object and experiencing it as a subject, they do more than simply reify and contain pain in ways that paradoxically create a momentary utopia from the pain. They concurrently intertwine the singularity of an event of personal experience, a particular collective social crisis, and the generality of capitalist long-wave phase changes. These distinct valences are not collapsed into one, overdetermined as a totality, or merely linked in a linear sequence, but are handled simultaneously at each level or scale. Today's particular zombie crisis is the DNR protocol moment, but the general one involves the ongoing crisis of social reproduction for the American middle class within neoliberalism.

The Zombie Class's Rude Awakening

Gérard Duménil and Dominique Lévy explain the modern period as producing two alternating kinds of long-wave systemic crises that scramble the alliances and antagonisms among the capitalist, laboring, and professional-managerial (more broadly middle) classes. Profitability crises, like those in the 1890s and the 1970s, are caused by the systemic loss of profit, and typically result in constellations of frightened bourgeoisie cleaving to high capitalist business interests and providing them with the managerial personnel that can disempower the laboring classes, who must bear the burden of further exploitation. In particular, Duménil and Lévy see neoliberal tactics of deregulation, privatization, and the financialization of everything as a specific set of tactics initiated in the 1970s to reconcentrate wealth in the hands of a tiny elite, the 1 percent, with the willing collaboration of the middle classes.

The other kind of crisis is one of financial hegemony, typified by the 1930s Great Depression and the current post-2008 moment, when

the prior alliance between business and professional-managerial classes falls apart as the latter perceives the former to have failed and be incapable of reconstituting the overall capitalist system. So rather than looking to a banker, like J. P. Morgan in the 1890s, to deliver them, the professional-managerial classes look to more intelligent leadership from one of their own, such as the academic John Maynard Keynes. Because the professional-managerial class needs a larger social mass to contest and replace the power of haute capital, it draws itself into alignment with the working class, despite the tensions of mésalliance. During the 1930s the professional-managerial classes attracted working-class support when the former regulated speculators and redirected capital investment toward social welfare and entitlement schemes in return for a more stable period of decreased labor unrest. With Duménil and Lévy claiming we are in the first moments of another 1930s-like crisis of financial hegemony and redirection of professional-managerial loyalties, they can be implicitly taken as explaining why Occupy Wall Street would fuse the unrest of unemployed and indebted collegians with labor unions, two groups that were usually pitted against each other during the 1970s–2008 phase.

[T]he viewer's emotional alignment . . . has become increasingly both against and with the zombie in ways that suggest that the impulse to be "versus" the zombie and splatter its stuffing is now joined with a longing to be the zombie, to walk in, rather than alongside, its shoes.

Yet any social divorce between the professional-managerial classes and business interests and the former's renewed sympathy with the working class is not an easy or smooth cultural transition. Such a rewiring of cooperation requires a complicated set of cultural rehearsals

to make these rearrangements work. For surely the middle class needs practice in making so different a social linkage. The return to generic narratives by middle-class audiences can now be seen as itself an indicative feature of the ongoing rearrangement of the composition of class alliances. For as one class dissociates itself from its prior linkages, it must consequently turn to different narrative-generating institutions (the *nomos*) like generic but high-production-value television. The work of changing cultural perspective away from business to labor is enabled by the production of works with an ambivalent point of view, where the former antagonist now seems to be an acceptable identity. AMC's *The Walking Dead* increasingly grants its working-class characters respect and inclusion within the mantle of leadership in ways that are vastly different from the zombie films of the 1970s, which often gloried in the assassination of laboring and lower middle classes.[10]

The change of perspective with regard to zombie identification, however, is not solely a matter of "downward identification," where the professional-managerial classes imagine what solidarity with a lower class might look like.[11] In addition to this new attitude about the working class, the recent zombie figurations also allow the professional-managerial classes to tell an inconvenient truth to themselves. For the focus on the particular end-of-life crisis of an individual subject is also a useful way for thinking about the declining state of a collective class subjectivity. It is a commonplace that since the 1970s capitalism has left the American working class as roadkill on the road to globalization. What is new about this moment is that the same is increasingly true for the American middle class, which is facing not simply a momentary downturn of stalled wealth accumulation but a more general developmental crisis as the core of the capitalist-world system moves eastward to South and East Asia. In this new phase business interests have themselves sought a new class trophy partner, abandoning the Western

bourgeoisie for a more vibrant East and South Asian nascent middle class. Global capital, consequently, has stopped caring about the Euro-American bourgeoisie's present longevity and sees it as little more than a meat puppet. The system strips away generationally accrued wealth by increasing the cost for those non-negotiable elements taken as defining a middle-class identity: home ownership, higher education, health care, and pension security.

The current moment is being experienced by the array of the American middle class as a time when their social durability and ability to ensure the transfer of privilege across generations is both fragile and artificially kept alive through the intervention of debt. In this case the crisis of senior health care is especially resonant for the baby-boom generation, as their longer-surviving parents' care is cannibalizing the funds necessary for their own mortgages, pension funds, and health care, as well as the money necessary for their children's education and support in the jobless post-university period.

Here, AMC's *The Walking Dead*'s figurative innovation that all humans are infected and will inevitably become zombies illustrates what the American middle class inarticulately senses about its own seemingly inescapable mortification. The Malthusian themes of such works register not "green" concerns about potential natural resource limits but, rather, the pinch of capitalist Darwinian pressures on an American middle class that used the prerogative of resource consumption as a sign of its own vitality[12]—that is, unless the American middle class shifts perspective and discovers new allies in the ranks of their former antagonists, the working classes. A conventional reading of Gothic cultural productions is that they express fear about the return of the socially repressed: the proletariat, devastated indigenous cultures, the historical legacy of racial and ethnic discrimination. If this interpretive claim seems persuasively true for older instances of the Gothic, the new

zombie representations do not function this way, for today they operate as a medium of emotional practice by and for middle-class viewers as they come to realize that *they* are the modern zombie class.

For a class that is swiftly mortifying, it seems fitting that anti–student debt campaigners have begun to stage zombified "Night of the Living Debt" demonstrations. For the zombie's body is both a sign of the existential and historical decline of middle-class authority and a laboratory of emotional practice for a new structure of feeling as the American middle class begins to recoil in horror from the grasping reach of business interests and toward a new, historical life protocol involving solidarity with those other victims of global capitalism, the working class.

Notes

1. I use "American" to convey the broad range of advanced industrial nation-states.

2. See Knox and Vereb, "Allow Natural Death." Also, Hospice Patients Alliance, "New Designation for Allowing a Natural Death ('A.N.D.') Would Eliminate Confusion and Suffering When Patients Are Resuscitated against Their Wishes" (http://www.hospicepatients.org/and.html) and bibliography listed in Sources, Allowing Natural Death (http://allowingnaturaldeath.org/sources), both accessed January 9, 2013.

3. For a brief review of DNR's history, see Loertscher et al., "Cardiopulmonary Resuscitation."

4. When genre responds to social problems, Jonathan Eburne rightly says, "Genre fiction is project-based art." See Eburne's "Arts and Letters" in this collection.

5. Žižek, *Welcome to the Desert* 11. See also Strong, *Bright Red Scream*.

6. Of course, Jameson's own redefinition of the older term *mediation* illustrates the process of indicating its own historical particularity in the way that I am describing above, since his moment of postwar American Marxism is substantively different from the prewar European context in which it was first developed.

7. The herme-mimetic differs from estrangement or alienation due to the latter's emphasis on disruptive effects on the viewer. Estrangement/alienation places an

object in an odd or decontextualizing setting in order to jar the viewer into recognizing the social relations that led to the production of that object. The alienation effect, in Brecht's handling, was meant to compel critical thought by the negative dialectic of alienating the alienated commodity, here the paid-for theatrical performance (Brecht). Brecht argued that non-diegetic tools, like signage or unexpected costume choices, and meta-diegetic narration would help the viewers initially remember that the play they are watching is a theatrical construction so that they might, consequently, see their own lives as constructed by specific social forces and conditions rather than simply the natural way of things. Even when the herme-mimetic uses shocking scenes, like the zombie world, it works more integrally with mise-en-scène and plot and does not try to fracture these through the use of meta-commentary or inexplicable costumes, and so on.

8. For the relation between Gothic and long-wave transitions, see Shapiro, "Transvaal, Transylvania."

9. The zombie may be driven by want but is not moved by desire or drive, and as such it oscillates between the Imaginary and the Real without reference to the Symbolic and its social conventions. As the zombie lacks symbolic language, we never face the need to interpret its gestures or decipher what it *really* wants.

10. If the zombie configures the fusion of two classes, the professional-managerial with the working class, then the recent use of the vampire tale (such as *Twilight*) might have been a last gasp of pre-2008, pre-bust fantasies about the middle class still being able to be invited to the party world of elite whiteness and consumption of luxury goods (designer homes, European holidays, etc.). If zombies, rather than vampires, magnetize viewers more today, it may be that slightly older dreams are simply recognized as no longer tenable after the crash.

11. About downward identification, see Kelleter, "*The Wire* and Its Readers."

12. See Newbury, "Fast Zombie/Slow Zombie."

JACK RAGLIN

The point is, it wasn't a surprise, the war . . . or emergency, or whatever you want to call it . . . it was already on. It had been, what, three months since everyone jumped on the panic train.

Max Brooks, *World War Z: An Oral History of the Zombie War*

While it has become de rigueur to portray the zombie onslaught as a war, this analogy is in fact seriously flawed and can result in lethal outcomes for humans who hew to orthodox strategies of offensive or defensive warfare. Consider that zombie warfare is not driven by a religious motive or geopolitical objective. Beyond the common innate drive to consume human flesh, zombies exhibit no cooperative group objective. Moreover, zombie predation does not appear to be driven by any planned or organized strategies conforming to the strictures of either traditional or terrorist warfare, although as described later, sufficient densities of zombies can spontaneously generate several rudimentary but lethal modes of uncoached clustering.

Conceptualizing the zombie conflict according to Carl von Clausewitz's (1873) definitions of either limited or total war is problematic, because humans cannot prevail over zombies by enforcing a truce or negotiating terms for surrender. The exchange of prisoners is not possible,

because zombies eat theirs. Unlike human-only wars, zombies never stop to regroup, marshal resources, or rest, so there is never a suspension of action. Aside from the highly unlikely outcomes of either total annihilation or absolute and permanent internment of the zombie population, there exists no viable strategy for defeating the zombie horde, so direct warfare with zombies is fated to fail. The possibility of curing or reforming zombies is remote, as is the formulation of effective vaccines that would protect humans from the yet unidentified infectious agent that induces the zombie condition. Victory requires another paradigm of engagement: the zombie should be regarded not as your enemy but as your competitor in a game of life and death.

Undead or Alive: The Game of Z-Tag

The event in which Team Zombie and Team Human are engaged is a variation of the simplest contest of all games, tag. As in the traditional form of tag, Z-tag has two sides with no official designation or declaration of either offense or defense. There are no formal rules or officials in Z-tag, so no penalties can be imposed. In Z-tag all members of Team Zombie assume the role of "it," even though they can be tagged in turn by means of decerebration. For players on Team Human, getting tagged results from either being consumed or infected, and in the latter case, switching sides to Team Zombie. Accordingly, each team has different objectives. Team Zombie's sole motive is to tag the opposition, and its "players" pursue this end without any concern for getting tagged or retired from the field of play. As a consequence, zombies will never resort to a defensive strategy or retreat, no matter how one-sided the play becomes. The goal for Team Human is to remain in the game without getting tagged by being eaten or infected. Hence, for Team Human, the optimal strategy for playing Z-tag is to evade zombies wherever possible

and resort to "retiring" zombies from the playing field by effectively executed head shots only when absolutely necessary. Zombies are also fixated on the same goal: brains!

Know the Opponent: The Away Team

To win in Z-tag, as with any sporting event, it is crucial to understand the competition, both the individual opponent—the single zombie's characteristics and physical capacity—and in terms of how groups of zombies work together as a team. While the image of a shambling zombie hardly conjures feelings of admiration, most coaches would be thrilled to have a team of athletes who possess the standard repertoire of zombie characteristics, and in fact many traits and behaviors ascribed to highly successful elite athletes are also evident in zombies. Key attributes commonly noted in elite athletes include the willingness to endure pain (Tesarz et al.), resist fatigue (Noakes et al.), and pursue long-term goals while delaying immediate gratification (Kitsantas and Zimmerman). As described by N. Durand-Bush and John Salmela, highly successful athletes are "dedicated individuals who are willing to do anything to become the best, even if it means sacrificing other important activities" (283). Consider that the zombie never complains; it feels no pain, and experiences no fatigue or weakness (i.e., muscular failure). It maintains an utterly constant pace with perhaps a slight burst of speed (i.e., end spurt) when within reach of the competition, a pacing strategy recognized as optimal for success in endurance sporting events (Abbiss and Laursen), and one that, ironically, requires considerable mental effort for human athletes (Raglin). The zombie is also singularly and relentlessly focused on its sole goal of tagging humans, and its attention is not diverted by irrelevant stimuli. It requires no food or water. There are no rest stops or bathroom breaks, time-outs, or huddles.

Nor are zombies hampered by the assortment of psychological issues that afflict many human athletes. Zombies do not experience performance anxiety (Raglin and Hanin) or self-doubt. They do not fear being tagged nor display any remorse for their fallen teammates. Psychological ploys and trash talk are wasted on zombies. They are also not susceptible to acute physical problems that are common in human athletes such as cramps or hyperthermia or chronic conditions such as the overtraining syndrome (Meeusen et al.).

When in sight of Team Human, the zombie becomes highly enraged and utters chilling groans that both demoralize Team Human and alert other zombies about the location of opponents. Defying Clausewitz's assertions about the consequences of extended war, Team Zombie will never succumb to the "gradual exhaustion of the physical powers and of the will by the long continuance of exertion" (2).

Shambling Together: The S-Strategies of Team Zombie

Despite the absence of a coach and any formal practice or training, zombies will exhibit organized team-foraging behaviors under special conditions. These are initiated when a zombie has sensed the presence of players from Team Human. The precise sensory mechanism by which zombies detect the competition remains unknown, but some accounts claim they possess an enhanced ability to smell humans (Brooks, *Zombie Survival* 7). While zombies do not possess a spoken language and show no outward signs of direct awareness of other team members, they do exhibit a shared comprehension that a zombie howl signals that humans are nearby. This behavior appears to be a primary stimulus akin to an innate instinctive drive rather than a conditioned stimulus acquired from learning. All zombies within hearing range (it is unknown if zombie hearing ability is either compromised or augmented by their

condition) will inevitably begin to move toward the source of the howl unless already engaged with other humans.

This simplistic set of behaviors that are evident in the individual zombie and the emergence of organized team play among zombies can be usefully conceptualized as an organic version of a Braitenberg vehicle: a mobile agent with no sense of self or the environment that possesses sensors responsive to particular external stimuli (Braitenberg). While Braitenberg vehicles can possess separate sensors that result in either approach or avoidance, the zombie has only the former and is responsive to only two stimuli: the presence of humans and the groans of other zombies signaling that humans are in the vicinity. As previously noted, aversive sensations such as pain and fatigue are not perceived by zombies, and there are no known examples of stimuli that zombies avoid. Although zombies lack awareness of other members of their team, research indicates that organized and even quasi-intelligent group behaviors can arise in non-sentient agents given special conditions (Berman et al.; D'Angelo et al.). The otherwise random pattern of movement paired with the singular drive to tag humans and to follow the howls of other zombies provide sufficient conditions for the manifestation of several team strategies as long as the following are present: (1) sufficient zombie density, (2) detection of members of Team Human either directly or indirectly from the howls of other zombies, and (3) environmental or geographical features that act to direct and eventually constrain the movements of Team Human.

A sufficiently high density of zombies in combination with specific environmental or geographical conditions signaling the likely or confirmed presence of humans will result in zombies spontaneously exhibiting coordinated team predation strategies referred herein as *S-strategies*. These are the (1) *Swarm:* an assemblage of zombies arrayed in rough columns moving in the same direction; (2) *Siege:* a high density

of zombies massed against a physical barrier separating them from humans, such as a wall, fence, moat, or river; and (3) *Surround:* zombies completely encircling a protected space within which humans have no clear route for egress. The outcomes of the Swarm are to *control* and then *constrain* movement in Team Human, at which stage the strategies may evolve into the Siege or Surround, the consequences of which are to *contain* and *consume.*

> **The zombie "engine" produces energy while not generating any heat, meaning it operates at 100 percent efficiency.**

It is proposed that these modes of coordinated behavior and communication in Team Zombie arise not as a consequence of agency but by means of *stigmergy* (Holland and Melhuish), an incidental form of collective behavior and coordination. As defined by Marsh and Onof, "stigmergy is the phenomenon of indirect communication mediated by modifications in the environment" (136). Stigmergy can be further differentiated into two categories. *Sematectonic stigmergy* involves communication resulting from the modification of the physical environment. For example, the urban environment is rife with both built (roads, sidewalks) and unplanned (worn trails) pathways that serve as a means of orienting and congregating zombies as well as increasing the likelihood that they will encounter humans who avail themselves to the same pathways. *Marker-based stigmergy* involves communication by means of a signaling mechanism. The most common example is the case of social insects such as ants, which deposit pheromones along pathways that are then followed by other ants, which in turn strengthen the trail by depositing more pheromones, increasing the probability that even more ants will follow the same path. It is not known if zombies respond to pheromones, either human or

their own, but the zombie howl operates in a similar manner by attracting other zombies (which may also begin to howl) and orienting them to move in the same direction.

The S-strategies are effective not only because they reduce the options for humans to escape but also because Team Zombie will persist indefinitely without respite, while Team Human will at some point be forced to send out players in order to secure resources (food, water, medicine, weapons, and ammunition) necessary for survival. The ever accruing density of zombies participating in protracted S-strategies will eventually make escape difficult, if not impossible, and may eventually result in zombies physically overwhelming barriers such as fences, walls, or moats by "piling on." The success of evading Team Zombie by means of stealthy countertactics is difficult to predict, because the modes of sensory information (e.g., smell, sound) by which zombies remotely detect humans and the range of their sensory abilities are unknown. It is also possible that zombies have acquired novel sensory abilities such as the ability to detect pheromones, either their own or human. Team Human must not fall prey to zombie S-strategies by resorting to countermeasures based on assumptions that zombies are employing deliberative tactics governed by conventional human warfare. To prevail against Team Zombie, humans must instead rely upon stamina, moving efficiently, and staying on the go. So how fast and long must Team Human move to stay ahead in the game of Z-tag? The answer lies in determining the athletic ability of the competition.

From Shamble to Sprint: The Romero (RU) Unit

The cardinal question of how fast zombies ambulate was answered by examining zombie cinema and literature. The basic unit of zombie speed, herein referred to as the Romero unit (i.e., 1.0^{RU}), was calculated

by observing ambulating zombies in *Night of the Living Dead* (1968) and from data provided by Max Brooks (*Zombie Survival Guide*), whose description of zombie pace is the most detailed found in the published literature. The basic Romero unit was determined by timing the footpace of ambulating zombies in *Night of the Living Dead,* and it was observed that the average stride (i.e., two footsteps) was completed at a frequency of .50 hertz (Hz), meaning it took two seconds to complete. Directly determining stride length from movie footage was not possible. However, the average stride length of apparently healthy young adult humans is approximately 26" for females and 30" for males walking at a normal frequency (i.e., approximately 1.0 Hz). Given that human stride length declines as a function of decreasing frequency (Kuo), it was calculated that a zombie stride frequency of .50 Hz would result in a maximum stride length of 22". Brooks reported an even slower zombie pace, with the fastest step frequency at .34 Hz (one stride in approximately 2.68 seconds), and this should then result in a shorter stride length, which was estimated to be 20". It was not possible to interpolate this value using data from human walking studies, because examples of stride frequency this low were not found in the literature (e.g., Danion, Varraine, Bonnard, and Pailhous).

Assuming in each case that a zombie is ambulating continuously over a twenty-four-hour period, the total distance covered would range from a minimum of ten to a maximum of fifteen miles. The average of these two pace values was deemed the basic Romero unit, and it yielded a stride frequency of 2.34 seconds and stride length of 21". The result would be that a zombie ambulating at 1.0^{RU} would move at a speed of .51 miles per hour and cover twelve and a half miles over the course of twenty-four hours. Observations of zombies in the cinema, however, revealed considerable variation in speed in ambulation, so a formal examination of pace in zombie cinema was conducted. It was anticipated

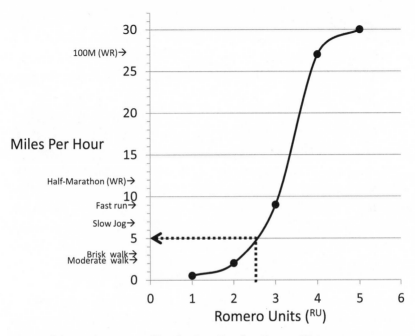

6.1. Mathematical Function of Zombie Pace Based on Romero Units.

that variations in zombie pace would deviate from the Romero standard at a linear rate (e.g., .5 mph, 1.0 mph, 1.5 mph), but instead clear discontinuities in pace and progressions in speed were observed akin to those in quadrupedal animals. Zombies, however, exhibit only one discrete transition in gait mechanics: they either walk at a shamble or somewhat more briskly, or they run at impressive speeds. No examples of jogging zombies (i.e., running at pace of 8–9 minutes per mile) were found in the cinema. Consequently, increases in zombie pace above the standard 1.0 Romero unit were based on a log function rather than a simple linear progression, as depicted in figure 6.1. A value of 2^{RU} equals a pace of 2.0 mph (equivalent to a slow walk in intact humans); a 3^{RU} is

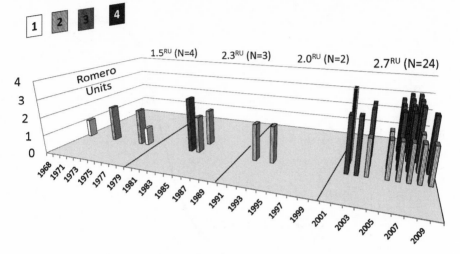

6.2. Zombie Pace (Romero Units) in Selected Cinema from 1968 to Present.

equivalent to a pace of 9.0 mph (a fast run); 4^{RU} is a pace of 27.0 mph (equal to the peak speed achieved in the men's world record 100-meter run); and 5^{RU} is a supra-human pace of 30 mph. These Romero values were then linked with appropriate verbal descriptors: 1^{RU} = shamble, 2^{RU} = slow walk, 3^{RU} = fast run, 4^{RU} = all-out sprint, 5^{RU} = faster than hell.

Using this Romero unit system, a survey of zombie movies was conducted in an effort to determine the overall average speed of zombies in the cinema as well as to ascertain if the pace of the undead has remained constant over time. A total of thirty-two zombie-themed movies (appendix A) produced from *Night of the Living Dead* to 2010 were identified, and the pace in each of these film was determined by presenting the list of movies and Romero values to members of several online zombie forums and asking them to provide their ratings. Mean values of the

collected data were established for each movie; each decade (e.g., 1960–1969); and the entire sample. The results of this analysis are presented in graphical format in figure 6.2.

The average of zombie locomotion for all the movies in the survey was 2.41^{RU}, which translates to a speed of 5.0 mph. Walking at this pace is uncomfortable and difficult for humans to maintain, as it exceeds the average speed (around 4.5 mph) where the transition from walk to run occurs. In fact, there were virtually no examples of zombies that moved at this average, and an examination of the distribution of zombie pace in the 2000s reveals a bimodal distribution revealing two classes of zombie athletes: those who shamble or stroll (50%) and those who run fast and relentlessly (50%). The decade-by-decade analysis reveals a general trend toward faster zombie locomotion, from an average of 1.5^{RU} in the 1960s to 2.7^{RU} for movies that appeared in the years 2000 to the present. The other evident trend is the proliferation of zombie movies over the past ten years. The finding that zombies have become faster in the past decade has significant implications for Team Human training and tactics.

Staying Ahead of the Pack: Know Thy Teammates

Winning in Z-tag requires outdistancing the opponent through the counterstrategy of stamina. Even in the absence of motorized or mechanical transportation (planes, trains, automobiles, bicycles, skis, stilts, pogo sticks), by merely walking at a comfortable pace, healthy adult humans can easily outpace zombies ambulating from 1 to 2^{RU}.[1] But in order to prevail in Z-tag, Team Human must both outdistance Team Zombie day in and day out and avoid becoming trapped in an environmental/architectural setting that would potentiate the likelihood of zombies implementing an S-strategy. This challenge becomes acute

when considering that Team Zombie is ceaselessly on the go after human targets. In contrast, Team Human must forage for food and water. Humans require adequate rest breaks, and it is unlikely that more than several hours of walking or hiking a day can be maintained. Further, the risk of injury is ever present.

Fortunately, Team Human is supremely well adapted for endurance activity, and some researchers (e.g., Lieberman and Bramble) have described humans as the ultimate endurance animal because of morphological adaptations (e.g., relative limb length, posture) that promote mechanical efficiency and economic bipedal locomotion as well as beneficial physiological adaptations—in particular, efficient thermoregulation achieved through copious sweating. At a moderate walking pace of 3.0 mph, an adult male human could match the distance a 1^{RU} zombie can cover in twenty-four hours unimpeded on flat terrain in about four and half hours at an energy cost of just over 1,100 calories (Hall et al.). Elderly adults may have difficulty maintaining this speed, as they exhibit a decrease in preferred pace due to the inevitable decline in aerobic capacity that occurs with aging (Malatesta et al.). Although children are somewhat less mechanically efficient, because their physiology and limb lengths and ratios differ from adults, their caloric cost would be less because of lower body weight. A more vigorous walking pace of 3.5 mph would add somewhat to the energy cost, because walking becomes less mechanically efficient at higher speeds, but this distance could be traversed in just under four hours.[2]

Jogging at a moderate speed of 7.0 mph (about an 8:30 per mile pace) would require only two hours to cover the same distance, but because running is less efficient than walking, the energy cost would rise to 1,400 calories. It would appear that Team Human would have no trouble staying ahead in Z-tag, providing that team members avoided

environmental or architectural settings conducive to Team Zombie S-strategies. Unfortunately, however, most players on Team Human are not in game shape. Less than half of the adult population of the United States participates in physical activity on a regular basis, and only a mere 22 percent engage in vigorous exercise three or more times a week on a regular basis. Furthermore, fully 25 percent of the population is totally sedentary (Dishman). It is unlikely that more than 5 percent of the adult U.S. population could complete a 12.5 mile run even once, and certainly not on a daily basis. The counterstrategy of speed alone will fail all but an elite few. Team Human must rely on walking and begin their training program now!

Where Does Team Zombie Get Their Mojo?

While the bioenergetics of walking or running in Team Human are well established (Rodman and McHenry), both the source of chemical energy (i.e., calories) for skeletal muscle activity in zombies and the process by which it is converted to mechanical energy are unknown. According to some accounts, it appears that zombies do not need any "fuel" to produce movement. As described by Brooks: "Defying all laws of science, Solanum has created what could be described as a completely self-sufficient organism" (*Zombie Survival* 16), and no examples could be found in the literature or cinema of zombies that needed to stop moving or even slow to rest or recover. Because the heart and cardio-vascular system do not function in zombies, and the lungs work only in order to support zombie "communication," the possibility that the zombie thanatoenergetic[3] system operates via aerobic metabolism is then highly unlikely, although passive absorption via osmosis could potentially provide some oxygen. The other two metabolic pathways for

producing musculoskeletal energy in intact humans do not require oxygen (glycolysis and alactic anaerobiosis); however, they are not possible without some source of stored carbohydrate that would need regular replenishing.

The assertion that zombies do not utilize consumed human flesh as a source of chemical energy (i.e., the calories available in carbohydrates, proteins, and fats), or that they use an alternative form of energy that can be converted by the skeletal muscle into mechanical energy in order to move, poses a profound problem, because it violates the laws of thermodynamics. In the case of humans—and presumably zombies—any form of skeletal muscle activity requires a source of chemical energy (i.e., glycogen, free fatty acids). Systems for converting chemical energy into movement (i.e., mechanical energy)—whether they are biological or mechanical—are not totally efficient, and a substantial proportion of potential mechanical energy is inevitably lost as heat. In the case of the internal combustion engine the loss is substantial, and as much as 80 percent of the chemical energy provided by gasoline is lost as heat, a percentage remarkably similar to that found in humans, so both humans and gasoline engines are between 20 and 30 percent efficient. Yet it is widely reported (e.g., Brooks, *World War Z*) that zombies do not produce a heat signal, meaning no chemical energy is lost as heat, either in the process of converting chemical energy to mechanical energy (i.e., motion) or through factors such as friction.

Consequently, zombies appear to violate the law of conservation of energy (the first law of thermodynamics), because they move without transducing some form of chemical substances the muscles can metabolize for fuel. Using the analogy of an internal combustion engine, despite having no gas in the tank, the zombie is always on the go and never has to stop to fill up. The absence of any heat transfer or loss (i.e., entropy), which would otherwise be evident as a heat signature, violates

the second law of thermodynamics. The zombie "engine" produces energy while not generating any heat, meaning it operates at 100 percent efficiency. If this is true, then the zombie moves by means of a process or mechanism that operates outside the known physical laws of the universe.[4]

Given the improbability that Team Zombie has gained an unfair advantage through side-shambling the known laws of the universe, gaining insights into the actual source of chemical energy involved in zombie thanatoenergetics is crucial for the success of Team Human. One possibility is that zombies acquire the chemical energy for skeletal muscle movement through catabolism of both fat and lean body mass, a process colloquially referred to as self-cannibalization. (The only example of this found in the zombie canon was discussed in an episode in the third season of *The Walking Dead*.) Under extended periods of extreme physical activity, inadequate caloric intake, or starvation, stored fat and carbohydrates may become depleted to the point to where the human body begins metabolizing its own tissues, including protein from muscles and organs (i.e., lean body mass), to supply energy. Provided sufficient hydration, a sedentary human may be able to survive from three to five weeks without food (Keys et al.), but a moderately active human would require considerably more calories and would likely not persist beyond two weeks. However, the energy requirements of zombies are far more modest. In the case of humans, 70 percent of energy is used to sustain basal metabolic processes (e.g., circulation, respiration), and another 10 percent goes toward the digestion

The human brain appears to be the perfect sport food for Team Zombie, provided zombies can find an efficient means of extracting it from its rather stubborn "wrapper."

of food, leaving 20 percent for skeletal muscle activity. By comparison the cardiorespiratory system is inoperable in zombies aside from the rudimentary lung function that allows zombies to moan. Accordingly, the zombie's caloric needs are just one-fifth or even less of humans', and a zombie could persist through catabolism for several months up to an entire a year, given some residual fat storage. At some point, however, supplemental nutrition would be required.

Brains: The Ultimate in Zombie Sports Nutrition

The likelihood that zombies do require some form of calories to provide energy for movement could explain the fundamental question of why zombies crave human flesh, and in particular, brains. However, it is widely believed that zombies do not digest the flesh they consume and that it does not serve as a source of chemical energy or provide any nutritive value. Ingested tissue is neither digested nor excreted, and many zombies eventually amass sizable gut loads of human flesh.[5] Despite an inert digestive system, this consumed flesh will still undergo a passive exogenous form of digestion from the activity of anaerobic microorganisms present in the gut and circulating in the external environment, the result being putrefaction and the decomposition of materials into amines and other products, some of which may conceivably serve as a potential energy source for zombie locomotion. These digested energy sources could be passively transported to skeletal muscles through osmosis, which may be enhanced somewhat by the increased membrane permeability of decayed and desiccated zombie flesh. Alternatively, an unknown active transport mechanism associated with the original source of infection might be responsible.

However, the zombie predilection for human brains suggests that this tissue may actually provide a preferred source of calories, and as

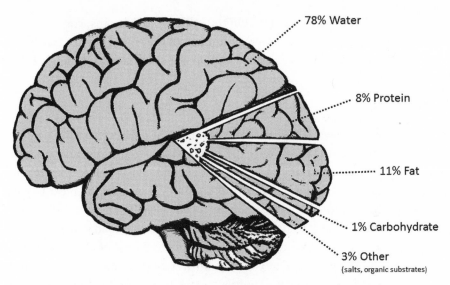

78% Water

8% Protein

11% Fat

1% Carbohydrate

3% Other
(salts, organic substrates)

6.3. Nutritional Breakdown of the Average Adult Human Brain. Total (1838 kcal) = Fat (1350 kcal) + Protein (435 kcal) + Carbohydrates (56 kcal).

demonstrated in figure 6.3, a nutritional analysis of the human brain reveals it to be a surprisingly well-balanced meal for the active zombie.

Consider that the average adult human brain weighs approximately 3.5 pounds and is composed of 78 percent water (which could serve as a solvent for water-soluble nutrients), 11 percent fat, 8 percent protein, 1 percent carbohydrates, and 3 percent insoluble salts and minerals. This combination provides approximately 1,800 kilocalories of chemical energy, equal to the daily caloric requirements of an intact human female. Also of advantage, the gelatinous consistency of brain tissue can be easily masticated by zombies with weakened or missing teeth. The human brain appears to be the perfect sport food for Team Zombie, provided zombies can find an efficient means of extracting it from its

rather stubborn "wrapper." On the other hand, humans would be best advised to avoid this option, as it presents the risk of kuru, a transmissible spongiform encephalopathy that is incurable and ultimately fatal.

Summary

Humans have little chance of prevailing in a direct conflict against a zombie horde that flouts the conventions, traditions, and rules of conventional warfare and possesses attributes that make its members impervious to tactics that would sap the will of even the most battle-hardened human opponent. But by reconceptualizing our conflict with zombies in the context of a sporting event, humans can gain the upper hand by drawing on their evolutionary endowment of physical endurance and stamina, not by running down zombies as prey in a protracted hunt, but by evading and outdistancing Team Zombie in the game of Z-tag. In order to prevail, the members of Team Human must resist the temptation to barricade themselves within the bastions of their towns and cities. To do so will inevitably result in succumbing to both physical and psychological illnesses associated with lengthy entrapment (Cantor and Price), if not directly at the hands of Team Zombie and their brutishly effective S-strategies. Instead, Team Human must abandon the architectural confines of civilization and take to the countryside, reclaiming the hunter-gatherer lifestyle that is a legacy of 99 percent of human history and that the psychologist William Morgan describes as a "return to our biological and sociocultural roots where regular physical activity was a way of life" (376). This option, which in this context is more accurately described as *hunted*-gatherer, should be perceived not as an oppressive existence in which humans are deprived of the fruits of civilization to live in bare-boned subsistence, but rather as a path to liberation that frees humans from the vapid consumerism and

constraining technologies that have contributed to the host of modern ills afflicting so many. In this context, the hunted-gatherer lifestyle achieves what the anthropologist Marshall Sahlins has described as a "Zen road to affluence" (2).

Appendix A: List of Movies Used to Establish Rates of Zombie Ambulation

Title	Date	Speed in Romero Units
Night of the Living Dead	1968	1
Dawn of the Dead	1978	1
Braindead	1992	2
Colin	2008	2
The Crazies	1973	2
Dellamorte Dellamore	1994	2
Day of the Dead	1985	2
Diary of the Dead	2007	2
Fido	2006	2
Re-Animator	1985	2
Shaun of the Dead	2004	2
Shock Waves	1977	2
Survival of the Dead	2009	2
The Walking Dead	2010	2
Zombie Diaries	2006	2
ZMD: Zombies of Mass Destruction	2009	2
[•REC]	2007	3
28 Days Later	2002	3
The Crazies	2010	3
Dawn of the Dead	2004	3
Day of the Dead	2008	3

Dead & Breakfast	2004	3
Død snø	2009	3
I Am Legend	2007	3
Night of the Comet	1984	3
Land of the Dead	2005	3
Planet Terror	2007	3
Pontypool	2009	3
Quarantine	2008	3
Resident Evil	2002	4
Zombie Strippers	2008	3

Notes

The author would like to thank Mildred Perkins for her expert assistance in analyzing zombie pace in the cinema. Michael Hosek of the Indiana University Department of Physics provided valuable insight and corrections in the discussion of the physics of zombie thanatoenergetics.

1. Against zombies that can achieve 3.0^{RU} (equal to a pace of 6:40 minutes per mile) or faster, the vast majority of humankind would have no chance on foot. Using finishing times from the 2012 Boston Marathon—which has qualification standards that are among the most challenging of any marathon—only 1.5 percent of all runners completed the race at a pace exceeding 6:40, and of these, only sixteen female runners out of the nearly nine thousand who completed the race could match or better this pace.

2. Caloric estimates are complicated by the addition of equipment. Carrying a 20 kilogram backpack at a pace of 4.0 mph would increase the energy cost by about 10 percent, but at speeds above 5.0 mph it is more efficient to run than walk (Keren et al.). However, hiking boots incur an energy cost that is more than six times that of a back-pack of equal weight (Legg and Mahanty).

3. Using the standard term of *bioenergetics* to describe zombie metabolism and locomotion would constitute a misnomer.

4. This presents the intriguing opportunity of harvesting the thanatomechani-cal energy from shambling zombies as a pollution-free power plant in the manner of a perpetual motion machine. Consider that the average zombie walking without rest

at a speed of 1.0^{RU} would cover approximately 12.5 miles in the course of twenty-four hours. Based on human energy equivalents for walking, it is calculated that the power produced from one minute of walking on a flat grade based on the human equivalent (50 kilogram body weight) would be approximately .5 W (watts). In the course of twenty-four hours the shambling zombie could produce 1.728 W/hours. Converting the mechanical energy from a single zombie walking to electrical energy by means of a mechanical treadmill operating at an energy conversion efficiency of approximately 90 percent efficiency would yield approximately 1.55 W/hours. As the average U.S. household consumes about 50 kilowatts a day (Department of Energy figures), thirty-two zombie-driven treadmills in constant operation would be required to meet this energy cost. The challenge of providing an appropriate incentive for this activity—a difficult proposition in humans (Dishman)—could easily be resolved by employing a human group-fitness instructor, some form of live "bait" (e.g., a prisoner), or perhaps merely a corpse. More exotic human biomechanical energy-harvesting systems have been proposed that could also increase the yield of zombie power plants, and these include piezoelectric flooring, suspension-loaded backpacks to reclaim energy from the vertical displacement in center of mass, and knee and ankle braces to harvest negative motion from braking movements (Reimer and Shapiro).

5. Oddly, it has been reported that zombies do not smell (Brooks, *Zombie Survival*), despite the cargo of roughly masticated flesh they tote within them and their own decaying carapaces. Otherwise the stench of putrefying flesh could serve as a potent weapon, immobilizing humans by causing nausea, breathlessness, and emotional distress. In fact, the U.S. military has experimented with so-called nonlethal malodorous incapacitates.

7 *Zombie Performance*

ATIA SATTAR

Come and get it! It's a running buffet! All you can eat!

Shaun, *Shaun of the Dead*

The zombie consumes us. It occupies our minds, books, screens, and streets; devours and squanders our flesh and bodies; infects us with disease; and overwhelms our very social order. And yet we chase after zombies. In recent years we have facilitated their rise as a veritable cultural phenomenon, compelling them into our movie-theater screens in greater and faster-moving hordes than ever before, into our homes with shows like *The Walking Dead,* and onto our college campuses with Humans vs. Zombies, a live-action game of survival. Even the Federal Emergency Management Agency (FEMA) and the Centers for Disease Control and Prevention (CDC) have launched a zombie preparedness campaign, encouraging people to equip themselves against a whole range of catastrophes. The zombie apocalypse, it appears, offers itself as a natural disaster par excellence.

But we humans do not simply want to destroy and survive the zombies; we actually want to *be* them. In walks and runs across the country, people regularly adorn themselves in fake blood, gaping wounds, and tattered clothing to perform zombie "undeath" in our very streets. The zombie survival guides in our bookstores now find themselves in the

company of titles such as *So Now You're a Zombie: A Handbook for the Newly Undead* (Austin); *Zombies for Zombies: Advice and Etiquette for the Living Dead* (Murphy); and *How to Speak Zombie: A Guide for the Living* (Mockus and Millard). For every piece of information on how to combat zombies, there is now parallel advice on how to enact zombie existence.

Whether on our screens or our streets, to perform as a zombie today is to perform as an infected, viral, decaying creature and not, as in its earlier manifestations, a product of hypnotic suggestion or radioactive energy. No longer the voodoo zombie of Victor Halperin's *White Zombie* and William Seabrook's *The Magic Island,* or even the radioactively regenerated creatures of George A. Romero's classic *Night of the Living Dead,* the zombie now keeps pace with capitalist society and scientific advancement, emerging from within the postindustrial research laboratory. For Stephanie Boluk and Wylie Lenz, the modern zombie is firmly situated within current scientific contexts: "As a force of evolution that still retains undead characteristics, the viral zombie does not replace the older style of zombie as much as find a way to reconfigure it in the light of emerging scientific discourses that tap into deeply felt post-AIDS, SARS, bird flu, and H1N1 anxieties. The zombie has been rationalized and assigned a pathology" (6). Indeed, the pathologized zombie has evolved along with our technologies and their ensuing anxieties. It mirrors our concern with epidemics, our need for emergency preparedness, and our obsession with organizing against risk.[1]

Yet as it materializes in the vials of sociohistorically situated laboratories, what is it that the imagined zombie virus and its resulting undead physiology allow us to enact? Scholars such as Sarah Juliet Lauro, Sharon Mader, and Bryce Peake explore the contemporary zombie phenomenon largely through the lens of social metaphor, regarding zombie performances on film, TV, or even in our neighborhoods as

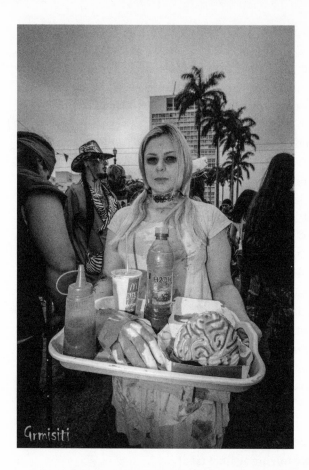

7.1. Gianluca Ramalho
Misiti. *Zombie Walk 2012.*
November 2, 2012.
São Paolo, Brazil, in *Flickr.*
http://www.flickr.com
/photos/grmisiti
/8149596469.

enactments of social revolution. These performance-based analyses so keenly situate the zombie within the frameworks of collective behavior and sociohistorical movements, however, that they overlook the singular, unorganized zombie figure. They are unable to grasp the zombie as a pathologized form of embodiment. The quintessential act of zombie

identity, after all, is human consumption, an act that, I argue, proposes a more visceral framework for understanding zombie enactments. When we cover our faces with cornstarch, liquid latex, and fake blood; rearticulate our bodily movements; and remodulate our voices into guttural moans, we embody an undead aesthetic. We sense ourselves not as metaphors or manifestations of an anxious society, but as bloody, contagious, all-consuming metabolic bodies. We prepare to feast on humans.

Performing Zombie

"What other monsters have such unity as a mass in death?" Such is the answer to the frequently asked question "Why are you dressing like zombies?" on the Toronto Zombie Walk's official website. Monsters. Unity. Mass. Death. The appeal of the zombie walk lies in its ability to bring people, visibly marked by death, together en masse, as a horde, with the explicit intention to terrorize people and pretend to eat them. Nonetheless, this macabre experience of unity belies an array of approaches as zombie actors and theorists seek to situate the act of zombie embodiment within meaningful sociocultural and historical contexts.

First, the external approach. For Bryce Peake, who participated in the Toronto Zombie Walk of October 20, 2008, the main challenge was retaining his consciousness. Even as he undertook the walk as an anthropological exercise,

> two and a half hours of walking, moaning, and staggering create the perfect conditions for trance-like stages. Only few moments, and one extended period . . . created conditions in which I could "check in" with myself—to think about what I felt, was feeling, and what to say about

it. Doing so often hindered my ability to get back in the mode of the Zombie Walk, which was more enjoyable in the brainless movements of zombie-ing. (55)

Peake's external approach, with its emphasis on "the brainless movements of zombie-ing," highlights his conception of the zombie as a figure without cognitive sensibility, without a mind. As such, he could either be aware of himself as a thinking human participating in a street performance of zombiedom, or he could actively participate and "become" zombie. Even as external zombie performance renders one devoid of mind, "brainless," it nonetheless provides access to transcendent mental states or "trance-like stages"; there is somehow, it would appear, an existential ghost in the zombie machine. "The zombie costume," continues Peake, "creates a bodily metaphor that allows for slippage into the unconscious" (57). Visibly occupying the zombie body, with its makeup and attire, facilitates a distinct psychological experience. The particular brand of mind, or affective mindlessness, associated with enacting zombie thus operates at both the individual and collective level. For Joe Giles, famed extra on *The Walking Dead,* the physical manipulation of oneself as zombie produces a like mental effect:

> The makeup only lets a part of myself come out that at any other time people would think I'm insane! I itch all year until I can be in makeup for Halloween or filming. Wearing it really helps you become the character and throws you in the mindset. I'm gonna sound cheesier than hell, but when I'm in the makeup, I really try to become the character. So after me sayin' all that, when I look in the mirror wearing makeup, I see the scariest zombie imaginable! (Joseph, "Interview")

Giles here also posits a binary of exterior and interior in acting as a zombie. Becoming the character operates as a response to the appropriate stimuli, to looking like "the scariest zombie imaginable." For both

Peake and Giles, zombie performance follows "the external approach to characterization,"[2] whereby outside appearance produces zombie (un-) consciousness. For Peake, this psychic state manifests as a descent into the self; whereas for Giles, some part of himself comes to the surface.

In contrast to the external approach, some zombie performers approach their enactment internally. Here the process of characterization is reversed: one first immerses oneself into the inner life of a character and then adds the external components, such as makeup, movement, and costume. The zombie star of George A. Romero's 2005 film *Land of the Dead*, Eugene Clark, describes the psychological work leading to his transformation as "Big Daddy" in the same vein:

> I had to sort of open up places in my heart where I didn't really want to go. Dealing with a lot of atrocities that occur around the world. Dealing with a lot of innocent people suffering. Dealing with heartbreak. Dealing with people dying unexpectedly, children in pain. You know you just go to those places and then personalize it, making it about people you know and making it real. Pretty soon, you find yourself in places where you don't want to go, but I thought the role warranted that. There were nights where I had to just walk; I didn't come down easily from some of those places. (Condit)

Clark's description begins inward, focusing not on how he looked as Big Daddy but instead on how he managed to channel all the hardships of the world into a believable zombie performance. His method accordingly complies with the acclaimed "method" in acting. In *An Actor's Work on a Role,* Konstantin Stanislavski, founder of the system called "method acting," articulated the actor's role in creating characters as follows: "You cannot create or come to know a living spirit through your brain, you do it, first and foremost through feeling" (xxiv). As he prepares himself to become the character Big Daddy, Clark begins with

feeling, opening "up places in [his] heart where [he] didn't really want to go." He then goes about "making it real," infusing his emotion into the material body of the acted zombie. But how can actors possibly come to know an undead, un-living spirit who wants to eat their brains, "first and foremost through feeling"? Indeed, Clark's immersion into zombie life is merely based on imagined conceptions of the zombie, a fictional entity, within the particular context of a Romero film, a context that unflinchingly emphasizes the abject. Clark's particular turn to places within himself "where you don't want to go" is certainly apt for a Romero zombie, an undeniably sympathetic character highlighting human abjection. Sympathy for wretched, miserable zombies offers an opportunity for human self-reflection, captured in the very conclusion of the movie. Once the city has been taken, Riley, the movie's male protagonist (Simon Baker), stops a tank from shooting the remaining zombies left in the city, saying, "They're just looking for a place to go, same as us." In fact, the entire attack on the city begins with a human attack on zombies outside the city walls; the zombies merely retaliate in response. Zombie behavior is thus framed, from the very beginning of the movie, as initiated by us, observed by us, and understood to be "same as us," acting humanly within a human context. We should hardly be surprised, then, that—whether internally or externally approached— the individual zombie is conceived along the same binary framework as humans, separated into distinct categories of external and internal, of body and mind.

Regardless of one's approach to enacting zombie, once gathered in a horde, individual zombie bodies are considered subject to a collective zombie consciousness. Their "unity as a mass in death" is read by scholars as a unity of purpose beyond simply dressing up and roaming the city streets. Peake considers the zombie invasion of our streets as facilitating an alternative, unified subjective state. Even as one is subject

7.2. "Surface of Spectacle," poster for Montreal Zombie Walk (2011). Poster created by Edith Boucher © edithboucher.com.

to trancelike "alternate planes of selfhood," the walk itself is not about individual identity. Rather, these walks manifest as mass events that "allow for a collective affectivity, by linking together participants, the collective conscious, and the imagery of death and dying" (56). The manifestation of blood, guts, and decomposing gray flesh on bodies moving en masse triggers an unindividuated, integrated experience of affect. Sarah Juliet Lauro similarly notes, "In playing dead, in trying to become blank, one becomes aware that some kind of subjectivity is nonetheless alive and well within us, be it the higher consciousness of the swarm identity, or the realization that we are seeing the surface of spectacle exposed as a screen onto which false consciousness is projected" (209). Lauro acknowledges the possibility of zombie walks spurring a collectively conscious "swarm identity." Yet she also recognizes that the "subjectivity" associated with zombie enactments may well be projected attempts to rationalize the street-invading hordes, to situate them within a social context serving a social purpose. Considered in this fashion, the zombie walk offers a morbid, brainless "surface of spectacle," cognized by spectators as they see fit.

Zombie: Revolutionary Consumer

The performed zombie is continually inserted into a system of signification whereby, in coming back to life from the dead, it exemplifies revolution. For Peake, there can be no doubt that "collective affectivity" moves beyond mere zombie affect. The writhing, bloody spectacle of a zombie walk exhibits the "affective solidarity" of a social movement, a mass event challenging social norms (57). "The Zombie Walk re-presents its political movements in the image of death, as a struggle between the fast-moving exterior of capitalism and the cumbersome interior of animate decomposition" (56). Peake thus evaluates the movement of

the zombie horde as a death-dealing political movement, confronting postindustrial capitalism with its slow-moving, yet inevitable, organic decay. Even Lauro acknowledges the potential for uprising in the site-specific appearance of zombie walks—that is, their emergence and continued performance in urban centers. Zombie-walking through city streets thus registers as a "willful rewriting of the everyday [which] may intend to obstruct the functionalism of the modern city and its facilitation of the capitalist grind" (209). A zombie walk's ability to clog and reconfigure pedestrian flow registers as an invasion of the quotidian workings of urban capitalism. As they walk through the city, then, falling to pieces, zombies somehow keep it together to seemingly stage an anticapitalist revolt.

In the capitalist setting the zombie drive to consume living human flesh becomes a metaphor for capitalist consumption. This metaphor owes a significant debt, of course, to George A. Romero's mall-occupying zombies in his 1978 film *Dawn of the Dead*. The film's presentation of zombies appears to have firmly fixed them, for all future consideration, as what A. Loudermilk calls "our *simulacral doubles* as cannibal consumers" (85; italics in original). As our doubles, zombies reveal our ceaseless drive to purchase, consume, and seek satisfaction in material things. They viscerally parody consumption for consumption's sake. What is more, their distorted doubling of human consumption is framed within an imagined apocalyptic narrative, a narrative where society as we know it has ceased to operate. Sharon Mader accordingly asserts, "Because zombies are self-reproducing, consumerism will continue even though the social order that produced it has completely collapsed. So, while the social order is indeed dead, the drives and desires that the consumer society engendered live on" (74). Not only do zombies continue to consume after the structures of consumer capitalist society collapse, but they are also able to create more consumers through self reproduction.

Any living being they bite becomes a zombie, replicating this desire for consumption.

The zombie revolution against capitalist society functions by pathologically replicating consumers. It collapses the system by taking too far the very structures of consumerism upon which capitalism relies. But what is to come after the revolution? "As it stands at the end of history, the zombie is simultaneously a vision of capitalism's fulfillment in the form of a stasis of perpetual desire, as well as a model of proletarian revolution, depicting the emergence of a new classless society," write Boluk and Lenz (7). Providing a contemporary model for a good old-fashioned Marxist revolution, the zombie apocalypse expresses the idealized possibility of wiping the slate clean and starting afresh with a "classless society." Ironically, such a society would be devoid not only of class but also of humans. Are we to be surprised, then, that despite both the zombie walk's projected penchant for revolution and its many manifestations across the country in recent years, revolution has not yet come to pass? Moreover, even in its cinematic representations, there is little or no reprieve for human survivors of the zombie revolution/apocalypse and, as such, no real possibility for a new kind of society. We see this lack of a human future in, for instance, Zack Snyder's 2004 film *Dawn of the Dead* or Juan Carlos Fresnadillo's 2007 film *28 Weeks Later*. Lauro perhaps captures this absence most succinctly: "The zombie mob's contribution is not that it models progress by looking to the future, but only that it reads our present moment's relationship to revolution as one that, like the zombie, is out of step with time" (22). Ultimately, what the zombie helps us realize is not the promise of proletarian revolution in a Western, postindustrial, capitalist society, but rather that revolution is as far beyond our reach as it is for any enacted zombie.

In this the zombie appears to be more of a symbolic revolutionary. The zombie offers its symbolic potential to any desired revolution. As

such, it operates, according to Phillip Mahoney, "as an 'empty signifier,' capable of calling into existence an active, global front dividing those who respond to the call—in 'whatever' fashion—and those who do not" (126). Zombie walkers, in our cities and films, do not, then, perform a revolution; if anything, they perform what a revolution looks like. The shuffling, blood-soaked zombie on our streets and screens takes the shape of any social critique we want to see. "It would seem that it is the very indeterminacy surrounding this phenomenon which allows it to take on a number of political significations," argues Mahoney, "The zombie multitude, finally, is itself peculiarly 'animated' by a purely linguistic call to the celebration of the empty form of sociality itself" (125–26). While in practice the zombie phenomenon accomplishes nothing more than sociality, "unity as a mass" for its own sake, it is nonetheless "animated" linguistically by varied political symbolism. "Sooner or later," however, writes Lars Larsen, "the opacity of our fascination with the zombie exhausts sociological attempts at reading of it. There is ultimately no way to rationalize the skepticism the zombie drags in." Indeed, our attempts at "reading"—that is, at giving meaningful sociological significance to the zombie, a figure shrouded from its very inception in indeterminacy (neither asleep nor awake, neither dead nor alive)—can lead us no closer to truth. Our rationalizations, much like the zombie itself, merely self-reproduce with the hope of catching their undead prey and pinning it down.

But what if there were no mindful symbolism within which to entrench the enacted zombie horde? That is to say, what if we unhinged zombie consumption from postindustrial, capitalist consumerism? The enacted zombie would neither signify an attempt to try to "become blank" in one's dually understood human self, nor would it, in so doing, encourage postindustrial society to "become blank" and start over. Moreover, it might finally be free from the limited logic of signification

and expression tied to mind/body dualism, to internal and external approaches in performance. Only then can we shift the framework away from asking what the zombie *means*—collectively, socioculturally—to finally ask what it is the individual zombie body *does*. And what the zombie does, like us, is eat.

The Metabolic Zombie

The foundation narrative for the Toronto Zombie Walk captures the metabolic necessities of zombie existence: "The zombie walk started one gloomy Sunday, a week before hallows eve in 2003. A handful of the living dead rose from their graves to wander the streets of Toronto in search of brains" (Toronto Zombie Walk). The driving force for the zombie walk, its designated quest, is the pursuit of human brains. And this drive for food, it would appear, defies death. The primary purpose of the enacted zombie is to eat, even as it unwittingly offers its physical surface as an empty signifier to those who are focused on sociocultural critique. The first rule of the zombie walk likewise articulates this principal focus for its participants: "Respect other people's property. Eat brains, but leave no marks behind" (Toronto Zombie Walk).

The emphasis on visceral human consumption in zombie culture narratives brings to light the ontological exigencies of zombie existence as they are presently conceived. Following these exigencies, zombie performance, at its phenomenological core, does not fit the framework of a traditional, knowledge-focused mind/body divide. The zombie is performed neither as a visible object body to be observed and known nor as an intra-sensing subject seeking to know itself. Rather, one enacts zombie for and through the simultaneous embodied processes of ingestion, digestion, and infection. The zombie is a metabolic entity.

Recognizing the need to understand realities of bodies beyond their configuration as objects and subjects, Annemarie Mol and John Law offer metabolism as an alternative analytical framework. In their essay "Embodied Action, Enacted Bodies. The Example of Hypoglycemia," they refer to ailing, medicalized bodies and, in particular, the hypoglycemic body, to illustrate the body enacted metabolically: "We all *have* and *are* a body. But there is a way out of this dichotomous twosome. As part of our daily practices, *we also do (our) bodies.* In practice we enact them. If the body we *have* is the one known by pathologists after our death, while the body we *are* is the one we know ourselves by being self-aware, then what about the body we *do*?" (54; italics in original). In contrast to the object-body we *have* and the subject-body we *are,* the body we *do* is metabolic: "Metabolism . . . is about eating, drinking and breathing; about defecating, urinating and sweating. For a metabolic body incorporation and excorporation are essential" (54). Signifying all the life-sustaining chemical processes within an organism, metabolism encompasses the bodily mechanisms that one unflinchingly *does:* ingestion, digestion, assimilation, and excretion.

The reality of the zombie is correspondingly metabolic. It represents the body one *does,* not a body that one *has* or *is.* As a zombie, one incorporates and excorporates, consumes and discharges, ingests and infects. In the metabolic system relevant to enacting a zombie, many things are linked together: survival with food (zombies do starve); food with the consumption of living humans; and the actions of consumption—in particular, biting—with the excorporation of infection. Furthermore, metabolism, for zombie and human alike, is hardly a volitional act; it is a bodily doing that is essential for continued existence: "One does not hang together as a matter of course: keeping oneself together is something the embodied person needs to *do.* The person who fails to do so

dies" (Mol and Law). Desensitized, dead, and decaying, the zombie does not hang together as a matter of course. Without human flesh it is also in danger of starvation. Even as the zombie hangs together, the boundaries of its body are literally leaky. But parading as it often does with missing appendages or protruding organs, it can exist without being physically and vitally whole; its hanging together metabolically does not require a hanging together physiologically.

The word *metabolism* derives from the Greek "*metabole*," meaning change. Metabole is itself a compound of two words: *meta-*, which means "after," "beyond," "about," or "over"; and *bollein*, which means, "to throw." Defined as the chemical processes that occur within the organism in order to maintain its existence, metabolism refers to the "continual 'overthrow' of fixed relations in a body's interaction with its environment." As a result, the body subject to metabolism is one where "inside and outside are not so stable" (Mol and Law 54). Hannah Landecker accordingly asserts, "Rather than a chemical factory for the conversion of substrates, metabolism is a regulatory interface shaped by the environment" (167). As an "interface," metabolism entails a joint operation between the body and its environment.

This metabolic conception of bodies offers an embodied phenomenology for understanding performance beyond the mind/body split. The zombie performer, metabolically understood, exists outside the traditionally institutionalized mind/body divide in the *theatron* of performance where the performer is active but blind to her narrative situation, and the spectator is inactive but able to see. We no longer simply have before us the fully formed acting body infused by the revelations of a holy actor awaiting observation. As such, we can shift our emphasis away from viewers deciphering existential, social, and communal narratives into the seemingly stable zombie body, a position exemplified in Simon Baker's concluding statement in *Land of the Dead:* "They're

just looking for a place to go. Same as us." We can inquire instead into the constant change and overthrow, the instabilities and possibilities of *doing* zombie in relation to its environment. Such a phenomenology grounds the enacted zombie body in the world it occupies (or is intended to occupy) and recognizes the performer and environment as system.

The systemic interaction between environment and body is, as Landecker notes, "regulatory." Metabolism governs and organizes one's immediate relationship with one's environment and, in particular, with the food that one ingests. It determines the substances an organism will find nutritious or poisonous. Consumption of the wrong substance can threaten to shut down the entire interface. Metabolism thus determines our biological relationship with food; it configures our perceptions of food and its consumption. Landecker here traces a history of metabolism from the nineteenth century to the present, illustrating how changing conceptions of the metabolic process in science have influenced how we come to understand food as a society. The metabolic relationship between man and nature in the mid-nineteenth century considered food as "a source of building materials for the body" and centered on the change of state undertaken by food once it was consumed and assimilated into the physiological body (172). By the end of the century, the focus in metabolism had shifted from the conversion of chemical substances, such as fats, proteins, and carbohydrates, to energy input and output, whereby food served as fuel for the biological motor.

The second half of the twentieth century saw yet another reconfiguration of metabolism, one that emphasizes the intermediary enzyme-catalyzed chemical reactions within living bodies. Such a configuration places emphasis not on the food that we consume but rather on the enzymes present within individuals and their ability to catalyze the molecular components of particular foods. Consequently, the "new metabolism" identifies individual insulin resistance, blood pressure, or

sugar and lipid imbalance at the core of the metabolic process. In this perspective, food operates as "more than fuel or substrate, in fact it becomes understood as a form of environmental exposure" (Landecker 167). Ingesting the food in one's environment makes one unflinchingly vulnerable to its molecular components, and one must regulate practices of consumption. It is significant to note here, however, that the scientific derivation of metabolism as an intermediary enzymatic process necessitating bodily and societal regulation is itself socioculturally and historically situated. Landecker asserts:

> The industrialization and conversions of matter of the nineteenth century have produced a completely altered landscape of fuel, substrate and the body over the last 150 years: large-scale agriculture, refined sugars and oils, calorie-rich and micronutrient-poor highly processed preserved foods, mechanization of manual labor and transport, and pesticides and consumer goods leaching potential "obesogenic" endocrine disruptors. Thus, we may see metabolism today as "post-industrial" in the doubled sense that it comes after industrialization, and, because of what industrialization has done to the body, the biomedical study of metabolism is increasingly more concerned with regulation than manufacture. (173)

Metabolism today is a result of how industrialization has altered the relationship between man and nature, particularly how it has changed the production of food and the bodies that consume it. Confronted with the impact of mass-produced "calorie-rich and micronutrient-poor highly processed preserved foods," social and cultural attention now focuses on the research and development of functional foods and nutritive supplements as a means to regulate health. Postindustrial metabolism is a "metabolism for the human condition in a technical society, where the

food is manufactured and designed at the molecular level, the air and the water are full of the by-products of human endeavor and manufactured environments beget different physiologies" (Landecker 190). But now that metabolism is conceived at the individual level, it does not, paradoxically, long allow for a diversity of metabolic experience. While each of us may bear our idiosyncratic set of metabolic imbalances and errors, our distinct physiologies, with the right supplements, enzymes, and manufactured diet we can all be technologically reformulated to eradicate individual difference. What is more, we can all be "healthy."[3] One is thus presented with a society obsessed with health, however nebulously defined, and "metabolism becomes a primary site for the social reshaping of the body and the hope for therapeutic intervention" (190). With its emphasis on regulation, metabolism no longer simply constitutes the chemical processes that sustain life, where food serves as building block or fuel; rather, it maps imbalances and then facilitates the technological return of society to a predetermined state of health.

Landecker's "new metabolism" coincides with the emergence of the fast-moving, food-driven, contagion-based zombie. The zombie experience is no longer a result of voodoo, suggestion, or radiation, but one born out of the postindustrial laboratory in the form of a virus, as seen in *28 Days Later, Resident Evil,* or *The Walking Dead,* to name just a few examples. In each of these instances, zombie physiology is a by-product of human endeavor and its manufactured environments. The resulting metabolic experience is marked by the need to feed. But this need to feed has little to do with health. Feeding is inextricably associated with infection and, therefore, with the zombie's ability to reproduce itself. The incorporation of living blood, skin, and flesh is simultaneously the excorporation of infectious auto-reproductive zombie cells. As such, a zombie bite leads to the reproduction of its metabolic conditions within

another. This "social reshaping of the body" offered through metabolism also effaces previous human imbalances, resistances, and "inborn errors" of metabolism (173).[4] It bestows on everyone a body all zombies *do*, unlike humans: unindividuated, relentless, leaky cogs in an undead ecological system. Zombie metabolism is also "a metabolism for the human condition in a technical society," produced in the postindustrial laboratory along with genetically modified and functional foods (190).

The Zombie Food Economy

The zombie food chain, popularly printed on T-shirts and mugs, offers a straightforward, no-nonsense map of the relationships between zombies and their larger biological community. This food chain consists of a linear sequence of trophic species, moving from plants that eat no other species, through animals, humans, and finally to zombies. Zombies displace humans at the top of the traditional food chain as the trophic species that consumes others, but at the same time it is not itself consumable by any other species in the chain. It presents the epitome of the consumer organism.

The mechanisms by which zombies are able to consume humans function along a series of networks that supplant the modern food economy. Jean D. Kinsey defines today's food economy as "the entire food chain from the laboratories that slice, dice and splice genes in everything from our crop seeds, pharmaceuticals, and animals, to the cream cheese we spread on our bagels" (1113). Referring here to the food system's supply and demand chain, Kinsey highlights the complex set of interactions composing the food economy, including the agricultural industry, farm production, scientific laboratories, ingredient and flavor companies, food manufacturers, retail stores, wholesalers, food

service establishments, the transportation and distribution systems in between, and, finally, consumers. In the zombie food system the mechanisms of human food production have ceased to function. Instead, the emphasis is placed on all the components that prepare, distribute, and dispose of humans as food.

Since zombies neither produce nor supply humans, the zombie food economy operates solely along a chain of demand. As Mader notes, "Consumption is detached from any productive sector of the economy; it seems to exist independently, to have, as it were, a life of its own" (72). When zombies require brains, they must seek out and acquire them. The sight of a living, breathing human offers any zombie a site for consumption, individually or communally, as well as a site for disposing of the resulting carcass. While slow zombies are most effective when attacking en masse, fast zombies rely on their individual speed and tenacity at acquiring human food. In either case, the zombie walk, shuffle, or run operates as the transportation and distribution system in the zombie food economy. For those seeking to partake in this economy, to enact zombie, learning how to walk as a zombie is inseparable from embodying zombie metabolism in relation to a specific ecology.

At the same time as it offers entry into the zombie food economy, zombie walking functions as "a mode of ecological practice" (Chamberlain et al. 8). It provides a particular way of being mobile and accordingly engaging with one's environment and ecosystem. As such, it offers a strikingly visceral example of how theater and performance, according to Franc Chamberlain, Carl Lavery, and Ralph Yarrow, "operate according to their own 'ecologics,' do their own environmental thinking" (8). The environmental thinking particular to zombies stems from the metabolic need to incorporate and excorporate, to ingest and infect. For the "zombie choreographer" of *The Walking Dead*, Matt Kent, learning

to perform this undead metabolic overthrow requires that actors "stay away from a kind of choreographed vocabulary that [zombies] have." He consequently aims to "really just give them [the actors] a vibe for what zombies do, and how they feel, how fast they move" ("Zombie School"). Performing zombie is more than enacting predetermined movements in sequence. In getting "a vibe for what zombies do," a sense of their bodily maneuvers, performers embody a form of ecological practice, including "a set of performance moves [which] aims to amend and/or extend daily functioning, to shift the mode of knowing and in so doing to emphasise criteria of flow, agency, response and availability, spontaneous form-ing" (Chamberlain et al. 14). Seeking to extend actors' "daily function-ing," "to shift the mode" of their bodily knowing, Kent does not offer a demonstration of a zombie walk to imitate. Rather, actors are asked, from the very outset, to deliver their own embodied walk as zombie. The zombie walk thus manifests itself as a particular ecology of performance whereby actors amend and engage their existing metabolic bodies into a new mode of environmental thinking.

But even as zombie actors and extras shuffle their way into the zom-bie food economy, their ecological existence is doomed from the outset. Zombie survival, after all, relies on a finite supply of humans. It follows that the zombie food economy, divested of systems of food production, is consistently faced with the threat of a food shortage. As Michael New-bury notes, the imagined zombie apocalypse facilitates a very particular and contemporary vision of an industrial food apocalypse. In his essay "Fast Zombie/Slow Zombie: Food Writing, Horror Movies, and the Agribusiness Apocalypse," Newbury assesses zombie films as "apoca-lyptic imaginings of agribusiness, food, and food supply chains" (90). In lieu of noting the landscapes of half-eaten corpses, run-down buildings, and abandoned cars that are ever present in these films, Newbury draws attention to the "fast-and-junk-food-laden images of Armageddon" (89).

In so doing, he parallels the very structure of fast-food production and consumption with the creation and performance of zombiedom.

> If, to the chagrin of food-apocalypse writers, "slow" food has increasingly become "fast," then the slow zombie has also been accelerated and intensified as the embodiment of a consumer signified by blindly focused, violent, and apocalyptic eating habits. On the one hand, the "infected" or "fast" zombies might be seen as locavores surviving on the landscape around them, but they have, unfortunately and paradoxically, turned eating local into the quintessential act of fast-food consumption. (104)

Newbury's reading of a simultaneous zombie and agribusiness apocalypse brings into conversation zombie films and apocalyptic food writing by the likes of Marion Nestle, Thomas Pawlick, Michael Pollan, and Eric Schlosser. Lamenting the turn toward mass-produced and highly processed fast food, these authors idealize and hope for a return to a pastoral, local food economy, a reimagined and more intimate relation between man and nature. The embodied performance of the slow food movement—that is, its practices of taking food from farm to table—accordingly offers "a new mode of ecological thinking" aimed at restructuring and revolutionizing agricultural and social practices pertaining to food and health. The revolution offered by a zombie apocalypse, as discussed above, is hardly so encouraging. Just as the zombie fails at the successful performance of an anticapitalist revolution, so too does it confound the promise of a local food economy. The zombie does perform a version of local eating in that it consumes only whoever is found (and perhaps even grew up) within its local ecosystem. But the intimacy thus attained is far from ideal. The ravenous chasing and gorging of humans by zombies promises only infection and, as such, a further eradication of human connection altogether.

Where the genre of apocalyptic food writing calls for a return to slow food and the pastoral, bearing "the dream and hope of a reintegration in which food will again become the basis of intimate connection to the natural and the local," the zombie film "extinguishes with brutal enthusiasm all aspirations to retrieving the pastoral, the natural, or alternatives to the industrial food chain" (Newbury 97). First and foremost, human protagonists in zombie films have little or no access to food that is unprocessed or locally produced, surviving as they do on high-sugar sodas and corn syrup–laden snack foods. Second, as humans are in turn devoured by zombies and eliminated from the ecosystem, there will ultimately be no one left to restore and reshape a noncapitalist food economy. Even the zombies die out in this scenario. The seeming revolt against agribusiness and its ensuing return to the pastoral operates more realistically on the level of a Malthusian catastrophe.

Based on the work of the British political economist Thomas Malthus (1766–1834), a "Malthusian catastrophe" refers to a cataclysmic event set to take place when population growth outpaces agricultural production. This worst-case economic scenario consists of a shortage of food and other basic necessities, leading to starvation, crime, and, ultimately, the destruction of the human race. In his 1806 *Essay on the Principle of Population,* Malthus warned of the dangers of unchecked population growth as follows:

> The power of population is so superior to the power of the earth to produce subsistence for man, that premature death must in some shape or other visit the human race. The vices of mankind are active and able ministers of depopulation. . . . But should they fail in this war of extermination, sickly seasons, epidemics, pestilence, and plague advance in terrific array, and sweep off their thousands and tens of thousands. Should success be still incomplete, gigantic inevitable famine stalks in

the rear, and with one mighty blow levels the population with the food of the world. (72–73)

Malthus's belief that the world population would grow exponentially in comparison to the production of food has long been discredited because of its assumption that resources were unchanging and its lack of consideration for human innovation and resourcefulness. Food production continues to outpace population growth, despite disparities in economic wealth and access to food by all populations. As Edmondo Flores insightfully declares, Malthusian theory failed because "Malthus formulated his population law as if land were a fixed constant and mankind an aggregation of zombies" (894).

The shadow of Malthus, however, still hovers over our world. Neo-Malthusians such as Paul Ehrlich have continued to consider the crisis eminent on account of a shortage of not only food, but also resources such as oil, land, and water. More recently, Jared Diamond, professor of geography at the University of California, proclaimed similar sentiments in a 2008 *New York Times* op-ed piece titled "What's Your Consumption Factor?": "Several decades ago, many people considered rising population to be the main challenge facing humanity. Now we realize that it matters only insofar as people consume and produce. . . . If most of the world's 6.5 billion people were in cold storage and not metabolizing or consuming, they would create no resource problem." It is not population increase itself that threatens our existence and dooms the planet, but our metabolic drive to consume, albeit some more gluttonously than others. Like other famous neo-Malthusians before him, Diamond offers sustainability and changes in environmental policy as a means to prevent the destruction of our planet's natural resources.[5] As neo-Malthusian philosophies now posit the lack of sustainability in agriculture and consumption as the driving force behind our inevitable

extinction, the zombies performed in films and on our streets follow the logic of such unsustainable, metabolic consumption.

Shutting down farming, agribusiness, and food production, the zombie apocalypse forces humans to scavenge for survival and fight one another for limited resources. But even zombies are subject to the Malthusian catastrophe. With every act of consumption, the zombie reproduces its metabolic condition, its hunger, within another—too often within a matter of minutes. In addition to parodying our metabolic excesses, then, zombies also perform the logical though perverse extension of the loss of biodiversity that imperils our ecological systems. Inevitably, the zombie population surpasses human reproduction, and once there are no more humans left to consume, zombies experience a crisis of their own and are faced with extinction. It is not an overpopulation of humans but rather the overpopulation of zombies that will finally render Malthus's population law true. The zombie food economy is an economy bent on extinction, not only of the living but also of the living dead. Zombie actors are eating themselves into oblivion.

Conclusion: The Promise of Infection

On Saturday, May 26, 2012, Ronald Poppo, a homeless man in Miami, was brutally attacked when thirty-one-year-old Rudy Eugene approached him under the MacArthur Causeway and started to eat his face. Describing the event to the police later, Poppo said, "He attacked me. He just ripped me to ribbons. He chewed up my face. He plucked out my eyes. Basically, that's all there is to say about it" (qtd. in Robles). A few days later, on Wednesday, May 30, Alexander Kinyua, a twenty-one-year-old student at Baltimore's Morgan State University, was arrested for murdering his roommate and eating his heart and brains.

These instances of violent cannibalism were immediately portrayed in the media as "zombie attacks," creating such a frenzy that, as the *Huffington Post* reports, "'zombie apocalypse' [was] Google's third most popular search term by Friday morning" (A. Campbell). And on the very same day, Friday, June 1, David Daigle, agency spokesman for the CDC, sent an email to the *Huffington Post* denying the arrival of the zombie apocalypse, perhaps regretting the hype created over its own zombie-preparedness stunt. The email stated, "CDC does not know of a virus or condition that would reanimate the dead (or one that would present zombie-like symptoms)" (qtd. in Campbell). The all-consuming, infectious zombie could not, scientifically speaking, exist.

These so-called "zombie" incidents, and others that followed,[6] nonetheless brought attention to the ammunitions manufacturing company Hornady, which had launched a line of certified zombie ammunition in October 2011. Hornady's Zombie Max bullets, devised to "make dead permanent" ("Z-Max"), gained considerable demand in early June after the attacks and quickly became the company's "most successful products" (Huber).[7] Hornady spokesman Everett Deger explained the logic behind this product to WWJ News Radio in Detroit as follows: "We decided just to have some fun with a marketing plan that would allow us to create some ammunition designed for that . . . fictional world" (qtd. in Huber). Yet success in selling Z-Max ammunition was possible only when the zombie figure transcended the "fictional world" for which its bullets were designed, violating its assigned cultural narratives.

The gruesome events of summer 2012, while far from an actual zombie apocalypse, illustrate the easy slippage from the cultural imaginary of flesh-consuming zombies to very real incidents of cannibalism. The attackers that we, as a society, identified as zombies, were not wearing any costumes, did not have on elaborate makeup, nor were

they responding or acting within the context of a larger collective affectivity. They were hardly performing a revolution. Still we saw them as zombies, even as they were stripped of their social symbolism and, in some cases, their clothing, left with nothing but their appetite for living flesh. Divested of all other signification, the zombie remains marked by its metabolic drive for consumption. At the same time, however, the absence of a rationalizing and revolutionary cultural narrative renders the newsworthy cannibal zombie endlessly terrifying. So horrifying, in fact, that even the CDC felt compelled, as the authoritative voice on infectious disease, to disavow all possibility of a zombie apocalypse.

At the moment that the zombie walks onto our streets not as a performed figure but as an actuality, not as an object or subject eliciting revolutionary fervor but as a metabolic devourer of flesh, we are confronted with our own potential for self-annihilation. Without predetermined revolutionary narratives breathed into an enacted zombie corpus, we are left with gluttonous, nonregulated metabolic needs and their by-products: chewed-up faces and plucked-out eyes. We are left with our unsustainable consumptive practices and, as such, with a neo-Malthusian catastrophe. What is more, were this phenomenon actually caused by a virus, we would be forced to face the unnatural productions of our postindustrial laboratories and our endlessly flailing endeavors to manage risk. The promise of zombie infection, then, lies in its remaining a fictional enactment, firmly fixed within the cultural imaginary. It can be allowed to function in society merely as an empty signifier, as a repeated performance that remains just that, a performance. Only in its imagined spaces, on movie screens or well-policed streets, can the zombie rise en masse and undifferentiated. And it is only here that one can embody zombie metabolism—that is, consume without having to face one's biological condition of consumption.

Notes

1. See Beck, *Risk Society.*
2. R. Cameron, *Acting Skills for Life,* 247.
3. See, for instance, J. Metzl and Anna Kirkland, *Against Health.*
4. Landecker notes, "understanding of metabolism as a laboratory whose working is basically the same for everyone, except those whose laboratory contains a broken instrument—an 'inborn error'" (173).
5. See, for instance, Diamond, *Collapse;* Donnella Meadows et al., *Limits to Growth;* and James Gustave Speth, *Bridge at the End of the World.*
6. See, for instance, Smith and Lush, "Zombie Apocalypse," and McCarthy, "Zombie Attack!"
7. Zahra Huber, "Zombie Bullets in High Demand."

8 *Zombie Race*

EDWARD P. COMENTALE

Profit, Profit, nigga I got it
Everybody know I'm a motherfucking monster
I'm-a need to see your fucking hands at the concert
I'm-a need to see your fucking hands

Kanye West, "Monster"

It begins with a thump, or rather, a scrape and a thump. *Shhh-thump.* The monster appears first as sound and then rhythm, or, rather, counter-rhythm. Its presence is made known, paradoxically, by its double absence, one physical and the other temporal.

It lags, behind itself, drags itself, before itself, somewhere in back of you, in front of you, over your shoulder—always where it is not. *Shhh-thump.* Its second beat is scarier than the first, not just because it is louder, closer, but because it recalls the first. The monster is always in two—two spaces, two times. It approaches as it recedes. It coheres as it falls apart. Each step revives as it destroys. Each step is the death of death, the death of death, over and over again.

Shhh-thump. Shhh-thump. It returns, not like a ghost, referring back each night to the same secret crime, but like a siren, always again itself, not itself, in a process of becoming itself. The footprint, the bloodstain, the heavy breathing—as Jeffrey Cohen notes, the monster is always also

a de-monstration, both a sign and the process of its own signification, a sign of its own passing, a sign of its own lumbering movement in time (ix). In its repetition, its re-presentation, the zombie performs the living death of language, of representation, and thus opens up the time and space of terror, of encounter. It is not so much an "other," an essence, or even an expression of such essence, but an indication, a dark index, of what is already happening or about to happen.

Shhh-thump. Shhh-thump. Shhh-thump. In time, this foot—always metrical and yet always uneven—becomes a groove. The terror of its empty beat, everywhere and nowhere, implies something like pleasure as well as protest. Agent Mulder had it right; the zombie only wants to dance.

MULDER: You know, Scully, I was just thinking about Lazarus, Ed Wood, and those tofurkey-eating zombies. How come when people come back from the dead they always want to hurt the living?

SCULLY: Well, that's because people can't really come back from the dead, Mulder. I mean, ghosts and zombies are just projections of our own repressed cannibalistic and sexual fears and desires. They are who we fear that we are at heart— just mindless automatons who can only kill and eat.

MULDER: Party pooper. Well, I got a new theory. I say that when zombies try to eat people, that's just the first stage. You see, they've just come back from being dead so they're going to do all the things they miss from when they were alive. So, first, they're going to eat, then they're going to drink, then they're going to dance and make love.

SCULLY: Oh, I see. So it's just that we never get to stay with them long enough to see the gentler side of the undead.

MULDER: Exactly.

(*X-Files*, "Hollywood A.D.")

The best zombie flicks, like the best of funk and hip-hop, work through the rhythms and counter-rhythms of this foregone conclusion: the delay and drag of inevitable assault; convergent and divergent lines of hands-in-the-air flight; the chase too soon, too slow, toward and away from some impossible event. The best moments of these films exist, spasmodically, between two beats, two deaths, as a dark dance out of which emerges something like an alternative art and a possible politics. They present the zombie not as an expression of something else, as a screen for personal trauma or historical crisis, but as a rhythmic field of intensities, and thereby as it raises a different set of demands: disincorporation, decentralization, and dissemination. In a word, the rhythm of the zombie is the rhythm of *diaspora*—the spread, the sporing, of zombie culture as cultural politics.

In talking race and zombies we begin with the deathliness dispersed everywhere through slavery and colonial power. If the figure of the zombie emerges from the slave trade of Africa and stalks the West bearing traces of this trauma, its threat lies precisely in its forced abandonment of humanist ethics and expression.[1] Take, for instance, Jean-Paul Sartre's famous introduction to Frantz Fanon's *Wretched of the Earth*. Here, in an explicitly Marxist reading, Sartre casts colonization as a violent system of exploitation that results in the production of "monstrosities." The humanist claims of the colonizers, he argues, serve only to justify the inhuman reduction of the colonized, an objectification of the other as slave. For Sartre, though, as for Fanon, this very deathliness, this inexpressive thingliness, becomes the precondition for revolutionary violence:

> Europeans, open this book, look inside it. After taking a short walk in the night you will see strangers gathered around a fire, get closer and listen. They are discussing the fate reserved for your trading posts and for

the mercenaries defending them. They might see you, but they will go on talking among themselves without even lowering their voices. Their indifference strikes home: their fathers, creatures living in the shadows, *your* creatures, were dead souls; you afforded them light, you were their sole interlocutor, you did not take the trouble to answer the zombies. The sons ignore you. The fire that warms and enlightens them is not yours. You, standing at a respectful distance, you now feel eclipsed, nocturnal, and numbed. It's your turn now. In the darkness that will dawn into another day, you have turned into the zombie. (xlviii; italics in original)

In this scenario the very thingliness of the ex-natives grants them both a new objective vision and a steely commitment to necessary violence. In fact, for Sartre, only the violence wielded by the colonized, in its radical indifference and inhumanity, can restore anything like their lost humanity. At the moment of attack, the death of his own death, the victim of colonization—"this walking dead man"—is renewed as a subject, while the colonizer is in turn reduced to an object (lvii). We cannot help "seeing in this trial by strength," Sartre writes, "a perfectly inhuman method used by subhumans to claim for themselves a charter for humanity. . . . The colonized are cured of colonial neurosis by driving the colonist out by force. Once their rage explodes, they recover their lost coherence, they experience self-knowledge through reconstruction of themselves" (lv). This revolt occurs on the other side of humanism and expression, waged through death as the sheer objectification of colonizer *and* colonized, situating both within a single horizon of monstrous form and force.

And yet there's another story to be told here, or less a story than another kind of negotiation, one that, by emphasizing the undeadness of form itself, looks beyond any specific instance of revolutionary violence and, in its emphasis on displacement and diaspora, bypasses the

utterly Western and potentially fatal logic of subject and object. In this we take our cue from Edouard Glissant's later description of the Caribbean as a "dead-end situation," ensnared "in nothingness." For Glissant, the average Martinican is a "happy zombi," simply "passing through his world." His life is governed by "remote control," possessed, mindlessly, by foreign languages, foreign economies, and foreign ideologies (57). For Glissant, as for all the writers and singers and dancers discussed in this essay, "deadness," the deadness of form as it slips past the expressive sovereignty of self and nation, informs a negotiation that cannot be reduced to binary systems of relation. In Glissant's work Martinique is less a unified region or culture than the site of manic repetition and radical derision. Caught between the inaccessible motherland of Africa and the impossible dreamland of France, the region knows nothing but empty forms, a constant shuddering into and out of competing ideologies. Here, "double consciousness" appears as endless "diversion," the ceaseless shuffling into and away from foreignness, a kind of empty possession that is also always a form of dispossession, the infection of and by other cultures and discourses. In turn, Glissant's own discourse abandons expressions and clarifications for repetitions and mutations, for densities, distortions, and obscurities. "Banging away incessantly at the main idea," he writes, "will perhaps lead to exposing the space they occupy in us. Repetition of these ideas does not clarify their expression; on the contrary, it perhaps leads to obscurity," and, thus, perhaps, "the recognized inscrutability of the other" (4). Similarly, the zombie, as a figure of colonization and its reversal, seeks nothing of expression or metaphor; rather, in the dark movement of its body, its voice, and in the rhythms and repetitions of its presence, it exposes a different kind of modernity and a different kind of politics. Simply put, when it comes to the postcolonial zombie, we're dealing less with monster as other than with monster as form of becoming, less with trauma and violence,

and even less with expressions of such, than with performances, with issues of voice and vocal possession, of media and mediation—again, disincorporation, decentralization, and dissemination.

This seems to be the strangely threatening subtext of the first sensationalist blast of ethnographic writings that emerged from Haiti during the U.S. occupation between 1915 and 1934. Take, for example, W. B. Seabrook's 1929 Haitian travelogue, *The Magic Island,* the book most often credited with introducing the figure of the zombie to Western audiences. In his chapter on zombies, "Dead Men Working in the Cane Fields," Seabrook strains to uphold the representational boundaries between the Western world and its primitive other, but he constantly comes up against the unsettling hybridity that marks Haitian race, class, religion, and science. Here the skeptical ethnographer, seeking to unearth the dark origins of the zombie legend, turns first to a Haitian farmer, Polynice, a man whose doubleness—"half peasant born and bred"—bespeaks the doubleness of the island as a whole (92). With Polynice as his guide, Seabrook's fantasies of Haitian otherness slowly begin to crumble. At one point he witnesses a woman murmur a prayer to Papa Legba and then cross herself before an image of Christ. He marvels, in turn, at a procession of "little black boys in white lace robes, little black girls in starched white dresses, with shoes and stockings, from a parish school, with coloured ribbons in their kinky hair" (97–98). As Seabrook notes, this cross-cultural contamination swings both ways, an apparent by-product of colonial history. Western culture and civilization might find itself perverted by the heart of darkness here, but such darkness proves already tainted by Western enlightenment. In what is perhaps his story's most ghastly moment, Seabrook learns that most of the island's zombies are associated with Hasco, an American corporation. "Hasco is perhaps the last name anybody would think of connecting with either sorcery or superstition," he explains. "The word

is American-commercial-synthetic, like Nabisco, Delco, Socony. It stands for the Haitian-American Sugar Company—an immense factory plant, dominated by a huge chimney, with clanging machinery, steam whistles, freight cars. It is like a chunk of Hoboken. . . . It is modern big business, and it sounds it, looks it, smells it" (95).

Civilization and primitivism, modernity and myth, technology and ritual—as Seabrook probes deeper and deeper into the Haitian heart of darkness, he slowly realizes that none of his cherished categories seem to apply. While Polynice fears the zombie because it signals the endless indenture of black slavery, Seabrook himself seems most horrified by the way it defies the representational system upon which Western power is based. When he finally comes face-to-face with a set of dead-eyed zombie laborers, "plodding like brutes, like automatons," he is struck by nothing so much as their *opacity*—their simple refusal to express either humanity or its other. The face of one zombie appears not simply pained, but "vacant, as if there were nothing behind it. It seemed not only expressionless, but incapable of expression." "'Great God,'" Seabrook exclaims aloud, "'maybe this stuff is really true, and if it is true, it is rather awful, for it upsets everything.'" The death in the zombie's face signals the deathliness of all form—the sheer arbitrariness, the unnaturalness of the sign, its apparently senseless circulation in time and space. By "everything," Seabrook explains, he means nothing less than "the natural fixed laws and processes on which all modern human thought and action are based" (101). Ultimately, though, this opacity is as much notable for its effects as for its causes. In his panic Seabrook turns to science, medicine, and ultimately the rule of law to re-master what has already been enslaved. Seeking a "fixed rule of reason," he turns to Dr. Antoine Villiers, a "scientifically trained mind," who reveals an article within the current Haitian Penal Code that states, "Also shall be qualified as attempted murder the employment which

may be made against any person of substances which, without causing actual death, produce a lethargic coma more or less prolonged. If, after the administering of such substances, the person has been buried, the act shall be considered murder no matter what result follows" (103). But the blow has been struck, and a certain uneasiness marks the rest of Seabrook's study, as well as each zombie text that follows in its colonial wake. Despite calling in the law here, Seabrook seems capable of only telling more zombie stories, coming across less like a rational investigator and more like an anxious folklorist—a "sensationalist"—offering his own performance to counter what seems to be the eternal return of the zombie's. He finishes his travelogue in bad faith, telling more and more anxious zombie tales that work to extend the very thing he fears the most.

According to Kyle Bishop, for "a Western, white audience," the "real threat and source of terror" in such stories lies not in "political vagaries of a postcolonial nation, the plights of the enslaved native zombies, or even the dangers posed by menacing armies of the walking dead, but rather the risk that the white protagonists—especially the *female* protagonists—might turn into zombies (i.e., slaves) themselves. In other words, the true horror in these movies lies in the prospect of a Westerner becoming dominated, subjugated, symbolically raped, and effectively 'colonized' by pagan representatives" (*American Zombie Gothic* 65–66). In all such stories, though, the threat of "reverse colonization" occurs at the borders of representation, via sound and rhythm rather than symbol and narrative. The clichéd markers of "primitive" culture—tribal drums, ecstatic dancing, crude totems, "voodoo" dolls—do not merely symbolize the primitiveness of non-Western culture, but demonstrate something of the mimetic and decisively repetitive nature of anti-imperial power. In fact, in both high modernist texts such as Joseph Conrad's 1902 novel *Heart of Darkness* and popular schlock like the 1932 film

White Zombie, the threat of "going primitive" occurs through a series of specifically rhythmic encounters—encounters that are defined as much by copying as contact, and thus inevitably leave power itself up for grabs.[2] Moreover, the threat of "going primitive" could just as easily be experienced as a kind of thrill, an ultimate release from the strictures of Western enlightenment and the pain of being a Western subject. As Barbara Browning observes, the Western account of African diasporic culture "relies on the figure of cultural contagion," but "artists and performers in the diaspora sometimes invert, ironically, the metaphor, such that 'Western influence' is itself shown as a pathogen. Or, more typically, they recuperate the notion of African 'infection' by suggesting that diasporic culture *is* contagious, irresistible—vital, life-giving, and productive" (6–7; italics in original). Indeed, if the American consumers of early zombie pop culture seemed themselves possessed by a "voodoo" spell, they were—by virtue of the very repetition of genre—entwined in a similar negotiation of power. In the pulpy short stories and mainstream Hollywood films of the '30s and '40s, the threat of cultural contagion is everywhere on display, but the details of plot and image make it nearly impossible to determine the origin or even the direction of colonial power. More often than not, the anxious logic of cultural contagion—in which the colonial world is negatively defined as dirty, diseased, and crudely mimetic—undermined the very ideology it was meant to uphold, a reversal that extended well beyond the colonial scene through the very proliferation of zombie films, stories, and pop songs that defined zombie culture more generally.

Take, for example, Jacques Tourneur's 1943 classic *I Walked with a Zombie.* The film signals its weirdly progressive politics early on, with the suggestion that the corruption of the Caribbean island of Saint Sebastian began with the slave trade. In High Gothic mode it sketches out

8.1. (Dis)Possession 1: Carrefour and Jessica in *White Zombie* (1943).

the dark secrets of the seemingly glamorous Holland clan—the tragic death of the planter-patriarch, the incestuous squabbling between the two half brothers, the mother's obsessive love for her sons. Toying with its audience's expectations, the film takes no small delight in dashing Betsy's naïve attraction to the island's exotic beauty against the family's inherent cynicism: "It's easy enough to read the thoughts of a new-comer," Paul Holland grouses. "Everything seems beautiful because you don't understand. Those flying fish—they are not leaping for joy. They're jumping in terror. Bigger fish want to eat them. That luminous

water—it takes its gleam from millions of tiny dead bodies. It's the glitter of putrescence. There's no beauty here. It's death and decay." Everywhere, though, this death and decay is brought about by a radical mimesis, the rhythmic appropriation and misappropriation of formal power. Just as the two sons come across as decadent copies of their once great father, Betsy has arrived as a replacement for a now zombified Jessica, who had previously replaced Mrs. Rand, the family's matriarch. In the film's most effective sequence, Betsy, having lost faith in Western medicine, leads Jessica to the ritual *houmfort* (a vodou temple), where she hopes to gain the advice of the local *bokor* (sorcerer or priest). The two women sneak through the cane past an ominous set of bones, a screech owl, and then a giant naked zombie (Carrefour, played with eerie stiffness by Darby Jones), only to emerge upon what seems the true heart of darkness: a ritual gathering, where they witness first a sword dance, a sultry spirit possession, and then, with a burst of manic drumming, an erotic stomp between two black women who seem to represent Betsy and Jessica's own primitive doubles. The girls join in the line of worshipers seeking advice from the father of the gods, Damballa, whose voice emerges from a nearby hut. When they get to the door, though, it opens unexpectedly upon Mrs. Rand, the matriarch of the Holland clan, who has been impersonating the father of the gods in order to maintain control over the local population.

Just as the local practitioners of vodou use little dolls to control their white oppressors, Mrs. Rand crudely mimics the formal properties of vodou ritual in order to assert her authority. It's a fascinating twist, not simply because it upsets the now familiar plot of "going native" to make room for something like female empowerment, but also because it restages the possession of colonial power via the native's own logic of possession. As Mrs. Rand explains, in her own brittle voice:

When my husband died I felt helpless. They disobeyed me—things went from bad to worse. All my husband's dreams of good health, good sanitation, good morals for these sweet and gentle people seemed to die with him. Then, almost accidentally, I discovered the secret of how to deal with them. There was a girl with a baby—again and again I begged her to boil the drinking water. She never would. Then I told her the god, Shango, would be pleased and kill the evil spirits in the water if she boiled it. She boiled the water from then on. . . . I found it was so simple to let the gods speak through me. Once started, it seemed such an easy way to do good.

Such possession apparently comes with a price. The surreptitious reversal in gender is just part of the story: this switch takes place via the abstraction of sound and voice and thus suggests a more radical decentering of power. Going primitive here figures less as an anarchic release of repressed energy than a sacrifice to form. Mrs. Rand is just as much possessed by vodou as she uses vodou to possess others. The end of the film suggests that in a fit of jealousy she herself caused Jessica's zombification, in a ritual initiated under the sway of the jungle rhythm. "That night," she explains, "I went to the houmfort. I kept seeing Jessica's face—smiling—smiling because two men hated each other—because she was beautiful enough to take my family in her hands and break it apart. The drums seemed to be beating in my head. The chanting—the lights—everything blurred together. And then I heard a voice, speaking in a sudden silence. My voice. I was possessed. I said that the woman at Fort Holland was evil and that the Houngan [the male vodou priest] must make her a zombie."

African American writers of the same era adopted similar strategies in their depictions of racial power and authority, and their work—either free of Western colonial anxiety or actively resisting its effects—helps

to clarify this power and its possibilities. Everywhere in the literature of the Harlem Renaissance and the writings of Afro-modernity, the very deadness of cultural form as it inflects the possibilities of human voice and human body becomes the precondition of political vitality, putting a radical racial spin on the aesthetic innovations of modernism at large. For example, in her famous 1938 study *Tell My Horse: Voodoo and Life in Haiti and Jamaica*, Zora Neale Hurston turns to the zombie as a "remnant" and a "relic." As "wreckage," Hurston suggests, the zombie figures the wreckage of the region at large, but less as metaphor or expression than a form of indication, darkly illuminating its social condition and its own historical moment (179). Hurston characterizes Haiti as a split nation, violently torn between races, classes, and ideologies. Its zombies seem to exist in a sort of a limbo, hopelessly detached from origins, forced to wander between otherwise incompatible worlds. Tapping into a folkloric tradition that extends well back to the colonial trade of nineteenth-century Africa, Hurston first explores the economic motives of zombie production. The centerpiece of her account concerns the "Give Man" process, a dark vodou ritual in which local mulatto owners trade their own souls to the dark *loa* (spirits or gods) in order to develop a zombie workforce. But Hurston, the writer, seems most interested in zombification as an act of inscription, one in which a human body is taken out of one story and forced to inhabit another. The bokor uses a strange and secret language to speak with the gods and then capture the soul of a man or woman; during the zombification process, money is exchanged for speech, vocal authority, which then commands the body of the zombie to serve other ends. In this, Hurston's zombies appear both excessively mediated and remarkably unmediated, at once named and unnamed, possessed and dispossessed. In fact, Hurston is drawn to the opaque voice of the zombie itself, which she describes as

a "broken sound" or "broken noise" (197). As the body of the zombie is disconnected from any organic community, she suggests, so its voice seems broken off from any coherent language. Its homelessness is made manifest in the wreckage of its speech.

At the same time, Hurston's text famously struggles with its own voice. In constructing her ethnography, the writer slips somewhat anxiously between folkish and professional discourses, and she frets everywhere about her own voice as it distorts or violates its objects of study. She specifically worries what it means to speak of and for the figure of the zombie. In one horrific scene she visits and then photographs what is believed to be a real zombie. A local doctor forcibly uncovers the zombie's head and holds it in position while Hurston snaps away at the "blank face with dead eyes" (195). Here anthropology itself, especially when conjoined with Western technology, figures zombification, the rendering undead of an otherwise vital subject. But it is precisely this deathliness at work in signs and significations that becomes a valid literary strategy and a form of resistance in Hurston's text. Hurston's chapter on zombies is succeeded by an account of vocal possession. Here we learn that the book's title phrase "Tell My Horse" refers to a process in which Guede, the boisterous god of the Haitian lower classes, mounts a person and speaks through his mouth. The phrase refers to the physical shuddering of the human mount, who, once gripped by the god, gives voice to the injustice and unfairness of his or her life, calling out bossmen, politicians, the police, children, and even former lovers. For Hurston, the voice that speaks through the mount is the voice of the ancestral past, connecting the possessed Haitian to a lost homeland, as well as the voice of unconscious desire, giving vent to the repressed energies of the underclass. But it is mostly, she claims, a "blind for self-expression," a way of circumventing censorship and allowing the

Haitian peasantry to speak truth to economic and political power without consequences. In this, Guede's voice becomes a voice of derision, of chatter and gossip. Celebrated on the eve of All Saints' Day, Guede is the god of burlesque and mockery, upending authority via citation and exaggeration. His voice does not represent or express power, but eats through it. A radically de-idealized, decentered voice, a voice without a subject, it exposes both the arbitrary dimensions of all voice and the pleasure of vocal mediation.[3] In fact, for Hurston, the voice of Guede is the voice of death and the voice of death in signs. "Perhaps that is natural," she writes, "for the god of the poor to be akin to the god of the dead, for there is something about poverty that smells of death" (223). In this, Hurston's study ultimately appears less like a scholarly treatise than a scholarly burlesque, mocking the authority of both folklore and science as it clears space, through ventriloquism, for personal intervention. Her vodou-inflected version of modernist form entails a campy graveyard deconstruction of power that, in emphasizing voice and vocal performance, inflects African American culture at large.

Richard Wright, on the other hand, was too much of a realist to be interested in zombies, and he could not be further opposed to Hurston in terms of politics and style. Still, in his work undeadness is thematized as both an affective state and a formal principle, bound up with narrative itself, and thus becomes the basis of a much more direct negotiation of racial politics. Wright announces his undead agenda with the stunning epigraph of his first collection, *Uncle Tom's Children*. "Uncle Tom is dead," claims the new generation of black Americans, thereby asserting their own revolutionary protocol even amid the persistence of racial injustice in the States. Wright's fiction as a whole is notable for its depictions of extreme affective states, but the stories presented here, from first to last, present racial subjectivity as a provocative state

of undeadness. Wright's protagonists are all notably subhuman; sometimes mere "blobs"; often shapeless; always defenseless, barren, and bare. In their fear and confusion they experience intense discombobulation, occult suggestibility, and sheer paralysis, a kind of manic stiffening that destroys all thought and will. In fact, most are literally condemned to death, awaiting some ultimate demise at the hands of their white tormentors. In turn, they play at death, staring blankly, nullifying gesture and expression, hiding in plain sight of the white world, and sometimes literally burying themselves in the ground to elude their white captors. The zombified state of Jim Crow blackness is perhaps most clearly displayed in a story titled "Down by the Riverside." Forced to shoot a white man in order to protect his pregnant wife (who also happens to be already dead), Wright's protagonist feels himself suspended over a black void, detached from his own body, which he then watches as it moves listlessly through a series of scenes until its final execution. Led through a hostile white crowd toward his grave, the protagonist "wanted to look around, but could not turn his head. His body seemed encased in a tight vise, in a narrow black coffin that moved with him as he moved" (114). Still, in each of these stories living death proves the precondition of a certain clarity and then agency. Specifically, as a form of numbness and indifference, of stiffening and hardness, living death signals the death of a limiting cultural tradition and an emptying of racial ideology. In his zombification the protagonist of "Down by the Riverside" achieves a state of knowingness beyond the romances of religion, family, and, ultimately, property: "None of it really touched him now," the narrator explains. "He was beyond it all now; it simply passed in front of his eyes like silent, moving shadows, like dim figures in a sick dream" (112). In turn, the protagonist wields his literal death in a final act of defiance, using it to expose the forces of power that shaped his life. Shot

8.2. (Dis)Possession 2: Inset from press book for the film version of Richard Wright's *Native Son* (1951). University of Mississippi, J. D. Williams Library, Department of Archives and Special Collections.

from behind in the very act of escape, his body falls into the river; as his corpse reveals the watery currents that pass around it, so his death, in its opacity, points openly to the terror of the Jim Crow South (123).

More pointedly, Wright's characters are famously caught up in forms over which they have little control; zombies all, they seem driven by larger ideological forces and often discover themselves committing, against their own will, horrendous acts of violence. Similarly, Wright's own fiction seems to slip into and out of undead genres—gothic horror, courtroom drama, the flood tale—as if somehow fated to repeat, if only

provisionally, the literary forms of the past. However, it is precisely this dark and often inscrutable play of form and repetition that signals the undeadness of Afro-American modernism as a vital aesthetic mode. In fact, each of the stories in *Uncle Tom's Children* begins with a song, and each replays (samples) that song in ways that transfigure its meaning. One tale, "Long Black Song," presents the subject of African American modernity as, specifically, a phonographic subject. Here a lonely Southern housewife is visited by a phonograph salesman and finds herself instantly drawn in by the mechanically spinning song—an old spiritual—that he plays for her. The rhythm of the song is disruptive, violent even, but also, in its repetition, erotic and seductive; it lures the woman away from her everyday routine and its racially inflected expectations. As sheer sound, spinning abstractly, opaquely, beyond the everyday spectacle of Southern life, it frees the woman to experience her body and thus her identity anew. However, once the woman's husband returns and discovers her affair with the phonograph salesman, the "Long Black Song" of the South becomes sheer repetition, inevitable deathliness. Silas chases his wife out of the house with a whip and then shoots the salesman when the latter returns the next day for his pay. Later a white mob circles the house and, after a few gunshots, tries to burn it down with Silas inside. As the male protagonists replay the past in all its furious violence, the woman fretfully "circles" the scene, like a record needle, listening to the voices that are already "echoes," helpless to intervene in a history that must replay itself once more (145–46). If earlier, phonographic sound, in its undead repetition, signaled sensual release and radical otherness, it now—as the silent structure of racial trauma—seems to lock history into its own violent groove. Still, the phonograph has done its work—a break has occurred. At the moment of trauma's repetition in sound, history loses force, and its actors are made aware of its inherent ghostliness, its utter emptiness. Time itself begins

to slip, to jump its groove. Afro-modernity as zombie modernity seems poised to move, jerking to a new techno-affective order.

Because, really, the zombie only wants to dance. Tellingly, Browning's model of diasporic contagion is explicitly musical. "Hip Hop," she explains, "is one moment in the history of the dispersion and popularization of black musical idioms, a process of cultural exchange which was concomitant with the first processes of global economic exploitation—that is, colonization. Reggae represents another such moment. Funk. Soul. Mambo. All 'infectious rhythms'—all spread quickly, transnationally, accompanied by equally 'contagious' dances" (5–6). In the cultural history of the zombie that follows the slave trade from Africa through the West Indies to America and beyond, there are nearly as many dancing zombies as there are laboring zombies. In the earlier literature of Haiti, the dancing zombie stands in as a form of exploited labor, manipulated to perform—in a kind of blank-face blackface—for his or her white masters.[4] Later in the century, on American soil, the dancing zombie comes to reflect the commercial manipulation of teen culture, the lusty hordes whipped up into a rhythmic frenzy by cool beats. It was only in the 1970s, however, that this shambolic figure took a more self-consciously political turn. In the punk movements of England and America, the dancing zombie figures white alienation and dissension. As Dick Hebdige notes, the image of the punk—blank face, tattered clothes, twitchy movements—served to hollow out the social markers of postindustrial capitalism. Stomping around in chains and safety pins, the punk as zombie defied the expressive ethos of the marketplace and exposed the arbitrary nature of its signifying code (see introduction to this collection). At the same time, though, the zombie became a central figure in the struggle for African and African American civil rights in its musical form. In the Afrobeat of Fela Kuti and the funk of the

band Parliament, the dancing zombie figures as both victim and threat, his body mangled by techno-modernist regimes yet still jerking and twitching to some revolutionary protocol within the music itself. Today, post-*Thriller*, the zombie's identification with popular dancing is strong enough to reverse the order of connotation; dancing now—whether as Lady Gaga, Beyoncé, Kanye West, or Thom Yorke—means to drag the foot, jerk the shoulder, or stumble backward, and in this it maintains its critical implications. Most important, from this perspective popular culture seems less like a negotiation of competing identities and expressions than the dynamic work of orientation itself, bodies falling in and out of preestablished forms, seeking out rhythms and counter-rhythms, modes of fit and resonation, effectively staging an alternative public sphere within the official one.

Take, for example, Fela Kuti's "Zombie," one of the earliest and most famous songs in the undead canon. Fela's influential Afrobeat fusion is remarkable in itself as an example of postcolonial hybridity. Born in Nigeria to a feminist activist mother and a Protestant minister father, Fela Kuti was sent to the Western world to study medicine and wound up messing with new musical forms—here, jazz and a Ghanaian horn-and-guitar-based genre called "highlife." Later, inspired in America by the Black Panthers, his music took an explicitly political turn, its multiethnic rhythmic complexity revamped to address the injustices of colonial rule. In Nigeria he formed the Kalakuta Republic, a commune-cum-recording studio (named after his first prison cell), declared his independence from the state, and changed his middle name to Anikulapo, meaning "he who carries death in his pouch." In this revolutionary spirit, in 1977 Fela and his band Afrika '70 released the album *Zombie*, the title track of which contained a scathing critique of the Nigerian military. Backed by a needling funk guitar riff and a shuffling African

rhythm section, Fela barks off a series of military commands meant to expose the empty-headedness of the police:

Zombie no go go, unless you tell am to go (zombie)
Zombie no go stop, unless you tell am to stop (zombie)
Zombie no go turn, unless you tell am to turn (zombie)
Zombie no go think, unless you tell am to think (zombie)

Recalling Hurston's claims regarding the god of the poor, Fela's vocal performance is astounding in its mockery; this is no bland political diatribe, but a raucous satire, with Fela sneering and giggling his way through the military routine. In live performances his backing band responded to the song's shouted military commands with broad goofy dance steps. In this the deathliness of the martial rhythm came up against its own dance-hall double, as if by following mechanization and the rule of law to the letter the group had been freed, at least momentarily, from its oppression. The song's rhythms are lock-tight but empty, and together they set the song into giddy motion, preparing the way for Fela's cracked sax solo, which both recalls and ridicules something like a national anthem. As Dorian Lynskey writes, "The song's sheer reckless jubilance is jawdropping. Mischievous boys would sing it to taunt nearby soldiers, marching sarcastically with sticks under their arms instead of rifles" (240). Within days of the song's release, in fact, a thousand members of the Nigerian army showed up at Fela's compound, seeking to reassert their original rhythmic protocol. They burned down the barricades and stormed through the dwelling, beating and raping its inhabitants. Fela's seventy-eight-year-old mother was thrown from a window, sustaining injuries that resulted in her death, while Fela himself was beaten to within an inch of his life. Afterward the pop star went into exile in Ghana, where his thinking about politics and identity retreated into an otherworldly mysticism, but sound and

rhythm remained a vital force in his life and his politics. "With my music I create a change," he explained in an interview. "So really I am using music as a weapon. I play music as a weapon."[5]

We might simply note here the undead nature of any cultural code, the necessary repeatability, or iterability, of the sign that makes a mockery of human expression and identity as original or unique. The very abstraction of the sign allows artists such as Hurston and Fela to travesty the law it presumably serves, adopting and adapting its undead forms in order to undermine them from within. But when it comes to dancing zombies, we must also consider the specific uncanniness of the recorded voice, which, when wielded by a bokor-DJ, becomes a strange source of both social order and social chaos. As Mladen Dolar writes, if the human voice serves to mediate body and sign, to reconcile matter to meaning, it also everywhere threatens to expose the incoherence and incompletion of being. On one side, voice teeters on the brink of physicality, meaningless sound, the zombie's low, dumb growl; on the other, it passes into mere signage, the empty language of the law, the directive still transmitted from the abandoned radio tower (59, 71). In this doubleness the voice wreaks havoc on the coordinates of both personal and social identity, at once providing an ideal reflection of existence and vexing it. As Richard Middleton argues, "Reflections of the vocal body have a capacity to short-circuit the 'normal' distinctions between inside and outside, self and other—for the moment we enter into the symbolic order, an unbridgeable gap separates forever a human body from 'its' voice. The voice acquires a spectral autonomy, it never quite belongs to the body we see" (para. 11). In stressing the vexed ontological status of such voices, however, we begin to see how they might establish identity and agency on new terms. Recording technology, Middleton argues, exposes the voice as an always already undead voice, as a constant displacement of human nature beyond nature, and thus as the

constant mediation of human identity beyond itself. At times, even, this same voice—as undead voice—grants the pleasure of such slippage, the pleasure of losing and finding the non-self beyond the self. The traumatized self is released from its pain, restored in not just the idealization of an immaterial voice but in a vital sound that is not its own, not its own expression. Such, I hope to show, seems to be the pleasure and the politics of zombie pop. Recording technology and the sheer repetition of the refrain works this cut or break, the deathly repetition that precedes restitution, allowing us to indulge in a pleasure that is neither fully natural nor fully artificial. As Middleton writes, "This is what the 'loss' of the body documented in the record form actually reveals—that these bodies, . . . *are the only ones we ever had.* It is within this space of sonic invention—a space not so much between two deaths as between two lives—that recorded voice, including even the work of the DJ, can contribute to saving a life" (para. 25).

Enter Dr. Funkenstein, "*the disco fiend with the monster sound / the cool ghoul with the bump transplant . . . / preoccupied and dedicated / to the preservation of the motion of the hips*" ("Dr. Funkenstein"). George Clinton's P-Funk mob found its stride in the mid-1970s as a ragtag musical horde at times consisting of more than one hundred musicians. The band emerged out of a troubled political climate (the civil rights struggle and the Detroit riots) and brought together a range of dissonant styles (African rhythms, modern jazz, doo-wop, slave spirituals, rock and roll), but their sound explicitly embraced monstrosity and freakishness as a source of renewal. "All that is good is nasty!" Clinton howled in the early days, like some corrupt revivalist, and from that point on his band—in sound, looks, message—dedicated itself to the funked-up body as a source of personal renewal, communal strength, and political dissent. In 1976, however, Parliament began to develop a

more technological approach to the funk revolution. Here, Clinton introduced his alter ego Dr. Funkenstein, a sexy space alien—leader of the "Afronauts"—who had come down to earth to spread his ancient wisdom of "clone funk" and repopulate the future in his image. Part mad scientist, part ghetto pimp, and part bokor, Dr. Funkenstein prescribed a techno-rhythmic cure for the repressed and alienated bodies of Western modernity, using the machines of electronic sound production to restore something like racial vitality. In concert Clinton emerged from the P-Funk Mothership in sunglasses, furs, and diamond-studded boots and, with his kinky commands and gestures, set to "body snatchin'"— first his band and stage crew (in tribal robes and face paint) and then the audience itself:

> *Microbiologically speaking,*
> *When I start churnin', burnin' and turnin'*
> *I'll make your atoms move so fast*
> *Expandin' your molecules*
> *Causing a friction fire*
> *Burnin' you on your neutron*
> *Causing you to scream*
> *"Hit me in the proton, baby!"*
> ("Dr. Funkenstein")

For Funkenstein, musical production is also always reproduction. His studio figures as a jungle laboratory, and the recording apparatus is a genetic operator, splicing and spinning the cultural code in order to spit out hot new configurations of being. "The mad scientist's funk is engraved in the groove," Middleton writes,

> the bodies of the dancers animated by system loops. Etymologically, "groove" and "grave" have linked origins, but there are sexual

connotations as well, as well as drug overtones—being possessed by grooviness. The record groove spins into the cybernetic apparatus. In its discursive nexus, life and death, subject and object, body and machine, are tightly conjoined. (para. 20)

In turn, Funkenstein's listeners are all happy "clones," "children of production," reanimated from death via the deathliness of form itself. Despite Clinton's preaching about African mysteries and the metaphysics of sex, his followers are animated through purely technological processes—the mechanical production of sonic difference in and as repetition. "Everything is on the one," they chant together, but their essential oneness is founded decisively on their own doubleness, in the rhythmic repetition of the "one" as the "two," in its undead return. Tellingly, the term *funk* refers to a nasty stench, a syncopated rhythm, and the act of fucking, but these three meanings here seem to overlap. At once primitive and futuristic, monstrous and mechanical, sexual and cybernetic, the "children of production" stage their protest in a series of rhythmic gestures that everywhere overturn not just the moral implications of their degradation but the very logic of repetition and originality through which that degradation is enforced.[6]

As Alexander Weheliye argues, in the audiovisual break that defines phonographic culture—the "cut" between sound and source—the black subject is dematerialized and rematerialized in his sounding. His sonic invisibility entails neither expression nor even its negation, but becomes the precondition for another kind of presence altogether; the body folded into sound entails a version of selfhood as a series of contingent *opacities* or *intensities,* at once open and defined, immanent and singular (32, 54). The phonographic subject, Weheliye claims, born out of this sonic disjuncture, bypasses the limited logic of origin and copy, of essence and expression, and becomes instead a series of "potent, yet

fragile singularities as modes of becoming-in-the-world" (68). At the same time, phonography transforms history into a series of competing tracks or grooves, varying rhythms that sound with and against one another in a more or less dynamic mix. Such grooves—as they imply both writing (graphism) and an affective mo(o)vement—suggest a mode of temporal change that is multivalent and nonlinear; sonic culture, like zombie culture, entails a proliferation of affectively charged spaces and temporalities, all cross-fading into and out of one another, creating ruptures, displacements, and syncopations within history proper. As Kanye West snarls on a track called "Power," "*The system broken, the school's closed, the prison's open / We ain't got nothing to lose motherfucker / we rollin'.*" Here, backed by tribal chants and a sample from King Crimson, Kanye offers up his music—his intensely rhythmic "shit"—as an alternative politics: "*They say I was the abomination of Obama's nation. / Well, that's a pretty bad way to start the conversation. / At the end of day, goddammit, I'm killin' this shit. / I know damn well y'all feelin' this shit.*"

But even in considering rhythm, what emerges at the other end of this process—this *shit*—is undetermined, undecidable. If the politics of expression and liberal humanism are replaced in this art by an opacity that is both more and less than human, at once prehuman and posthuman, and open on all sides to an uncertain history, as—in a word—a form of waste, barren and abject, it also seems easily contained within the logic of monster as other, as abject. What does it mean to embrace such monstrosity, especially as a kind of kinky, rhythmic pleasure? Or, rather, how does one embrace monstrosity without letting it signal little more than lack, absence, or, worse, trash, dereliction, and impoverishment?

We might ask the question in a more pointed way: Why did Michael Jackson need to wear monster makeup in order to perform? Or why, in a life mocked by personal abjection and cultural shame, a life

reduced to a dancing, shuffling thingliness, bereft of maternal comfort, put on stage by a corrupt father to entertain a hostile crowd, why would a performer choose to redouble his own monstrosity, his own loss and decay, and perform it a second time? By the time Michael Jackson rose to fame, the racial logic of minstrelsy had long been subsumed under the postmodern logic of citation. From the start, Jackson came across as an astounding mimic, borrowing from both black and white sources, male and female, American, British, and Caribbean. But above all else the performer was drawn to the lonely, misunderstood monsters of classic Hollywood cinema and even the schlocky slime creatures of the 1950s B movies. His first solo hit was the title song to *Ben,* a 1972 horror film about the uncanny bond between a lonely boy and a psychically controlled horde of killer rats. In the song, Jackson adopts the perspective of the lonely boy and addresses the leader of the evil rat pack, using the opportunity to express his own feelings of alienation: *"Ben, you're always running here and there / You feel you're not wanted anywhere."* No doubt Jackson's identification with monsters ran deep. In fact, he often wore monster makeup to the studio to practice his song and dance moves, a habit that ultimately led to the conceptualization of "Thriller," his 1983 hit single, and the groundbreaking video produced in its wake.[7]

Arguably, Jackson's identification with monstrosity inspired his infamous experiments in plastic surgery and skin pigmentation. As David J. Skal suggests, however, the star's experiments figure less as anxious attempts at eternal youth or racial disidentification than as performances of monstrous change and the destabilization of identity:

> Perhaps it wasn't surprising that the star of "Thriller" should be intent on transforming his face into a kind of living skull. From some angles, the bone-white skin, cutaway nose, and tendril-like hair resembled nothing so much as Lon Chaney's Phantom of the Opera.

The comparison is apt, because it underscores Jackson's and Chaney's parallel cultural function: the embodiment of a powerful transformation metaphors [*sic*] for a public basically unsure and fearful about the actual prospects of change in a supposedly classless and mobile society. (318–19)

In other words, for Jackson, quotation and monstrosity go hand in hand; in performance, more so, they figure a kind of alienation as well as an escape from that alienation. As Peggy Phelan argues, "Jackson's introjection of other performance tropes allowed him to simultaneously exploit and unravel the distinction between source and quotation. . . . The embodied nature of live performance transforms referencing from the textual realm of quotation and allusion to the psychic realm of introjections, one constituted by diffuse and ephemeral systems of notation" (944). Jackson's monstrous system of notation, enacted everywhere on his decaying body and faltering voice, functions at the borderline of presence and absence, agency and abjection, revealing, in its own shambling form, both the thrill and threat of zombie culture at large.

In "Thriller," the originally recorded song, Jackson presents himself as both monster and victim, one perhaps suffering because of his own monstrosity. He seems drawn both toward and away from some horrific event, caught between a traumatic past and an impossible future. But the drama is all vocal and, as such, encapsulates what Phelan describes as Jackson's lifelong struggle "to come into voice, into public consciousness" (945). In other words, in "Thriller" Jackson reveals that the anxious project of selfhood relies upon the voice and the voice's shifting relation to some other. Here, in fact, his demand for a response, for human recognition ("*I have something I want to tell you*," he chirps in the video, "*I'm not like other guys*") exposes the monstrous nature of all voice; its own errant drift toward and away from the other:

It's close to midnight and something evil's lurking in the dark
Under the moonlight, you see a sight that almost stops your heart
You try to scream, but terror takes the sound before you make it
You start to freeze as horror looks you right between the eyes
You're paralyzed

As Phelan writes, "Jackson's strongest works are performative speech acts, creating the feeling they express—love, hope, grief, anger, resignation" (945). Here, though, the dance of the voice around some unnamed and inherently threatening other ultimately frees it to come into its own.[8] In fact, using all the empty clichés of the horror tradition and the vocal clichés of black soul and funk—clichés that presumably get in the way of anything like personal expression—Jackson manages to convey not just his own uncompromising presence or even his own power but also something like pleasure. Like Elvis before him, another monstrous minstrel, Jackson riffs through a compelling category of vocal identities—pop, soul, funk, blues, and so on. As voice, though, as a shambling vocal form, at once empty and aggressive, his performance turns its own monstrosity into something other than lack or abjection. In its frantic dance around the moment of encounter—*"You're out of time,"* he sings—his voice translates the terror of its situation into something playful; the pain of the past and the threat of the future, in their rhythmic syncopation and tonal modulation, become the disarming thrill of *now,* sheer sonic becoming.

In the famous video that accompanied the release of *Thriller,* Jackson appears as not just one monster, but several—werecat, Frankenstein's creature, mummy, and, of course, zombie. His image, like his voice, appears to be caught in a series of campy mediations, a fact brought home by the film-within-a-film narrative that doubles Jackson as monster and then hero, only to reverse it all over again to expose yet another

monster within. One by one, each of these transformations is emptied of its threat, as just another copy, so that when the zombies finally emerge from their graves, they embody not so much the pain but the rhythmic possibilities of undeadness. No doubt, with their rotting flesh and distorted movements, Jackson's dancing ghouls are menacing, and Jackson himself, when he turns, glares at his girlfriend with nothing but hate in his sunken eyes, yet the horde seems so thoroughly gripped by their own monstrosity that it shudders them into dance. As with Jackson's voice, these bodies raise a certain demand, but their expressions and gestures are not outwardly aggressive; all of the menace is drawn inward, into the syncopated transitions of their own movements. As Jackson's voice dances in and around the impossible event, so their bodies shuffle in and out of time, stumble into and out of space. They kick one foot out to the side and then—slowly—drag it back in before stomping on the beat. *Shhh-thump.* Hands swing like cat claws to the right and then to the left, before landing again in the middle. *Shhh-shhh-thump.* Shoulders lurch forward, while legs stomp backward. *Thump-shhh-thump-shhh-thump.* In this the rotting *ballet de corpse* performs composition as much as decomposition. Together, the dancers shake off corporeal constraints only to take on new ones, decoding as recoding and vice versa, until the entire process begins to resemble something like pleasure. Ultimately, they stomp off down the road and, one by one, turn to face the spectator, until Jackson himself whips his head around and the makeup is gone. "'*Cause this is Thriller!*" he shouts and then immediately launches into a set of signature moves. As Phelan notes, in reference to Jackson's famous moonwalk, Jackson created a future for himself by moving backward, by repeating the steps of the past (944). Here, though, with "Thriller"— in the midst of death and disfigurement, through the very deathliness and displacement of form—he attains something like the power of *now.* Monstrosity reveals itself not as simple otherness or even abjection, but

as the syncopated process of becoming, the halting movement of bodies within and against the official regimes of space and time.

To see the zombie as an opacity, as an obscure density of noncalcified substance, shuffling within fields of similar densities, strips the genre of all humanist claims. To see not just the zombie but a human protagonist such as Ben in *Night of the Living Dead* as an opacity, as a cut and a groove, circulating within and against the cuts and grooves of white history at large, transforms the very terms of all politics as cultural politics. At the end of Romero's film, Ben's body—killed, mutilated, and dragged—appears in a series of grainy newspaper photos, apparently reduced over time to a tiny black blob, yet one that still moves, albeit negatively, to the rhythms of power at large. Even as he's killed and killed again, "Ben" continues to raise a demand, a counter-rhythm of form and force. Here, in fact, the rhythm of the body competes with a series of other repeating rhythms—of the survivor, the police force, the press, the cinematic machine, the academic essay machine, exposing the political nature of each. In this the zombie's body appears less as a dancing machine than more generally as a territorializing refrain, an aggregate of forms that in its jerky repetition marks out a space and time of operation—rhythm, in Gilles Deleuze and Félix Guattari's formulation, as a functional assemblage, a series of motifs and counterpoints that works to catalyze bodies in relation to one another and thus as an instance of power. "Meter," the two authors write, "assumes a coded form whose unit of measure may vary, whereas rhythm is the Unequal or Incommensurable, that is always undergoing transcoding. Meter is dogmatic, but rhythm is critical: it ties together critical moments, or ties itself together in passing from one milieu to another" (*Thousand Plateaus* 313). The zombie, then, as rhythmic refrain, moves toward and away from its own death, jammed up and then loose again, at the threshold of existential consistency. The moment of repetition—the second

beat, the second footstep, the second revolution—becomes, as it does on the dance floor, both the moment of death and the death of death, the death of death, a dub-beat death march, at once freezing and freeing up the entire mechanism in relation to the livid field of the whole.

Perhaps, even in this terrifying gap between one death and another, zombie culture as dance culture opens up a radical ethical domain and serves as a vernacular mode of ethical exploration. Here, Benedict de Spinoza provides the best model, for his early modern view of bodies and ethics speaks clearest to our late modern, posthuman view of hordes and masses. As philosopher of immanence, Spinoza deals only in substances and modes; in his *Ethics* the human body figures as a mode of extension, a modality, affected by other modalities, by the shapes, sizes, and speeds of all other bodies. "All bodies either move or are at rest," Spinoza writes, as if constructing his own zombology. "Each body moves now more slowly, now more quickly." For Spinoza, such bodies do not vary in substance, but in affect, insofar as they are affected by one another, modified in their relations with one another, and sometimes, together, form a composite body, or a horde:

> When a number of bodies, whether of the same or of different size, are so constrained by other bodies that they lie upon one another, or if they so move, whether with the same degree or different degree of speed, that they communicate their motions to each other in a certain fixed manner, we shall say that these bodies are united with one another and that they all together compose one body or individual, which is distinguished from the others by this union of bodies. (126–37)

Importantly, for Spinoza, the virtue of any body is defined as its power to persist in its own form and relation. "Virtue" is nothing other than acting, living, and preserving our being by the guidance of reason, insofar as such being is opposed or augmented by other forces in a single

environment. Thus, lurching forward and back, referring to nothing other than its own assemblage, the zombie body collapses self-serving categories of right and wrong and forces us to consider the nature of good and bad encounters, to think beyond the humanist imaginary of the ego and instead consider relations and proportions of corporeal and corporate well-being. Indeed, *zombie* may be merely another name for "virtue" itself, the body's ability to persist in its own being and power. The zombie attack appears as an attack only from within a humanist worldview; it merely exposes power as such, as the rhythmic appropriation of time and space, and, in response, we need to translate our affective terror into adequate reason and ethical inquiry.

In fact, "Thriller" is no less important for the copies it has inspired. Watch, for example, the viral video of the dancing inmates of the CEBU Provincial Detention and Rehabilitation Center, a maximum-security prison in the Philippines.[9] In 2007 more than three hundred inmates, many of whom were imprisoned for murder, performed a truncated version of Jackson's zombie dance from "Thriller." The footage, uploaded onto YouTube, quickly generated millions of hits and inspired copycat performances in prisons across the world. Here, sure, the zombie dance—with its classic foot drag—serves as a way of disrupting, or at least challenging, official order; the prisoner, doing time, facing the end of time, uses his body as a mechanical assemblage to insert himself and his horde back into vital time (or at least the vital time of cultural consumption). By submitting to a dead form, by performing "Thriller" for a second time, the group affects something like the death of death, and, so while facing death's row, they reverse their own sentencing, gaining, at least for a moment, some reprieve. Byron F. Garcia, the CEBU prison chief who planned the prison dance, claims that his decision to use "Thriller" was based on an identification between Jackson and the

prisoners: "I saw in the lyrics and video of Thriller much of what jail culture is like. Because of the hideous conditions in jails, prisons are like tombs and inmates are like ghoulish creatures. The only difference is that dancers in the MJ Thriller video come with make-up and costumes. The Dancing Inmates come as themselves. People perceived to be evil." According to Garcia, however, the dance ultimately works beyond the logic of identity and expression to expose and perhaps reset the power relations between prisoners and society: "The message is, governments must stop looking at jails darkly. We have to stop being entertained and thrilled by the sting of sin. We have to look at prisons beyond the cycle of crime and punishment and certainly look inside underlying social, cultural and psychological implications of rehabilitation." But the moment cuts both ways. Subsequently, the dance was revealed as an attempt by the prison chief to keep prisoners in line and quell gang violence between rival cellblocks. According to prison authorities, the dance was staged as an example of "revolutionized penology," and since then it has become a lucrative stage show, performed once a month for paying public audiences, who watch from viewing platforms surrounding the exercise yard. At the jail, visitors can have their pictures taken with the zombie inmates, and they can buy souvenir zombie prison shirts. Here, then, the zombie dance figures as a double act of deterritorialization and reterritorialization, but its ethical force is not at all blunted by its spectacular regimentation. In fact, its mediation is precisely what makes it available as an instance and negotiation of power, one that inspires both terror and critical insight. Certainly, here, as in the best zombie films, the exercise of pop culture and government power becomes as much an issue of machinery and rhythmic assemblages as it is an issue of rights and expression, and indicates, even in this commodified form, a violent encounter that is always already under way as well as impending.

Ultimately, then, to see the zombie as rhythmic opacity, as a cut and a groove, circulating within and against the cuts and grooves of Western history at large, means to rethink the terms and implications of diasporic culture—and to rethink diasporic culture, perhaps, as all culture today. Taking the evolution of dub music in Jamaica as his model, scholar Steve Goodman (aka Kode9, a London-based DJ and producer) redefines the "Black Atlantic" as a site of sonic outbreak and contagion. Everywhere along the migrational pathways of Afro-modernity, Goodman argues, the viropolitics of rhythm and frequency confront the corporate viropolitics of consolidation and branding. Sonic parasites ride on the back of the expanding economy, hijacking local populations via the nervous system, possessing individual bodies one at a time and swaying them into rhythmic group motion. Here, Goodman argues, postmodern culture takes one funky step forward. In the hands of the studio engineer, sonic contagion pushes "memetics" beyond memory and cognition, repackaging the meme as an "individuated block of affect," a "synaesthetic pulse pattern," at once affective and machinic, alive and dead. Hence, Ishmael Reed's "Jes Grew" virus—"unprintable" and yet "irresistible," at once virtual and visceral (Goodman 211)—a fully Spinozist virus, incubated in the studio lab, dispersed through the empty air, replicated across space and time, and thus rhythmically engaged in a tactical redesign of power relations (157). But more than just a hipper, blacker version of postmodern play, or a politically charged version of remix culture, diasporic virology theorizes itself on the actual dance floor, creating in the body of each dancer an "alternative, diasporic orientation" to the world (159). This sonic contagion—locally contracted and yet globally displaced, affectively charged and yet technologically abstract—proves nothing if not radically ecological. Eschewing universalism and downplaying humanist fantasies of expression, it demands, like the zombie attack itself, an affective inventory of

8.3. (Dis)Possession 3: Lady Gaga and Kanye West, *Fame Monster* Deluxe Album artwork booklet. David LaChapelle, photographer.

forces, frequencies, and economies, and then a tactical deployment of rhythmic and vibrational process for mobilization on a global scale.

Zombie culture, as a popular subculture, takes many forms these days—the zombie flash mob, the zombie march, the zombie prison dance. These phenomena work in similar ways, abandoning expression, even the expressive potential of style, in order to crack open, with their own opacity, the official regimes of space and time. I'd like to conclude, then, with an example that suggests just how far the zombie mode can

be extended as a convention as it exposes convention itself as an undead form and thus as a mode of survival. In 2009 indie-rock icon Bon Iver released a small four-song EP that concludes with an a cappella tune titled "Woods." The song consists of only four lines, a small pastoral haiku:

> *I'm up in the woods*
> *I'm down on my mind*
> *I'm building a still*
> *To slow down the time.*

The track is built off a series of Auto-Tuned voices, which, in their rhythmic rise and fall, do not so much name, but create an abstract space of comfort and persistence. The use of Auto-Tune here proves significant, because it allows the artist to emphasize the artificial nature of the voice as it works to reconstruct nature as such. But that's nothing. In 2010 hip-hop star Kanye West picked up Bon Iver's tune and used it as the basis of another song, "Lost in the World," the culminating track on his critically acclaimed album *My Beautiful Dark Twisted Fantasy*. Here, Kanye extends a long tradition in soul and funk by depicting himself and his music in monstrous terms, born of undead forms, remixed and remodeled in order to create a new space of identity and power. His song begins with Bon Iver's white pastoral, but slowly reterritorializes it with a tribal beat and then a politically charged rap about the dangers of black life in the city. The jumble of styles and sentiments is held together by both the steady rhythm and Kanye's voice, rising to a fascinating crescendo, singing,

> *I'm lost in the world*
> *I'm down on my mind*
> *I'm new in the city*
> *But I'm down for the night.*

Here, Kanye layers Bon Iver's "still" with the word "city," so the line becomes *I'm building a city,* and then, layers "time" with "night," at once extending Bon Iver's pastoral gesture and reclaiming it as an alternative space and time for himself. As Virgil covers Theocritus, as Danny Boyle covers George A. Romero, so Kanye covers Bon Iver, reterritorializing an indie pastoral as a space of hip-hop survivalism. The point is driven home by the introduction of a snippet from Gil Scott-Heron's revolutionary diatribe "Comment #1," which outlines the long history of racial violence and slavery that underpins the American pastoral. The entire undead assemblage culminates with Scott-Heron's black power vocal, intoning,

> *Who will survive in America?*
> *Who will survive in America?*
> *Who will survive in America?*

—a refrain that proves both the power of convention and its sheer provisionality. Thus, as cultural refrain, the zombie dance remains a significant form of construction and critique, a horizon of expectation and exhortation, a lively space of death and dissent.

Notes

1. For the earlier history of the zombie figure in its relation to migrant labor and the slave trade within Africa, see Comaroff and Comaroff, "Alien-Nation."

2. Here, my argument draws on Michael Taussig's astounding observations in *Mimesis and Alterity: A Particular History of the Senses.*

3. See excellent commentary in Ed Cameron, "The Voice against the Voice"; Amy Fass Emery, "The Zombie In/As the Text"; Annette Trefzer, "Possessing the Self."

4. See, for example, G. W. Hutter, "Salt is not for Slaves"; Inez Wallace, "I Walked with a Zombie"; and Charles Birkin, "Ballet Negre," all in Peter Haining, *Zombie!*

5. Qtd. in Lynskey, *33 Revolutions Per Minute,* 244.

6. See related commentary in John Corbett, *Extended Play*, 20ff.

7. See Jackson's revealing 1999 interview with MTV, "MTV: The 100 Greatest Music Videos Ever Made": http://www.youtube.com/watch?v=b_VmQzVF-CI.

8. See my related work on Elvis and the "vocal drive" in *Sweet Air*, chapter 4.

9. "Thriller," performed by inmates of the CEBU Provincial Detention and Rehabilitation Center, http://www.youtube.com/watch?v=hMnk71h9M3o.

SETH MORTON

Euretē moi he entolē hē eis zoēn, autē eis thanaton.
(And the commandment, which was ordained to life,
I found to be unto death.)

Saint Paul

Biohorror: Skepticism or *Kynicism*?

Carl Grimes, the cowboy-hat-wearing son in *The Walking Dead,* gives
his father, Rick, a cold reminder about the world they live in: "The cos-
tumes, the candy—everyone walking around, acting like nothing is
happening around them. They're all stupid. The roamers [zombies] don't
go away because you can't see them. I hate this place, Dad. It doesn't
feel real. It feels like everyone is playing pretend. . . . I don't want to get
used to this. It will make us weak" (Kirkman 16). This cynical political
philosophy—more "pragmatic than argumentative"—marks Carl as a
member of Generation Zombie (Žižek, *Sublime Object* 29). Unlike the
adult survivors in his group, he barely remembers a world before zom-
bies, harboring no idealistic nostalgia about "recreating" what once was.
In *Critique of Cynical Reason,* the German philosopher Peter Sloterdijk
describes the new generation of late twentieth-century cynics as those

*If we can't hope for control
—let alone influence—
we might as well survive in
spite of the brutal biohorror.*

who understand "that things must first be better before you can learn anything sensible. . . . Basically, no one believes anymore that today's learning solves tomorrow's 'problems'; it is almost certain that it causes them" (xxix). Slavoj Žižek derives his signature concept from this zombified version of political reason: "they know very well what they are doing, but still, they are doing it" (*Sublime Object* 29). In this regard the cynicism present in zombie texts touches on an important political question: what does it mean to have a politics after a better, more reasonable world no longer retains credibility? This problem in turn concerns the existential contours of a world that is consensually shaped for a zombielike aimlessness in which *they know very well that they're becoming more and more like zombies, but still they are doing it.*

As Sloterdijk observes, cynicism is an essential feature of the modern political landscape. His formulation of cynicism as *enlightened* false consciousness goes a long way toward explaining how politics work once zombies are in the majority. The skeptical inability to make politics with zombies, to refigure what a zombie means in political terms—that is, if it can be a person or not—trades on the cynical belief that zombies are by definition ruined for and thereby barred from political life. Thus, Carl-like cynicism also serves as a kind of nihilistic pragmatism: if we can't hope for control, let alone influence, we might as well survive in spite of the brutal biohorror. That said, one may first have to suspend cynicism in order to begin to understand the living death of a political situation that presumes enlightened false consciousness as a given.

At the beginning of his seminal work, *Homo Sacer: Sovereign Power and Bare Life* (1998), Giorgio Agamben, the contemporary Italian

philosopher, invokes two definitions of life: "*zoē,* which expressed the simple fact of living common to all living beings (animals, men, or gods), and *bios,* which indicated the form or way of living proper to an individual or a group" (9). Just as there can be no single term for life, there is seemingly no single term to express what we mean now by the word *zombie.*[1] Formerly, two terms were used that are semantically, morphologically, and folklorically different: *zombie,* which expresses the horror of living dispossessed of a soul, and thus lost to the gods, and *ghoul,* which indicates an improper relationship between eating and death—that is, the charnel-house buffet. The proliferating names for the animated corpses still populating pulp fiction and B movies, comic books, and video games speak to an exhaustion of "life itself" for thinking—life as a means of thematizing plenitude, delimiting lack, or demarking everything else in between. Efforts to qualify and distinguish modes of life and non-life, to erect taxonomies of quasi-life, are directly related to the horror of skepticism, a horror of the unknown at the heart of the presumption of life. The message hovering around zombies is that the experience of living may afford no wisdom about what it means to live.

This chapter not only draws on the theoretical concept of biopolitics to help shed light on fictions about the walking dead, but it also follows the zombie turn into the discursive field of biopolitics to show how biopolitics and zombie theory might be productively intertwined.[2] Biopolitics can be loosely understood as a concept of political power that developed in the wake of Michel Foucault's critique of sovereignty. In Foucault's own words, biopower "is the power to make live. Sovereignty took life and let live. And now we have the emergence of a power that I would call the power of regularization, and it, in contrast, consists in making live and letting die" (*Society Must Be Defended* 247). In

biopolitics the revenant of sovereignty lives on in a different, often diffuse guise. When read biopolitically the zombie pushes politics beyond its limits, highlighting the ways technicity, temporality, and a logic of autoimmunization dominate a political world once the idea of life has been conceptually undermined. In order words, the figure of the zombie sets in motion and thereby allows us to explore a set of biopolitical vectors, providing an axis for speculative biohorror.

Yet, before taking on the zombie as biopolitical subject matter par excellence, let's shore up our fortifications by taking a look at how the discourse of biopolitics has "evolved" in the last fifteen years. After Foucault the formative text is Agamben's *Homo Sacer*, which, as it deploys assorted feats of classical erudition, draws together insights from the idiosyncratic German-Jewish critic and philosopher Walter Benjamin and the rogue German political theorist Carl Schmitt:

> The principle of the sacredness of life has become so familiar to us that we seem to forget that classical Greece, to which we owe most of our ethico-political concepts, not only ignored this principle but did not even possess a term to express the complex semantic sphere that we indicate with the single term "life." Decisive as it is for the origin of Western politics, the opposition between *zoē* and *bios*, between *zēn* and *eu zēn* (that is, between life in general and the qualified way of life proper to men), contains nothing to make one assign a privilege or a sacredness to life as such. Homeric Greek does not even know a term to designate the living body. The term *sōma*, which appears in later epochs as a good equivalent to our term "life," originally meant only "corpse," almost as if life in itself, which for the Greeks was broken down into a plurality of forms and elements, appeared only as a unity after death. (*Homo Sacer* 42)

Situating biopolitics at the limit of life and death, Agamben defines the conceptual ground rules for undead political theory. He forces

a field-defining question at the heart of all biopolitical and zombie thought today—namely, is every kind of biopolitics necessarily thanatopolitics? Does the inclusion of "life" as a political category inevitably lead to the administration and management of death? If we were to maintain Agamben's *doxa,* then the answer is a resounding yes. Agamben has become such a lightning rod for biopolitical debate because of a certain rigidity in an analysis in which the Nazi death camp comes to epitomize conditions of the modern liberal state. When life becomes a category of political administration, death must soon follow.

Yet the pressing political stakes in Agamben's work obscure the technological origins of the biopolitical substrate. For Foucault, the possibility of biopolitics, and even the concept itself, is first and foremost a set of technologies beyond good or evil. Agamben essentializes the ambivalence inherit in this technicity by structuring a first philosophy that derives its power from language: "Politics . . . appears as the fundamental structure of Western metaphysics insofar as it occupies the threshold on which the relation between the living being and the *logos* is realized" (8). Here, as in his famous discussion of bios and zoē, the constitutive structure between politics and metaphysics is language, and the suggestion, as in any first philosophy, is that redefining the terms of life would precipitate into a different formation of the biopolitical. In the Foucauldian trajectory, as well as with Sloterdijk and the present study, the stakes are much more ambivalent. Never mind that Agamben's own etymologies have been called into question,[3] the absolute correlation between language and being makes meaning itself a blind spot that never stabilizes in the way it needs to for Agamben's purposes. He rightly gives importance to *homo sacer*—the body that is both sacred and killed with impunity—as a category that exists as an excluded inclusion, but his own methodology comes up short in managing the very terminological variance that he helped introduce.

Moving beyond Agamben, and drawing on insights from Jacques Derrida's late work in particular, important, contemporary biopolitical thinkers such as Roberto Esposito, Eugene Thacker, Martin Hägglund, and Cary Wolfe have attempted to develop a logic of life that does not rest on an appeal to a metaphysics of presence.[4] In such appeals, "life," like "truth," "being," or "the divine," readily stands in for the unexplainable. If the processes of modernity are set to the task of secularization, then "life itself" represents the latest site of resistance, a reactionary formation of "truth" that holds with it the promise of an enlightened future. Politics administer life in the same way that the Church administers the divine. But the reason we attack "life" is the reason we attack any formation of "truth": it marks the possibility for experience in the world and designates a limited possibility for political and aesthetic imagination. Beyond that, though, there is an even greater project: an ontology without metaphysics; in other words, an understanding of being and experience without recourse to a substrate such as "life," "science," or "truth"—that is, life made bare from the ideology of life. In Thacker's words, "What has gradually emerged is the idea of a life that is radically distributed and disseminated, both in terms of its spatial topography, and in terms of its temporal causality" ("After Life" 182).

Thacker's insistence on an idea of life that calls for a constitutive relationship between time and space underscores the connection between theories of life and recent work by Hägglund on Derrida:

> The arche-materiality of time follows from the structure of the trace. Given that every temporal moment ceases to be as soon as it comes to be, it must be inscribed as a trace in order to be at all. The trace is necessarily spatial, since spatiality is characterized by the ability to persist in spite of temporal succession. Every temporal moment therefore depends on the material support of spatial inscription. . . . Without

temporalization a trace could not persist across time and relate the past to the future. Accordingly, the persistence of the trace cannot be the persistence of something that is exempt from the negativity of time. Rather, the trace is always left for an unpredictable future that gives it both the chance to live on and to be effaced. ("Arche-materiality" 270)

Hägglund's rendition of Derridean materialism points to an understanding of life that is entirely dependent on a reanimating force—the trace—that automatically and necessarily constitutes being with its opposite. Life is always inscribed in death. This way of thinking about the "undead" as co-imbrication marks how the power of life/death persists in objects of transmission and contagions of experience. It is at this moment that the zombie shambles out of the corner as an autoimmunitary terror: life turned spectacularly against itself in its efforts to protect and sustain itself.

Derrida first uses the idea of autoimmunity in his analysis of religion and science in the essay "Faith and Knowledge," his point being that while religion and science appear as opposites, they both use the fundamental logic of the other in order to continue. More urgently, Derrida uses this logic to analyze politics after the attacks of September 11, 2001. In 2003's *Philosophy in a Time of Terror,* he advances the autoimmunitary paradigm to suggest that the very political and economic structure that built the West always contains the possibility of turning against itself in acts of terror or political transformation. "Here is the first symptom of suicidal autoimmunity," he writes, "not only is the ground, that is, the literal figure of the founding or foundation of this 'force of law,' *seen* to be *exposed* to aggression, but the aggression of which it is the object [...] comes, *as from the inside,* from forces that are apparently without any force of their own but that are able to find the means, through ruse and the implementation of *high-tech* knowledge, to

get hold of an American weapon in an American city on the ground of an American airport" (95; italics in original).

The much observed resemblance between zombies and viruses conceals a similar biopolitical thesis. In zombie texts, transmission and continuation are contained within—even as they violently oppose—human life. Zombies thus signal not viralism as much as the constitutive death/life structure of autoimmunism; in a classically Derridean fashion, they designate autoimmunity for death from life and vice versa. Hägglund's insistence on the status of the trace as a form of transmission and continuation (as opposed to being ontological or theological) is operationally ambivalent; it is neither good nor evil, but describes and explains the necessary conditions for change itself, for what it means to be exposed to "an unpredictable future." More than a cute cipher for decoding Derrida, autoimmunity comes into its own as a router between political, ontological, and existential imperatives. Thus, the stakes and conceptual dynamics of autoimmunity need to be drawn out carefully. Provisionally we can say that the concept speaks to a certain undead potential for self-destruction, a potential that is inherent in every individual or community to turn against itself from within. If Agamben revolutionized thinking about life by introducing two forms in the mode of bios and zoē, then the discourse of autoimmunity helps us to understand how beings and communities traverse from one form to another. Romero puts this point in an all too obviously tragic light at the end of *Night of the Living Dead:* Ben's greatest enemy was never the zombies; rather, it was the white posse commanding sovereign power that can't distinguish him from a zombie in the end.

If Thacker, Derrida, and Hägglund find common cause in autoimmunity as a necessarily contradictory impulse that allows something like life, the community, the body, or the political to emerge and

continue, then Esposito's work in *Immunitas: The Protection and Negation of Life* (2011) and *Bios: Biopolitics and Philosophy* (2008) can be understood as an attempt to ground this general principle in a formation that would allow for an affirmative biopolitics, a biopolitics that would not necessarily slip into a thanatopolitical—or death-driven—regime. The impulse behind this work is to augment the set of terms that Agamben introduced without falling into the specific philosophical quandary that Agamben dug himself into. Esposito thus attempts to think apart from the metaphor of a self-present "body" (and the attendant ideological trappings that scale into a "body politic") in favor of what he calls "flesh," a materiality that is neither dead nor alive and that in principle cannot be contained through the discourse of a body. Wither the self and its imaginary construct of unity, and hail the flesh as a "universal weave" for thinking about a life that is thoroughly embedded in political and ecological systems. Here, life is strictly managed and controlled through political access. For Esposito, flesh is about community (or, as he has it, "co-immunity"), and his interest in biomedical science is motivated by a universal communitarian impulse to survive.[5]

The impasse between negative and positive biopolitics helps to explain the popularity of zombies in popular culture. Both zombies and biopolitics occupy disturbingly similar worlds in which life is mostly a target for skepticism and cynicism. In an era where all strategies of resistance to the forces of biopower and technologies of the self appear to be foreclosed from the outset, the zombie text offers what appears to be an ultimately conservative fantasy: a small community of survivors can barricade themselves from the onslaught of the population and remain safe, for a time, in a protected space of domesticity. The politics of zombie worlds are foremost biopolitical in the way they address the need for a community to form and create a zone of immunitary

protection: boarding up the house or shopping mall from any potential threat. This reading of zombie biopolitics makes sense of the oddly brightening arc of the Romero trilogy; the latter attempts to assert bios and zoē as co-implicated terms, from dusk till dawn and the day after following the extinction event. The zombie is increasingly used as a tabula rasa for understanding human behavior (the laboratory scenes in *Day of the Dead* or the second and third seasons of *The Walking Dead*, for example), while humans constantly resort to barbarism when faced with the breakdown of political order. As a whole, these films ambulate around a cynic's appreciation of the radical way that the human and zombie cohabitate in a world of flesh.

Following Hägglund's and Thacker's leads, then, I propose that the zombie is a form of thinking and being itself, an analogical substrate that is able to coordinate a web of thinking about life in order to better flesh out the stakes of biopolitical thought in the wake of an autoimmunitary paradigm. Operating alongside any logic of "bare life" is also a constitutive structure of shared exposure, an exposure to a radical mutability, whether it is radiation or zombie plague that gives any form of life its name. Thus, in order to clarify the autoimmunitary paradigm that connects zombies and humans, it is important to trace the ways that both autoimmunity and zombies rely on forms and strategies of transmission. In what follows I explore how the zombie logic positions itself between two antithetical versions of biopolitics, the first associated with Agamben's insistence on a thanatopolitical drift and thus an unstable metaphysics of presence, and the second, derived from Derrida, associated with a kind of ambivalent system of autoimmunization that destroys itself in order to expose itself to a different set of possibilities. One way to conceptualize autoimmunity is as a kind of miscommunication by oneself to oneself; zombie *kynicism,* in the same way,

hinges on the committed belief that the zombie is a human stripped of its communicative powers and all that remains is an angry mob of miscommunication. This co-constitutive yet awkwardly communicative structure of transmission is what allows the autoimmunitary paradigm to produce a being without ontology and a time without temporality, and thereby points to a different kind of politics altogether.

"We are all infected"

The zombie, according to Rick Grimes, is the final destination of us all—both the living and the dead. Romero's rules apply. That's the secret: everyone who dies, whatever the cause, comes back as a zombie. Instead of platitudes, Rick offers a powerful paradigm for zombie studies, a force field for rethinking the ontological difference between the human and the nonhuman other. "We are all infected." As this secret was being concocted on the show, a spike of interest in zombies occurred in the "real world." After the headquarters of a *fictional* Centers for Disease Control self-destructed in the final episode of the second season of *The Walking Dead*, the *real* CDC decided to use this development as a "teachable moment," publishing a mock preparedness guide for a zombie apocalypse on its blog: "You may laugh now, but when the zombie apocalypse happens you'll be happy you read this, and hey, maybe you'll even learn a thing or two about how to prepare for a *real* emergency" (Khan). *You know very well that you're really becoming more and more like zombies, so here's how to prepare for a real emergency.* Wink, wink.

The CDC's itemized list is followed by a reassuring statement that the U.S. federal agency charged with disease control and prevention would do everything it could to investigate, control, and eventually

break the cycle of transmission in the event of an actual zombie apocalypse. Insofar as this marks the moment when the cultural phenomenon of the zombie took over the government, it also marks the moment when biopolitics reaches a level of excess that it could no longer maintain the quarantine between fictional and real worlds. Ironically, as the real CDC stupidly proclaims its willingness to learn nothing from the TV show about the ubiquity of zombie biohorror (ensuring us that when the real zombies come, we will at last be able to see government research prove its real uselessness), the logic of infection falls out of the fictional zombie once and for all. This neatly highlights the way that the zombie has come to mean something more than a flesh-eating undead monster.

To be fair, the zombie necessarily organizes a biopolitical horror, an image of out-of-control population rendered in a monstrous form.[6] It pressures the constitutive structure of life and makes visible its own horde as an emblem of modernity and a site of strategic thinking about the administration of life. In other words, it makes life/non-life its theme, rewriting the terms through which something like life or politics can be thought or talked about. As Thacker writes, "The swarm is distributed and horizontal, but also driven by an invisible, intangible life force—'life' is at once transcendent and immanent to its particular manifestations. Something drives the swarm, but this something is also nothing—at least nothing that stands above and apart from the singular phenomenon of the swarm itself" ("After Life: Swarms" 182). The zombie is thus inhuman in the way it appears organized by an intangible life force that is not dependent on an enclosed body. However, as a reflection of the human in a diminished capacity—a reflection evidenced in the way that survivors routinely treat zombified friends and family members with a fundamental skepticism toward their status as nonhuman other—the zombie introduces this inhuman characteristic of life into life itself.

This co-implication of zombie "life" (life as transmission and continuation) and human "life" (the ideology of transcended experience) makes visible how the CDC's fanciful operating procedure doubles down on many of the conceptual pitfalls that come with thinking through zombies or biopolitics, pitfalls that in both cases stem from their respective overburdening as allegorical and conceptual tools. Thinking life or death—thinking biopolitics and thanatopolitics—would appear irrevocably fated to become a discourse of banal truisms or life philosophies.[7] While these frames of analysis usefully describe how systems of governmentality understand and operate vis-à-vis a human or nonhuman other—the move that turns zombies into a free-floating metaphor or alternatively turns biopolitics into a strategic collection of tactics toward and within government—they rush over the constitutive terms and logics that allowed these theoretical frameworks to become visible in the first place.

To be sure, the theoretical limit most often deployed for thinking about the zombie is Agamben's division of life into bios and zoē. This division explains why and how the zombie lends itself so readily to allegorical thinking about the dialectics of the privileged and the marginalized. The zombie, of course, supplies a version of "bare life" that usefully illustrates a series of problems that emerge when life is classified into structured taxonomies about the proper and improper. What becomes more and more pronounced across the Romero zombie saga (epitomized in the insurrectionist stirrings led by Big Daddy in *Land of the Dead,* for instance) is how the zombie—by becoming more than zombie—pressures the Agambenian notion of "bare life." The all-too-neat human/zombie split, reproducing the division between proper and improper life, doesn't hold. Again, "We are all infected." The inhuman threat of zombie undeath already in-forms human life through a reciprocal identification that is always hidden in the open. To be a zombie or

not to be a zombie is always only a matter of time and absolutely nothing more. This stark dichotomy, where the only choice is no choice, reveals a fundamental blind spot that a system of life/bare life or human/zombie life creates: *to what form of being is this system tethered*? The zombie as life's final formation suggests that it is tied to both of these equally and thus necessitates a mode of analysis that can understand how that tethering floats between two things that always appear as opposites. Furthermore, when the conceptual purchase of the human inexorably erodes, life increasingly appears as the exceptional state for the protection of mere matter, whereas horrific death is increasingly disclosed as the vehicle for the posthuman critique.

Autoimmunity and Zombie Technicity

The nihilistic pressure that the zombie places on life complicates temporality. The impossibility of finding the answer to infection through etiology instantiates a double bind on both past and future horizons. As such, zombie texts (usually) begin and end in medias res, the world's population locked in a never-ending struggle against (inevitable) zombification. The common commitment in these texts is an understanding of temporality that is organized around neither a single Archimedean point in history nor through the coming of a universal event worthy of the name. Neither apocalyptic nor postapocalyptic, the zombie text goes beyond and before such temporal schema and looks more like what Derrida has described as a "politics to come." For Derrida, this notion of politics "would be more in line with what lets singular beings (anyone) 'live together,' there where they are not yet defined by citizenship, that is, by their condition as lawful 'subjects' in a state or legitimate members of a nation-state or even of a confederation or world state. . . . It does

require another thought and another putting into practice of the con-
cept of the 'political' and the concept 'world'" (Derrida et al. 130–31). At
issue for Derrida here is how the idea of the impossible event demands
a reconfiguration of the political body toward the radical possibility
of an event to come that is itself impossible to formalize. The demand
that this event puts on the community is a complete reconfiguration
of the "body" as a stable and indivisible structure. Despite the radical
and apocalyptic valences of zombie films, the rise of the zombie body
is not an event in the properly Derridean sense of the term, because its
operations are always already co-inscribed within the experience of the
survivors themselves. As a paradigm for biopolitical thinking, then, the
zombie speaks to a kind of radical porosity, where the inside is always
radically exposed to and indeed indistinguishable from the outside.

 That the zombie designates autoimmunity within life—a trans-
mission that has always already occurred—gets out their capacities for
transmission and continuation, spreading from here to there, from text
to text, manifesting all over. Zombies zombify everything. In this they
resonate with Thacker's notion of swarm life. Part of the swarm char-
acter of zombies means the biohorror of ubiquitous banality—undeath
everywhere by routine. Zombies, in this way, point suggestively to the
nagging presence of an inhuman technical substrate, a required con-
taminant in-forming life. The key tension for this autoimmune struc-
ture exists between a notion of a properly human and natural commu-
nity and a kind of vital technicity, epitomized by the zombie, that tends
to destroy as it preserves the former. "Becoming zombie" consequently
seems less about freedom/autonomy than about rethinking the para-
digm of life around issues of technology and community. The undead
operate in the service of life by conditioning the set of possibilities for
what it means to live. Zombies therefore become a horizon of finitude,

against which human life organizes itself, yet the anti-life of the former is paradoxically implicated in the powers of life that the latter seek to preserve. If this horizon is understood in a merely temporal frame, then zombies as a homogenizing force enact a compression of the natural history, an entropic drift run completely amok.

This temporal structure allows the zombie to be thought of in relation to Derrida's event "to come." The zombie horde as an immanent and radical modulation of inhuman swarm life portends the absolute end moment of a certain structure of temporality inaugurated through the generation of the community. The swarm as decentralized chaos is not only a reconfiguration of communal organization, for it is itself already inscribed in the community through the very way the survivors are conditioned to operate through a system of transmission, technology, and death—in short, they are forced to act in the service of the thing their community attempts to exterminate. Life is therefore always already organized around and acts in the service of death. Derrida says so much of the two sources of religion and science in "Faith and Knowledge" (life/health, on the one hand, and death/technology/transmission, on the other) as they are inscribed mechanistically within the source of life: "everything that binds the tele-technoscientific machine, this enemy of life in the service of life, to the very source and resource of the religious: to faith in the most living as dead and automatically surviving, resuscitated in its spectral phantasma, the holy, safe and sound, unscathed, immune, sacred" (84).

With zombies, death is mechanistically vitalized. Never stopping, never available for revival, zombies are *kynically* immortal. Neither human nor nonhuman, the zombie presents the human driven to continue in its own extremity in a diminished capacity. Human and zombie exist on a continuum organized by different degrees of immunization that

always eventuate into a moment of autoimmunity—necessary insofar as every act of immunization necessarily risks misrecognizing itself as the threat that needs to be exterminated. From the position of the zombie, the human threat is immunized by consumption and transformation; from the position of the human survivor, the zombie threat is immunized by killing zombies or retreating behind barriers. In both cases, though, death and transmission are wielded as tools of immunization that become forms of suicidal autoimmunization. Autoimmunization cuts both ways but doesn't pit life against death; each entity in its own way acts in the service of maintaining the division between life and death. Thus, instead of thinking of zombies through the valence of a proper form of life, this system of immunization always produces an autoimmunitary valence where zombies are not merely a form of human life turned against itself, but rather a formation of transmission, tele-technicity, decentralized control, and flesh turned against itself. In the name of the survival of the community, the humans are forced to participate in their own form of zombification vis-à-vis this logic of transmission, technicity, and death.

The autoimmunitary paradigm makes sense of the zombie as a cipher of biopolitical thought that separates life from moral frameworks. The zombie as autoimmunization escapes the binarism between human/zombie, life/death, bios/techné and imagines instead a different sort of conceptual apparatus. This autoimmunitary valence finds its form in Derrida's rendition of autoimmunization as a machinic function that opens a community up to new possible energies and dynamics:

> Community as common auto-immunity: no community [is possible] that would not cultivate its own auto-immunity, a principle of sacrificial

self-destruction ruining the principle of self-protection, and in this view some sort of invisible and spectral survival. This self-contesting attestation keeps the autoimmune community alive, which is to say, open to something other and more than itself: the other, the future, death, freedom, the coming or love of the other, the space and time of a spectralizing messianicity beyond all messianism. (Derrida et al. 87)

Autoimmunity, for Derrida, begins with the community's attempt to form itself; this attempt at closure always fails and necessarily exposes the community to an outside. A necessary mutability within the community exposes the community, from within, to a threat of change. Zombie biopolitics shot through with an autoimmunitary logic exposes the zombie to a discourse where life, health, and the community are not understood as ultimate values, but rather as concepts that are presupposed with a sense within a mechanistic vitality that imbues them with a specter of death and transmission. At the same time, imagining biopolitics through the zombie exposes biopolitics itself to something other than itself, to an idea of the political that is organized around autoimmunity rather than through a metaphysically charged idea of life itself.

For Derrida, this highly reflexive, creative, and destructive force is neither positive nor negative, but rather best understood as a phenomenological description that addresses the dynamics that are necessarily put into play in the fallout of a metaphysics of presence. The zombie as a limit case for a cultural imaginary's rethinking of death and transmission becomes a biopolitical object in the way it forces one to reconsider what can be thought of as political in an era when the discourse of the "body" is shot through at any and all scales with explicit and implicit political possibilities. Specifically, the zombie points to a biopolitics of a mechanistic life and community, to the way that survivors are forced

9.1. Seeking immunity in *Night of the Living Dead* (1968).

to reconcile with a set of realities for which there is no institutional or properly political frame of reference. Romero's films and zombie texts at large are therefore obsessed with borders, walls, and boarded-up rooms that are always improper transformations. A road is blocked, a window is boarded up, systems of access become safe zones or quarantines of enclosure.

Imagining zombie autoimmunity through the idea of transmission offers a more specific way to think about the biopolitical paradigm that zombies put before us. Specifically, transmission can be understood,

following Derrida's analysis of technology in "Faith and Knowledge," as an outward movement that always exposes the immunized community to some new threat or new potential energy. In zombie texts, transmission is thematized through two media: radio and television, on the one hand, and flesh, on the other. First, the survivors use radio and television broadcasts in their attempts to gain knowledge of the zombie apocalypse and coordinate escape plans. Johnny, Barbra's fated brother in *Night of the Living Dead,* makes an important discovery about transmission just before he utters his famous line, "They're coming to get you, Barbra." Still in the car, he hears on the radio, "We're coming back on the air after an interruption due to technical problems." Apparently the radio was always on, but the station wasn't transmitting anything but dead air. It's at this moment that the soundtrack swells with an ominous tone. It is this moment of transmission malfunction that reveals the genre of horror.

Romero revisits this dynamic in *Dawn of the Dead,* which opens in a television studio during the chaotic opening act of the zombie apocalypse. As the state of emergency unfolds in real time, the protagonist Francine, a TV producer, must decide whether she should broadcast old—or "dead"—information about medical evacuations. Her producers want her to broadcast the old information simply for the sake of keeping the public calm, but in a moment when she realizes the dynamics of making live and letting die, she wipes away the old information and abandons the transmission room. What ought to be signaling is not, and those who shouldn't do so—the dead who now walk the earth—transmit without restraint. Besides staging the fundamental chiasmus of life/death and transmission/reception, these scenes speak to the fundamental exposure of all things within a system of communication. There was no signal, yet Johnny and Barbra were always exposed to the

possibility of a signal. This exposure to the possibility of communicability is formalized in the way transmission stages an interface between kinds of flesh.

Transmission through flesh occurs via the zombies themselves. In *Immunitas* Esposito links the desire to incorporate a political entity into a body to an originary difference occurring on the level of flesh. The burden of his treatise is to rethink the dynamics of the body through a structure that doesn't come part and parcel with all the ideological compromises that are implicit in a unified, sovereign "body." Accordingly, flesh is the technical element that escapes complete incorporation to a body: "Flesh is nothing but the unitary weave of the difference between bodies. It is the non-belonging, or rather the intra-belonging, that prevents what is different from hermetically sealing itself up within itself, but rather, to remain in contact with its outside" (121). The zombie is the monstrosity of flesh, a radicalized form of incorporation that produces flesh without a body proper. The entire pile—all innards, no outsides—represents an indefinable heap of waste with no internal or external borders. It messes about the formation of community with its uncanny swarm intelligence, fording rivers, for instance, in Romero's *Land of the Dead,* or scaling border fences in *World War Z.* If flesh, for Esposito, marks a threshold of nonidentity that is simultaneously "the way of being in common of that which seeks to be immune" (121), its entropic physical drift echoes that forming and reforming zombie horde, which incorporates without digesting. The zombie horde remakes the tension between flesh and bodies: what it consumes is also what resists incorporation into its body, and thus it always risks its own expulsion. In this register the flesh is found on the side of the humans, yet the zombie, as a decentralized, massified swarm, is nothing more than a transmitting interface between different kinds of living and nonliving flesh. So

much physics leaves a strange crypto-metaphysical remnant. That zombies are waste that do not produce waste (that they seem to consume without physical need) speaks to how they stage a radical reduction of a body to nothing less than a locus of flesh with a drive to receive more flesh. Zombies do away with any idea of futurity, making them the death of death, the ultimate monstrosity, a vision of the last man, the absolute end of history, and therefore an exploratory space for the ever present threat of thanatopolitics that appears equally in Romero's world as the zombie horde or, for Ben at least, as a mob of trigger happy yokels.

The zombie produces repetition without a difference, materializing Derrida's horizonal limit of messianism that biopolitical thought seeks to overcome by negotiating the transformation of bios into Thanatos. While Esposito uses flesh to weave the immunitary logic into a shared desire for immunization, the flesh of zombies attunes this idiom more precisely to a thematic of transmission and exposure. As humans it's easy to sympathize with the survivors and their flesh, and to perceive the zombie as a radical evil, which eradicates and fulfills the time of history, but contrary to Derrida's view, what truly makes zombies a radical evil is the way their mechanisms of exposure and transmission is always already inscribed through human tele-technicity. The critical challenge is to critique from a perspective that acknowledges that zombies aren't real, that they're nothing more than a theoretical substrate for thinking. The practice of biopolitics vis-à-vis the zombie wagers that there is more to gain through analyzing the concepts that underpin the phenomenon of the zombie than by translating it into a metaphor for an object of biopolitical thought. In this regard the final analysis of an undead biopolitics uses an autoimmunitary paradigm to cultivate a certain kind of exposure in order to survive.

It is in this spirit that we are all the walking dead. Derrida's rewriting of the eternal, the safe and sound, the holy, the indemnified boils down

to an analysis of survival. According to Hägglund's reading of salvation and survival in Derrida: "We must therefore distinguish between salvation as immortality and salvation as survival. The religious idea of salvation as absolute immunity is necessarily an idea of immortality, since every mortal being is autoimmune" (*Radical Atheism* 130). Turning away from the religious, survivalism inscribes a logic of finitude and death into its core. Hägglund continues: "My argument, however, is that Derrida's notion of the messianic without messianism follows the radically atheist logic that we traced in his notion of the *salut* without salvation. A radical atheism cannot simply denounce messianic hope as an illusion. Rather, it must show that messianic hope does not stem from a hope for immortality, but from a hope for survival (the negative infinity of time)" (136). In the zombie world the discourse of the "survivors" becomes absolutely crucial. Survival names the process by which an individual or a community necessarily exposes itself to the vicissitudes of time. The zombie world is the system through which a logic of survival is forced to confront the dead in order to point itself toward justice. In other words, survival means dealing with the dead, the inheritance of history, before necessarily succumbing to the very forces that one struggles against. As Derrida writes in *Specters of Marx,* "To exorcise not in order to chase away the ghosts, but this time to grant them the right, if it means making them come back alive, as *revenants* who would no longer be *revenants,* but as other *arrivants* to whom a hospitable memory or promise must offer welcome . . . not in order to grant them right in this sense but out of a concern for justice" (175; italics in original). In this complicated chiasmus, justice is served by welcoming the unwelcome and by making the dead alive by exposing the past to the mutability

Neither human nor nonhuman, the zombie presents the human driven to continue in its own extremity in a diminished capacity.

of time. Similarly, the zombie figures the question of life according to an inhuman life principle that is always and in all cases dependent on a set of contradictions. Thus, the evolution of the zombie genre, which is deeply haunted by objects of burial, helps us situate the dynamic scope of biopolitical thought. The specters of history that haunt the survivors appear themselves as a scalar monstrosity. The struggle for survival has less to do with management of the population than with the founding of a community that is best able to deal with the radically scalar body that massifies everything. This survival is dependent on a community that is no longer grounded on a concept of life or politics in the proper sense. Rather, the zombie keeps the community on the move and moves the biopolitical onto a phenomenological substrate of now radically mobile notions of life, technology, and community itself.

Notes

1. My appropriation of Agamben's famous opening to *Homo Sacer* is meant to suggest that popular genres have been fostering biopolitics avant la lettre for well over a hundred years. The Greeks may have observed the unity of life only after death, but death itself isn't what it used to be, and, pace Agamben, what increasingly fails to appear as a unifying force after life is death itself. In this regard recent theoretical work on these questions by a new generation of thinkers who spin off of Jacques Derrida, such as Eugene Thacker, Martin Hägglund, Ray Brassier, and Roberto Esposito, provides a crucial leverage point for biopolitical thinking, because its efforts are to question the fundamental assumptions and logics that would even allow a concept like life—and, more pointedly here, death—to be introduced into something like a contemporary political discourse. This study finds important contact points in Eugene Thacker's work in *After Life* and *Dark Theory* as well as Martin Hägglund's reading of Derrida in *Radical Atheism,* in addition to Derrida's seminal treatments of politics and life in essays like "Faith and Knowledge," *Philosophy in a Time of Terror,* and *Rogues,* as well as Roberto Esposito's positive biopolitics evidenced in *Immunitas* and *Bios.*

2. The term *biopolitics* was first introduced by Michel Foucault in his lectures *Society Must Be Defended* (1975–76); *Security, Territory, Population* (1977–78); and *The Birth of Biopolitics* (1978–79). It names a theoretical field that thinks through how

notions of life and death are understood and administrated through modern systems of power.

3. Consider Laurent Dubreuil's magnificent and sometimes devastating "Leaving Politics: Bios, Zōē, Life."

4. Zombies help us split the difference between a biopolitics that is based on an ambivalent bureaucratic technicity or on a crypto-vitalist first philosophy emphasizing the crypt. They do this by underscoring the important conceptual work that the immunitary paradigm plays in modern critical theory. Roberto Esposito's investment in the theory of immunization and autoimmunitary represents the most recent attempt to create a logical frame that can account for the ways Foucault and Agamben have opened up the biopolitical. Timothy Campbell's introduction of Esposito in America through Esposito's *Bios* (2008) and Campbell's own *Improper Life: Technology and Biopolitics from Heidegger to Agamben* (2011) use the logic of autoimmunity, first introduced in theoretical discussion's by Jacques Derrida in "Faith and Knowledge" (1998), in order to move away from the terminological strictures that bind up Agamben's work. Whatever the promise an immunitary paradigm holds for the future of biopolitical theory, it allows for a rethinking of life, death, and transmission that sheds new light on the zombie as biopolitical monstrosity.

5. Esposito's rise of the flesh at the expense of the self might be a tacit argument for becoming zombie. Thought of differently, we might say that the question of biopolitics raises a set of complications that cannot be addressed or understood on the side of politics proper and one that might be better suited for thinking alongside a cultural interest in the undead. Most treatments of biopolitics are quick to point out obvious ways that life and politics are merging through stem-cell research, mass farming, oil and gas demands, pharmaceutical and health care policy, and the like. While it seems abundantly clear that ours is an age when the modus operandi is, in Foucault's words, "making live and letting die," the scalar totality of biopolitics intruding into the everyday experience of the world speaks to what Thacker has described as the "increasingly unthinkable" character of the world, which for Thacker necessitates the genre of horror as an attempt to think about this fundamentally unthinkable character. See Thacker's *In the Dust of This Planet*, 1.

6. Aaron Jaffe's chapter, "Zombie Demographics," in this book details how the zombie operates as a system of demographic monstrosity.

7. Timothy Campbell's fear, as expressed in the opening of *Improper Life,* that the "pernicious proportions" of biopolitics might foreclose the term's ability to stage a meaningful examination into the imbrication of life and politics seems finally realized. One version of zombie biopolitics is simply a reworking of neoliberal machinations; a world of risk management in the style of Ulrich Beck now turns its

gears toward another problem that it may or may not have produced. This operational system is found in equal measure in Maurizio Lazzarato's "From Biopower to Biopolitics," which understands Foucauldian biopolitics as a strategic relation of power in order to effectively manage the social body, and in Max Brooks's *World War Z*, which catalogs the oral history of the global zombie apocalypse as it is experienced on all levels of the social body. Both of these texts analyze on the level of social systems without recourse to the underpinning theory of life that makes this system appear as such. Lazzarato's essay is great for thinking about Foucault on a large scale, but the formation of biopower drops out of the analysis. On the other hand, Brooks's novel, a cunning pastiche of Studs Terkel's *Good War: An Oral History of World War II*, is a fictionalized ground-level account of a complexly administered, worldwide (and ultimately successful) technocratic biopolitical campaign but treats the zombie as any other generic global catastrophe. For Brooks, as the CDC preparedness guide suggests, the zombie threat is nothing more than another instance of a global phenomenon that demands the creative and collaborative forces of global and local entities working in tandem to manage the zombie threat.

ANDREA RUTHVEN

The corpse is death infecting life.

Julia Kristeva

While Julia Kristeva doubtless did not have in mind the undead corpse of the zombie when she wrote of the abject and how it forces death upon the living, the walking dead undeniably embody abjection. It is not strange, then, that in representations of zombies, in film, literature, television, or other media, the primary focus is on how the humans who have not been infected confront and battle those who have returned from the dead. Those who engage in zombie fighting are necessarily confronting and denying the death (among other things) that the posthuman monster represents. This analysis of Seth Grahame-Smith's *Pride and Prejudice and Zombies* (2009) looks at how the heroine of his contemporary novel is rewritten to be physically strong, capable of independence, and yet still chained to the necessity of finding the ideal mate that is the touchstone of the original Jane Austen text. The pervasiveness of postfeminism is apparent in the book as Elizabeth Bennet fights off the monsters even while the ideal end for her is to marry well.[1] Her education and the fact that she is one of the best in her field are subsumed under the ability to use these skills to secure a man. In fact, it is her very prowess in fighting the zombie offensive, her abilities with

a sword, and her capacity for killing that win her the esteem of those around her and garner her the greatest prize of all: Mr. Darcy, a rich and handsome (and equally well-trained) husband. Despite the fact that her militarized body and violence are constructed as being first and fore-most for the defense of herself and her loved ones, her finely tuned body *is* heteronormatively attractive, though this is presented as an added bonus, the result of so much training for the defense of others and not the primary motive for her training. Her body is of primary concern, especially because it is one of the principal tools in the fight against the zombie hordes. It contrasts starkly with the zombie body: where one is contained, in control, and integral, the other is messy, falling apart, and contagious. Arguably, though, the difference between the body of the zombie and that of the zombie slayer hides a more chilling similarity: that both raise the heteronormative necessity of eliminating the other.

From Whence It Came

The zombie, as a monster in films, novels, and legend, is an easily rec-ognizable figure. Even so, it is necessary to ask, as do Jen Webb and Sam Byrnard, "What is this thing called zombie? Although they are, of course, a fantasy, we know enormous amounts about them" (83). Worth acknowledging, however, is that what we now know as a zombie is a rela-tively new character in the horror genre. Indeed, there are three types of zombies, only one of which is frequently represented on screen.[2] While we are primarily interested in the contemporary manifestation of zom-bies, the flesh-eating ones that Elizabeth Bennet and her sisters must fight, it is worth briefly turning to one of the other two: the Haitian vodou zombie as the point of departure for the cinematic zombie.

Contemporary media manifestations of zombies are the direct de-scendants of the version found in George A. Romero's 1968 film, *Night*

of the Living Dead: a lumbering, slightly decomposing, autonomous consumer of human flesh and brains that is often used as a metaphor for the never-ending consumption of capitalism. These zombies, however, were not the product of spontaneous imaginative generation. Rather, they can trace their kinship to the zombies of Haitian vodou culture, in which the zombie is a person or reanimated corpse whose soul and free will are taken away. The result is that the "resurrected individual is deprived of will, memory, and consciousness, speaks with a nasal voice, and is recognized chiefly by dull, glazed eyes and an absent air" (Ackerman and Gauthier 474). Resurrected by someone, usually for the purpose of exacting labor from the reanimated corpse, the zombie is, for all intents and purposes, a slave to its master. This contrasts sharply with contemporary zombies, which are slaves primarily to their drives for consumption. Before Romero's film, then, the zombie was a different type of monster, one that he reworked and re-presented, giving rise to a new kind of cinematic horror. The shift from zombie as slave to zombie as "independent" being, however, is indicative of a shift toward the humanist model of choice and free will. This interpretation of the zombie as a being that satisfies its own desires, rather than those of its master, can be seen as paralleled by the postfeminist heroine and the rhetoric that considers (Western) women's ability to choose the products they will consume as demonstrative of their equality to men.

That the zombie as we now know it should be so closely tied to cinema is important because of the link often made between capitalist systems of consumption and zombie patterns of consumption; considering that the film industry itself is one form of capitalist consumption, the fact that the zombie is a product of it is telling. It is often used to critique the repetitive consumption championed by the capitalist model while at the same time being dependent upon it for its genesis. This symbolic function of the zombie, to critique the economic model that gave birth

to it, is analogous to the way Elizabeth chooses to ignore that it is her deeply constrained, zombie-fighting body that both entraps her within the patriarchal structure and could potentially liberate her from it.

The Zombie of the Self

Once we understand what the zombie represents, it becomes interesting to ask ourselves why there is such an imperative to fight against it; why not just run away? The first thing to consider is that there is no cure for the zombie plague; science cannot rescue us this time, because "the zombie apocalypse is one that allows for the success of no human ingenuity" (Ackerman and Gauthier 271). Rather, it "offers a wide array of examples of human attempts to overcome the onslaught of the dead, but to no avail" (271). This has become common knowledge for contemporary cinema-goers and consumers of zombie culture. Even Elizabeth Bennet, in *Pride and Prejudice and Zombies,* asserts that only the naïve place their hope in the development of a cure (125). With zombies there are really only two possibilities—slay or be slain—thereby creating an atmosphere in which all citizens are somehow militarized, requiring them at the very least to defend *themselves* if not others. Despite the nihilistic image painted by the realization that there is no solution and that the zombies will eventually prevail, the imperative to fight is strong. So what exactly is gained by fighting besides the continuance of a life of zombie slaying? The answer to this, I would argue (perhaps pessimistically), is to be found in the zombie itself, because the same drive that pushes the zombie to continue to find and feed off of human flesh is what pushes humans to continue to fight the zombie; as Christopher M. Moreman explains, "Just as the living fight for their lives, so too do the zombies strive for nourishment, both to no avail" (275). Both are automatic responses that can be neither controlled nor rationalized. The

zombies will not be eradicated by science or human ingenuity, and the only hope for the future of the human race is simply to continue killing as many zombies as possible, preventing them from reproducing faster than they can be eliminated. Moreman writes, "While survivors can usually outsmart the zombies and are able to physically handle a few at a time, attempts to destroy all zombies are fruitless as the horde simply keeps growing as more and more humans are transformed" (271).

But the horror of the zombie does not end here. They are also monsters that are frightening because they are constant reminders of what humans wish to forget—the incarnation of death—and the thin line that separates us from them is the very thing that also joins us to them. When faced with the zombie it becomes impossible to deny death, only to forestall it, because "they force death upon the viewer relentlessly. The horror of the zombie lies, to a large extent, in the realization that each of us will die regardless of what we might do to forestall it" (Moreman 273). The inescapable fact of death and the need to confront it when faced with a zombie is paramount. For Kristeva, the relationship of the self to the abject is one of mutual sustentation. The zombie, as the walking abject, is the constant reminder of what must be rejected from the self in order to survive. She argues, "If dung signifies the other side of the border, the place where I am not and which permits me to be, the corpse, the most sickening of wastes, is a border that has encroached upon everything" (3). For those who would fight the zombies, each slain object is the reaffirmation of the living body and the negation of death. In order to survive, to not give in to the abject, it is necessary to accept the zombified self that unreflectively pushes aside and attempts to eliminate the walking corpse.

The zombie cannot be rehabilitated, cannot develop a conscience and renounce its murderous ways or its very monstrosity, thereby enabling the heroine to fall in love with it. To quote *New York Times* writer

Chuck Klosterman, we find that "you can't humanize a zombie, unless you make it less zombie-esque." By combining these two points—there is no cure for zombies, and zombies are not lust objects—it is possible to arrive at the crux of the matter. During the apocalypse, zombies are the common enemy and must be killed to ensure self-preservation. There is no room for sympathizing with them or falling in love with them. They must be slain or you risk becoming one of them.[3] Even though it is necessary to kill them, doing so engages one in a rote activity, one that becomes almost mechanized. Because they are the mass of evil that always has to be confronted but never individuated, fighting the zombies is akin to being a zombie. There is no consideration of the act of slaying, only the repetition of the need to kill without reflection. What is being defended is the social order that comes under attack from the undead hordes, with the end goal being that of protecting as much as possible the pre-zombie way of life. The ability to fight zombies day after day, all the while knowing there is no cure and no end in sight, requires that the still-living adopt some measure of the zombie mind-set. As Webb and Byrnard have suggested, "What is remarkable about so many zombie movies is that the survivors of the plague/accident/alien invasion that caused the infection do so little to distinguish themselves from the zombies; it's very much a case of *as you are, so too am I*" (86; italics in original). The result is that the same mindless repetition engaged in by the zombies—namely, that of seeking out and eating human flesh—is reenacted by those who seek out and kill zombies. There is no reflection on what is being done, only the enactment of the need to kill.

Postfeminist Violence

What happens when this contemporary monster is transported into an early nineteenth-century novel? Turning to one literary manifestation

of the zombie, I will argue that as a heroine fighting the zombie menace, Elizabeth Bennet is herself partially zombified, rendering her a post-feminist heroine who, in combating the zombies, is also paradoxically fighting to maintain the patriarchal system that confines her. Without suggesting that she has an alternative, I would suggest that the libratory potential of the position of the heroine is undermined by postfeminist discourse, re-encoding the heroine as heteronormatively desirous and desiring.

Elizabeth Bennet and her sisters are zombie-fighting warriors who have all trained in the Shao Lin temple in China and are masters in the use of the katana sword and other weapons. They are the defenders of their family and of the neighborhood and can decapitate a walking corpse with a sword, shoot one through the eye and into the brain, or, with a swift kick, knock the head off.[4]

The original argument from Jane Austen's text is maintained, with the added twist of a world in which for the past fifty years the dead have been rising from their graves and attacking the living. Those who can afford it are sent to Japan or China to train in the martial arts and learn to defend themselves and their nation. On their return they are enlisted in the service of the king and required to continually fight the living dead. Everyone, man or woman, who is trained must pledge to fight the zombies.[5] Women, however, are relieved of their duties as warriors should they marry. While not forming part of the regular army, the Bennet sisters are all enlisted into the service of their monarch, and they dedicate regular hours every day to training and

Elizabeth Bennet is herself partially zombified, rendering her a post-feminist heroine who, in combating the zombies, is also paradoxically fighting to maintain the patriarchal system which confines her.

to hunting and killing zombies. Their involvement in zombie fighting is twofold: on the one hand, it protects them and their loved ones from harm, and on the other, it offers them the possibility of earning a living once their father dies. They can, as Elizabeth notes, become mercenaries or bodyguards, living from the trade they have been taught (Grahame-Smith and Austen 55). Obviously, to have to work for a living would be a step down in the world for these daughters of the gentry, but they have been provided with the means to do so, should the occasion arise.

While not part of the militia, the Bennets are militarized, and as Nira Yuval-Davis has argued, "One of the main motivations for women to join the military is an opportunity to empower themselves, both physically and emotionally" (178). However, this empowerment is problematic in some ways, not least of which is that it involves the adoption of violence, or the willingness to commit it, as a means of reaching independence. Elizabeth and her sisters, in their games together and when fighting the zombies, are often extremely violent. While, as has been noted by Laura Sjoberg and Caron Gentry, "The reality is that women who commit violence interrupt gender stereotypes. Instead of requiring protection, they are the people from whom others should be protected" (7), there exist a variety of techniques employed to "legitimize" women's violence and rob it of this potentially disruptive capacity. Among these are the sexualization and maternalization of the actions or the incorporation of these actions into state-sanctioned systems of violence, as happens with the Bennet sisters.

The military is a site of condoned violence and aggression; women who are fighting on behalf of their country are often, and not unproblematically, "permitted" to be violent because this aggression is contained within a discourse of protection—self-defense or defense of loved ones is acceptable. For the most part, Elizabeth Bennet's acts of violence are always represented along these lines. While at several times

10.1. A post-feminist body in action. *Pride and Prejudice and Zombies* (29). Philip Smiley, Illustrator.

she may wish to take violent revenge on others or defend her honor,[6] she usually controls herself. In this way she is constructed not as threatening to society, but preserving of it.

Neither Elizabeth nor her sisters appear to engage in gratuitous violence. The one exception to this rule is a curious one and worth some further attention.[7] When Elizabeth visits her friend Charlotte Lucas, she is introduced to the great Lady Catherine de Bourgh, a woman who is famous for her fighting skills and for her wealth. This encounter is frustrating for Elizabeth, because Lady Catherine underestimates Elizabeth's skills and insults the Chinese master who trained her, so when she is challenged to a fight against Lady Catherine's three best ninjas, Elizabeth is keen to prove herself. She confronts each of the ninjas, in turn and blindfolded, but is disdainful

The imperative to eradicate as many zombies as possible is, for Elizabeth, the double imperative to deny also the part of herself that is physically similar to the zombies, the part that is soft and fluid and at risk of infection.

of the human life she is taking. Where her violence in the rest of the novel is primarily confined to killing the "unmentionables," here she is killing people. Elizabeth, in fact, engages in acts that can be read as excessively violent. She not only disembowels one of her opponents, but she also strangles him with his own intestine. To the third ninja, "she delivered a vicious blow, penetrating his rib cage, and withdrew her hand—with the ninja's still-beating heart in it" (Grahame-Smith and Austen 132). She proceeds to take a bite of it, blood dripping down her chin. I do not want to dwell too long on the fact that in this scene there is a disturbing dehumanization of the oriental "other," as Elizabeth's

violence is rendered acceptable in that she is killing what have been constructed as Lady Catherine's possessions—some ninjas brought back from Japan. In this episode Elizabeth is displaying her talents, trying to demonstrate her capacity as a warrior. Except for Mr. Collins and a few servants, the display is primarily for the women, specifically Lady Catherine, the alpha woman.

As a counterpoint to the excessive violence Elizabeth demonstrates when she is challenged by a more powerful (socially and economically) woman, I want to consider how Elizabeth displays her talents when the one who challenges her is male. In this episode she again illustrates the skills she learned while training in China, this time for Mr. Darcy and Colonel Fitzwilliam as well as the others. She chooses to demonstrate for them her ability to walk on her fingers. She has tied a "modesty rope" about her skirt and "placed her hands upon the floor and lifted her feet heavenward" (Grahame-Smith and Austen 136). Compare the gore and violence of the first scene with this tamer display. When Lady Catherine comments that Elizabeth "has a very good notion of fingering," Darcy replies, "'That she does' in a manner such as to make Elizabeth's face quite red" (138). This innuendo about her "fingering technique" that Mr. Darcy makes, sexualizes Elizabeth's physical skills. Her body is undeniably strong and physically capable of a variety of feats, both violent and not, but by making that body conform to ideals of femininity or womanhood, to the ideals that will render her attractive to her male audience, she becomes an object that they can look at. Rather than the active body that fights off three well-trained ninjas, her performance for Lady Catherine's nephews is passive, involving the no doubt difficult but comparatively sedate act of walking on her fingers. When her warrior skills are put on display for a primarily female audience, when she has been directly challenged by another woman, she is merciless and

brutal. When the audience is masculine, however, she demonstrates a different type of skill—one that can, as it does for Mr. Darcy, elicit heteronormative desire.

Much of Mr. Darcy's attraction to Elizabeth is, as in the original novel, a result of her singular education combined with her more independent personality. This independence of character is reworked in the zombie novel to become closely attached to Elizabeth's capacity to restrain her violence or for the violence to be restrained. When Mr. Darcy first proposes to Elizabeth, she kicks him into the living room fireplace. Unable to control her violent impulses, she engages her suitor in hand-to-hand combat.[8] In this instance, the first one in which Mr. Darcy sees Elizabeth's skills used against someone other than a zombie, she is restrained by him, as his own ability exceeds hers. By the end of the novel, Elizabeth learns to repent her attack on her beau and accepts that in order to be attractive to him, and for him to understand her feelings for him, she must limit her violence to the zombie hordes. This is apparent when she is challenged in combat by Lady Catherine and, despite eventually beating the woman, refusing to kill her. For Elizabeth, the "failure to kill her when she had the chance" was a demonstration of weakness that "would forever turn Darcy's eye away," and yet it has the reverse effect, convincing him that she did love him, else she "would have beheaded Lady Catherine without a moment's hesitation" (Grahame-Smith and Austen 299). While she may have been attractive before, it is her ability to control her violence that Darcy reads as the capacity to love him.

Postfeminist Bodies: Zombified Bodies?

In his study of comic book culture, Bradford Wright questions to what extent heroines are constructed as role models for girls and to what

extent they are another extension of male desire. He argues that comic book heroines are "not so much a pitch to ambitious girls as an object for male sexual fantasies and fetishes" (21). I would take this one step further: in today's postfeminist culture, these heroines, such as Lara Croft, Buffy the Vampire Slayer, or Silk Spectre of the *Watchmen, are* constructed as role models for young women, role models who clearly represent how the healthy or attractive heteronormative body, obtained through women's rigorous self-discipline, is most potent in its ability to elicit the desiring male gaze.

In her study on *Gender and the Media,* Rosalind Gill illustrates how "contemporary femininity is constructed as a *bodily characteristic.* No longer associated with psychological characteristics and behaviours like demureness or passivity, or with homemaking and mothering skills, it is now defined in advertising and elsewhere in the media as the possession of a young, able-bodied, heterosexual, 'sexy' body" (91). As a zombie-fighting heroine, Elizabeth Bennet's body is subject to great scrutiny. Consider how her "rival" for Mr. Darcy's attentions, Caroline Bingley, describes Elizabeth's body:

> I must confess that I never could see any beauty in her. Her midriff is too firm; her arms too free of loose flesh; and her legs too long and flexible. Her nose wants character—it is unbearably petite. Her teeth are tolerable, but not out of the common way; and as for her eyes, which have sometimes been called so fine, I could never see anything extraordinary in them. They have a sharp knowing look, which I do not like at all; and in her air altogether there is a self-sufficiency and composure which is intolerable. (Grahame-Smith and Austen 218)

What Caroline describes here, it must be acknowledged, is a body that fits quite well with the contemporary notion of female attractiveness: a firm midriff, long and flexible legs, no loose flesh. Admittedly,

Elizabeth's body is not the direct result of an attempt to mold her figure so as to be attractive. Rather, it is through following her goals to become a warrior that she comes to have a physically fit and desirable body. Returning to Rosalind Gill for a moment, we find that discourse in the media codes the female body—and often feminism itself—so that "women are presented not as seeking men's approval, but as pleasing themselves and, in doing so, they *just happen* to win men's admiration" (91; italics in the original). This is doubly true for Elizabeth, who by having a "profession" becomes both more physically desirable to Mr. Darcy and more appropriate as a mate.

The attention to Elizabeth's body is extremely important, not only because of the way the postfeminist heroine is constructed as acceptably violent but also because she is (hetero)sexually desirable. It is worth returning to the figure of the zombie for a moment as what Elizabeth is fighting against (and theoretically the only acceptable target for her violence) and what her body is contrasted against. With their infectious bite and degrading bodies, zombies are a constant threat to the bodily integrity of the living. This threat of contagion is the threat of losing control over the body, however imaginary this control might be, as zombification automatically connotes the inability to impose the will on the body. Shannon Winnubst articulates the relationship between the abject body and what she terms the "body-in-control" as follows: "To be a body-in-control, it must be tightly sealed—rigidly separated, distinctly individual, and straightly impermeable . . . strict boundaries between itself and the Other are what allow this subject to count itself as a solid individual. . . . And yet it is fluids that it contains—soft, gooey, sticky fluids circulate through this body's veins and cavities" (6). The imperative to eradicate as many zombies as possible is, for Elizabeth, the double imperative to deny also the part of herself that is physically similar to the zombies, the part that is soft and fluid and at risk of infection.

For the body-in-control to be perceived at risk of contamination by zombies, the similarity between the two bodies (us and them) must be, at least unconsciously, recognized. As Webb and Byrnard note, "The transmission of the 'virus' between us and them indicates our closeness: viruses (mostly) travel between like species" (84). It is this similarity that is most frightening and what must be fought against. For the postfeminist body—the carefully sculpted, heteronormatively attractive one—it is necessary to project the image of a body that is whole, contained, and most certainly not leaky or excessive. Elizabeth's body occupies the dual position of physically attractive (at least by contemporary postfeminist standards) and responsible for eliminating the threat the zombie poses to humans—both the threat of bodily contagion and the threat of disrupting the social order. Killing the zombies is a reaction to the need to defend the self from the threat of death that they embody and also to the need to negate the abject, the part of the self that is uncontrolled or uncontrollable, that is always threatening to exceed the bounded limits of the contained, militarized body.

It is not only Elizabeth's *body* that is constructed as a postfeminist ideal but also, through her training and education, her attitude and manners. Indeed, as Darcy lists the requirements of the ideal woman, he illustrates the increasingly unattainable levels to which a woman must aspire if she is to elicit heteronormative desire. He is no longer satisfied with the upper-class woman's education. His suitable life partner must also be a woman who has received a zombie-slaying education, something, as noted previously, that is rare, difficult to attain, and not for those of the lower classes. Hence, Darcy's longer list indicates the demands placed on women (and increasingly men) for greater discipline in order to fit the mold of heteronormatively attractive bodies. This new woman "must have a thorough knowledge of music, singing, drawing, dancing, and the modern languages; she must be well trained

in the fighting styles of the Kyoto masters and the modern tactics and weaponry of Europe. And besides all this, she must possess a certain something in her air and manner of walking, the tone of her voice, her address and expressions" (Grahame-Smith and Austen 34). This is a daunting list indeed, and the ideal, for Darcy, is a woman who is trained in both the traditional "female arts" and the new, zombie fighting ones as well as the more mysterious "something" that only he can identify—a "something" that could keep a woman guessing and constantly trying to measure up. The same training that can help a woman to earn independence by giving her a trade is the very one that makes her more desirable. For Rosalind Gill, "This is the new superwoman: intelligent, accomplished, effortlessly beautiful, a wonderful hostess and perfect mother who also holds down a demanding professional position" (82). In enumerating the reasons why Darcy had fallen in love with her, Elizabeth states that it must have been because

> you were disgusted with the women who were always speaking, and looking, and thinking for *your* approbation alone. I roused, and interested you, because I was so unlike *them*. I knew the joy of standing over a vanquished foe; of painting my face and arms with their blood, yet warm, and screaming to the heavens—begging, nay daring, God to send me more enemies to kill. The gentle ladies who so assiduously courted you knew nothing of this joy, and therefore, could never offer you true happiness. (Grahame-Smith and Austen 311)

This account, aside from raising the question of *who* Elizabeth's foes were (as it is unlikely that she would have painted herself with the blood of a zombie), points to how it is her difference from the other women of their acquaintance, who are not zombie slayers, that makes her attractive. While her manners and "liveliness" make her a socially acceptable mate for Darcy, what distinguishes her from the "ladies who so

assiduously courted" him is her knowledge of the martial arts (311). She further suggests here that, unlike those other ladies, she did not court him, did not seek to win his approval or his love, and perhaps it is this trait, more than the others, that she thinks eventually won him over. As Gill further argues about the media's co-optation of feminism as a way of attracting the opposite sex, "her pursuit of feminist goals (or, at least, goals encoded as feminist signifiers within the discourse of advertising) makes her more, rather than less, attractive to men" (97).

Monstrosity reveals itself not as simple otherness or even abjection, but as the syncopated process of becoming, the halting movement of bodies within and against the official regimes of space and time.

However, just as we saw in the scenes where Elizabeth exhibits her various talents, her character necessarily combines traits coded as more traditionally feminine with those of the good warrior. Elizabeth may assert that she believes the "Crown [was] more pleased to have [her] on the front lines than at the altar" (Grahame-Smith and Austen 115), but those very skills that can put her at the front lines are the ones that eventually lead her to heteronormative happiness. What makes Elizabeth more of a postfeminist heroine than one who espouses third-wave feminist ideals is arguably not the fact that she welcomes the opportunity to become Darcy's wife, but rather her position as a warrior fighting the zombie menace. It is this role that engages her in the repetitive and mindless activity that requires her to discipline her body above all else.

While the zombies threaten British society, and women are urged to move out of the domestic sphere and into the active social sphere, these heroic ladies are, in a sense, fighting to protect the patriarchal order. By battling against what challenges the social order, they are fighting

to maintain it. For the Bennet sisters, and indeed for many physically aggressive heroines, they are even further entwined in the patriarchal order, because of their role as fighting heroines and because, despite being highly effective warriors, the Bennet sisters are always subordinated to a patriarchal figure. By joining the ranks of the warriors, they swear allegiance to their Chinese master, and upon their return to England, to the king, because they have taken a "blood oath to defend the Crown above all things" (Grahame-Smith and Austen 185). Further, upon marriage it is assumed that they will "retire them [their sword and martial arts training] as part of [their] marital submission" (85). The possibility for new constellations of power is diminished as the skills that would permit other relations are inevitably recodified as the very ones that are desirable for heteronormativity and controlled by the patriarchy. Through the swearing of allegiance, first to the Chinese master (if not first to their own father), then to the king, and finally to a husband, the Bennets are at no point serving themselves.

The zombie apocalypse does, however, open up the possibility for women of the Bennets' social class to enter the workforce: "Jane and Elizabeth tried to explain that all five of them were capable of fending for themselves; that they could make tolerable fortunes as bodyguards, assassins, or mercenaries if need be" (55). Unfortunately, while the heroine is certainly a strong, independent-minded young woman, the task of fighting the undead hordes is not a liberating one. It is one that further entrenches women within a patriarchal system that, rather than offer new social structures, uses the rhetoric of postfeminist girl power to convince its heroines that they are not forced into domestic bliss, but that they have freely chosen it themselves. It cannot be overlooked that a good warrior, for the Bennet sisters, is one who obeys her master, and this is very good training indeed for the good wife.

Notes

1. I use *postfeminism* consciously here, in contrast to *third-wave feminism,* as a social and theoretical model that champions the position of women in contemporary society and the use of their bodies and sexualities as tools for gaining power within the patriarchal order rather than effecting meaningful change to it.

2. For a comprehensive study of the different forms and meanings of the African and Haitian zombies, see Ackerman and Gauthier. The third type of zombie is the philosophical or P-zombie, which is the source of debates and theorizing about the relationship between the mind and the body and human consciousness. For more on this see Tanney, "On the Conceptual, Psychological, and Moral Status of Zombies."

3. Though admittedly, against the never-ending incurable onslaught, the desire to stop fighting and to simply become one of the mindless consumers could be comprehensible, the repulsion felt by those who come face-to-face with zombies is usually enough to propel them to continue fighting and to resist becoming one themselves. For a curious case of what happens when a human accepts his or her zombie fate, see Charlotte Lucas's decision in the novel (64, 109). She admits to Elizabeth that she has been bitten, and rather than ask for Elizabeth's help in avoiding her fate as a zombie, she marries Mr. Collins and spends the rest of her life in an increasingly zombified state, complete with fantasies about eating the brains of those around her.

4. While the text is full of examples in which Elizabeth and her sisters demonstrate their prowess, see page 14 for the ballroom scene, in which the sisters must fight together to defend their friends and neighbors, or page 24, in which Elizabeth alone fights some of the unmentionables as she is walking to visit Jane at Netherfield.

5. Proper zombie training is a costly endeavor, not something affordable for the majority of the population, because it involves at least one prolonged trip to Asia. As a result, only the privileged can afford this overseas education. For women, the possibility, and even the desirability, of this training is not entirely clear. While it does not fit into the category of a trade (because it is out of reach of the lower classes), it is not looked upon as entirely suitable by all of the women in the novel—namely, the Bingley sisters and the Bennets' mother. And yet the most revered woman in the novel, Lady Catherine de Bourgh, is respected both for her social position and for her exceptional skill at killing zombies—almost besting Elizabeth herself. The exact social position of the female zombie killer is, thus, unclear and perhaps best considered as something unfit for all but the exceptional (as is the case with Lady Catherine and, by the end of the novel and because of her marriage to Darcy, with Elizabeth as well).

6. Curiously, Elizabeth is extremely sensitive to slights either against her family's honor or anything that can be construed as criticism of her loved ones. Her reaction to

these affronts is to wish to harm physically, usually to kill, the perpetrator. When Mr. Bingley ceases his attentions to Jane Bennet, Elizabeth wants to murder both of his sisters in revenge. While she never follows through on these desires, the level of violence she deems acceptable as punishment for social slights is remarkable. See 94–95 or 178.

7. While it is true that Elizabeth almost exclusively conserves her violence for fighting zombies (other than in the excerpt under consideration), she does engage in two hand-to-hand combat situations: the first is when she fights Mr. Darcy, and the second is when she fights his aunt, Lady Catherine de Bourgh. Both of these incidents are constructed as inevitably requiring violence. In the first it is because Mr. Darcy has interfered in Jane's potential relationship with Mr. Bingley and must be punished. In the second it is Lady Catherine who directly attacks Elizabeth, and she must defend herself. When she wins the fight, Elizabeth has the opportunity to kill her opponent, which of course she declines, preferring to be generous and also loathe to (possibly) kill the aunt of the man she loves.

8. See pages 149–53 for the proposal/combat scene between Mr. Darcy and Miss Elizabeth Bennet.

TATJANA SOLDAT-JAFFE

Every universe, our own included, begins in conversation. Every golem
in the history of the world, from Rabbi Hanina's delectable goat to the
river-clay Frankenstein of Rabbi Judah Loew ben Bezalel, was sum-
moned into existence through language, through murmuring, recital
and kabbalistic chitchat—was, literally, talked into life.

Michael Chabon, *The Amazing Adventures of Kavalier & Clay*

Introduction

Guk.

Glakk.

Guk.

Guh.

Gar.

Zombies don't make good conversation partners. When Sydney
and Grant, the two main characters in *Pontypool* (2009), realize that the
disease that transforms humans into zombies might be carried through
language—specifically, English language—they look for a source. In
the sudden realization that *understanding* language is the source, Syd-
ney asks Grant, "How do you stop understanding? How do you make it
strange?" Such questions point to crucial issues concerning the nature
of human language and the possibility of zombie language. First, they

11.1. Rick has a zombie conversation, *The Walking Dead*, Vol. 1.

encourage us to examine general definitions of language use and communication. Must language always involve meaningful exchange? If language requires negotiation between a sender and a receiver, how do the murmurs, moans, grunts, or growls of the zombie function? Second, they ask us to consider how the presence or absence of language serves as a criterion for the distinction between humanness and zombie-ism. In a way, if communication is not successful, you're probably dealing with a zombie; if you're dealing with a zombie, you can't communicate with it.

We come across many examples in culture and science in which the a-human human—the automaton, the anthropoid, the undead—lacks language, the artificial or unnatural creation unable to communicate and therefore deficient of the rational thinking that typically defines humanness. In this regard, in the shadow of the zombie we find the Yiddish folkloric creature, the golem, and, "In the Shadow of the Golem,"

11.2. Rick and Glenn talking, *The Walking Dead*, Vol. 1.

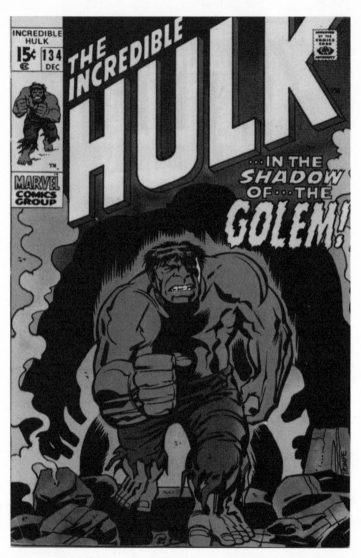

11.3. "In the Shadow of . . . the Golem!" *The Incredible Hulk,* 134, December 1970.

his comic book variant, the Hulk. In each case, language deficiency suggests the absence of the reflective cogito and thereby denies the "object" its human existence. The golem is made to follow commands without any self-reflection; the Hulk becomes an animal-like, language-poor brute when he gets mad ("Hulk Smash!"); and the zombie lacks any signs of empathy or rationality. But even though in all three instances the creature is decidedly deficient in language, the existence of each—despite all seeming nonhuman qualities—remains shadowed by the presence of language.

In *The Land of the Dead* (2005) the film's human protagonist Riley uses reconnaissance about zombie communication to include both the living and the living dead in his definition of *people.* The walking dead seem to resemble decrepit and disoriented pedestrians until their language is observed: "These aren't just walkers. . . . They're like . . . regular folks," he says. His confusion mirrors the calamity that zombies always represent: humans who were once alive that continue to exist as walking corpses. At what point does a person cease to be a human and become "living dead"? Is it a matter of diet (that it feeds off flesh), appearance (that it looks like a corpse), health (that it spreads infection), or language (that it cannot communicate)? Most likely, all the changes are necessary, but in many zombie texts we see a repeated correlation between language and humanity that suggests that language use is decisively what makes humans human. In the very first episode of *The Walking Dead,* for example, an accurate language assessment saves the life of the protagonist Rick Grimes after he gets knocked unconscious by one of the survivors, the young boy Duane. To establish if Rick is a "walker" and whether he should be "put down," the boy's father, Morgan, inquires whether Rick's unconscious, insensate body before him "said something." Duane responds affirmatively: "He did. I think he

called me 'Carl.'" To this Morgan replies, "Son, you know that they [the zombies] don't talk!" The observation of language use—what's more, communicative address—saves Rick's life when Morgan and Duane thereafter pull his human body to safety.

Linguists have long been fascinated with the nexus of human and animal language—similarities and differences. The linguist Charles F. Hockett identifies thirteen basic design features of language, which he claims are universal—"all of the languages of the world share them" (36). Among these he singles out seven design features specific to human languages: semanticity, arbitrariness, discreteness, displacement, productivity, traditional transmission, and duality of patterning. These features conclusively define human language as arbitrary but meaningful—in other words, as a culturally contractual relationship between the signifier and the signified. It is "the meaning" ultimately that elevates language to a system of communication, according to Hockett, because communication represents the act of negotiation between the participants; negotiation cannot successfully take place if aims, needs, and viewpoints are insufficiently defined. As such, communication requires the individual's self-reflectivity, rationality, and logic as well as collective social relations; or what Lev Vygotsky calls the full spectrum of human experience confined by *znachenie* (meaning) on the one side and *smysl* (consciousness) on the other side—the internal and external forms of a word, the social and inner speech (Wertsch 19–31).

In *Pontypool* the state officials provide a public announcement in French that outlines a plan for protection that is seemingly informed by Vygotsky's theory of

If language requires negotiation between a sender and a receiver, how do the murmurs, moans, grunts, or growls of the zombie function?

social speech, because it spells out that (1) only the English language is infected; (2) survivors must restrain from all terms of endearment; and (3) survivors must avoid contact with close family members. Dr. Mendez, who finds refuge in the radio station and offers insight into the viral epidemic, gives his final diagnosis before he himself falls victim to the virus: "We are witnessing a new arrangement for life. Our language is its host. It could have sprung spontaneously out of perception. If it found its way in our language it could leap itself into reality and change everything and it spreads out when the contaminated word is spoken. [...] If the bug enters us, it enters us when we understand it. It's when the word is understood. It copies itself in our understanding." The notion that engagement with and assessment of meaning occurs through self-reflexivity is a trope that echoes in Walter Benjamin's work. Benjamin differentiates between "the mental being" (*"geistiges Wesen"*) and "the linguistic being" (*"sprachliches Wesen"*). Whereas the linguistic being (thing, zombie) can communicate its existence but fails to comprehend because it lacks something of mental meaning (*"daseiendes Geistiges"*), the mental being uses language to recognize (*"erkennen"*): "it articulates itself in the fact that man recognizes himself in language. Awareness is possible only in the sphere in which the mind communicates itself in language. The things do not understand, man does" (*Gesammelte Schriften* 787; my translation). The ultimate difference between the human and the thing is whether language applies self-reflexively; for the human, this means that the recognition of oneself leads to the conscious of one's or an other's existence, whereas the thing (for our purpose, the zombie) remains incommunicado (*"stumm"*) because it can only present itself.[1] In *Pontypool* one zombie, the assistant Laurel-Ann, can only follow voices but cannot "perceive or comprehend." She is only "rooting for voices," as Dr. Mendez explains, and will eventually lose track of the location of people if she cannot hear them.

Drawing on examples from the zombie canon and Yiddish folklore, and focusing on two zombie texts in which language zombifies—Bruce McDonald's 2008 film *Pontypool* and Ben Marcus's 2012 novel, *The Flame Alphabet*—I argue that language plays a critical role in conceptualizing a-human figures, specifically the zombie and the golem. I contend that we need to examine language in its indexicality of humanness in relation to two contexts: (1) in which language is absent but crucial to the nature of existence (as in the context of the zombie in *Pontypool* and the context of the golem) and (2) in which language is performative as an agent causing the transgression from *life to death* (as can be found in *The Flame Alphabet*) or from *subject to object* (as in the context of the golem and the zombie). This point is important for zombie research because it explores the notion of the zombie in its moment of transgression with language being the agent and ipso facto enabling this transgression. Instead of studying "zombie-ism" as a fait accompli (a zombie can be assessed as such only after "zombification"), we are looking through language at the "zombification" process.

The possibility of zombie language give us another important lead in this chapter in terms of clarifying the extent to which linguistic performance undermines the importance of linguistic competency (a feature that can be attributed only to human language). Here, I'm thinking primarily of George A Romero's fourth Living Dead installment, *Land of the Dead* (2005), in which zombies seem to be developing language behavior. Is the zombie's growling sufficient for communication, and can it count as speech? In *Land of the Dead* (against all preestablished notions of zombie-ism), zombies are observed communicating through grunts. That this seemingly rudimentary use of language enables limited communication suggests that we might have to introduce a modification to the indexicality of the zombie, as the zombies in *Land of the Dead*

represent nonhuman humans—that is, linguistic nonhumans—but not dead people.[2] These intricacies that are fundamental to the discussion of zombies and language are epitomized in the term *zombie linguistics*.

The Language-Deprived Zombie

In his analysis of Edgar Allen Poe's story "The Facts in the Case of M. Valdemar" (1845), Roland Barthes explores the ways that death limits language agency. In Poe's short story, a mesmerist puts a terminal, tubercular patient in a suspended state to learn what effects mesmerism might have on a dying person. Once entranced, the patient reports, "viva voce," that he is dying and finally that he is dead. The patient is left in this state for seven months, his skin cold and pale, his body without pulse, heartbeat, or perceptible breathing. When the narrator attempts to awaken the patient, the patient begs the narrator either to put him back to sleep or to wake him. As the patient finally utters repeatedly, "Dead! Dead!" the narrator pulls his dead subject out from the trance, and the latter's entire body instantly disintegrates into a "nearly liquid mass of loathsome—of detestable putrescence." The most important passage in this short story is when the patient self-assesses that he is dead: "Yes;—no;—I have been sleeping—and now—now—I am dead" (128).

Barthes concludes his textual analysis by observing that "there is a gaping contradiction between Death and Language; the contrary of Life is not Death [...], but Language: it is undecidable if Valdemar [the patient] is living or dead; what is sure is that he speaks" (108). Language may be undead, yet language use, returning to Benjamin, is the only way to recognize the state of life, and as such language is expected to deny a priori a dying person's ability to verbalize that he or she is dead.

Even though we can recount numerous mythic narratives where death speaks, it is always in order to say, "I am alive." Language agency finds its limits, as it can trespass from death to life and back, but it cannot deny its categorical imperative that language can be knowledgeably used only by a self-reflexive living being—a practice that is denied to the zombie, even in the next evolutionary step achieved by zombies in Romero's *Land of the Dead*.

A precise definition of language is notoriously difficult to provide; language is arbitrary and elusive. Instead of asking *what language is* (the definitional approach), the functional approach—*what language does*—offers us more insight into the zombie language problem. The purpose of language commonly rests in its capacity to communicate. Following Anna Wierzbicka, secondary linguistic functions involve the facilitation of human capacity for self-awareness and abstract thought, the sharing of feelings and ideas, or the discourse about meaning. Even though a definition of language is challenging because of its properties, the functions of language disclose what makes us human as it sets parameters: it indicates when we become human (postpartum) and when we cease to be human (postmortem). And yet these distinctive parameters of language seem to meet their challenge when we are confronted with gray areas of existence that indicate a violence of the binary qualities of life and death trespassing the limits of existence: the half dead, the living dead, the undead, or the artificial. Such a transgression is given in the fictional context of the zombies.

The prototypical zombie is speechless, incapable of emotion, slow moving but persistent. Although zombies react to environmental stimuli (e.g., recognizing humans as non-zombies, responding to light, or fireworks, or jukeboxes playing Queen's "Don't Stop Me Now" in *Shaun of the Dead* [2004], or responding to music and meaningless utterances

in *Pontypool*), they do not un-derstand language, nor can they communicate. *Pontypool* makes language a deliberate mecha-nism in the process of "zombifi-cation" as language, the English language, and specifically the meaning of the English words in-fects human kind. The film is set in a radio station in Pontypool, a

The idea of meaningful noise—a human shriek as opposed to cricket chatter or garden-variety zombie grumbling—suggests that the string of sounds is aimed to be and processed as meaning-distinguishing.

small village in Ontario, Canada. The protagonist, Grant Mazzy, is first confronted on his way to work with a zombified woman whose outward appearance does not resemble a zombie (she is clean and well dressed in pearls, a little black dress, and makeup). The only behavioral oddness Mazzy notices is that she shows up in the middle of nowhere, in a snow-storm, or what seems to be, either begging him for help or informing him about something—a message Mazzy never understands through the closed car window. Her sudden appearance is followed by her sud-den disappearance. We see more signs of language incomprehensibility at the radio station where Mazzy works as a radio jock. Listeners call in with recordings of crowds that seem to be rioting and chanting sense-less phrases. A family invited to perform Christmas songs at the station gives the next hint that something is off with language as one of the two children starts spewing nonsense: "I cannot remember how it ends. It keeps starting over and over again: pra, pra, pra, pra, pra. . . ."

Only when Grant's assistant, Laurel-Ann, gets infected by listen-ing to incoming calls and tapes, and when Dr. Mendez starts mixing codes and using his native language in incorrect contexts, does the au-dience realize that the "zombification" process happens progressively.

The mean of infection departs from traditional zombie transmission through physical scratches or bites to one suited to the broadcast booth, as it were, embedded in the scratches and bytes of mass-mediated linguistic transmission. In turn, each victim displays increasingly abnormal language behavior before entering a zombie state (as opposed to a sudden beastly assault and transformation).

The final revelation, of the extent to which language has an active role in the viral spread, comes in the scene when Sydney, who is about to fall victim because she has been exposed to the chants of incoming infected zombies, is urged by Mazzy not to listen to the noise or the voice in her head ("don't understand it!"), but to reverse the process by using language senselessly. She responds by asking Mazzy how they could possibly "make language meaningless"—that is, how could they strip language of its primary function (meaning)? And, then, whether they, Sydney and Mazzy, "should be talking at all?" Here the protagonists discover that foreign language (they start speaking French), written language, and gibberish seem to defy the virus. Finally, Sydney successfully reverses the process by redefining the word *kill*. She begins to repeat, mantra-like, "Kill isn't kill [. . .] kill is a baby, wonderful, morning [. . .] to kill is to kiss." After kissing Mazzy, a gesture that seems to sanction the new meaning of *kill,* she sets to work on other words, so that "*sample* is *staple*" and "*happening* is *handy.*" Thus, it seems here that meaning (and, as suggested by the authorities' broadcasted instructions, the meaning of particular words) has always been the carrier of the zombie virus, and the lack of meaning is the first symptom of the "zombification" process, but the lack of meaning also ultimately helps to defy the virus if applied in a timely manner.[3]

Following J. L. Austin, the meaning of a language—and more specifically words—derives predominantly from its denotational power.

For a word to contribute to the meaning of a proposition, the word's occurrence in that proposition, both in the affirmative and in the negative, should result in a description of a possible state of affairs. The meaning of the proposition *it is raining* reads in its affirmative "it is raining" or "there is a possibility that it could rain" and reads in its negative "it is not raining" or "there is not a possibility that it will rain." The affirmative as well as negative describe a possible state. Accordingly, the meaning of the proposition *ducks are ferocious drivers* is meaningless because neither the affirmative "ducks are indeed ferocious drivers" nor the negative "ducks are not ferocious drivers but timid drivers" describes a possible state of affairs. Whereas meaning, as Vygotsky puts it, is a construct of culture, the reflection *on* meaning, the skill to manage the arbitrariness of language—to revisit Hockett—that protects the language user from the absurd and limits his or her freedom to use language ("not everything goes" as the proposition has to fulfill the truth requirement) is a mental process that is human specific. But meaning also seems to infect the language user to the extent that language becomes irrational, as can be seen in *Pontypool*. When Sydney is asked to stop thinking about the meaning of the sentence to produce the antidote, she is asked to stop being self-reflexive.

Reflection articulated and performed through language is the key ingredient to the classification of the human. This assessment is in agreement with William S. Larkin's work in which he inquires what a person is and under what conditions a person continues to exist—that is, when do we say that a person is a *res cogitans* (a thinking thing) or just a *res corpo realis* (a bodily thing)? The answer that he puts forward is that a person ceases to exist when he or she stops being a *reflective cogito*. Reflection, according to Larkin, is the tool of consciousness in which speech is a form of activity that lets us experience social relations

while consciousness communicates with and acknowledges the "other" through language. Because the speaker is dependent on a listener and the listener is dependent on the speaker, language requires and sustains a relation of mutual interdependence. Larkin is making the point that language overcomes the subject/object dichotomy—to borrow Heidegger's distinction, it is the difference between *Dasein* and *Mitsein*.

In *Pontypool*, after infection, meaningful language turns into chants, gibberish, and rampant monologues ignoring the other and devoid of intersubjective interaction. The viewer, for example, cannot detect immediately that Dr. Mendez has been infected, because his physical appearance has not changed. However, an increase in rate of speech, the incoherent repetition of words and phrases, and the use of meaningless words all reveal that he has fallen victim to the virus. It is the communicational competence that gives first, that raises the audience's attentiveness that something is about to happen, before the subject turns into the object.

If language is commonly used as a categorical distinction between what is zombie and who is human, the notion of *noise* introduces a new complexity into the discussion. In *Night of the Living Dead* (1968), Ben gets into an argument with Harry about the relation between noise and communication. Famously, Ben chides Harry for failing to unlock the door to the cellar hideout, because zombies threaten to enter. Having ignored shouts for help from the people upstairs as they try to fight the zombies back, Harry later defends his nonaction by claiming that he "misunderstood" the noise. For humans, noise can be perceived as meaningless or meaningful, as the following exchange suggests:

> BEN: Didn't you hear the racket we were making up here?
> HARRY: How are we supposed to know what the hell was going on? It could have been those things for all we knew.

BEN: The girl was screaming. Surely you know what a girl's screaming sounds like. Those things don't make any noise!

The idea of meaningful noise—a human shriek as opposed to cricket chatter or garden-variety zombie grumbling—suggests that the string of sounds is aimed to be and processed as distinguishing meaning. As such, Ben's definition of noise goes beyond aimless accidental disturbance; his assessment of noise includes attention-seeking (targeted) communication devices—a plea for help or the expression of fear, for instance. So why do zombies not produce what we would consider meaningful noise? The short answer would be that they do not have the brain processing to do so.

"Let the earth bring forth a soul of a living creature."

However hypothetical, for noise to serve as a communicational device demands neural networks in the brain for processing and deciphering. The zombie brain lacks this complexity—at least, in the versions Dr. Jenner anatomizes in *The Walking Dead*. He explains to the group, using a computer model called Test Subject 19, the processes in the brain that take place when a person is bitten and then partially revived as a walker. Jenner maintains that upon infection the human brain first shows deathlike symptoms and then returns to only very limited functionality. Would noise in the form of limited communicational devices such as grunting or growling serve such minimal neural activity? How little brain capacity and how much or how little "meaningful noise" is necessary for an act of communication to be successful?

Romero's zombies in *Land of the Dead* suggest that very little is necessary, but even this little bit makes the zombies of that film seem more human, as grunts and growls take on speechlike functions as in seeking attention; relaying instructions and orders; or indicating

directions, anguish, or frustration. The following exchange between Riley and Mike illustrates their stunned assessment of the zombies and their grunts and growls:

> MIKE: They're trying to be us.
> RILEY: No, they used to be us. Learning how to be us again.
> MIKE: No way. Some germ or some devil got those things up and walking . . . but there's a big difference between us and them. They're dead. It's like they're pretending to be alive.
> RILEY: Isn't that what we're doing, pretending to be alive? He knows we're here. Christ. It's like he's talking to them. Let's go.

Riley's last comment refers to Big Daddy's grunts that signal to his fellow zombies that he can sense humans. As a matter of fact, we can detect at least three different types of meaningful zombie noise in *Land of the Dead:* (1) the moan, an inward, unmotivated sound; (2) the grunt, a low, short, guttural sound; and (3) the growl, an aggressive, low, guttural sound of hostility.

This "meaningful" zombie language coincides with the unfolding of a social structure that suggests a collective identity in Romero's film. The zombies form a community that mirrors one that used to be before the apocalypse: the zombie butcher who is still running around with a cleaver; the young couple that still walks, holding hands; the musicians in the band who somehow intuitively still understand that they form a band but no longer know how to play the instruments; the gas station operator, Big Daddy, who still steps out to operate the pump every time somebody accidentally activates the bell. These zombies are held together through a vague memory and, as a collectivity, migrate to the "city" to seek revenge, using grunting as their channel of communication.

In *The Walking Dead* grunting is not just an atrophied means of communication but a life-saving device when Glen and Rick pretend to be zombies in an attempt to get to a box truck that is supposed to help them escape the invaded city of Atlanta. Covered with blood and viscera of a dispatched walker, they enter the zombie-infested streets. In a critical moment as a zombie comes dangerously close to Glen, Glen sends out a grunt that causes the zombie to move on. Although it is unclear how the zombie "deciphered" Glen's grunt—we do not know to what extent the zombies indeed can "understand" meaning, distinguishing sounds as opposed to noise—the grunt can safely be read as "zombie speech" or a zombie marker. But this still leaves us with the question about the factors that mark noise as meaningful or meaningless.

First, language acquisition research defines children's first productions and perceptions of noise as reoccurring patterns and regularities in a string of sounds. Detecting these prosodic patterns in speech input will lead to their discovery of phonemes (meaning-distinguishing sounds) and words and then eventually cracking the human linguistic code. The most helpful tool in this enterprise is the categorical perception of sounds, the tendency to perceive a range of sounds that belong to the same phonemic group as the same. As such, humans do not necessarily identify every single sound, but identify sounds as members belonging to a particular group of sounds. It is a "many-to-one-mapping" according to categories of similarities and differences. Patricia Kuhl, one of the first psycholinguists in this field of research, argues that categorical perception is not unique to humans but can also occur in mammals, "such as chinchillas and monkeys." Even though we cannot determine if the zombie sounds constitute language, it is enough to establish that when it comes to the zombies in *Land of the Dead,* at least, those sounds seem to carry limited meaning. And in their capacity for

limited meaning they can serve for communication. We can deduce this assessment from the opening scene in which the radio voice alludes to a possible zombie apocalypse: "If these creatures ever develop the power to think . . . to reason . . . even in the most primitive way. . . ." The rest of the movie is famous for elaborating a particular type of zombie that is capable of comprehension and learning, and, hence, of forming a homogenous group that is capable of retaliation and looking for "a place to go."

Language as the Switchboard

Ben Marcus similarly employs the idea that language is the carrier of a deadly infection in *The Flame Alphabet*. Like *Pontypool*, this novel portrays language as the carrier of a deadly virus and offers us an insight into what it is like to "turn into a zombie." Here, the "infectors" are children and the "infected" are the adults. Although Marcus never explicitly calls the "infected" zombies, they share the same features: they are gray faced, with slushed insides and rotten brains, pale, lethargic, with stiffening muscles and hardening joints (4, 17, 84). The reader witnesses the spread of the virus from the perspective of the protagonist Sam and his wife, Claire, who attempt to fight the virus carried and spread by their daughter, Esther. Although the children in the story are also infected by the virus, they show resistance until they become adults.

As in *Pontypool*, Marcus's novel depicts language as poisonous and corrosive (13, 16). Every word communicated between child and parent has an immediate caustic effect. Claire feels physical pain after talking to Esther and needs days to recover from the conversation (though there is never full recovery, and every exchange takes Claire closer to death). Unlike *Pontypool*, though, in which the characters disinfect language by

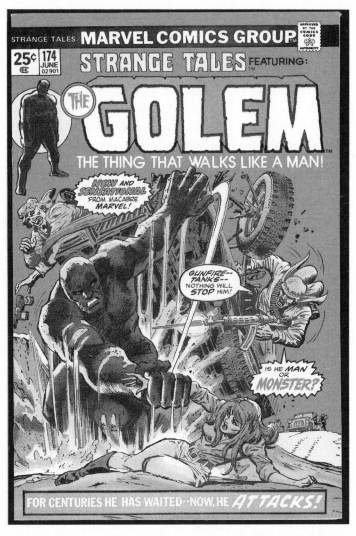

11.4. "For centuries he has waited . . . now, he attacks!" *Strange Tales,* 174 (June 1974).

stripping it of rational meaning, the infected subjects in *The Flame Alphabet* cannot find a way to inoculate the linguistic medium and instead pursue something like communicational quarantine.

Meaninglessness is not the cure here, but uncertainty is preferred over disclosure and understanding. Self-referentiality is dismantled and I-statements get blocked, stripping speech of its power (Marcus 48–49). These "grammatical amputations," in the words of one character, shift agency from the speaking subject to the language corpus so that experience cannot be rendered in speech. The result proves a recipe for survival, but not a final solution, as Sam aptly explains, "Without language my inner life [. . .] was merely anecdotal, hearsay" (223).

In his fight to create a solution to this disease, Sam realizes that the problem rests in the act of communication itself, because "communication kills" (83). His mission is to find a new system of communication, because "an ultra-restricted language with a new grammar is the way out of this," a language that is meaning-independent (20, 63). This, he imagines, can be done only by destroying the language and building it anew. A wilted alphabet, rebus writing, rune writing, pictograms, cryptography, or Braille, the misspelling of words, and other applications of defunct and undeciphered scripts come to his mind, because these symbols would make language "too strange to read" and "foreign enough" to "estrange [the speaker] from language" (64, 147, 183). He "could squint away the particulars, fuzz them into nothing," create a "non-alphabet" (162, 210). And yet all of these measures fail, because, as Sam's Jewish belief reveals to him, the entire alphabet comprises God's name, all words reference God ("all words are variations on his name") and are written in fire—hence the title, *The Flame Alphabet* (65).

The idea that language gives life and takes life is a concept not new to Jewish folklore studies. As a folkloristic creation, the golem precedes the zombie. The golem legend represents the creature as an artificial

being created from earth and clay and brought to life through a miraculous combination of letters. The resultant word is believed to derive from the Hebrew word *gol'mi,* meaning "my unformed limbs." Taken into the first-person possessive form, it changes into *golem,* which means "unshaped" or "without form." The word appears as such for the first time in the Old Testament in Psalm 139:16, which reads,

> My body is no mystery to Thee,
> How I was secretly kneaded into shape
> And patterned in the depths of the earth.
> Thine eyes did see my limbs unformed in the womb.
> (Psalm 139:16)

The golem was said to appear in difficult times of persecutions. The leading story recounts that in 1580 the Jews of Prague were accused of blood libel—that is, of using Christian children's blood to make Passover matzo (Passover bread is usually made out of flour and water). As a consequence, the Jews were forced into a ghetto, stripped of all rights, and denied any protection; in turn, killing and victimization of Jews became a normal state. The presiding rabbi, Rabbi Judah Loew ben Bezalel (also known as the Maharal [teacher] of Prague), turned to kabbalah (Jewish mysticism) for help. With the assistance of two rabbinical students, the rabbi formed a homunculus, a clay manlike figure. Adding a few incantations to HaShem [God] and the spirits within, he finally, as a last step, inscribed into the golem's forehead the Hebrew word אמת(*emet*), which is both one of the many words for God but also means truth. The matter without form or a soul came to life and rose to obey the will of the rabbi—that is, to save the Jews. In another version of the story, the rabbi placed a scroll/a *shem* (which is the Hebrew word for "name" [similar: HaShem—the name]) with the holy inscription into the golem's mouth.

Eventually the golem's time came to an end as the citizens of Prague complained to emperor, fearing for their lives. The emperor took this as an opportunity to decree that no more pogroms against the Jews would be tolerated but also that the golem was not necessary anymore. Depending on the story, the rabbi either removed the first letter from the word *truth*, which he had originally written on the golem's forehead, the *alef*, thereby arriving at the word מת (*met*), which means death. An alternative version would claim that he removed the scroll from the golem's mouth.[4]

The creation of the golem, the formation of a body out of dirt, follows the divine narrative that can be found not only in the Old Testament but also in the Midrash, the official interpretation of the biblical exegesis by selective rabbis who represent the Jewish authorities. The Midrash contains Rabbi Leazar's comment on the biblical phrase "Let the earth bring forth a soul of a living creature," namely, that "this refers to the soul of Adam" (Gen. 1:24). The description of the creation of man is continued in Genesis 2:7, where the Bible states, "And the Lord God formed man of the dust of the ground, and breathed into his nostrils the breath of life; and man became a living soul." Although the golem is created by the power of the word, he does not have language, a key ingredient for, as established earlier, the definition of humanness; the absence thereof relates the golem to the common zombie. And yet we see a crucial distinction between the legend of the golem and the notion of the zombie. Whereas the lack of language identifies the zombie, effecting, as a fait accompli, the transition from the subject to the object, language in the legend of the golem takes an active role—it becomes an agent—as it gives and takes life.[5] The shift from תמא (truth) to תמ (death) infuses life into the pile of mud, but it also terminates life; language gains performative power as its denotative meaning performs the task.

The Performative Power of Language

The notion that language carries performative power goes back to kabbalistic linguistics found in the *Sefer Yetzirah*. The Midrash serves as the ultimate authority for the *Sefer Yetzirah,* also known as the Book of Creation, one of the oldest kabbalistic texts. This book renders a detailed explanation of the different Hebrew letters and the significance of their numerical value to the creation of the world, because the permutation of the letters can alter natural events. The significance of the letters of the Hebrew alphabet is emphasized in chapter 2:

> Twenty-two foundation letters
> Three Mothers / Seven Doubles,
> and Twelve Elementals. . . .
> The Three Mothers are Alef Mem Shin . . . Mem hums, Shin
> hisses, and Alef is the breath of air. . . . (Kaplan 95)

The three key letters listed in the *Sefer Yetzirah—Alef* (א), *Mem* (מ), and *Shin* (ש)—are the same ones responsible for the creation of the golem.[6] This is crucial for understanding that the golem was created with the help of the "three mothers," which are the "primary letters" ("*Alef* being the first, *Mem* being the middle, and *Shin* being one of the final letters"). These letters are called *mothers* because they are derived from the concept "understanding," which, according to the Kabbalah, is the primary feminine principle (Kaplan 31).

Let us look at the word *understanding* more closely, because it is a key factor in the creation of the golem but also a differentiating quality in the comparison between the zombie and the human being. In the biblical context the meaning of *understanding* is twofold: first, according to the *Sefer Yetzirah,* the letters were given to Abraham, the father of

the Israelites (1:3); and second, the meaning of the word *emet* in Hebrew is truth, and the three letters according to kabbalistic linguistics mean understanding. The combination of truth and understanding brings the golem to life. Truth and understanding are also common themes in the divine narrative of the Garden of Eden (Genesis 2–3). Truth stands for the word of God symbolizing the golem as a supreme creation, whereas understanding is a distinctive quality that defines the human. Understanding is a key component in my argument. Knowledge precedes understanding (we cannot understand if we don't know, a point of argument that takes us back to the definition of the meaning of a word), and knowledge is represented in the Bible as the Tree of Life. Adam and Eve realize (understand) that they are naked and do not want to be seen as such by God. Proverbs refer to the Tree of Life as wisdom:

> Happy is the man who finds wisdom, and the
> man who gets understanding. . . .
> She is more precious than jewels, and noth-
> ing you desire can compare with her. . . .
> She is a tree of life to those who lay hold of her;
> those who hold her fast are called happy.
> (Proverbs 3:13–18)

Hence, the performative power of language in the context of the golem rests in its creation of a being that, as Gershom Scholem points out, is "in some sense competing with God's creation of Adam" (159). Language ultimately represents the creative power of God. According to the *Sefer Yetzirah*, the letters have been carefully crafted by God. The book elaborates:

> Twenty-two foundation letters:
> He engraved them, He carved them,

He permuted them, He weighed them,
He transformed them,
And with them, He depicted all that was formed
and all that would be formed.
Engraved them out of nothingness and permuted them so that
a given combination appears in different sequences.
Through the various combinations of letters, God created all things.
(100)

Understanding is a key concept in *The Flame Alphabet* as well as *Pontypool*, contexts that I have argued are important to establish the difference between zombies and humans. The production of the secret letter in *The Flame Alphabet*, the antidote, resonates with the details of the Kabbalah. Very similar to the *Sefer Yetzirah*, the protagonist weighs, changes the form, transforms, engraves, and carves the letters out of material.[7] In search of the secret letter that would save humanity, the protagonist attempts to create an "indifferent," "unmoved," and "ambivalent" letter that would—in combination with the rest of the alphabet—produce a "non-alphabet." Sam is looking for ambivalence, not meaning in the new language (Marcus 208). Upon finishing the letter, he realizes that its shape resembles an item he had been secretly using to receive the rabbi's words—the word of "truth"—the word once vital to their well-being and now lost. Sam creates a symbol of "truth," which coincidentally, is the same word that kills his wife as he tries to cure her. The act came too late for his wife, already having lost speech and exhibiting cold, dead skin. Sam learns that Claire collapsed shortly after their meeting due to an unknown cause. Nobody knew the cause of death except for Sam, who relates her death to the "Hebrew letter nearly boiling in her hand," stating that "no one noticed her fist clenched over the Hebrew letter that might have poisoned her" (243, 249).

Life without Language without Life

With linguistics in mind—commonly defined as "the study of language"—I have looked at the role of language in the creation of the living dead as well as how language is being utilized by the living dead. In both cases it is the performative dimension of language that facilitates the creation of the a-human in which "meaning" constitutes a fundamental building block, because the meaning of language (to be precise, the meaning of particular words) enables the crossing of the border between life and death (*Pontypool,* the golem). But as much as meaning creates the a-human, meaning (of language) is denied to the a-human because only a *reflective* cogito can access the meaning of language.

Zombie linguistics provides us with the tools to understand the a-human in its *complexity* as it explores the parameters of language exchange (what is language without human life?). I have argued that a-human language is solely performance-based as opposed to competence-driven. Language competence studies language as a cognitive phenomenon looking into the individual intuitive knowledge of language users, whereas language performance studies consider language behavior as a collective phenomenon with the individual user annexed to shared behavior. If we understand "zombie language" as a performance and not a competence-lacking linguistic behavior, it gives us more intellectual space to explore dimensions of language usage that would be otherwise categorically excluded.

I maintain that if we were to attribute (even with its limitations) language use to zombies, calling them the a-human would be preferred over calling them "the living dead, the undead, the half-dead, or the walking dead," because "dead" signifies a terminal stage that would exclude a priori a traditionally defined language use. The notion of the a-human leads us to an altered indexicality of zombie-ism, because the

zombie would represent not the marked opposition to "alive" but a yet to be determined state that accepts a certain flexibility within commonly mutually exclusive parameters of life and death. Zombie linguistics argues that the parameters have shifted from "meaningful language as communication" to "language as meaningful communication"; this change allows accommodations that would include discrete human signs (the difference between the meaning of the words life/truth and death inscribed on the golem's head) as well as variations of paralinguistic language exchange such as noise. Even as a fictional phenomenon, zombie linguistics invites us to explore linguistic systems that defy previously shared language constituents. However deficiently, the zombie stalks the limits of human language. Part of its power—a power that the shadow of the golem behind the zombie helps expose—is the condition of language itself as a kind of a-human living death.

Notes

1. Allen Dingen haftet etwas Sprachloses an, das aber nur als solches erscheinen kann, weil seine Sprache irgend etwas daseiendes Geistiges nicht auszudrücken vermag. Das meinen wir wenn wir die Dinge stumm nennen. Und so ist ihr geistiges Wesen nicht ihre Sprache; es ist nicht vollkommen mitteilbar. Das geistige Wesen der Dinge so fern es sich mitteilt ist ihr sprachliches. Nur durch das sprachliche Wesen der Dinge kommen wir zu ihrer sprachlichen Erkenntnis. [...] Von den Dingen ist nur eine vollkommene Erkenntnis durch Sprache, nicht nach ihrem geistigen Wesen im Denken für uns möglich. / Das geistige Wesen der Dinge teilt sich nicht vollkommen in ihrer Sprache mit. Das geistige Wesen des Menschen jedoch ist in der Tat seine Sprache. In seiner Sprache teilt sich sein geistiges Wesen vollkommen mit, das drückt sich darin aus, daß der Mensch sich in der Sprache erkennt. Erkenntnis ist nur in dieser Sphäre in der der Geist sich in der Sprache mitteilt möglich. Die Dinge erkennen nicht, der Mensch erkennt. See for more Walter Benjamin, "Über Sprache überhaupt und über die Sprache des Menschen," in *Frühe Arbeiten zur Bildungs- und Kulturkritik,* 2: 786.

2. The variation in the representation of the zombie is best captured in Romero's movies. Comparing Romero's first movie, *Night of the Living Dead* (1968), with his last movie, *Land of the Dead* (2005), we see a more skillful, more adaptable, and smarter zombie emerging in the latter.

3. All social criticism set aside, I am less interested in why only the English language is infected and why only certain words are supposedly affected (something the plot does not pick up on again) than what it means for a language to be the primary carrier of the deadly virus and how it carries the deadly virus.

4. Another story claims that the golem went into the retirement serving only the Jews and the synagogue, but not in the function of the protector. And finally, there is also the ending in which the rabbi's successors revived the golem when Jews were once again persecuted.

5. We encounter a reincarnation of the golem in the Marvel comic book character the Hulk, aka Robert Bruce Banner, who, according to his creator, Stan Lee, is a self-conscious adaptation of the Golem. Like his Yiddish cousin, the Green Golem is a savior rendered in inhuman flesh who is both a defender and a danger, who cannot manage his "super powers," and, pursuing this connection of zombie linguistics, whose language use is marked deficient, restricted to grunting and growling (Meinrenken 38). In *The Amazing Adventures of Kavalier & Clay*, Michael Chabon's fantastic roman-à-clef about, among other things, the Jewish origins of the American superhero comic business, he writes that the comic-book kabbalists formed their golems of "black lines and four-color dots" (119).

6. The Yiddish word for truth has a *sin* (English /s/) instead of a *tes* (English /t/) word-final (*emes* for *emet*). In the Hebrew script both sounds are represented by the same letter, and, according to the *Sefer Yetzirah*, both letters, the *sin* and the *shin*, belong to the family of the "hissing sounds" also known in linguistics as fricatives, and carry the same power. This distinction is noted but not important for this discussion.

7. Compare Kaplan (124) with Marcus (208–209).

JONATHAN P. EBURNE

Then the idea hit him. Moses ran into his apartment and removed a leaf from the Book Isis had given him. He returned to the balcony where below the crowds had taken trees and were now using them to pound on the Palace gate. Moses uttered The Work aloud. 1st there was silence. Then the people turned toward the Nile and they saw a huge mushroom cloud arise.

A few minutes later, screaming of the most terrible kind came from that direction. The crowd dispersed, trampling 1 another as they rushed for the shelter of their homes. This was a turning point in the Book's history.

Ishmael Reed, *Mumbo Jumbo*

Ten-Dollar Dreadfuls

Genre fiction is project-based art. Whether cowboy Western or intergalactic sci-fi, genre writing entails a double inventiveness according to the set of directives imposed upon each story in advance. On the one hand, by definition such writing exercises a creative function following explicit conditions of constraint, whether formal, aesthetic, historical, moral, or economic. From the pulps to the remainder bin, genre fiction necessarily knows its limits; this is part of its "project." On the other

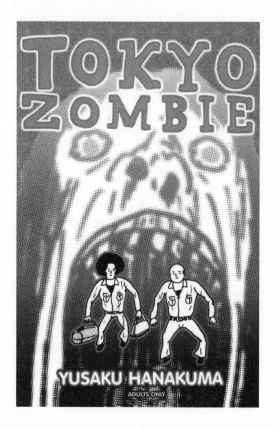

hand, it also recognizes and formalizes these limits as constraints in the first place, a gesture as constitutive of a genre's artistic project as any subsequent improvisation or "genre bending" that arises in tension with these constraints. "Write a detective novel," someone might say, and we already know what this means. It's no different with zombie stories. The zombie genre, which began to take shape in the 1930s, reaching a kind of market saturation during the past decade, resembles virtually all other popular modes of genre fiction in the necessary restriction of its

imaginative conditions. Every genre story, after all, must at once name and confront the exhaustion—or at least the exhausting familiarity—of its conventions. And keep on pursuing the project.

Despite their affinity with the so-called penny dreadfuls of the Victorian era and the dime novels and comic books of the first half of the twentieth century, however, what we might call the "ten-dollar dreadfuls" of today disclose an exponentially greater field of exhaustion. Contemporary zombie books and films also bear a categorically higher pricing threshold today than the cheap, ephemeral fiction known as the pennies and dimes of a century ago. There is an explicit economic logic for this, of course, beyond the so-called natural course of inflation. Indeed, a mass-market zombie paperback, a manga such as *Tokyo Zombie,* a trip to the movies, or a cut-rate DVD tends to gravitate beyond the ten-dollar mark with an alarming trans-media synergy. Or rather, given the relative quaintness of these various relics of industrial modernity, we might more accurately refer to this price point as the result of entropy rather than synergy. The set of constraints against which the zombie genre defines itself has come to incorporate the very economics of the literary marketplace, the sphere of cultural production itself. We're no longer talking about just the rules of fiction here—or about the life and death of the popular novel—but about the laws of culture itself. Today's zombie fictions play out not only along the formal conventions of their genre but also across an ever collapsing field of conventional analog media (and, increasingly, digital media as well). Ten dollars is the retail horizon, in other words, for residual media formats that linger on but are no longer especially thriving: printed books and magazines, comics, sound and video recordings, cinemas, and brick-and-mortar retail stores. Ulrich Beck has named such forms "zombie categories," referring to sociological categories (such as the family or the nation-state) that continue to organize our thinking in spite of their exhaustion as

viable terms for understanding contemporary reality.[1] Books, universities, and recorded media might be added to Beck's description. By this logic, zombie stories are no longer simply stories written *about* the walking dead; they are the generic counterpart of today's analog media and conventional institutions of culture. It is for this reason that we would do well to study how such stories nevertheless manage, in the words of Raymond Chandler, to "continue to assault the citadel" (1019).[2] How is it that they manage to keep going?

The arts and letters are dying, as the story goes. Who knows? Perhaps they are already dead. In the United States and worldwide, austerity programs and budgetary belt tightening have zeroed in on cultural programming and institutions of higher learning as targets for funding cuts: schools, libraries, arts organizations, universities. Likewise, in the commercial sector, access to films, plays, books, and the visual arts has become increasingly restricted: theaters, video rental stores, and book shops have all but vanished, edged out by the algorithmic selection systems of Amazon and Netflix. Blockbusters and best sellers are quite often the only sellers—until they, too, fall short. There remain, of course, isolated bands of survivors, clinging desperately to one another in small urban enclaves. Yet theirs is a fragile ecosystem at best. Across this blighted cultural landscape, the symptoms of artistic and literary death are too abundant to enumerate: from the rise of online course instruction and "intelligent design" to the proliferation of reality television, the demise of the arts and letters is marked, for many, by the upsurge in mindless junk. Where there was once *Masterpiece Theater*— or simply the theater—there is now "16 and Pregnant" and a surfeit of Hollywood remakes. Where there were once modern classics—or so the story goes—there are now zombies; the culture industry replicates the living dead in both form and thematic content.

Such cartoonishly apocalyptic visions of today's cultural landscape, however well intentioned, offer little by way of insight into the possibilities for survival or resistance. According to such logic, the arts and letters comprise a dwindling natural resource to be conserved, mourned, or written off. Whether symptom or epitome of this post-sustainable cultural landscape, zombie stories nonetheless have something to teach us about the possibilities for endurance and even inventiveness from within this exhaustion, a kind of thinking that is commensurate with their project-based initiative to invent in spite of everything. In doing so, zombie stories, like other generic forms, exercise a function proper to the arts and letters rather than comprise a symptom of their demise: in their hypostatic attention to the "zombie categories" of the culture industry, zombie stories face up to the exhaustion of the arts and letters, exercising a creative function precisely in terms of such categorical limits.

Like the penny dreadfuls of the nineteenth century and the detective serials and Westerns of the interwar and Cold War years, I reiterate, zombie stories delineate a field of project-based art. In other words, they take up their conditions of exhaustion and constraint as a formal apparatus, perhaps even as the very premise of their construction as works of fiction. To find the continuities between such genre fictions, we need look no further than the ever proliferating sets of rules that inform us not only about the many ways to kill a zombie or stay alive during a zombie apocalypse but also about the trans-generic conventions of zombie stories themselves. The unwritten laws of cultural survival now confront us, head on, as a discrete set of imperatives. Consider the "universal" visual instruction codes of Roger Ma's *The Zombie Combat Manual,* which offers diagrams for how to fight off the zombie hordes, as well as its inverted counterpart, John Austin's *So Now You're a Zombie,* a

handbook for the "newly undead" that offers self-help for unsuccessful practitioners of zombie combat.[3]

In either case, these handbooks ironically take up the narrative conventions of contemporary horror film and fiction as equipment for living (or at least for surviving, whether under apocalyptic conditions or as living dead). Likewise, the numbered checklists of *The Zombie Survival Guide,* not to mention the intra-diegetical directives we find in the opening scenes of the 2009 film *Zombieland,* rehearse a similar set of conventions as basic laws for survival. The formal codes of the genre have become so familiar, so utterly knowable, as to exceed the parameters of fiction altogether. The rules, however worn out, now propose to walk among us.

In rendering explicit their rehearsal of such familiar rules, such texts reveal their continuity with S. S. Van Dine's equally arch elaboration of the hitherto-unwritten laws of the detective genre. In his 1928 magazine article "Twenty Rules for Writing Detective Stories," Van Dine, himself an author of such stories, writes: "THE DETECTIVE story is a kind of intellectual game. It is more—it is a sporting event. And for the writing of detective stories there are very definite laws—unwritten, perhaps, but none the less binding; and every respectable and self-respecting concocter of literary mysteries lives up to them" (189). S. S. Van Dine (the pseudonym for the *Smart Set* writer and Nietzsche scholar Willard Huntington Wright) was invested not only in the issue of "respectability" he paradoxically upholds and parodies but also in the urgency of "living up," or making a living. For Van Dine's alter ego, Willard Wright, this had as much to do with supporting a cocaine addiction as it did with working in the increasingly popular pulp genre of the 1920s. The rules of the game, in other words, applied to the living writer as a necessary set of expertise. The minor metafictional adaptation from Van Dine's

12.2. Fluxus-inspired visual instruction diagrams for coordinating zombie horde attacks. From John Austin, *So Now You're a Zombie.*

credo for detective fiction to zombie stories is that the characters in the latter are as subject to (and, if they are to survive, as aware of) these rules as any writer or, for that matter, of any "informed reader." Indeed, the comic premise of the various zombie survival and combat guides is that the roles of horror fan (reader) and horror protagonist have been collapsed. The generic conventions of zombie fiction must be available not only to those aspiring writers and characters who hope to stand a chance of surviving but also to the inhabitants of the allegedly extra-diegetical terrain of so-called reality—that is, the kinds of people who buy zombie combat manuals, survival guides, and self-help books. None of this, of course, comes as much of a surprise, since such intra- and extra-diegetical play has itself become a commonplace, especially in horror fiction and film, as the *Scream* series formalized most explicitly. Everyone knows how to kill a vampire; everyone knows not to leave the house alone at night; everyone knows not to assume a wounded antagonist is dead. *Don't be stingy with your bullets,* the narrator of *Zombieland* reminds us. *Know the Enemy,* advertises Max Brooks, on his web page for the *Zombie Survival Guide.*[4] Any fictional character who stands a chance of survival must play the part of a reader (or aspiring writer); any reader is interpolated as a fictional character.

Live by the credo. Beyond demonstrating the continuities between zombie stories and other genre fictions, my point here is to propose that zombie stories derive their generic specificity from their own historical self-awareness of this resemblance. In a genre that includes *détourned,* mashed-up works of "classic" fiction (such as *Pride and Prejudice and Zombies*) in addition to the ironic survivalist instruction guides—not to mention an ever growing corpus of short stories, novels, films, comics, video games, flash mobs, zombie walks, and television serials—this self-consciousness takes multiple forms. In addition to a preoccupation with the rules that condition intra-diegetical survival and generic endurance

alike, this self-awareness extends also to the historical conditions of its production and distribution as a generic form. The advice not to be skimpy with one's bullets applies just as shrewdly to a film director as to a character in a zombie story.

Analogously, such advice draws reflexively from the "lived experience" of other zombie stories, films, and video games, a cultural field recycled as "practical" knowledge. The formal conventions accumulated since the 1930s become explicit rules of conduct or self-help talking points; the *zombies* may not realize that they're dead, but the *zombie genre* is rife with self-awareness—its debt to George A. Romero, to 1930s horror, to sensationalistic myths about Haitian vodou. By "awareness" here I am not referring to something anything especially human or conscious, however; this historical self-consciousness is as much the result of a formal apparatus as any discrete cognitive moment of subjective illumination. Whereas their apocalyptic scale and postapocalyptic landscape invoke the world-historical grand narratives we identify with such terminal scenarios—whether empire and decline, posthumanist ontologies, or the end time of Francis Fukayama's "Last Man"—zombie stories are no less steeped in the metaphoricity of their generic conventions, the saturated cultural field upon which they draw, and which they mechanically (some would say even mindlessly), yet no less inventively, reproduce.

But this very capacity for mechanical reproduction demands that we shift our attention to projects rather than postmortems. What is significant about the gratuitous reproductivity of zombie stories may be less what goes into them—by way of exhausted conventions—than what comes out of them. Rather than brandishing Walter Benjamin's famous suspicion toward technological reproducibility as a slick mechanical force luring us into ideological submissiveness, I propose that the reproductive function of zombie stories already accommodates our

submission to the marketplace and the exhaustion of our messianic political hope. Their plodding, staggering persistence instead opens up to other critical possibilities, however provisional. Thought, I would argue, and newness are the two wagers laid upon the endless, "mindless" reproduction of dead cultural matter we find at work in the zombie arts and letters.

Five Recyclable Rules

Zombie stories are predicated, we might say, on their own historical belatedness. The penny dreadful and the dime novel are grounded historically in the rise of cheap commercial printing; the proliferation of railroads, shipping routes, roads, and other means of distribution; and the postindustrial emergence of a working-class general readership. The "walking dead" of the zombie genre, on the other hand, refer at once to the once-aspiring proletariat now reduced to a soulless, indiscriminate mass as well as to the exhaustion of the very conditions that brought the penny dreadful to prominence. The zombie genre is thus no less generated by the zombification of the print and media industries themselves, as I have been suggesting: the hollowing-out of commercial publishing and institutions of culture, along with the networks of bookstores, cinemas, and recorded media that sustained the intellectual life and mass culture of the twentieth century. According to the technophile logic of the marketplace, these too are the "zombie categories" upon which the generic conventions of the zombie genre are founded and whose exhaustion and cynicism they might be seen to rehearse. Precisely because of this, the zombie arts and letters also extends to the way we think about, interpret, reflect upon, and teach the arts and letters—that is, to the very sphere of speculative inquiry that occupies some of the most hallowed—or, for some, the most moribund—sites

of high culture. The mechanical self-consciousness of the zombie genre has become our own.

Because zombie stories are not only populated by undead corpses and un-discarded generic conventions but are also rendered popular through media networks that have likewise fallen into decay, the cultural reference points are nearly infinite. As they continue to inundate the popular marketplace, zombie stories can allegorize almost anything, from race relations and the legacy of slavery and colonialism in the United States, to genetic alteration and epidemiology, as well as, even, to the very media saturation of the millennial generation. Rather than formalize a cohesive set of historical conditions to which the zombie genre can be reduced allegorically, however, I wish to consider the semiotic prolixity, the very allegorizability, of the genre itself as its generative function. The genre's precocious historical and ideological adaptability, that is, discloses a field of formal and conceptual positions that belongs neither to history nor to ideology alone, nor, for that matter, simply to genre or medium either, but instead to the exhausted meta-discourse about these things—that is, the living-dead field of university scholarship and critical theory that seeks to disarticulate and comprehend such formations. In place of a linear progression from birth to decay, from dawn to living death, the zombie genre embodies the arts and letters—including the critical thinking proper to it—as a terminally saturated terrain, as an ecology of post-sustainability, we might say. It is a wasteland that emerges not after the speculative end of history but that comprises the very field of meta-history and speculation itself. The persistence (and, I would argue, the challenge and the heuristic interest) of the zombie genre derives from this systemic rather than linear or serial proliferation. Zombies are everywhere.

What follows, then, is something of an anatomy—or autopsy— of the numerous critical and conceptual formations that find their

articulation in zombie stories as "ways to read" the zombie genre. These positions correspond, in turn, to many of the axes around which contemporary scholarship in the arts and letters tends to organize its sense of purpose and exigency—its aspirations to thought and newness—as it persists in the tireless work of critical exegesis while remaining ignorant of its own spectacular demise, even as pronouncements such as "the death of theory" and the "return to aesthetics" remain fresh on its lips. What follows is a partial and unsystematic survey of such positions for the sake of illumination, as well, I hope, as for the sake of confronting the scholarly and critical sector of the arts and letters with its own transmedia status as project art.

Rule #1: The zombie returns.

As with other forms of Gothic and neo-Gothic horror, the zombie genre lends itself to interpretations that privilege figures of revenance and return, from the Freudian uncanny to the Derridean specter of an unknowable and monstrous *to come.* Zombie stories, like zombies themselves, formalize a historical logic of unsettled accounts and the return of the repressed. In the case of Ishmael Reed's 1972 zombie novel, *Mumbo Jumbo,* for instance, this recursive logic applies at once to the repressive process of zombification itself—the instrumental reason of slavery, colonialism, monotheism, and capitalism—as well as to its countermeasure in the spiritual arts of voodoo priesthood. The story of oppression and resistance is a long one, and its iterations, its incarnations, periodically rear their heads. As PaPa LaBas, the novel's protagonist, reflects on his career as a *houngan* (voodoo priest) at the novel's close: "What are you driving at? they would say in Detroit in the 1950s. In the '40s he haunted the stacks of a ghost library. In the '30s he sought to recover his losses like everybody else. In the '20s they knew. And the

'20s were back again. Better, Arna Bontemps was correct in his new introduction to *Black Thunder*. Time is a pendulum. Not a river. More akin to what goes around comes around" (Reed 218). Zombies figure the return of the historically repressed; zombie stories can likewise unearth, exhume, and redress historical repression—offering the possibility of a counter-history, an alternative way of knowing.

As both a walking corpse and a recycled historical metaphor, moreover, zombies can certainly be understood as fictional devices for figuring the strange historical persistence of mass ideological constructions, whether the aftershocks of colonialism, fascism, and apartheid or the totalizing effects of liquid capitalism, neoliberalism, the culture industry, and so on. The walking dead are driven by an artificial causality with limitless indexical and figural possibilities; the generic form, too, is itself resurrected twice over, reprising the historical and ideological cachet of Cold War horror films as well as the colonial fascination with Haitian vodou. This means that zombies figure mass ideological effects as repetitions (oh, yes, we've seen this before, when it was a mass uprising, a fascist demonstration, or a spectacle of enchantment), but repetitions that are at once "dead" and shocking at the same time. Ulrich Beck's notion of zombie categories draws precisely from this understanding, drawing its critical energy from the creeping horror that such living-dead categories have been among us all along. Zombies are the figures for suspicious hermeneutics.

I'd like to quickly point out two subsets of this critical position. The first tendency directs its attention toward critiquing the political consequences of ideological persistence itself, whether in pointing out the incipient fascism of certain state formations or the dehumanizing corporate excesses of neoliberalism. Tirelessly, vigilantly decrying the violence exercised under the aegis of "zombie categories" and the culture of control alike, such criticism often garners the identificatory

charge that the critics themselves are no less zombielike than the effects they enumerate, their suspicious hermeneutics and moralistic insights purely mechanical, even lifeless, in their dogged continuity. I might, for instance, focus on the laddishness of zombie fan culture (as opposed to the more heterogeneously gendered fan culture of vampire fictions such as the *Twilight* series), and in doing so also investigate its generic inheritance of sexual violence, voyeurism, and rape as the basis of its exploitative fantasies. There is nothing particularly new to say here in terms of a critical insight, but this does not make the critique any less true or shocking; indeed, what's important is precisely that such exploitation persists.

Analogously, a second and very different set of critical possibilities arises in attending to the metaphorical possibilities of zombie attacks and takeovers as reprises (or potentialities) of new forms of political collectivity and agency, from the multitude to the flash mob. As an inverse figuration of mass politics, zombies become the new political subjects of the late-capitalist global landscape, driven on less by a fully articulated revolutionary ideology and more by the sheer, pulsing excesses of late capitalism itself. Are people made up to look like zombies dehumanized participants in a late-capitalist culture of the copy, are they potential revolutionaries and urban occupiers, or are they just a bunch of harmless nerds? With its excessive and exhaustive metaphoricity, the zombie becomes a figure for all kinds of returns.

Rule #2. Zombies must be destroyed!

With similar polyvalence, the widespread ultraviolence of the zombie media dramatizes more than anything the notions of bare life and the sovereign exception as developed by the likes of Carl Schmitt and Giorgio Agamben. Zombies are the mass embodiment of a political theology.

Indeed, Agamben does wrong to situate the concentration camp as the limit case of such notions. For it is in the carefully proscribed world of zombie fiction that it becomes imaginatively possible for the biomechanical persistence of the human body to function independently of anything living or human, and it is of course in the world of zombie stories that it becomes not only diegetically necessary but also affectively and ethically permissible to kill and maim with impunity. Under the conditions of a zombie apocalypse, "zombie combat" becomes a categorical imperative, not only universally applicable but domesticated as a form of self-help.

We have become familiar with such considerations when expressed through the public scrutiny of shoot-'em-up video games: the hypothetical, imaginative conditions that necessitate mass murder as a game's fictional premise risk bleeding into real life. The worry here is less that impressionable young children might mistake "fake" acts of violence for real ones than that the very imaginary consistency of a worldly totality might itself come to look fake. The conventions and excesses of zombie stories sustain both the demand and the doubt about such "sovereign exceptions" in ways that permit auto-critique and continued exploitation all at once. We see in an early page of *Tokyo Zombie,* for instance, a woman kicking the head off her boyfriend's mother, who has been buried up to the neck in the dirt of "Black Mount Fuji," a common site for burying corpses.

We are familiar enough with the baroque lengths to which horror-film protagonists eventually pursue their forms of zombie combat that the incident is virtually naturalized as a moment of Oedipal camp. The curious point is that none of these characters are zombies yet; the comic violence here is a function of the genre, not of the zombie "plague." The buried mother embodies, we might say, Agamben's *"homo sacer"*—the figure who can be killed with impunity, never rising to the status of a

12.3. Homo soccer. From Yusaku Hanakuma, *Tokyo Zombie*. Copyright © 2013 Yusaku Hanakuma/seirinkogeisha.

sacrifice—to the extent that even her beheading recalls the notion in its inauguration of a perverse game of "homo soccer."

Perhaps the most camp-violent version of this generic "sovereign exception" takes place in Peter Jackson's *Dead Alive* (1992), a film all the more explicitly governed by a domineering Oedipal mother. Here the paradigmatic zombie exception is a baby; in one scene, set in an almost supernaturally picturesque park, the infant suffers a series of dreadful mishaps that would otherwise prove the death of any normal on-screen parent—runaway pram, seesaw catapult, head trauma. As the resistant kernel to the protagonists' gore-strewn climactic zombie massacre, the demon baby is variously (though unsuccessfully) assaulted through an ever intensifying array of cartoonish exaggerations: diced in a blender,

beheaded with shears, bludgeoned with a frying pan, incinerated, and so forth. We are complicit with such acts of violence, the film suggests, but we are also in on the fact that it is just a movie. The baby is, after all, a demonic, brain-dead zombie, at once clearly evil and demonstrably artificial: a sovereign exception within both the film's diegesis and its camp-violent pact with its spectators. In other examples, however, we face paradigmatic moments of poignancy in recognizing the dehumanizing effects of such exceptions—that is, "we survive the zombie apocalypse, but at what cost."

Rule #3. Zombies are fictional.

Ethnographic surveys of vodou ritual practices aside, generic zombies have long since exceeded their historical points of origin. Precisely because they are fictions, and often fantasies of violent exception, zombie stories at once capitalize on and yet also disclose the spectrality, the virtuality, of the modes of sovereignty they envision. Taking a cue from Peter Jackson's film, I would propose that the same generic apparatus that induces us to "enjoy our symptom"—to participate ironically in the spectacle of violence and humanity we witness—becomes the ironic instrument for making it possible to recognize, in however comic or arch a fashion, the operative intensity of its own apparatus, its own ideological investments. Take, for instance, the deeply self-aware scene in *Shaun of the Dead* (2004) in which it becomes permissible to say the treasonous injunction to "kill the Queen." The film's climactic scene unfolds at the local pub, where the film's core of living protagonists finds itself characteristically under siege against the teeming zombie hordes. After the jukebox spontaneously begins playing the Queen song "Don't Stop Me Now" (already a meta-commentary on both zombie persistence and

Shaun's newfound sense of determination), the film's protagonist suddenly takes charge, directing his fellow survivalists: "Diane, get them somewhere safe. David, kill the Queen." The ensuing battle, like the treasonous wordplay, is explicitly unthreatening; the artificiality with which the botched efforts to dispatch the bartender zombie shift from weapon to weapon highlights the prosthetic rather than intrinsic quality of its staged violence, no longer spectacularized but manifestly, even politely, framed on a domestic scale. Can we not see the tentativeness with which the young actors strike the older actor with their pool cues as not only futile but oddly humane? At the same time, its proliferation of possibilities—its confusions and substitutions—also testify to the working apparatus of the film itself: it can do anything it wants, even though it chooses not to. It is, after all, only a movie.

Rule #4. The zombie apocalypse discloses (or in fact constitutes) a posthuman future.

With *Shaun of the Dead* still in mind, let's recall the final scene of the film, in which Nick Frost's Ed, now a zombie, still lives and plays video games with his buddy Shaun, only now with a heavy chain around his neck. This scene in many ways epitomizes the vision of a postapocalyptic yet crypto-utopian eclipse of the human envisioned by a number of recent scholars in the field of object-oriented ontology, for whom a posthuman ecology constitutes a humanism without humans.[5] For such thinkers, that is, systems of objects, animals, insects, plants, minerals, or digital codes circulate in ways that satisfy many of the same demands, and perform many of the same tasks, levied upon secular humanism—that is, the pre-apocalyptic ecology to the exhaustion of which contemporary consumers, writers, readers, and pseudo-humans have contributed.

Speaking ecologically about contemporary criticism is nonetheless compelling, therefore, for it offers an ecology of exhaustion itself. Zombies, and zombie fictions, arise as a product of the exhausted, post-sustainable systems they come to terrorize, whether media networks, world systems, or the biosphere. Zombies are the zombie concepts of a zombie ecology, the governing symptoms of the always already.

Rule #5. We've seen it all before.

The novelties and innovations of the genre are drawn from a familiar trove of stock possibilities, reusable shocks, and reflexive gestures. In this regard there is little distinction between this generic project and the institutional work of humanistic inquiry more broadly. Universities, university scholarship, and critical thinking are likewise comprised of both familiar routines and increasingly shopworn crises: funding shortages, program closures, and the surging hordes of new technology that threaten to overwhelm humanistic practice as we know it. The general conditions of institutional crisis, failure, and unrest are not simply analogous to the zombie apocalypse depicted in fiction and film; they are made of the same stuff. And the consequences, too, are the same: we will keep repeating ourselves, and we will keep going on, even if it means citing Samuel Beckett yet again. We can't go on; we will go on.

The postapocalyptic wasteland of zombie fiction is nothing less than the critical terrain staked out by the scholarly humanities: a terrain that is not simply metaphorically prolix but comprised of metaphor; not simply allegorical but comprised of allegory; not simply attentive to media environments but constituted by such media environments. Indeed, to the extent that zombie stories might be viewed as the inverse or perverse double of the field of humanities scholarship—its "mindless,"

affordable, popular, ironic, and para-literary doppelgänger—I suggest that any such synoptic approach to the genre offers an occasion to reflect on the implications of this resemblance. But zombies and the humanities are not doubles of each other; they each constitute a meta-discourse that operates according to the same system of possibility and foreclosure that finds itself exercised at every turn.

There is little here, once again, that hasn't been seen before. What sustains each genre in its perpetual tendency to recycle, though, is precisely the "intellectual game" of this very recirculation itself, as S. S. Van Dine put it. Newness (or epiphany) is less the result or product of the game of endless reinvention than its wager. With this in mind, we might wonder to what extent the humanities—and critical thinking in general—expands its historical investments by heeding its own belatedness and redundancy, rather than either scorning or acceding to the mindlessness of the brain-eating zombie.

I'd like to respond to this question by returning to my initial claim that genre fiction is a form of project-based art. The critical positions or "readings" of zombie stories I have sketched out here are grounded, of course, in the aesthetic product of zombie writing and filmmaking. Yet the very tendency toward the endless reproduction of these positions, as well as the virtual interchangeability of examples, suggests that we might do well to shift our emphasis from products to projects when it comes to the work of scholarship and humanistic inquiry. To proclaim the bankruptcy of a field that is at once utterly exhausted and yet which opens up to almost limitless possibilities is to bemoan a false paradox. What we instead face is the exigency of both formalizing and playing out, perhaps even mechanically reusing, the habitual givens established within this field. In a manner that I consider illustrative, zombie stories capitalize on this played-out and simultaneous openness to play, in their proprioceptive relation both to the generic lineages and world-historical

resonances from which they emerge. What does this "capitalizing" look like, and to what extent does it constitute a kind of thinking?

Phantom Pregnancy

One of the more clever approaches to this recursive "capitalizing" offers a lesson in small-scale capitalism that has taken place under the auspices of a commercial publisher. Using the commercial book as the particularly exhausted and post-sustainable medium as its basis, the Philadelphia-based publisher Quirk Books produced one of the great success stories of the "ten-dollar dreadful." In 2009 Quirk released the runaway best seller *Pride and Prejudice and Zombies,* a mash-up of Jane Austen's novel with schlocky scenes of zombie mayhem and martial-arts zombie combat.

Significantly, the novel and its sequels are the invention of the press itself rather than the brain child of its author(s), whether Jane Austen or Seth Grahame-Smith, the writers who actually penned the mash-up. The project is instead the invention of Jason Rekulak, the creative director at Quirk Books, who contracted out the writing of the first novel to Grahame-Smith, a TV screenwriter who had himself authored a rule-based genre handbook titled *How to Survive a Horror Movie: All the Skills to Dodge the Kills* (2007). In its corporate authorship and publisher-driven concept, *Pride and Prejudice and Zombies* is never anything other than an industrial product, however revisionist it might seem in its introduction of a set of female protagonists to the zombie genre. What is significant to the book's innovation as a concept, though, is precisely the shift in emphasis it effects from the *text* of the novel—which is by definition borrowed, mashed up, zombified—to the book itself as a material artifact and commodity. Its cover designed to approximate the characteristic design of a Penguin edition—and

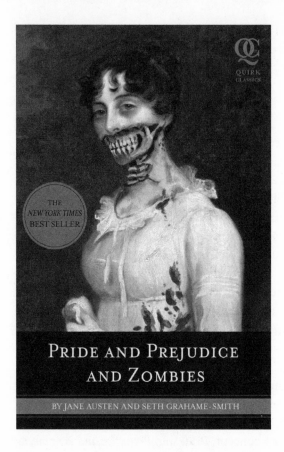

12.4. Designed from the outside in. Cover image, Jane Austen and Seth Grahame-Smith, *Pride and Prejudice and Zombies.* Copyright © 2013 Quirk Productions Inc.

later reprinted in a Deluxe, faux-leather "classic" edition with color illustrations and a scholarly afterword—*Pride and Prejudice and Zombies* both acknowledges and fully exercises the zombie genre's metaphorical resonance with the living-dead state of commercial publishing. The other titles printed by Quirk (which include *A Field Guide to Stains* and *The Geometry of Pasta*) are likewise envisioned as book objects whose material and economic status determines their form and content alike.

As Rekulak explains in an interview with Steven Shaw: "We pay a lot of attention to the design of the book, and we publish strategically, so that the object becomes the selling point, not just the words."[6] Though firmly embedded in the marketing strategies of a commercial publisher, this logic is far from cynical or limited to capitalist production; rather, the shift from genre to medium as a terrain for formal (even "mindless") experiment exercises a creative function that is consistent with other forms of recursive or curatorial art, which Kenneth Goldsmith and Marjorie Perloff have each recently labeled, even championed, as "unoriginal" and "uncreative."[7]

A further example, which both allegorizes and performs how we might think of medium itself as the terrain for project-based art, is the far different sort of book artifact we find in Daisuke Ichiba's *Grossesse nerveuse* ["Phantom Pregnancy" or "Neurotic Pregnancy"], a folio-sized book of drawings by the Japanese artist published by the French print collective United Dead Artists.[8] The suite of images presents a disconcerting array of spectacularly violent acts and disfigurations, from the most sadistically murderous to the supernaturally, even hermetically, artful. A woman holds an infant-sized bundle that drips blood; the bundle is swaddled in a blanket of widened eyes. By contrast, the woman's own eyes are virtually expressionless, whether deadened by shock, determination, or indifference. In a later image a young woman sits contemplatively on a train full of decomposing passengers; outside the train, volcanoes spew sinews and paisley whorls of toxic smoke.

As striking as the violence is the familiarity of the images in *Grossesse nerveuse*. The scenes are, on the one hand, strongly steeped in Japanese history—whether the pastoral scenes and domestic spaces of Japanese printmaking or war-era soldiers and apocalyptic scenes reminiscent of Hiroshima and Nagasaki—as well as in the graphic style of the interwar avant-garde, such as the work of George Grosz and Max

12.5. Nerve-rackingly graphic. From Daisuke Ichiba, *Grossesse nerveuse.*
Copyright © 2013 Daisuke Ichiba.

Ernst. Such scenes are replete, on the other hand, with explicitly out-of-
place body parts and emotional affects alike: figures in the images are by
turns scarred, monstrously hybrid, or otherwise disfigured, their organs
transposed, almost magically—and often perversely—displaced, or, in
other cases, violently removed through unspeakable acts of cruelty.

In their unsettling pageant of disfiguration, Ichiba's images do not so
much simply expand the sphere of violence mechanized in horror films
and stories, I would suggest, as to explode the limited discourse on the
nature of the *graphic* developed there. The pen-and-ink drawings attend
to the extent to which graphic violence is actually graphic—exploring,

we might say, the ways in which violence, but also horror, pain, and bodily deformation, can be literally and materially inscribed. Ichiba's *Grossesse nerveuse* invites us to reflect on the extent to which the images literalize the book's titular concept, in drawing out a fascinating series of graphically violent intimacies. In doing so the folio presents a series of affect games whose capacity to be pregnant with their own (or our own) neurosis becomes their serializing imperative; some images may succeed in such a project, others may not. Yet even in doing so, the very concept of a "grossesse nerveuse" induces us to question whether such a "pregnancy" is ever anything other than imaginary, the very metaphorical rendering of pregnancy as a virtual act of artistic communicability itself purely specious: a phantom pregnancy.

The challenge here, I maintain, concerns approaching the arts and letters most broadly—from the writing of popular fiction to the terrain of creative and conceptual inquiry—with a similar eye to the projects its historically exhausted field both demands and invites. What might be some of the ways we might take up such projects? We have seen in criticism as in other fields a renewed attention to the book as an aesthetic and material object; accordingly, the past decade has witnessed the proliferation of zombielike cenotaph handbooks such as Simon Critchley's *Book of Dead Philosophers* (2009) and Alain Badiou's *Pocket Pantheon* (2009), which appeared, not coincidentally, the same year as *Pride and Prejudice and Zombies.* How else to respond to the so-called death of theory than with such ironic, yet hopeful, memorial guidebooks? In addition, the field of scholarly publishing in the humanities continues to be overrun by innumerable "Short Introduction" series and readers' guides, which comprise the aggregate countermeasure to contemporary explorations into the possibilities of so-called new media. But this concentration on medium constitutes only one of the facets of the contemporary critical terrain, what we might consider an object-oriented

production model. I would propose instead that we consider investing less in objects or products than in projects.

That is, to the extent that the material artifacts that humanities scholars produce (and why not make them objects of fascination) are "pregnant" not with their own self-presence but with the *nervroses*—the neurosis, the anxieties, the compulsions—whose traces they bear. In other words, the project that animates such works cannot be exhausted by its material remainders; whatever principle or set of principles that might comprise the formal structure of the project designates something other than the "rules of the game" at the formal origin of a work. What we are left with instead is the post-facto shadow of this project, the vestiges of an operational set of directives for which the material work constitutes at once the trace and the alibi. Once we have the scholarly artifact in front of us—whether book, journal, or sheaf of dry papers—what we see is less a "finished" product than the evidence of, and communicative medium for, the imperatives exercised in producing it. The work is a trace of its project, but an anticipatory trace: a fore-shadow of what remains possible in spite of everything.

The ambition of a book about zombies cannot be said to produce the last word on its topic, the exhaustive study of an exhausted topic. Rather, in exhuming the format of an edited scholarly volume as its vehicle, it confronts the generic and scholarly demand continually to produce and recirculate "new" scholarly knowledge. This demand is the very wager of the game. Even as markets collapse and academic programs close, the very persistence of literary and scholarly circulation insists upon the possibility of curating rather than inventing new readers, new students, new participants in a zombie medium. The point is hardly to remain doggedly, if not blissfully, ignorant of our own intellectual demise. The point, rather, is to keep going.

Notes

1. See, for instance, Beck and Beck-Gernscheim, *Individualization,* esp. Jonathan Rutherford, "Zombie Categories: An Interview with Ulrich Beck," in *Individualization,* 202–13.

2. Chandler, the great crime-fiction writer, attributes the persistence of mystery writing to the notion that no mystery story had yet "exhaust[ed] the possibilities of its form and [could thus] hardly be surpassed" (1019). I propose instead that the genre of zombie stories has long since exhausted the possibilities of its form and yet persists all the same.

3. See also Brooks, *Zombie Survival Guide.*

4. See Brooks, Zombie World, http://www.maxbrookszombieworld.com.

5. See, for instance, Bogost, *Alien Phenomenology,* and Bennett, *Vibrant Matter.*

6. As Rekulak explains, "There are certain categories of book that are very vulnerable to the Internet; for example the encyclopedia business has been transformed by the Internet. I would also be very nervous if I worked at a travel guidebook company. There are other books, though, that will probably never make the jump. Why read *Pride and Prejudice* on a screen, for example? Books like that are probably immune to the threat of digital publishing. If you think about it, cars didn't eliminate bicycles. One of the appeals of Quirk Classics is that they are like the books that you read at school" (Shaw).

7. See Goldsmith, *Uncreative Writing,* and Perloff, *Unoriginal Genius.*

8. See the United Dead Artists website: http://www.lewub.com/udaroom. Accessed June 1, 2013.

13 *Zombie Philosophy*

JOHN GIBSON

When we have to change our mind about a person, we hold the inconvenience he causes us very much against him.

Friedrich Nietzsche, *Beyond Good and Evil*

Here is a list, very incomplete, of things one should keep in mind when attempting to write seriously about zombies. Zombies do not exist. Zombies are not related to werewolves or vampires.[1] Zombies are not, literally, mindless consumers, enraged proletarians, or stupid Americans—although some were perhaps once these things—and there is little use in casting them, even metaphorically, as *essentially* such, especially when attempting to offer a "theory of zombies." This is because zombies do not form a natural kind, not even a *fictional* natural kind. Within the genre, zombies vary greatly in behavior, cognitive power, and athletic ability: some shamble, some run at or near Olympic speeds; some are incapable of manipulating even simple objects, others play video games with erstwhile friends; some behave better, at least not worse, than the living, others are Nazis; some are created by ill-advised government programs, others by hearing (Canadian) English.[2]

All of this makes it difficult, and likely a colossal waste of time, to make grand, general pronouncements on the nature of the living dead, the interest they hold for us, or their basic cultural significance, which

is just as well, since I do not have a theory of zombies. In fact, my claim is that zombies can offer a particular kind of philosophical and aesthetic reward precisely when we *do not know* just what they are, what animates them, or what it amounts to when we get to work killing them, self-defense notwithstanding. What I am after here is not a general account of zombieness or the point of the genre (there isn't one). Instead, I want to make available a certain way of taking an interest in the zombie and a range of philosophical and aesthetic possibilities that the undead, if you will, embody. As Arnold Isenberg, the great and now dead (*dead* dead) philosopher of art had it, the job of the critic is not to say "true things" about art so much as to open up novel and, one hopes, valuable ways of experiencing it, and here I continue in that tradition, though with the method suitably modified for camp and gore.

My claim is that zombie art—I use "art" loosely, to include every-thing from a horror flick like *Night of the Living Dead* (1968) to a novel of high literary aspiration like Colson Whitehead's *Zone One* (2011)—can, in rare but wonderful moments, both raise and turn on its head a tradi-tional way of thinking about what is sometimes called *person skepticism* or, to say the same thing, *skepticism with respect to others* (hence the importance of *not knowing* just what zombies are and just what it means to kill them). And at times zombie art does so in a way that is more or less sublime, but sublime in a novel sense, what I will unsurprisingly describe as the *skeptical sublime.* I obviously need to explain what I mean by "skepticism" and "sublime," and I promise to bring these ideas down to earth as I proceed. But note, or trust, that skepticism is one of the longest-standing and most vexed issues in Western philosophy, and the sublime occupies a similar position in modern aesthetics. I hope the reader will see why one might be interested in uniting them, and why it is a way of paying a compliment to the genre to argue that the zombie can bring them together in a powerful and unique way.

Doubts That Will Not Die

Let me explain, generically and painlessly, what I have in mind when I speak of skepticism as a kind of stance one can take (or suffer) with respect to the world, as well as what it means to assume this stance toward persons. Part of what I ultimately wish to claim is that, contrary to a common interpretation, zombies do not represent the return of ancient and repressed energies but are in fact quite modern creatures, in the sense that without a certain inheritance of modern skepticism about persons, we will be hard-pressed to explain at least one crucial respect in which zombies can provoke our interest in a way mere ghosts, ghouls, and graveyard fiends cannot.

What is skepticism? The term has such a wide range of uses in academics and intellectual life more generally that one must not expect anything resembling a tidy and uncontentious definition to be possible. That said, most who have thought seriously about Western philosophy's skeptical heritage agree on a few basic points. The first is that skepticism has nothing to do with those forms of hip cynicism and cool contrarianism that pervade our cafés and classrooms and with which skepticism is often confounded.[3] As a philosophical position, skepticism is best seen as designating not quite a belief or a conviction, for example the belief that the powers that be are liars, that established bodies of knowledge are fraudulent, or that no one but me really gets it. These are, after all, claims to know something—namely, that something is false or very likely so. And this is altogether too much knowledge for the skeptic, who knows neither whether something is true *nor* false and whose doubt is more methodic, consuming, and intelligent than that of the naysayer or crank. Skepticism, as either a philosophical position or a pathology, shakes our confidence so thoroughly that conviction itself is rendered impossible and the very grounds for belief vanish, except, of

course, the belief or conviction that knowledge is impossible, perhaps the one truth to which the skeptic can claim cognitive access (though consistent skeptics will wish to doubt this, too). This is why the motto of the great Pyrrhonian skeptics of antiquity, our skeptical primogenitors, was the blanket exhortation "withhold assent!"[4] And as we move to the modern tradition of thought about, if not always endorsement of, skepticism—names that appear on most au courant lists are René Descartes, David Hume, Immanuel Kant, Friedrich Nietzsche, Ludwig Wittgenstein, Jacques Derrida, and Stanley Cavell, although this ignores a great many—we find the picture of doubt and its apparent inescapability treated not as a curiosity from the history of ideas, but as a problem that rears its ancient head with virtually every step we seem to take forward in philosophy.

Put as baldly as possible, one can minimally characterize skepticism as a condition of mind in which it comes to appear reasonable to think that the word might be radically otherwise than we think it is, *at least as far as we can know* (hence the skepticism). To borrow a term from Theodor W. Adorno, it is a sense of inescapable "nonidentity" between how we perceive, speak, and think about the world and the way the world *actually* is—say, a sense that everything we rely upon when we attempt to understand the world might be spectacularly ill-suited for the task at hand.[5] Now, many philosophers think skepticism, even so conceived, is at some level a good thing, a stance that is essential for a healthy, honest mind;[6] the Greek skeptics surely did, as do many of the trends in theory and philosophy that have been in vogue since postmodernism stepped on the scene. And note that if skepticism strikes you as a little silly, you would probably find much more ridiculous a person who suffered his convictions so thoroughly that he could not even acknowledge the possibility that the world might be any other way than he believes it to be. At some level, intellectual honesty seems to call

on us to take this possibility seriously, although it is also easy to make a rather big deal of it.

The point I wish to make about skepticism—and here I stop speaking in a general tongue and begin to say things that are philosophically contentious—is that skepticism, and the kind of generalized doubt that issues from it, is not interesting if taken as marking the mere idea that the world might be otherwise than we think it is. For it to have teeth, it must result in a way of interacting with the world. It is a mistake to think of doubt as a cold, staid cognitive state. It may at times be that. But at other times it behaves in a way that makes it appear remarkably similar to a passion. And doubt, like passion, can be a good thing, since to have none of it is to make one appear equal parts naïve and machinelike. But doubt also has a terrifying capacity to become unhinged, even to destroy its object, just as anger, envy, and, at times, even love, do. And if this seems unlikely when talking about skeptical doubt in general philosophical terms, it will not once we move to a particular inflection of skepticism, *person* skepticism, in which the skeptical doubt can damage, literally and often horribly, our connection to those features of the external world that matter most to us. At any rate, if skepticism as a general epistemological posture strikes us as reasonable, even a little sexy, skepticism with respect to others is another beast altogether. Let me explain.

Strictly speaking, skepticism with respect to persons is possible whenever one finds a reason to doubt that a particular human body houses a genuine *human being,* in the full moral and cultural sense of the term. This is a kind of skepticism that was likely made possible as soon as the Greeks started calling other people barbarians or, for that matter, heroes (barbarians are in part animals in human clothing, and heroes are gods; for an example of each, consider Euripides's treatment of Medea). But the particular notion of person skepticism I am after requires

a distinctly (early) modern invention, a new picture of the self as the locus of personhood and as distinct from, as Galen Strawson puts it, the "living, embodied, publicly observable whole human being" (21). It is the picture of a person we begin to see clearly in the work of Descartes, whose famous "cogito ergo sum" reduces the person to a *self* and the *self* to a mental entity that resides deep in our "psychological"—once upon a time we would have said "spiritual"—interior.[7] Here's the skeptical rub: in our interaction with others we have access only to their outward shell, *to bodies,* and thus we at best have only indirect evidence that there is actually a human self loitering behind the eyes and hiding behind the heart. So when we ask, as at times we do, whether a certain colleague or relative is a monster or a person, we can never peek inside and settle the question decisively.[8] Needless to say, this picture of selves, of personhood, as a matter of what goes on in the inside of the human, makes possible an especially pernicious kind of skeptical doubt, one brought to view nicely when Descartes himself looked out his window and asked, perhaps seriously, whether all those people on the street below might just be automata (Descartes 23). Descartes was just having some skeptical fun when he asked this, but the very fact that the question is intelligible reveals something frightening—namely, that we implicitly possess the power to see others without thereby seeing other humans. *This* is what is made imaginable, and it offers doubt a clear invitation to go off the leash.

Borrowing from Stanley Cavell, I introduce the idea of *skeptical anxiety,* taking it to designate the kind of skeptical experience we have with respect to others when doubt registers as a kind of *worry,* a sense of puzzlement about the status of another that threatens to change, usually for the worse, how we receive that person and the kinds of claim (ethical, political, etc.) they can make on us. Think it of it as the kind of worry that risks unburdening us of the sense that a genuine community

is possible with another, that the other is *really one of us*. To be sure, there are times when we feel pleased, in a self-righteous kind of way, to experience this skeptical anxiety, such as when one finds oneself in line at the DMV or in a shopping mall thronged with enthusiastic shoppers. It can flatter us to feel human unlike (and above) those around us, a phenomenon Friedrich Nietzsche called the "pathos of distance" (*Geneaology of Morals* 26). But to give ourselves to the satisfaction of this pathos is also to open the doors to all manner of moral and political nastiness. Indeed, a skeptical anxiety of this sort can be seen at some level as underwriting a good amount of modern evil, particularly of the sort that was brought to us by the makers of the modern slave trade, the holocaust, and other examples of the vastness of our capacity to deny not merely the humanity but the *humanness* of others. In the realm of art it is an anxiety that will be familiar to anyone who has thought seriously about *The Tempest, Heart of Darkness,* or *Creature with the Atomic Brain.* That is, it should be familiar to anyone who has thought seriously about what academics like to call "otherness" or, uglier still, "alterity," and how the "Is it human?" question that the experience of otherness can provoke often plays out in an astonishingly horrible manner, in both life and art.[9]

This anxiety is clearly skeptical in nature because it registers the doubt—or, better yet, fear—that, for all we know, some others among us are not quite other people, in the sense that we find it intelligible, if not reasonable, to think that if we could look within certain others, we might not find ticking whatever it is that makes one tick like a genuine human or true person, whatever a "genuine" human or "true" person may precisely be (and it is gospel in the philosophical tradition I am using here that no answer is forthcoming to these questions). What is interesting, in philosophy but especially in the arts, is the range of dramatic possibilities of exploring this capacity to see others as *Homo sapiens* yet

not quite human, animated but not fellow, living yet not members of, as Wittgenstein would put it, *our* form of life.[10] This is why much modern art and philosophy interprets this skepticism about persons as tragic and emblematic of a certain sickness of thought (think of Primo Levi's *If This Is a Man*). We see in the most horrible moments of both modern art and modern culture a playing out of what it means to take a skeptical stance toward others and of the great moral and cultural price we pay for it. As Stanley Cavell puts it, we see that "it is in respect to others that we live our skepticism (*Claim of Reason* 447). In other words, the tradition of work on skepticism I am going on about takes this skepticism to be dangerous stuff, if also, unfortunately, altogether human. Hence all those theories that urge an act of reception to hold near the people who the skeptic in us makes distant, say, if one reads Levinas, by an act of *recognition*, or, if one reads Cavell, by an act of *acknowledgment*.

One needs to be careful here, and the claim is not, of course, that for every person who denies the humanity of another we will find one in the throes of skeptical delirium. People can believe, *really* believe, all sorts of nonsense and stupidity, and a believer is not a skeptic. But if persons, even cultures, can be quite convinced that some group or another is not human, my point is just that skepticism, as described here, is needed to tell the whole story of how this could come to be (some academics would call it a "genealogical" or "originary" claim rather than a psychological one). It will just be one chapter of the story—other chapters, perhaps more central, will be dedicated to all the stuff Marxists go on about—but it will be one we must read if we wish to understand the phenomenon clearly. At any rate, even if one is unconvinced by the political and moral claims I have made on behalf of person skepticism, it does allow us to say something interesting about the zombie, to which I now return.

The Uncertain Dead

This modern skepticism about others offers endless opportunities for the artist of the undead. The zombie often dramatizes, but with a crucial twist, a hallmark anxiety of modern philosophy and art, one I think we can now see as a distinctly skeptical anxiety. The zombie turns on its head this sacred tradition of thinking about skepticism and otherness just outlined. What is wonderful, and wildly immoral, about much zombie art is that it gives us reason to think that this skepticism that is so essential to the story of modern evil is at times a good thing, and in fact the key to our survival.

One can begin to detect some of what I have in mind here when one considers the concurrence of two common tropes in the zombie flick. The first is the idea of the *familiar* zombie, and the second is the idea of a possible cure for what ails the zombie. Combined, you have a nearly perfect skeptical concoction, but in this case one that raises the possibility that all those zombies you've been dispatching might indeed be human, people, at least latently. Rather than turning the fellow human into a degraded "other," as most philosophy and twentieth-century art interprets the problem of person skepticism, the zombie flick has the power to turn a degraded other into a potential human. For it raises the possibility that it is *our sons, wives, husbands, and neighbors* we've been shooting in the head, and that they are not just shells of what they once were but, *as far as we know* (hence the skepticism), are just experiencing a kind of prolonged absence, in which case killing them is very much to kill a fellow human, in fact to diminish the ranks of the species you are presumably trying to save.

This is why it is crucial to much zombie art that *no* explanation is forthcoming of how the zombie virus quite makes zombiehood possible. For the viewer as well as the survivor of the zombie apocalypse, the very

fact of zombies baffles, since their hunger and continued locomotion contradicts virtually everything we know about biology, physics, and the cosmos in general. It is for this reason that one can feel comfortable stipulating from an armchair that *any* zombie film that offers a tidy and plausible account of the possibility of zombie "life" will be a lesser work of zombie art. If the genre is to work as skeptical magic, we need to see the zombie as animated by a great question mark and not a physically or scientifically intelligible force. To render zombies intelligible, to explain just how they can do their zombie thing, is to turn them into workaday monsters and so to compromise the almost metaphysical sense of confusion they can provoke, a sense that is essential for getting these mindless dead to give the intelligent living the kind of experience zombies, at their philosophical and aesthetic best, can deliver (more on this in a moment, when I turn to the sublime).

Forget that it is pretty unlikely that our zombie familiars will be coming back—and, if they do, presumably with serious cosmetic disadvantage. Chances do not matter when talking about skeptical anxieties. When Descartes invented modern skepticism by asking how we know that we are not just dreaming, his expectation was not that we'd find it probable that we indeed are. It isn't probable. It is our inability to dismiss the possibility, however remote, that is so unsettling, and that wreaks such havoc upon what we once thought we knew. This is why a genuinely skeptical doubt is so hard to shake, once felt: you *know*— and this, again, may be the one thing we know—that no knowledge is forthcoming that could relieve your doubt. Likewise, the mere making possible, imaginable, that the walking dead are just really, really ill raises an immensely important moral, political, and epistemological question: *What* is it that we are killing? Or, simply, just what is it, living or dead?

One must keep in mind that even if we accept that zombies are dead and bound to remain that way—that they shall *never* recover from their

affliction—this still does not resolve our basic skeptical worry. It makes all the difference in the world if a zombie is *one of ours* who has passed on or *one of them* who just won't go away, since we cannot, presumably, mess with the dead human the way we can mess with the merely walking dead: certain rights and forms of respect still apply in the case of a human corpse. And the genre, at its best, makes this unresolvable, undecidable, and so keeps the skeptical anxiety dramatically present. Every zombie flick has a character for whom the zombie apocalypse provokes something like spring break fever, an opportunity for unbounded homicidal fun. And it is a central gimmick of the genre to get the viewer wondering whether she should feel utterly repulsed by this or just say, "Why not?" Just as for Descartes, the consequences are severe if we find that we cannot eliminate the skeptical doubt these questions raise: what are these things, what stance should we take toward them, and how should we perceive them? In this respect the zombie is an analogue of what art critics sometimes call an *anxious object*. An anxious object "does not know whether it is a masterpiece or junk," and an introspective zombie, if it could just speak, would likely tell us the same, though with the distinction put in humanistic rather than aesthetic terms (a person being, if not a masterpiece, then, like one, an object of significant value; the zombie would be junk) (Rosenberg 12).

The posthumanist, antihumanist, and trans-humanist (what's the latter, exactly?) will object at this point. My way of putting the matter, it may appear, makes everything entirely too dependent on the question of whether the zombie is potentially a form of *human life*. And this smacks of the foul speciesism humanists are thought guiltily of embracing, placing, as they often do, the human at the center of the moral universe and leaving no room for all the other things with which we share existence.[11] But none of this really matters here. I take it as a simple fact that the genre makes the question of whether a zombie is a latent human

central to the skeptical game it often plays. But of course it need not be such. One can easily imagine a posthumanist rendering of the zombie apocalypse (though good luck at the box office) in which the survivors, rather than worrying about the potential humanity of the zombie, just worry about the fact that they are and so whether they have a kind of moral status. After all, we think it is wrong, and ugly, to kill snakes, bears, and annoying bugs just because of the problems they pose for us, and so too with a zombie, one would think. Surely there could be a work of zombie art that complicates the skeptical questions I am raising, likely to decent dramatic effect, without making the matter hang on the human question. In short, if we heed the posthumanist call for "a new and more inclusive form of ethical pluralism" (Wolfe, *What Is Posthumanism?* 137) that extends beyond the category of the human, the genre can accommodate. In this case it will still deal with skepticism *with respect to the other,* and the difference will be that we will not take "other" to designate necessarily another *human.*

Yet the genre itself seems content to complicate the question of whether the zombie is a latent *person.* The very best example of this that I am aware of comes from the television series *The Walking Dead.* The show itself does an extraordinary job of exploring the plenitude of forms of zombie perception the genre makes possible. It plays upon what philosophers and psychologists sometimes call "aspect-dawning" and the difference between seeing-that and seeing-as, which, among other things, explains the ability of an object to appear suddenly as a different object, often due to a subtle shift in the cognitive or perceptual stance we take toward it (Wittgenstein's duck-rabbit is the most popular example of this[12]). The scene I have in mind—from the episode titled "Pretty Much Dead Already"—revels in the chaos that is created when these different perspectives, these different forms of seeing-zombies-as, come crashing into one another. There is the old humanist, Hershel, a

veterinarian who is a *pater familias* and proprietor of the farm where the group of survivors seems to have found sanctuary (no zombies seem to be around, and the survivors can do things like bake cakes). Hershel's perception of zombies is crucial to the scene I have in mind and to my point, since he is the one who most powerfully feels the skeptical worry that, despite appearances, the zombies might simply be ill; indeed he hides his infected relatives and neighbors in a barn to keep them safe while he hopes beyond hope for a cure. Hershel insists on perceiving zombies as *people*, as suffering, and so in effect *passive* and hence blameless with respect to their crimes against the living. At the opposite end of possible forms of zombie perception is Shane, a deputy who simply hates zombies, though his hatred likely represses a deeper anxiety. He in effect sees zombies as just a bunch of assholes. There is Rick, the sheriff and the de facto head of the survivors, who neither hates nor loves zombies but sees them as obstacles to be overcome, somewhat like the stoic frontiersman from old Westerns who does not have anything against the natives but won't hesitate to shoot if they begin circling wagons. And then there is Carol, the most tragic of the bunch, who is looking for her lost daughter and seems to be terrified of how she will perceive her if found infected: as a child who is in need of protection or as a child who is in need of a burial.

In the scene I have in mind Shane discovers all those zombies in hiding and wants to get busy killing them. After a brief debate, he says "to hell with it" and liberates them from the barn, in this way creating the context that will justify killing, or whatever one calls it, the undead. And of course the young lost girl appears, now zombified, and her mother's eyes register a supreme form of skeptical bewilderment; Hershel sees his lost family and neighbors about to face a firing squad, and Shane sees a bunch of assholes to be killed. But in each case one sees a crisis of confidence in how each perceives the zombies, a fragility

in their conviction that they know what they are seeing. It is a terrific scene, especially because it does not feign to settle the question of how the walking dead should be perceived. Before any of the characters, or the viewer, can draw a conclusion, necessity rears its head and the survivors have to defend themselves, as if it is the nature of such questions to be put aside instead of answered. Of course it has to be that way, for reasons both artistic and philosophical.

It seems fair to me to characterize the dramatic core of this scene as skeptical, and the show works whatever magic it has because it more or less successfully complicates the problem of zombie perception by showing it of a piece with the general problem of skepticism with respect to *others*. Or so this one scene does. It is true that the remake of *Dawn of the Dead* (2004) includes that scene in which a father sees his infected wife give birth to a little zombie baby—the father mistakenly tries to cuddle it—but its effect is schlocky rather than skeptical. However, this moment from *The Walking Dead* strikes me as getting as close to a philosophical achievement as one can get on cable TV.

The Incomprehensible Dead

If one will grant me this outline of a skeptical reading of at least one representation of zombieness, I can say something about why this zombified enactment of skepticism can approximate the sublime.

To save time, I pluck indiscriminately near the intersection of Immanuel Kant and Paul de Man and say things with which likely neither would agree.[13] Kant, of course, is the great architect of the modern concept of the sublime,[14] and it is de Man who brings the Kantian sublime in line with characteristic forms of twentieth-century disappointment with thought and language. Kant, it should be said, would be delighted that we are celebrating a zombie annus mirabilis around the time of

the death of Thomas Kinkade, Kinkade being the popular American painter of landscapes, main streets, and firesides. And this is because in the realm of the aesthetic, the sublime has much greater status than the pretty and the "just so." In fact, Kant's various comments on the sublime and the beautiful—in the realm of the aesthetic, the beautiful and the sublime are the only categories that traditionally matter—suggest that George A. Romero might be Milton's equal in art. Not quite, but Kant does give us reason to think that the monstrous and not an assortment of water lilies might be the stuff of the highest art.[15] For Kant, poetry is the greatest of the arts, and Milton is the greatest poet. And while Kant himself often seemed to restrict the notion of the sublime to nature, many others would find it perverse to think of Milton as anything other than the supreme poet of the sublime. Indeed, if he, as Kant thought, is the greatest poet, it must be in part because his poetry is the most perfectly sublime. And it goes without saying that many of Milton's most sublime moments are in the first two books of *Paradise Lost*—namely, those that concern Satan and his fall.[16]

To understand why the monstrous rather than the formally perfect (that is, the beautiful, for our purposes) is able at attain to the sublime, consider that monsters themselves, in both high literature and low film, are built out of what some scholars of horror call "category transgressions."[17] Monsters are categorically transgressive in the sense that, in their very person, they combine classes of things that strike us as naturally or conceptually opposed. Hence this idea of a *fallen* angel, a *man* wolf, a murderous *doll,* or the *living* dead, a category transgression that is so unabashedly direct that it should register as ridiculous but somehow works. If the horrible object is just right, our attempt to understand it— to make it fully available in thought—is shot through with an almost delirious violence: it confounds but exhilarates, bewilders but entices. For de Man, what we find when contemplating a sublime object is that

we cannot fully arrest the world in thought and language, that there is a *beyond,* a region of massive interest to us but to which we have no cognitive or linguistic access. For this reason the experience is both humiliating yet liberating—that is, both painful and pleasing. We feel the presence of light but we cannot see what it is illuminating, and it results in a kind of Dionysian ecstasy that enlivens the mind not despite the fact that it encourages a bit of suffering, but because it does. And this combination of bewilderment and awe, of deliriousness and delight, is symptomatic of the experience of the sublime, and in fact is arguably what largely constitutes it.

Now, it matters crucially here what kind of object we are experiencing. The idea of, say, an ambitious bidet is categorically transgressive, but contemplating it will never amount to a sublime experience, since we are put in touch with nothing of significance when marveling about its possibility. But when contemplating Satan, a fallen angel, a rebel against the very source of law, we surely are, and this is why we need great nature or great art to experience the sublime. For in working through the concept of Satan, we are put in touch with what matters most to us, morally, humanly, and, for some, theologically. And while this contemplation is bound to end in frustration—in bewilderment rather than understanding—we very much do delight in the experience of being brought closer to it, since it places us in the proximity of *value,* like a cipher that holds out the promise of a great truth. It is bound to end in philosophical frustration, but it is still a powerfully philosophically experience, and it is one that is conditioned *by art* and not a mere argument and, for this reason, that it is capable of immersing our frustration in aesthetic delight. Kant's philosophy cannot do this, but Milton's poetry can, even if at moments they share the same subject (moral freedom, for example). Likewise, what keeps the idea of the living dead from being just plain silly is what I have argued is the

skeptical anxiety it provokes, forcing us as it does to work through what matters in a way that on the surface is almost as grand as we get from Milton. What grounds our reception of something as someone? What does it mean to see a human body but not quite see a human? How can we perceive someone familiar as wholly other? And, most important, how ought we receive someone, or something, in the absence of any certainly as to what it is?

These skeptical questions the zombie provokes entitle us to say something interesting about the nature of the sublime itself—in fact, to offer an addition to the traditional categories of the sublime. Kant himself found no less than five kinds of sublime in his career (the noble, terrifying, splendid, dynamical, mathematical forms of the sublime, although eventually only two would stick; more on this in a moment), and of course others have added to it, too. To simplify perversely, the beautiful—say, a beautiful painting, face, stretch of nature, or beer—delights because of its "just-rightness" for the human mind and the senses that feed it. When I open myself up to world aesthetically and find that I can receive it as beautiful, I experience a kind of harmony, a sense of perfect fit, between the object and those powers of thought and perception I enlist when contemplating it. The object is *as though* made for my mind and my senses, such as they are, and there is a sense of perfect intelligibility, of perfect comprehension of the object (even if we are, strictly speaking, getting it all wrong). But the sublime object is endlessly puzzling for philosophers and theorists of art, because it seems to work its particular magic not despite but precisely because of its "just-wrongness" for the human mind, such as it is, opening up as it does a powerfully felt gap between the object and our capacity to grasp it, to experience it as fully intelligible, at least in a way that would satisfy us completely. I say "completely" because there may be scientific,

psychological, and other explanations available, but just as when we contemplate one who kills for the mere fun of it or just as an electrical fire that announces itself just in time for a Boy Scout congress, we can still feel mightily burdened with questions of the "but *how*, really?" variety. There is something, if not unexplainable, then unimaginable, something that defies our sense that we really get it, even if reason provides a respectable answer. Kant's two basic categories of the sublime embody this well: the "mathematically" and the "dynamically" sublime. The dynamically sublime is, for example, the aesthetic rapture occasioned by a display of huge power or force (think of romantic paintings of violent storms at sea), and the mathematically sublime is occasioned by an image that hints at an "impossible" expansion of space, time, or objects (think of the stoner overwhelmed by the awesomeness of the idea of deep space).

So here we are. The zombie sublime—the kind of sublime experience the genre is most apt to provide—surely includes moments of the dynamic and the mathematical sublime: the great, violent hunger that animates zombies (the dynamic sublime) and the virus, capable of turning both the living *and* the dead into the living dead and so nearly unbounded in its ability to keep the apocalypse rolling (the mathematical sublime), just to give a couple obvious examples. But as I have been arguing here, there is an often unique and irreducibly *skeptically* sublime moment at play in addition to these. The skeptical sublime, as one might call it, is tethered both to the forms of doubt that are inescapable for those who have to live with zombies in the aftermath of the virus, and to the possibilities of dramatic investment this makes possible for the consumer of zombie art. The awkward confrontation with one's zombified familiars, the hesitant mercy killing of the just-bitten, the expression that registers a second thought about one's brio with a machete, are

all invitations to the skeptical sublime, at least if the acting and writing do their part to make this possible. This is essential, and intentionally so, to some of the genre's better moments. But we can now also see, I hope, that regardless of how works of zombie art understand their own dramatic business, if *we* read them as in part dramas of doubt, as in part enactments of this odd but pervasive modern problem of person skepticism, we can elevate the better products of the genre out of the gutter of teen horror fun and offer them a philosophically and aesthetically respectable address.

Conclusion

At this point I suspect many readers are thinking *bullshit!* No zombie flick quite does what I have been talking about here. But it is just a contingent fact of cinematic history that a Milton has not yet done a remake of *Night of the Living Dead.* At any rate, if one thinks I have been discussing not actual representations of zombies but something more abstract and suspicious, like the very idea of a zombie, that should be fine. Just pretend that what I have discussed here is the outline of a philosophically and aesthetically ideal work of zombie art, and my point is that there are very good chances that it could be almost perfectly sublime, and that this would be because of the skeptical possibilities the genre is well suited for exploring.

Notes

I thank Ed Comentale, Aaron Jaffe, and Espen Hammer for helpful criticism and advice while writing this chapter.

1. I ignore the fact that the monsters in *I Am Legend* (2007) appear to be hybrids of zombies and vampires, in cosmetics if not in nature. Of course the *Underworld* film franchise crossbreeds werewolves and vampires, but that is neither here nor there for a chapter on zombies.

2. To support some of the more outlandish claims made here, for an example of English as a cause of zombification, see *Pontypool* (2009); for an example of zombies that play video games, see *Shaun of the Dead* (2005); and for an example of zombie Nazis, see *Død snø* (2009).

3. My own sense of what skepticism is, and its importance to both art and culture is clearly, and heavily, influenced by the work of Stanley Cavell, though Emmanuel Levinas should be mentioned here, too. For primary texts, see Cavell, *Claim of Reason* and *In Quest for the Ordinary*, and, especially, the essays on Shakespeare collected in Cavell, *Disowning Knowledge*. For an excellent survey of Cavell's thought, see Hammer, *Stanley Cavell*. Also worth reading are Sheih, "Truth of Skepticism," and Putnam, "Philosophy as the Education of Grownups." For relevant works of Levinas, see Levinas, *Otherwise Than Being* and *Humanism of the Other*, and see M. Morgan, *Discovering Levinas*, for an interpretation of Levinas's thought to which I am indebted.

4. For studies of the roots of ancient skepticism, see Annas and Barnes, *Modes of Scepticism*, and Thorsrud, *Ancient Scepticism*. For an excellent study of the ancient skeptic tradition that links it to modern philosophers, in particular Nietzsche, see Jessica Berry, *Nietzsche and the Ancient Skeptical Tradition*. For clear and, usually, accessible general discussions of skepticism (and kindred topics, such as truth and knowledge), see Koethe, *Scepticism, Knowledge, and Forms of Reasoning*; Blackburn, *Truth: A Guide*; Landesman, *Skepticism: The Central Issues*; and, especially, Stroud, *Significance of Philosophical Scepticism*.

5. Though Adorno himself was no skeptic. For a discussion of this in light of Adorno's concept of "nonidentity" (*das Nichtidentisch*), see O'Connor, *Adorno*, 60–64.

6. I thank Ed Comentale for getting me to clarify this point.

7. This, and everything else I say about Descartes, comes from Descartes's *Meditations on First Philosophy*. For a helpful discussion of the "cogito" argument and skepticism, see M. Williams, "Metaphysics of Doubt."

8. Of course this conception of a person or self does not have a date of birth and cannot be neatly linked to the ideas of any single philosopher, not even Descartes, and so to call it Cartesian, as many do, is simply to identify the author whose work best embodies the view and has played a privileged role in popularizing it. For a discussion of this, see Thiel, *Early Modern Subject*.

9. See Gibson and Bertacco, "Skepticism and the Idea of an Other," for a discussion of this with respect to so-called colonial and postcolonial literature.

10. Wittgenstein's most famous use of "lebensform" is in paragraph 19 of *Philosophical Investigations*, in which he claims that "to imagine a language is to imagine a form of life."

11. Hence posthumanists tend to urge that we replace humanism with *vitalism*—that is, with a view that extends the range of existence that matters (and matters not just from the human perspective) not only to animal life but to nature and, perhaps, beyond.

12. Here it is, for the curious.

13. I draw from Kant (1998) and de Man (1990). See Guyer, *Kant and the Experience of Freedom* (186–91), for a comparison of their views, one of which I am indebted to here.

14. Kant did not introduce the notion of the sublime to modern aesthetics, although he did organize the concept into its most influential and persisting form. Kant wrote about the sublime as early as 1764 (in *Observations on the Feeling of the Beautiful and Sublime*), but his treatment of it in *The Critique of Judgment* (1790) is in effect the source of the modern concept of the sublime. The notion of the sublime itself makes its way into modern aesthetics in the seventeenth and eighteenth centuries, in good part by way of the writings of British travelers, often after making the "Grand Tour" of the Continent and commenting on the glorious terror of certain expanses of the Alps. The writings of figures such as Anthony Ashley-Cooper (the third earl of Shaftesbury), John Dennis, Joseph Addison, and Edmund Burke are especially important in this regard. Kant was, of course, influenced by many of these writers.

15. See Abaci, "Kant's Justified Dismissal of Artistic Sublimity," for a discussion of this puzzle. See Crowther, *Kantian Sublime,* and Guyer, *Kant and the Experience of Freedom,* for excellent general discussions of Kant's theory of the sublime.

16. See Budick, *Kant and Milton,* for an excellent study of Kant's interest in Milton and the light it sheds on why Kant saw poetry, especially in its Miltonian inflection, as the highest form of art.

17. See, for example, Carroll, "Why Horror?"

STEPHEN SCHNEIDER

We take great pleasure in drinking big zombies.

Simone de Beauvoir, *America Day by Day*

When Betsy Connell, female lead in Jacques Tourneur's *I Walked with a Zombie* (1943), confesses that is she isn't in fact familiar with zombies, her interlocutor, Dr. Maxwell, first tells her that she is dealing with "a ghost, the living dead" and then informs her more cheerfully that the Zombie is also a drink, at which point Betsy finds herself on more familiar territory. "I tried one once," she says, "but there wasn't anything dead about it." Uttered in 1943 at the height of Hollywood's tiki craze, these lines are no doubt an inside joke. By this time, actors and audience alike were more than familiar with the real Zombies that had overrun America's bars and the mystical powers they allegedly possessed. And much like Val Newton's cinematic living dead, the Zombies served at bars such as Don the Beachcomber and Trader Vic's evoked echoes of Haitian vodou, supernatural possession, and the mystical, transatlantic origins of the zombie myth.[1]

But the analogy between the liquid Zombie and its cinematic counterpart doesn't end there. Just as Val Newton, Bela Lugosi, and, later, George A. Romero can be said to have invented something like "zombie style," so the early Zombie cocktail represents the first formal

expression of tiki mixology. Cinematic and alcoholic zombies alike have inaugurated a seemingly endless epidemic of imitation and re-production, a host of derivative zombies that often seem to claim little from their forebears but a name. "B" zombies abound on the screen and in the glass, with formulaic horror movies finding their analog in the premixed Zombie cocktails found in today's liquor stores and supermarkets.

While all good zombie stories attend to the origins of the undead, the story of the Zombie cocktail also tells us how the drink became the cultural icon that it is today. This story, not surprisingly, starts not in Haiti but in Hollywood's McCadden Place, where Donn Beach mixed the first undead drink in 1934. And while the fortunes of Beach's Zombie have waxed and waned over the intervening decades, it has none-theless continued to possess our collective alcoholic imaginary. Under-stood in this light, the Zombie cocktail wasn't just one of tiki culture's ur-texts; it also allowed for the spread of tiki culture across the country. But even as this logic of transmission accounts for the Zombie's spread and reproduction, so too it begs the question of what exactly makes an authentic Zombie in the first place.

And it is this question continues to animate interest in the Zom-bie today. With the arrival of the "cocktail revival," the Zombie has reemerged as a central figure in American cocktail culture. However, as I have already suggested above, it isn't so much the Zombie's his-torical resonance but rather its metonymic reach and self-referentiality that seem to account for its enduring influence. Put another way, it isn't simply the Zombie's mysterious origins and formulations that attract fanatics, so much as its evocation and troubling of the very categories of consumption, production, and authenticity. In the context of the cock-tail revival—a movement that is defined by its eloquence as much as its

craft—the Zombie emerges not simply as an ur-text for tiki but also for the postmodern cocktail found in bars today.

The Aesthetics of the Cocktail Revival

It could be argued that nothing more clearly announced the success of today's cocktail revival than the 2011 publication of Jim Meehan's *PDT Cocktail Book*. In the foreword to Meehan's book, cocktail historian David Wondrich compares the *PDT Cocktail Book* to an earlier classic: Harry Craddock's *Savoy Cocktail Book*. Much as the *Savoy Cocktail Book* did for London in the 1930s, the *PDT Cocktail Book* "perfectly encapsulates what we drink in bars today in a way that's both timelessly elegant and concisely and efficiently contemporary" (Meehan 6). And while hyperbolic forewords are nothing new, it remains true that until 2011 an encyclopedic understanding of the cocktail revival was in all likelihood not possible.

What Meehan's book reflects is the widespread resurgence of mixology in many of America's top bars, with premium spirits, fresh juices, and house-made syrups taking the place of premixed margaritas and sugary, electric blue mystery drinks. With the establishment of such celebrated bars as PDT, Franklin Mortgage and Investment Company, Violet Hour, the Pegu Club, and St. Charles Exchange, drinkers could once again order such forgotten classics as the Alaskan, the Aviation, the Last Word, and the Zombie. But despite this apparent return to the golden age of the cocktail,[2] today's cocktail revival reflects contemporary rather than historical drinking trends. For the most part, the cocktail revival has been the province of high-end bars and speakeasies, which seem a far cry from the nineteenth-century saloon. The cocktail owes its history in part to efforts to make medicinal bitters more

drinkable;[3] the drinks of the cocktail revival, however, are made with premium spirits that both reflect considerable advances in the science of distilling and evince a fetishization of hard-to-come-by ingredients and flavors. And while the limits of transportation and preservation no doubt gave nineteenth-century cocktails a local character, contemporary talk of artisanal and seasonal cocktails leans more on contemporary farm-to-fork and seasonal eating trends than it does on older bartending practices. The cocktail revival isn't simply about restoring a lost set of drinks to their rightful place behind the bar; instead, it is about the cultivation and deployment of a particular kind of taste—one that ostensibly combines a sophisticated palate with an appreciation of craft and history.

But as Eric Felten so eloquently put it, "It *is* possible to be serious about drinking without being a serious drinker, especially without taking oneself too seriously" (3). For all of its pretensions, the cocktail revival is at its base defined by what Bourdieu calls an ethic of fun, an ethic in which "pleasure is not only permitted but demanded" (367). For advocates of fun, "their life-style and ethical and political positions are based on a rejection of everything in themselves that is finite, definite, final . . . that is, a refusal to be pinned down in a particular site in social space" (370). This "practical utopianism" is further defined by a "new intellectual popularization which is also a popularization of the intellectual lifestyle" (371). We might understand the contemporary cocktail as an object that allows for the condensation of these energies, one that allows for the cultivation of a popular intellectualism (the outpouring of eloquence associated with the cocktail revival is a case in point) as well as a range of new ostensibly flexible bar experiences.

Obviously the fun ethic that defines the cocktail revival no longer rails against the same targets identified by Bourdieu. Bourdieu suggests that the new petit bourgeois is defined by its rejection of all things petit

bourgeois—a stable social station, a respect for social institutions, a conservative sexual morality. The contemporary fun ethic, however, focuses not on the morals of an earlier generation but on the inadequacies of an earlier regime of consumption. The cocktail revival, and the popular intellectual style that attends it, rejects middlebrow mass consumption and fetishizes a return to a more local craft of the cocktail— one that emphasizes history, tradition, and bartender know-how. The cocktail thus comes to function not just as a drink but to some extent as a spectacle—a specific refraction of the act and politics of consumption itself (see Debord).

This ethic of fun is further reflected in the numerous volumes that have accompanied the resurgence of cocktail culture.[4] Ted "Dr. Cocktail" Haigh's *Vintage Spirits and Forgotten Cocktails* (2004), Felten's *How's Your Drink?* (2007), David Wondrich's *Imbibe!* (2007) and *Punch* (2010), and Dale DeGroff's *The Essential Cocktail* (2008), to name only a prominent few, all look to situate the contemporary turn to craft cocktails within the broader history and culture of mixology. These books don't simply contain what had hitherto been hard-to-find recipes; rather, they contain the histories of the drinks presented, the stories surrounding the recovery of these drinks, and famous anecdotes about celebrity bartenders and drinkers. So while at a glance these books might seem to perform the same function for the twenty-first century that the *Savoy Cocktail Book* did for the 1930s, they differ from early cocktail books in their constant return to the history of the cocktail and its revival. But my argument here is not that the cocktail revival somehow mistakes its own historical claims, that it gets its own narrative wrong. After all, the cocktail revival is as much about the new—new ingredients, new recipes, new techniques—as the old. Rather, I want to suggest that, for cocktail revivalists, cocktails aren't simply a better class of drink; they also represent a different kind of bar experience.

The ideal drink, as Roland Barthes reminds us, "would be rich in metonymies of all kinds" (*Roland Barthes* 96). And while Barthes never elaborated on this assertion, we might suspect that he understood the ideal drink not just as a draught to be consumed but also as a set of cultural commonplaces that we might inhabit.[5] The ideal drink, then, alludes to a host of other practices: the exact composition of ingredients, the bartender's craft, bar culture itself. Along these lines, we might suggest that the cocktails of the cocktail revival are defined by their various metonymic relationships: the cocktail offers a host of virtual experiences in addition to the actual experience to be found in the glass. Some of these experiences, as we've already seen, are associated with participation in the historical and anecdotal narratives that surround classic cocktails, while others are to be found in the personal meanings and preferences we ascribe to our drinks. But these virtual experiences neither subsume the drink itself nor make the act of drinking it any more than it is; any cocktail is, at the end of the day, defined by its taste. Nevertheless, it isn't simply alcohol or accompanying adjuncts that we take in, but rather a host of other narratives warranted by the well-executed cocktail. In this reading both actual and virtual cocktails exist in productive tension with one another, with taste determining a cocktail's metonymic power even as that metonymic power makes the same cocktail more than the sum of its liquid parts.

So while cocktails are, in the final analysis, something wet to drink, they are also something to be enjoyed, dwelt upon, discussed. We might like the taste of gin, but we drink a martini because it allows us to participate in a broader set of cultural narratives that extend from a simple desire to dress up and go somewhere nice to more complicated invocations of James Bond and jetsetter culture. It goes without saying, then, that the contemporary cocktail is first and foremost an exercise in pastiche

(Jameson, *Postmodernism* 16). It invokes bygone eras to which it has no real commitment, narratives and cultures of which it has no real understanding. Ultimately, however, this is what makes cocktails fun. Our commitment to a given cocktail need only last until the glass is empty. But as long as there's something left to savor, we can go on imagining that we're one step closer to the drinking culture of the nineteenth-century saloon or of the speakeasy, or of *Mad Men* or James Bond.

While the model of consumption that emerges from the cocktail revival is fraught with anachronisms, I suggest that these anachronisms emerge immanently from mixology itself. Mixology as a practice relies at least in part on a logic of repetition. When we order a Manhattan, we expect it to taste more or less like every other Manhattan we've ordered; one of the mixologist's goals, then, is to render a given cocktail perfectly each and every time. However, this goal is necessarily undermined by the drink itself. Insofar as it constantly references its own production by a specific bartender at a specific place and time, it militates against the very repetition that defines it. The cocktail constantly reminds us of the mixologist who made it, the bar we're sitting at, and the cocktail culture we're participating in. After all, most of us want to drink pre-Prohibition cocktails, but we don't necessarily want to live in pre-Prohibition America or drink at her bars. And when pushed, we probably prefer our pre-Prohibition drinks made with modern premium spirits and ingredients according to the best mixology practices we currently have available.

This eclecticism—the desire for historicity alongside the demand for contemporaneity—has further led to the introduction of such innovations as ice spheres, foamed ingredients, even "deconstructed" edible cocktails that bear little resemblance to drinks of an earlier period. But even these novel elements, anachronistic though they may be, are licensed by their existence within the larger metonymic framework

of the cocktail revival. We'll tolerate innovations in the drinks we or-
der—such as the substitution of bourbon for rye, Peychaud's bitters for
Angostura bitters, amaro for vermouth—as long as the drink itself still
seems to invoke (if not always meet) our expectations. While in the case
of a drink like the martini this leads to a certain degree of austerity—
a fetishization of ostensibly exact reproduction every time—in many
other cases it leads to innovation. The Manhattan becomes, with the
addition of dry vermouth, a Perfect Manhattan; with the addition of
cognac to the base, it becomes a Vieux Carré; add Bénédictine, and
it becomes a Cocktail à la Louisianne.[6] In this case the Manhattan is
marked not only by its reference to a stable rye-vermouth-bitters recipe
but also by its reference to a host of other drinks and the whole cultural
network that preserves and disseminates them.

Given the contemporary cocktail's emphasis on both historicity
and contemporaneity, on the actual and the virtual, the alcoholic and
the metonymic, it should hardly seem surprising that cocktail revivalists
have turned their attention to tiki drinks. As tikiphile Jeff Berry rightly
reminds us, tiki mixologists were emphasizing many of the practices
that today define the craft cocktail scene: the combination of distinct
brands of rum, the use of fresh juices and fruits, and the augmentation
of drinks with house-made syrups and ingredients (*Beachbum Berry's
Sippin' Safari* [hereafter, *Sippin' Safari*] 8–9). Indeed, not only do these
different practices define tiki mixology, but they also suggest that, along
with the saloons of the late nineteenth century and speakeasies of the
Prohibition era, tiki culture represents a unique drinking culture with
a distinctly American origin. Just as important, however, tiki culture
might have been the first drinking culture to openly embrace the pas-
tiche common to today's cocktail culture. And given the status of the
Zombie as the drink that ushered in the whole tiki craze in the first
place, the quest to rediscover the DNA of the first Zombie was probably

a foregone conclusion. But as I argue below, what emerges from this quest is not just the recipe for the "original" Zombie but also the story of how that Zombie's authenticity was constructed in the first place.

Drink of the Dead

Few drinks have so completely captured America's alcoholic imaginary like the Zombie. "Beware, in your Hollywood visit, never to have a Zombie . . . ," averred the *Lowell Sun*'s Charles Sampras shortly after the Zombie's eruption onto the American scene, "for you will never be the same. . . . You do a Corrigan before you finish the mint-topped glass . . . you are shuttled into dreamland of the South Seas . . . you are transported far away . . . and you are 'neath magic Polynesian skies.'" (qtd. in Berry, *Sippin' Safari* 115). But despite its mysterious history and its terrifying reputation, the Zombie—and the tiki culture from which it emerged—were for the most part the inventions of one man: Donn Beach, or Don the Beachcomber. Beach started life as Ernest Raymond Beaumont-Gantt, son of a New Orleans hotelier. According to the most popular version of his life, Beaumont-Gantt worked as a bootlegger during Prohibition before traveling the world in search of some greater raison d'être. Upon returning to the United States, he based himself in Los Angeles and set about opening a restaurant that would serve as something of an homage to his itinerant past. The result was Don the Beachcomber, the world's first tiki bar, which opened in 1934 at Hollywood's McCadden Place. Combining rum-based drinks and Chinese food with exotic tropical scenery, Don the Beachcomber was the first iteration of what would become tiki style.[7] Gantt subsequently changed his name to Donn R. Beach, which appears to have been not just a marketing gimmick but also a genuine adoption of the beachcomber persona. Among the many rum drinks that came to be served at Don the Beachcomber,

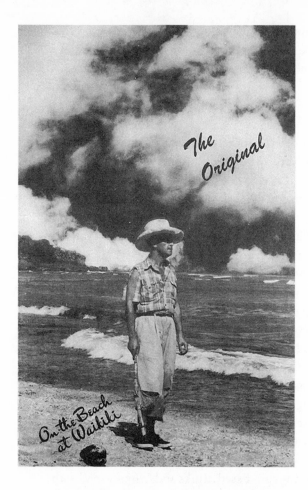

14.1. The Last Man in Search of Cocktail: souvenir postcard from Don the Beachcomber's.

the Zombie was Beach's crowning achievement: it was this one drink that "kick-started the whole Tiki craze, and put Don the Beachcomber's on the map" (Berry, *Beachbum Berry Remixed* [hereafter, *Remixed*] 167).

The story that commonly surrounds the creation of the Zombie has it that Beach himself first mixed this drink for a traveling businessman

waiting on a flight. After consuming three of Beach's hefty concoctions, the businessman reported that he felt like "the living dead." And while this story accurately captures both the genial character of Beach and the legendary force of the Zombie, it is certainly more legend than history. And as the Zombie achieved greater popularity, this legend only grew in stature.

Such tales were fortified by the aesthetic character of the zombie itself. Emerging onto a Hollywood scene that had given birth to Bela Lugosi's *White Zombie* only two years before, the Beachcomber Zombie evoked both the tropical climes of the Caribbean and the more sinister connotations of voodoo, black magic, and possession. Donn Beach was thus transformed into witch doctor and griot, his naïve customer into a victim. The drink owed some of this reputation to Beach's theatrics: the composition and preparation of the Beachcomber Zombie was, much like the undead the drink was named for, shrouded in mystery. While Beachcomber bartenders would mix run-of-the-mill cocktails at the bar, Zombies were typically mixed in a back room before being delivered— often by Beach himself—to guests (Berry, *Sippin' Safari* 13). In many cases even the bartenders didn't know what went into the drink—the various ingredients for the Zombie were stored in coded bottles (116). The resulting drink was allegedly so powerful that customers were limited to ordering two per visit.

The sinister nature of the Zombie was further amplified by the base liquor used in the cocktail: rum. According to Wayne Curtis, one can't even write the history of rum without first contending with a "parade of unsolicited testimony . . . invariably involving a teenage indiscretion, a bottle of inexpensive rum (often Bacardi), and a special intimacy with shrubberies. [Tales] almost always followed by a solemn vow never to touch rum again" (11). Not surprisingly, many encounters with the Zombie met with similar vows. Rum gave the drink not only its transatlantic

character but also much of its fearsome disposition as well. Something of this character is contained in the name *rum* itself; while the origins of this word aren't definitively known, it is commonly thought to be a contraction of *rumbustion* or *rumbullion*—terms denoting strife or uproar. Its more popular names—kill-devil or demon rum—likewise suggest something of rum's power over the social imaginary of the eighteenth and nineteenth century (21, 149). A by-product of sugar refining, rum was "cloying, greasy, nasty-smelling stuff," the drink of pirates and society's less reputable elements, produced with little regard for quality control, and from the outset associated with intemperance, degradation, and ruin (5). And whether as a result of its sheer potency and questionable production or from its intimate association with slavery, profiteering, and privateering, rum remains to this day a spirit that threatens not only to intoxicate but also to possess.

The Zombie's mythical power was further enhanced by the drink's mysterious recipe. The Beachcomber Zombie's exact combination of ingredients was shrouded in secrecy, so much so that twenty different bars may well make a Zombie twenty different ways. This not only led to the modern-day quest of tiki aficionados to crack the Zombie's DNA but also to a sense of wonderment at the drink's flavor and apportionment. Correctly mixed, the Zombie is more than the sum of its parts: rum and citrus provide a surprisingly balanced foundation for hints of spice, juniper, anise, and bitter orange. But perhaps most noteworthy is the Zombie's ability to mask the hefty rum base and thus hide much of its kick. This virtuosic mixology does little short of elevate the Zombie to the status of a voodoo potion, the effect of which can be rightly compared to "a soothing swim in the river of Lethe" (Berry, *Sippin' Safari* 121).

Thus the Beachcomber Zombie became more than just a drink; it was something to fear, a potent challenge that a drinker may or may not

survive. Indeed, the two-drink limit, as cocktail author David Embury noted in 1948, was less a limit and more a dare: emboldened drinkers would no doubt believe they could handle a third Zombie and were prepared to court a fate worse than death to prove their mettle (279). However, the Zombie evoked not the fear of death, but rather the desire to see just how real those fears were; drinkers hoped not to dodge the Zombie's ruinous effects, but rather to experience them firsthand. Put another way, drinkers hoped to capture the exact moment when they, too, would inevitably turn zombie: eyes rolled back in their head, face drained of color and expression, mind and will shattered. Under the spell of the Beachcomber Zombie, these ruined drinkers would stand awkwardly, mumble a garbled farewell, lurch through the door and out into the night; we're left to imagine, then, the wave of walking corpses that each day spilled from Don the Beachcomber out into McCadden Place.

The metonymic qualities of the Zombie need hardly point, then, to anything real: our fascination with the Zombie stems not only from the potency of its ingredients, or from the way they combine to hide that very potency, but also from the drink's promise of a supernatural high. While I suspect that most drinkers maintain a healthy skepticism about the existence of voodoo, possession, and magic potions, the Zombie nonetheless offers them the closest thing to an actual encounter with these forces. Of course, this encounter shouldn't be understood as a desire for the supernatural, any more than a zombie walk should be understood as a desire to actually be a zombie (it's far too trivial to be taken seriously). The Zombie emphasizes form over content, style over substance, figure over ground: it invokes tropical climes, voodoo, possession, only to evacuate these commonplaces of any kind of stable meaning. Rather, this desire suggests that the figure of the zombie, much like the contemporary cocktail, reinscribes consumption as an

aesthetic practice, one that delights in the Zombie's cultural history as much as it does the combination of flavors found in the glass.

A Zombie Apocalypse

All good zombie stories attend to the origins of the undead, necessarily attending to the location and the moment of infection, and recent accounts of the Zombie cocktail are no exception to this rule. Berry's extended treatment of the cocktail in *Beachbum Berry's Sippin' Safari* provides the general narrative. Laboring in what might fairly be called a postapocalyptic landscape, Berry encounters only imposters—hollow shades of the Beachcomber Zombie and its descendants. Yet as Berry digs, he uncovers not only the Beachcomber Zombie's original composition (see below) but also the narrative of its creation. This narrative circles again and again around the Zombie's production: the recipe for the drink, the manner of its creation by Beach and later imitators, its inevitable spread from McCadden Place across the country. But perhaps more important, this narrative highlights both the birth of tiki culture in post-Prohibition Hollywood and how that culture grew out of establishments like Don the Beachcomber. As I argue below, it wasn't in the founding of Don the Beachcomber, but rather in the spread of tiki culture across the country that the authenticity of the Beachcomber Zombie was established.

As suggested above, the status of any given cocktail can seldom be divorced from its production, which also lies at the heart of most cocktails' semiotic relationships. Most immediately, cocktails point indexically to the moment and location of their creation—to the craft of the bartender and the ambience of the bar itself. Similarly, the symbolic network that surrounds the cocktail points to its production in the form of both recipes and stories devoted to cocktail history. In some cases

these recipes and stories pinpoint exact origins for a drink, as in the case of the Zombie. In other cases, such as that of the old-fashioned or arguably the martini, these histories are more general records of mixing practices and cocktail cultures. But all share production, specific or general, as a commonplace, and it is this obsession with accounting for a given cocktail's origin—and similarly its authenticity—that in no small way produces the metonymic aura prized by Barthes.

The Zombie, with its tale of the thirsty jetsetter, establishes just such an aura. But despite its invocations of voodoo and possession, its promise of ruin, the Zombie most likely had a far more modest origin: the Zombie moniker suggests not only the living dead but also that category of

> *Thus the Beachcomber Zombie became more than just a drink—it was something to fear, a potent challenge that a drinker may or may not survive.*

drinks known as corpse revivers. Indeed, Beach's story of the hapless jetsetter invokes this history, though in this case with a fatal inversion: far from bringing the dead back to life, the Zombie sent its victim to an early grave. And given the Zombie's original name—the Zombie Punch—it would seem that Beach combined the proportions of Planter's Punch with medicinal adjuncts like bitters and absinthe—common ingredients in corpse revivers—to create his own faux-tropical hangover cure.[8] While the name change makes sense for a faux-tropical corpse reviver (we might guess that Beachcomber patrons recognized the pun), the Zombie's presentation as a highball most likely reflects the popularity of tall drinks at the time.

Understood in this light, the Zombie's purported history obscures as much as it reveals and downplays to a significant degree the efforts Donn Beach expended to cultivate and safeguard the Zombie's image

and reputation. Beach even alludes to this in the Zombie description attached to the 1941 Beachcomber menu: "The Zombie didn't just happen. It is the result of a long and expensive process of evolution. . . . In the experiments leading up to the Zombie, three and a half cases of assorted rums were used and found their way down the drain so that you may now enjoy this potent 'mender of broken dreams'" (Berry, *Sippin' Safari* 115). After all, while Don the Beachcomber evoked tropical climes with both its décor and drink menu, tiki culture emerged not from the Caribbean or the South Pacific but from the Hollywood of the 1930s. Beach's decision to use rum as the base for drinks owed as much to rum's relatively low price and plentiful supply in the years following Prohibition (17). By keeping drink prices low, Beach hoped to attract to his bar young, newly professional women—a demographic he believed would attract male customers in turn. The Polynesian food he added to the menu came from a Chinese restaurant down the street and was added as a result of liquor-licensing demands that food be served alongside alcohol. And, finally, the complicated combinations of rum, juice, and syrups had less to do with actual tropical drinks like Planter's Punch or the daiquiri (which remain almost spartan in their simplicity) and more to do with Beach's attempts to baffle would-be imitators.

Imitation zombies were to be expected; after all, if there's one thing a zombie seems to universally guarantee, it's the existence of other zombies. This logic reaches even greater intensity in tiki culture, where drinks riff on one another relentlessly and where reproducing other bars' drinks is part of the game. Donn Beach, naturally, was the flashpoint for much of this mixology: "Those recipes that Don the Beachcomber didn't invent himself, the Beachcomber's competitors created using his canon as their template" (Berry, *Sippin' Safari* 10). A great tiki drink, then, has to necessarily call to mind the Zombie, the mai tai, the Scorpion; nevertheless, it also needs to show enough innovation to warrant

its own moniker. Even in the case of variations on the one drink—as the infinite number of Zombies and mai tais seems to suggest—each version needs to prove itself worthy of the name. If your drink is good enough, no one will question what you call it; but if you call it a Zombie, you better make sure it can hold its own.

Given these demands, it should come as no surprise that tiki bars were known from their earliest days for stealing one another's drinks—in name, at least, if not always in flavor. In some cases this simply meant that one bar claimed to have invented another bar's signature drink; for example, both Donn Beach and Victor Bergeron—otherwise known as tiki impresario Trader Vic—at one time claimed to have invented the mai tai, and by 1947 Vic was also including his own Zombie recipe in his bartender's guide (even though he personally thought they were "too damn strong") (Berry, *Sippin' Safari* 118). But in other cases bartenders would move from tiki bar to tiki bar, taking their notebooks—and their drinks—with them. The mobility of both bartenders and drink recipes thus led Beach to safeguard his signature recipes in a number of ways. Most notably the Zombie used a large number and wide variety of ingredients, combining three different rums—Jamaican dark, Puerto Rican gold, and 151-proof Demerara—with lime juice, a clove syrup known as falernum, Angostura bitters, grenadine, an anisette such as Pernod, and a proprietary ingredient known as Don's Mix.

This combination of flavors could be expected to baffle even the most discerning of palates, and even if you could deduce the combination of rums and the other standard ingredients in the drink, Don's Mix would no doubt give you some trouble. Don's Mix was itself a combination of two parts grapefruit juice and one part Spices #4, another proprietary Beachcomber ingredient. In fact, it took Berry several years to crack the secret of Spices #4. This first involved tracking down the company that produced this ingredient for the Beachcomber restaurants,

though this proved to be a dead end—the company had long been defunct and its owner passed on. In fact, it wasn't until Berry met veteran tiki bartender Bob Esmino that he discovered exactly what Spices #4 was: cinnamon syrup (Berry, *Sippin' Safari* 124).

Beach's paranoia proved to be on the mark. The Zombie achieved even greater notoriety as tiki culture spread, and Don's signature cocktail began appearing on bar menus across the country. Indeed, with the rise of tiki bars and cocktails over the 1930s and 1940s, something like a Zombie apocalypse took over American bar culture. Unable to crack the Beachcomber recipe, tiki bars took to inventing their own bastardized version of the drink. As a result, the first published recipe for a Zombie comes not from Donn Beach but from Patrick Gavin Duffy in the 1940 edition of his *Official Mixer's Manual.*[9]

The Duffy Zombie (1940)

¾ oz. Pineapple Juice
¾ oz. Papaya Juice
Juice of one lime
¾ oz. Powdered Sugar
⅓ oz. Apple Brandy
1 oz. Rum, 90 Proof
2 oz. Tropical Gold Seal Rum, 86 Proof
1 oz. White Label Rum
Ice generously and shake. Garnish with a slice of pineapple, a green and a red cherry. THEN FLOAT ON TOP RUM OF 151 PROOF. Top off with fine powdered sugar.

But while Duffy's recipe loosely follows the general contours of tiki mixology—it combined multiple rums and juices and used apple brandy and 151-proof rum to round out the drink's flavor—most derivative Zombies were soulless copies of the Beachcomber original;

as the contagion spread, these Zombies migrated from bar to bottle, ultimately becoming available as commercial mixes for the would-be home bartender. Indeed, by the time David Embury's *Fine Art of Mixing Drinks* was published in 1948, Embury concluded that "twenty different bars serving this drink will probably put out eighteen to twenty versions of it" (279). The Zombie was, in Embury's estimation, "undoubtedly the most overadvertised, overemphasized, overexalted, and foolishly feared drink whose claims to glory ever assaulted the eyes and ears of the gullible American public" (279).[10]

For the most part, then, Embury has proven somewhat prophetic. His generally negative assessment anticipated the fascination that the Zombie has held for drinkers of all stripes for the better part of a century. In more recent decades this interest probably stems principally from the drink's potency and its place in cocktail lore as a weapon of mass inebriation. But the Beachcomber Zombie seems to have itself fallen victim to its own success, a causality of the Zombie apocalypse it inaugurated. While Don the Beachcomber had expanded into a national chain in the 1940s and 1950s, most locations had closed by the late 1980s, and Donn Beach himself died in 1989. During the same period, cocktails disappeared from most bar menus, having been replaced by the sickeningly sweet drinks and commercial mixes to which the Zombie helped give rise. Even the 1983 edition of Duffy's *Official Mixer's Manual*—the first book to offer a Zombie recipe—contains a revised recipe that is little more than an overload of rum and fruit juice (87).

Embury's comments are worth lingering on for two reasons. First, they suggest that we can at least in part date the demise of cocktail culture into an oft-lamented fruit-and-sugar drinking culture to the proliferation of Zombies behind American bars. Certainly, the Zombie wasn't the only drink to encourage this trend; tiki culture in general proved to be remarkably marketable. But the Zombie—along with Trader Vic's

mai tai (which is itself available in a bottle mix)—might be the most famous example of this trend. However, what Embury's remarks also suggest is that the popularity of the Beachcomber Zombie—and, as I argue below, its current fetishization—was precisely based on the fact that it existed in a world of inferior copies.

It might seem like a stretch to suggest that Donn Beach not only anticipated but in fact encouraged the Zombie apocalypse of the 1940s. Certainly the mystery he cultivated surrounding the drink indicates that he at least prepared for the oncoming zombie pandemic. But I want to argue that all these safeguards further suggest that Beach was relying on this pandemic as a means of creating stature for his own drink. Embury recognizes this logic when he declares himself "allergic to secret formulas for mixing drinks at a bar or in the home" (279). "All this mystery," he concludes, "is calculated to inspire curiosity and thus advertise the drink." He likewise declares the two-drink limit "the cheapest kind of advertising" and finds the number and complexity of ingredients redundant and overwrought (279). But perhaps the most important point to make about Embury's comments is that they suggest that the way Beach marketed the Zombie was to some extent common knowledge. To imagine, then, that Beach was relying on these marketing ploys both to encourage inferior imitations and to preserve the mystique of the Beachcomber Zombie doesn't seem so farfetched. Understood in this light, all Zombies (regardless of their DNA) turn out, then, to be Beachcomber Zombies. Far from locking the Zombie down, Beach's proprietary safeguards virtually ensured the drink's corrupt reproduction in bars across the country.

Imitation zombies were to be expected; after all, if there's one thing a zombie seems to universally guarantee, it's the existence of other zombies.

Reanimating the Zombie

Despite the ravages of the zombie apocalypse, and the dark decades of the 1970s and 1980s, the cocktail revival set the stage for a renewed interest in both tiki culture and the Beachcomber Zombie. This kind of Zombie thus seems to have attracted the same kind of critical interest, amateur and professional, as every other kind of zombie. As I've already suggested, this shouldn't come entirely as a surprise: tiki culture seems to have understood early on the aesthetic dimensions of the contemporary cocktail, relying on metonymy and pastiche in much the same way as the contemporary speakeasy (albeit in the service of kitsch rather than class). But perhaps more important to liquid Zombie research is the community of fanatics and researchers that has come to comprise much of the energy behind the cocktail revival. Tiki culture has likewise received a good deal of attention in its own right from tikiphiles such as Berry and Sven Kirsten. These communities of aficionados, and the way they combine research with playful enthusiasm, have made the search for the authentic Zombie one of the central stories of the cocktail revival.

While one can now find the recipe for the Beachcomber Zombie in most recent reputable cocktail books, the discovery of this recipe is almost entirely the work of Beachbum Berry. In two books—*Beachbum Berry's Sippin' Safari* and *Beachbum Berry Remixed*—Berry sought to recover the Beachcomber Zombie from the plague of lifeless drinks bearing its name. Indeed, Berry almost dismissed the drink on account of how bad most zombies actually tasted (*Sippin' Safari* 119). But as Berry began searching for earlier Zombie recipes, he came across two that had promise—one from Louis Spievak's self-published *The Barbecue Chef,* and another from a 1956 issue of *Cabaret Magazine* (*Sippin' Safari* 116, 121):

The Spievak Zombie (1950)

1 oz. unsweetened pineapple juice

1 oz. fresh lemon juice

1 oz. fresh lime juice

1 oz. passion fruit syrup

teaspoon brown sugar

dash Angostura bitters

1 oz. gold Puerto Rican rum

1 oz. 151 Demerara rum

1 oz. white Puerto Rican rum

Dissolve sugar in lemon juice. Shake everything well with crushed ice and pour into a Collins glass. Garnish with a mint sprig.

The Cabaret Zombie (1956)

¾ oz. fresh lime juice

½ oz. grapefruit juice

1 ½ oz. unsweetened pineapple juice

¼ oz. falernum

1 ¾ oz. gold Puerto Rican rum

1 oz. dark Jamaican rum

1 oz. 151-proof Demerara rum

¾ oz. maraschino liqueur

¼ tsp. grenadine

2 dashes Angostura bitters

6 drops (⅛ tsp.) Pernod

A handful of crushed ice

Put everything into a blender, saving ice for last. Blend at high speed for no more than 5 seconds. Pour into a chimney glass. Add ice cubes to fill. Garnish with a mint sprig.

While there were considerable differences between the two recipes, both produced drinks that had the balance and quality associated with Beachcomber tiki drinks.[11] The question, then, was which one to regard as the definitive Beachcomber Zombie. This conundrum was finally solved when Berry obtained the 1937 notebook of Beachcomber bartender Dick Santiago; this notebook contained the recipe for an "old" Zombie Punch that Berry believed might be the original 1934 version served at the Hollywood Beachcomber (Berry, *Sippin' Safari* 123).

The Santiago Zombie (1937)

¾ oz. fresh lime juice
½ oz. Don's mix
½ oz. falernum
1 ½ oz. Lowndes Jamaican rum
1 ½ oz. gold Puerto Rican rum
1 oz. 151-proof Demerara rum
Dashes of Angostura, grenadine, and absinthe
(Berry recommends adding 6 oz. of crushed ice and following the same directions as those for the Cabaret Zombie).

The commonalities between the Santiago and Cabaret Zombies—both used the same base rums, grapefruit juice, and a combination of Angostura bitters, grenadine, and Pernod—thus allowed Berry to confirm the veracity of the Santiago recipe and to identify the Cabaret recipe as a Beachcomber derivation. His discovery of a third Zombie recipe from Las Vegas, one that bore much the same DNA as the Santiago and Cabaret Zombies, allowed him to confirm the relationship between the two beyond a doubt (Berry, *Remixed* 172).

Having restored the Beachcomber Zombie to its rightful position in the catalog of faux-tropical drinks, Berry was able to reveal the host of

pale imposters for what they were and recover the tenets of early Beach-comber mixology as evidence of an earlier era when cocktail culture was defined by craft and quality rather than sugar and strength. But perhaps most interesting is how this argument—and it is an argument of fetishization as much as it is one of recovery—extends the very logic by which Beach made his drink famous in the first place. As corrupted Zombies infested bars across the country, so the Beachcomber Zombie became an increasingly scarce commodity—a commodity that has con-tinued to stand for a lost tiki culture for at least the past eighty years. This story doesn't simply undergird Berry's quest for the Beachcomber Zombie; it plays out again and again as this quest is narrated in Berry's books.

And perhaps this explains the resurgent popularity of the Zombie among tikiphiles and cocktail snobs today. To be sure, there still seems to be little consensus among bartenders and cocktail writers on which Zombie recipe produces the best drink. While well-known authors such as Dale DeGroff and Jim Meehan have embraced the Santiago Zombie, others such as Ted Haigh continue to return to the Spievak Zombie (DeGroff 190; Meehan 271; Haigh 290). For these authors, the Zom-bie not only preserves the history of tiki mixology; it also provides a foundation for the contemporary cocktail revival and its emphasis on craft. The Beachcomber Zombie—understood here as both the recipe preserved in Dick Santiago's notebook and the fantastic stature that that drink eventually achieved, as both potent, mind-erasing draught and reclaimed tiki treasure—thus continues to capture the imagination of mixologists and drinkers alike.

Without a doubt, the economy in which the Beachcomber Zombie circulates has changed. In the 1930s Beach was looking to commod-ify and market the Beachcomber brand, and proprietary knowledge

certainly created the kind of value he needed. In 2014 the Zombie stands for something different—a certain kind of craft, quality, and attention to detail that precisely rails against the mass commodification of mixed drinks: the Beachcomber Zombie is no longer just the stuff of legend, but it is also the province of the discerning gourmand. This idea is itself an effect of the market operations that produced the Zombie in the first place. The pastiche that defines the contemporary Zombie no longer refers to exotic climes or Haitian stories of possession, but rather to earlier liquid Zombies and the tiki culture to which they belonged. And just as important, the contemporary Zombie necessarily invokes the Zombie apocalypse it ushered in and now promises to cure. Even if this Zombie can once again be made according to Dick Santiago's 1937 specifications, then, its authenticity is based not so much on its historicity as it is on its fidelity to tiki style. This is hardly a new phenomenon: if tiki culture is in fact postmodern, it is at least part because the Zombie has always had something of this self-referential logic at its core. The story of the Beachcomber Zombie thus becomes one that is less about the discovery of the first authentic tiki drink and more about how that very narrative of authenticity was produced, immanently, in the first place.

Conclusion

Much as the contemporary zombie movie has inevitably become a re-make of earlier zombie films, so too the contemporary Zombie cocktail invokes not just tiki mixology but also every Zombie cocktail that came before it. The recently restored Santiago Zombie, then, isn't simply the cocktail's original DNA, but also the contemporary continuation of the Zombie myth. Thus it brings with it the story of the hapless jetsetter, the character of Donn Beach, the strange history of tiki mixology and

its decline amid the Zombie apocalypse of mid-century. And so while the recipe comes from tiki's ground zero, the Santiago Zombie carries with it every metonymic relationship that has become attached to the Zombie over the last eighty years.

Of course, this point is hardly limited to the Santiago Zombie. Within the cocktail revival this logic extends to every cocktail. Each has an origin, an exact formulation, and a history, and it is these stories that we encounter when we sidle up to the bar. It is these stories that also warrant each cocktail's claim to authenticity, even though that authenticity can be asserted only within the context of a new, contemporary cocktail culture. These questions of production and authenticity seem to have attended the Zombie from its inception. To consume the Santiago Zombie is to once again assert its authenticity against its competitors, even though it both produced and depended upon these competitors for its very survival. Indeed, the drink's fearsome reputation was likewise warranted by this Zombie horde, which anchored and disseminated the drink's symbolic force alongside its alcoholic base. But the point here isn't simply to deconstruct the Beachcomber Zombie's claims to authenticity—after all, it was in fact the first Zombie cocktail, and it still tastes a damn sight better that most of its imitators. Rather, my point here is that arguments about authenticity only make sense in a world where the Zombie has already escaped its glass and infected our larger cultural imaginary. And perhaps more importantly, these arguments continue to point to how this infection occurred in the first place.

Put another way, the authenticity of the Santiago Zombie could be achieved only by its reproduction—faithful or otherwise. While the Zombies found at Don the Beachcomber remained central to the drink's notoriety, their lifeless imitators nonetheless continued to spread the Zombie's reputation far and wide. And it is this symbolic economy through which Zombies must invariably move today: the

recovery efforts of Berry, and of the cocktail revival more generally, are premised on the very commonplaces established by both the Santiago Zombie and the apocalypse it unleashed.

Notes

1. The author wishes to thank Jeff "Beachbum" Berry for his permission to include the recipes here and for providing much of the historical information used in this chapter.

2. Typically considered 1885–1920 (Wondrich, *Imbibe!* 45).

3. For Eric Felten, "The surprise wasn't that the medicine was more palatable with a slug of liquor, but that the liquor benefitted from the complex herbal flavors in the liquor" (16).

4. The cocktail revival is as much textual as it is alcoholic. As David Wondrich puts it, "We've got geeks and blogs and tweets and—Lord knows—we've got cocktail books." The range of books speaks to the revival's semiotic reach: "We've got historical ones . . . colorful ones, technical ones, personal ones, local ones, big ones, small ones, and ones that practically mix your drinks for you" (Meehan 6).

5. Barthes does, however, elaborate on the metonymic dimension of drinks: "Drinks one drinks all one's life without really liking them: tea, whiskey. Drinks-for-times, drinks-for-effects, and not drinks-for-flavors" (*Roland Barthes* 96). Eric Felten similarly notes, "Many novelists look to define their characters in part by what they drink; in our most glib moments, we may do the same for ourselves. If you have a creeping suspicion that others are defining you—and judging you—by the drink in your hand, you're not far wrong" (2).

6. There are other subtle differences between the Manhattan, the Vieux Carré, and the Cocktail à la Louisianne, but my point here is less about strict lineage as it is about resonance: the cocktail aficionado at least in part encounters these cocktails as related ideas and practices and appreciates them as part of a larger cocktail culture in which all these drinks circulate.

7. Arguably, tiki culture was *formally* established when Don the Beachcomber moved across the street and expanded into "an 80-seat restaurant, complete with gift shop, rum cellar, Chinese grocery store, and flower stand" (Berry, *Sippin'* 17). These various elements speak not only to the eclectic mix of influences that made up tiki culture but also to its increasing coherence as a style.

8. The standard recipe for Planter's Punch contains 1 part lime juice, 2 parts sugar, 3 parts rum, and 4 parts water (Embury 313). The earliest Zombie recipe, the 1937 "Zombie Punch," preserves these general ratios—albeit with an increased volume of rum and water (crushed ice). The most common corpse reviver recipe—the Corpse Reviver #2—combines equal measures gin, lemon juice, Cointreau, and Lillet Blanc with an absinthe rinse (Craddock 52), and while there is little similarity between the core ingredients for both drinks, the use of an anisette in the Zombie Punch (along with the hapless jetsetter narrative) suggests that Beach was familiar with corpse revivers and offered the Zombie as his own spin on that genre of cocktail.

9. There is one earlier recipe that appeared in a 1938 article in the *Winnipeg Free Press:* "The serving glass should be approximately 14 ounces and frosted. Into it is shaken one ounce of Demerara 150 proof rum, one ounce of heavy Jamaican rum, one ounce of Guadalupe rum and one ounce Porto Rican cartadora. To this is added one ounce of Falernum and one ounce of simple syrup, the juice of one whole Mexican lime and four dashes of bitters. Decorate with fruits in season, and mint." Note that this recipe is no closer to cracking Beach's code than was Duffy's ("Zombie Zowie").

10. Nevertheless, Embury had to include a Zombie recipe in his volume, attesting to the drink's popularity (280). The overall importance and quality of *The Fine Art of Mixing Drinks* notwithstanding, Embury's Zombie recipe bears little resemblance in structure or flavor to the Beachcomber Zombie.

11. Berry notes that the Spievak Zombie contained considerable departures from the mixology of Donn Beach, particularly in its use of lemon juice and a shaker. Nonetheless, Berry warrants that if Spievak's Zombie is in fact a fake, then it is "a fake of such awesome acuity that he equaled the talents of the master he defrauded" (*Remixed* 122).

Afterword: Zombie Archive

JEFFREY T. NEALON

The Year's Work at the Zombie Research Center both constitutes its own unique archive and contributes to the growing archive of scholarly work on what might be the central figure that traverses our present, the zombie. When taking stock of this archive, or any archive for that matter, one is inevitably forced to ask the question, Why create a research archive around this topic rather than another? Why zombies, why now?

There are of course myriad—sometimes conflicting, always compelling—answers to that question on offer in this volume, and likewise within the wider scholarly zombie archive, but almost all answers to the "Why zombies now?" query lead to the conclusion that there's substantial traffic between the figure of the zombie and the status of "normal" life today—that the zombie shows us something important about our current biopolitical, neoliberal, or existential situation.[1] For example, no less an expert than Max Brooks, author of the *Zombie Survival Guide* and *World War Z*, suggests that the current craze for zombies in American popular culture remains clearly and intensely tied to the ravages of the recent past: "9/11, Iraq, Afghanistan, Katrina, anthrax letters, DC sniper, global warming, global financial meltdown, bird flu, swine flu, SARS. I think people really feel like the system's breaking down" (Brodesser-Akner). Our collective lives, it seems, have become completely territorialized and inhabited by a kind of terrorist notion of imminent death. No longer understood as an externality to be controlled or an end to

be mourned, mass death is refigured in the present as a plodding figure coming for us constantly, inexorably, from within our own communities, our own subjectivities. We are all zombies, it seems.

Which is nothing if not ironic, given the sunny rhetoric offered up by the affective capitalism that likewise saturates our present—where everything from cars to frozen Trader Joe's meals to the iPad is sold to us not as a thing merely to be utilized for some specific purpose (getting around, eating, or checking email), but as an "experience" that will contribute to the project of "Making Life Better," as my university's logo from a few years ago promised.[2] The zombie, as a figure for our biopolitical present, importantly reminds us that life is always and inexorably defined by death, or at least that any definition of life harbors death within itself. Life as we know it is characterized by death, constantly menacing our individual lives, although we're sort of used to that from the early twentieth-century days of existentialism. So the impending sense of doom today comes from elsewhere: we live in a world where death is threatening not only my life or your life but also whatever's left of the collective life of the entire socius. Mass extinctions are coming for *Homo sapiens,* as they have for 99.9 percent of all the species that have ever lived on this planet.

Indeed, as several of the provocations in our zombie archive suggest, the figure of the zombie is intimately related to Michel Foucault's theorization of biopower as the operating system of our present. Recall Foucault's formula for biopower: it's a contemporary regime in which we are all made to live or left to die.[3] Which is, of course, a formula for life and death that's famously inverted from the early modern era of sovereign power, where subjects caught in the webs of power could be made to die (should they offend the Crown for any reason) or otherwise merely left to live. The power of the sovereigns, as Foucault pointed

out, had little to no investment in the everyday lives of the vast majority of people, who were not deemed important enough to worry about. The regime of discipline, however, brought increasing surveillance onto the plane of everyday life;[4] and that level of

[M]ass death is refigured in the present as a plodding figure coming for us constantly, inexorably, from within our own communities, our own subjectivities.

power's interest in the mundane has certainly intensified in our biopolitical present, when even the most banal everyday choice (Why Crest, not Colgate? Why Google this term, not that one?) has become subject to an immense and unprecedented amount of scrutiny. Individual preferences have become mass references in an unprecedented way, and we live in a Foucauldian biopolitical world defined by those demographic vistas.[5]

Paradoxically, Foucault shows us that the more open and flexible any given biopolitical regime remains on the individual level, the more effective the means of control it can yield on the collective level. As Foucault argues in *The Birth of Biopolitics,* for example, neoliberal market capitalism (the model by which we increasingly understand ourselves and our world) produces effects of social control much more efficiently than a society of sovereignty, or a society characterized by direct disciplinary surveillance of individuals. Market capitalism configures this more effective control precisely because of its supposed commitment to individual "openness," choice and flexibility. Neoliberal society, like the power relations out of which it arises, can hold better and saturate a greater area of the socius when its grip is not merely negative (repressive) but is positive (enabling) as well. In short, the entire surface of "life" has become the bearing area for power today (think of the near

disappearance of the work/life distinction in the past few decades), a power that seeks only to increase its saturation. Biopower roams, zombielike, endlessly in search of more, more, more.

Foucault sums up this form of non-disciplinary power in the last lecture of *Birth of Biopolitics:*

> You can see what appears on the horizon of this kind of analysis is not at all the ideal or project of an exhaustively disciplinary society in which the legal network hemming in individuals is taken over and extended internally by, let's say, normative mechanisms. Nor is it a society in which a mechanism of general normalization and the exclusion of those who cannot be normalized is needed. On the horizon of this analysis we see instead the image, idea, or theme-program of a society in which there is an optimization of systems of difference, in which the field is left open to fluctuating processes, in which minority individuals and practices are tolerated, in which action is brought to bear on the rules of the game rather than on the players, and finally in which there is an environmental type of intervention instead of the internal subjugation of individuals. (259–60).

With changes in the dominant modalities, practices, and targets of power, so too are the forms of social control transmogrified, made lighter, more intense, simultaneously more individual and more global. The individual's entire life becomes the pivot of power for the late Foucault (just as the site of training in institutions had been the primary pivot and control mechanism for discipline); and about the only thing we have in common as a neoliberal collectivity is that we're "alive." At least for now.

Hence, the triumph of biopower means we're all harnessed to the project of making life better (we're all "made to live"), whether we choose it or not. Like our zombie brethren, we unconsciously pass on

the biopolitical virus virtually everywhere—in the activities of individuals, states, families, and markets. China, for example, is in the midst of the greatest social re-engineering program in the history of the planet, where by 2025 more than 250 million Chinese will be moved from rural villages into a series of prefab mega-cities.[6] Why? one wonders. Not so they can work in disciplinary settings (on the assembly line or in the gulag), but so they can do their twenty-first-century biopolitical duty: buy stuff and go to restaurants. So their lives can be made better. These 250 million Chinese are, in Foucault's sense, being "made to live," where formerly they were more or less left to their own devices in their rural surroundings. One can't help but think of this second great leap as having unconsciously been modeled on George A. Romero's zombies, plodding though the shopping malls in search of who knows what.

Of course, it may be that the zombie likewise marks a mutation within that very biopower, or a further intensification of it. The mid-twentieth-century welfare state was undoubtedly the highest manifestation of Foucault's biopolitical formula of "made to live or left to die." In the twentieth century, we in the so-called first world were managed biopolitically, as a productive population or a demographic group of individuals—encouraged at every turn to make a living, get an education, earn a wage, and stay healthy, in the name of the socius's health. In short, you were thrown into the project of "getting a life" by the liberal capitalism of the early to mid-twentieth century and then offered a retirement pension from that life of productivity as service well done. Those outside the loop of citizenship or productive society were more or less provided with sustenance but largely ignored, left to die.

But with the neoliberal evisceration of that welfare state capitalism, with the complete unraveling of the liberal state, we in the first world have perhaps jumped the "or" in Foucault's dual formulation (made to live *or* left to die). More precisely, we've seen that "or" morphed into an

"and": we are made to live after the new economy (you must work, you must consume, you must produce—desires for more and better life keep the world economy afloat), *and simultaneously* we are left to die, insofar as you will get no support from the nation-state when and if shit goes bad: if you lose your job, get sick, get disabled, get addicted, get caught, post the wrong picture, or leak the wrong material. We are at present made to live *and* left to die, at one and the same time. The ways we are made to live—through the cowboy capitalism of the individual professional consumer—are premised on the increasingly ironic fact that we are or will be left to die by neoliberalism. There will be no safety net for most of us, no golden years of retirement where we can simply be paid off and left

The archive, like the zombie, is a question of survival, the living-on or potential reanimation of dead material traces left by the past.

alone while a new generation is made to live. Thereby the figure of the zombie archives our lives at the limits of this contemporary biopolitics, as we're all a quite literally new kind of dead (wo)man walking. As such, *The Year's Work at the Zombie Research Center* constitutes a crucial archive for making our way, for lurching through the present toward an uncertain future.

But after reading through and thinking about the widening archive of work on zombies, I'd also like to suggest that the growing importance of the archive itself (as a theoretical site and as a place where work increasingly gets done in the humanities) is likewise linked to this zombie logic of the living dead. Because the archive, like the zombie, is a question of survival, the living on or potential reanimation of dead material traces left by the past.

Indeed, our current zombie fever is a kind of archive fever, in the Derridean sense: the mad attempt to hoard it all (water, shotgun shells, food, Hemingway's letters, Derrida's papers), against the inexorable zombie flow of time and finitude. The mad, doomed attempt to survive—this is what Derrida names archive fever: "From the first breath, this archive as survivance is at work. But once again, this is the case not only for books, or for writing, or for the archive in the current sense, but for everything from which the tissue of living experience is woven, through and through" (*Beast and Sovereign* 132). The possibility of the zombie archive—what's to be preserved, what's remembered versus what's forgotten or un-archived—is woven into the very stuff of our supposed living experience: the archive is nothing other than a series of traces that can be warehoused and reanimated in circumstances and contexts far beyond our control. Hence, for Derrida, the politics of the archive: "There are no archives without political power," he insists in "Trace and Archive."[7]

To say "archive" and "power" is to say the same thing twice, insofar as anything that is archived has been already subject to a series of social, ethical, and biopolitical procedures: what to archive, and what simply to let go. What's made to live on in the archive, and what's left to die? As Derrida puts it, "To keep, precisely, one destroys, one lets many things be destroyed; that is the condition of a finite psyche, which works . . . by killing just as much as by assuring survival. To assure survival, one must kill. That's the archive, archive fever" ("Trace"). And Derrida consistently argues that precisely because nothing or no one "is" fully itself, everything (living or not) is subject to time and the trace—to finitude and decay. So every trace and every life is a zombie, a living death, but not every trace or every life is archived, stored in a specific, accessible place to await possible reanimation by forces that might survive it. In

other words, it may be that everyone and everything is a zombie, a life defined only in terms of its decay, but not everyone or everything is part of the zombie archive—not every trace will be warehoused or potentially reanimated. "There is no archive without the trace," Derrida points out, but "every trace is not an archive" ("Trace").

The archive, as a living-dead zombie, is then not a question merely for the past or simply a device for remembering days gone by. In fact, as Derrida puts it, "the archive . . . *pre-occupies* the future"[8] ("Le cinéma" 85; italics in original), which is to say that the archive steers or canalizes our view of the future. The archive narrows our vision but also offers us a foothold or oblique path forward, even as it reminds us of the dangers we face every step of the way. "Archivization is thus a type of work made for organizing a relative survival" ("Trace"), as survival is never the kind of thing that's ever more than relative. Survival in Derridean terms—for the human, the animal, or the archive—is nothing more than the biopolitics of living on or living through the necessity of finitude. In the end, it's not about wresting an authentic, fully present notion of "life" from its zombified tomb in the archive; rather, it's about the future, which (like everything else in Derrida) is an incalculable combination of promise and threat. The future is never fully alive as pure possibility, but never fully dead as a closed horizon. Hence the crucial importance of the archive as a road map, as a series of concrete interventions like the ones offered here in *The Year's Work at the Zombie Research Center*.[9]

And what have we learned from a year's work, from this particular zombie archive? We've learned a lot about specifics and transversal connections—about zombies in life, death, and even cocktails. But perhaps the overarching lesson is about life as survival, about what life has become in our biopolitical present. Because you can't defeat zombies (at least partially because they're you); likewise, any given individual certainly can't defeat the "make live and let die" logic of our archive, of

our biopolitical present. In the end perhaps we're always thrown back to the question of survival—not the binary terms of living or dying, but the liminal futurity of somehow living on, using the hoarded and make-shift tools of the zombie archive to try to light an oblique path. Perhaps funnyman Mel Brooks, father of "zombieman" Max Brooks, puts it best: "The zombies aren't comedy. It has to do with life-and-death survival, the modus operandi for the need to survive. Not to be happy—that's something else. To survive" (Brodesser-Akner). To translate this insight into the Foucauldian terms with which we began, we learn from the zombie archive that the present is neither good nor bad, but where we live now sure as shit is dangerous.

Notes

1. For an excellent overview of approaches to the figure of the zombie, see Lauro and Embry's "Zombie Manifesto."

2. As a primer in affective (or late-late, or post-postmodern, or whatever you want to call it) capitalism, one could do no better than Apple's summer 2013 ad campaign, offered in verse in the *New York Times*, June 30, 2013 (12–13):

> This is it.
> This is what matters.
> The experience of a product.
> How it makes someone feel.
> When you start by imagining
> What that might be like,
> You step back.
> You think.
> Who will this help?
> Will it make life better?

3. See the final section of Foucault's *History of Sexuality*, Volume 1, called "Right of Death and Power over Life": "One might say that the ancient right to *take* life or *let* live was replaced by a power to *foster* life or *disallow* it to the point of death" (138; ital-ics in original). Foucault characterizes this as a "*biopolitics of the population*," a regime

"whose highest function was perhaps no longer to kill, but to invest life through and through. The old power of death that symbolized sovereign power was now carefully supplanted by the administration of bodies and the calculated management of life" (139–40).

4. See Foucault's "Lives of Infamous Men," where he argues that everyday life, far from constituting a bulwark against power, was in fact discovered and mined as a productive terrain by the disciplinary power of the eighteenth and nineteenth centuries.

5. See Nealon, *Foucault beyond Foucault* (45–53).

6. See Ian Johnson, "China's Great Uprooting: Moving 250 Million into Cities."

7. Derrida, "Trace et archive." Let me profusely thank Michael Naas for calling my attention to this Derrida text, for schooling me on the topic of Derrida and the archive, and for allowing me to crib his translations. For more on this topic, see Derrida's *Archive Fever: A Freudian Impression,* and Naas's brilliant unpacking of the Derridean archive in chapter 6 of *The End of the World.*

8. "L'archive . . . *pré-occupe* l'avenir" (85).

9. Indeed, it seems important that this archive remain specifically dated and marked as "*a* year's work in zombie studies," as the archive's stake is always a future located somewhere it can't name or control. In part because of this existing archive, the year 2020's research in zombie studies will have to be different.

Works Cited

Zombie Media

28 Days Later. Dir. Danny Boyle. 20th Century Fox, 2002. Film.

28 Weeks Later. Dir. Juan Carlos Fresnadillo. 20th Century Fox, 2007. Film.

Against the Dark. Dir. Richard Crudo. Sony Pictures Home Entertainment, 2009. Film.

The Birds. Dir. Alfred Hitchcock. Universal Pictures, 1963. Film.

The Blair Witch Project. Dir. Eduardo Sánchez. Haxan Films, 1999. Film.

Battlestar Galactica. Glen A. Larson, Ronald D. Moore, et al. SyFy, 2004–09. Television.

"Ben." Michael Jackson. Motown, 1972. Side 1. Record.

Cloverfield. Dir. Matt Reeves. Bad Robot Productions, 2008. Film.

Colin. Dir. Marc Price. Nowhere Fast Productions, 2008. Film.

"Comment #1." Gil Scott-Heron. *Small Talk at 125th and Lenox*. Flying Dutchman/RCA, 1970. Side 1. Track 4. LP.

Creature with the Atomic Brain. Dir. Edward Cahn. 1955. Film.

Dawn of the Dead. Dir. George A. Romero. Laurel Group Inc., 1978. Film.

Dawn of the Dead. Dir. Zack Snyder. Universal Pictures. 2004. Film.

Day of the Dead. Dir. George A. Romero. Dead Films Inc., 1985. Film.

Dead Alive. Dir. Peter Jackson. WingNut Films, 1992. Film.

Dead Island. Techland, 2011. Video game.

Deadgirl. Dir. Marcel Sarmiento. Hollywoodmade, 2008. Film.

Deliverance. Dir. John Boorman. Warner Bros., 1972. Film.

Diary of the Dead. Dir. George A. Romero. Dimension Extreme, 2008. Film.

Dig, Lazarus, Dig!!! Nick Cave. Mute, 2008. LP.

Død snø (*Dead Snow* in UK & US). Dir. Tommy Wirkola. Euforia Film, 2009. Film.

Dracula. Dir. Tod Browning. Universal Pictures, 1931. Film.

"Dr. Funkenstein." Parliament. *The Clones of Dr. Funkenstein.* Casablanca, 1976. Side 1. Track 3. LP.

The Evil Dead. Dir. Sam Raimi. New Line Cinema, 1981. Film.

Fido. Dir. Andrew Currie. Lionsgate Films, 2006. Film.

Frankenstein. Dir. James Whale. Universal Pictures, 1931. Film.

From Dusk till Dawn. Dir. Robert Rodriguez. Dimension Films, 1996. Film.

La Horde. Dir. Benjamin Rocher and Yannick Dahan. Le Pacte, 2009. Film.

I Am Legend. Dir. Francis Lawrence. Warner Bros., 2007. Film.

I Walked with a Zombie. Dir. Jacques Tourneur. RKO Radio Pictures, 1943. Film.

Invasion of the Body Snatchers. Dir. Don Siegel. Allied Artists Pictures Corporation, 1956. Film.

Land of the Dead. Dir. George A. Romero. Universal Pictures, 2005. Film.

The Last Man on Earth. Dir. Ubaldo Ragona and Sidney Salkow. American International Pictures, 1964. Film.

Left 4 Dead. Turtle Rock Studios and Electronic Arts, 2008. Video game.

"Lost in the World." Kanye West. *My Beautiful Dark Twisted Fantasy.* Roc-A-Fella/Def Jam, 2010. Track 12. MP3.

"The Man Comes Around." Johnny Cash. *American IV: The Man Comes Around.* American Recordings/Universal, 2002. Track 1. CD.

"Monster." Kanye West. *My Beautiful Dark Twisted Fantasy.* Roc-A-Fella, 2010. Track 6. MP3.

"MTV: The 100 Greatest Music Videos Ever Made." MTV. 1999. http://www.youtube.com/watch?v=b_VmQzVF-CI. Accessed December 16, 2013. Web.

Night of the Living Dead. Dir. George A. Romero. Image Ten, 1968. Film.

Night of the Living Dead. Dir. Tom Savini. Columbia, 1990. Film.

The Omega Man. Dir. Boris Sagal. Warner Bros., 1971. Film.

Otto; or, Up with Dead People. Dir. Bruce LaBruce. Jürgen Brüning Filmproduktion, 2008. Film.

Patient Zero. Radiolab. Season 10. Episode 4. November 14, 2011. http://www
 .radiolab.org/2011/nov/14. Accessed May 1, 2013. Podcast.

Plague Inc. Ndemic Creations, 2012. Phone app.

Plan 9 from Outer Space. Dir. Ed Wood. Valiant Pictures, 1959. Film.

Planet Terror. Dir. Robert Rodriquez. Dimension Films, 2002. Film.

Plants vs. Zombies. Des. George Fan. PopCap Games, 2009. Phone app.

Pontypool. Dir. Bruce McDonald. Maple Pictures, 2009. Film.

"Power." Kanye West. *My Beautiful Dark Twisted Fantasy.* Roc-A-Fella/Def Jam,
 2010. Track 3. MP3.

Quarantine. Dir. John Erick Dowdle. Vertigo Entertainment, 2008. Film.

[•REC]. Dir. Jaume Balagueró and Paco Plaza. Filmax International, 2007. Film.

Resident Evil. Dir. Paul W. S. Anderson. Constantin Film, 2002. Film.

Resident Evil. Capcom, 1996–2012. Video game.

Return of the Living Dead. Dir. Dan O'Bannon. Orion Pictures, 1985. Film.

The Revenant. Dir. Kerry Prior. Lightning Entertainment, 2009. Film.

The Seventh Seal (Det sjunde inseglet). Dir. Ingmar Bergman. AB Svensk
 Filmindustri, 1957. Film.

Shaun of the Dead. Dir. Edgar Wright. Universal Pictures, 2004. Film.

Survival of the Dead. Dir. George A. Romero. Artfire Films, 2009. Film.

Them! Dir. Gordon Douglas. Warner Bros., 1954. Film.

"Thriller." Michael Jackson. *Thriller.* Epic, 1983. Side 1. Track 4. LP.

"Thriller." As performed by the dancing inmates of the CEBU Provincial
 Detention and Rehabilitation Center. Commentary by Byron F. Garcia.
 July 17, 2007. http://www.youtube.com/watch?v=hMnk71h9M3o. Accessed
 December 1, 2012. Web.

Twilight. Dir. Catherine Hardwicke. Summit Entertainment, 2008. Film.

United Dead Artists. http://www.lewub.com/udaroom. Accessed June 1, 2013.
 Web.

Urban Dead: A Massively Multi-Player Web-Based Zombie Apocalypse. Des.
 Kevan Davis. http://www.urbandead.com. Accessed May 25, 2013. Video
 game.

The Walking Dead. Frank Darabont et al. AMC. 2010-present. Television.

"Days Gone Bye." Season 1. Episode 1. October 31, 2010.

"Wildfire." Season 1. Episode 5. November 28, 2010.

"TS-19." Season 1. Episode 6. December 5, 2010.

"Pretty Much Dead Already." Season 2. Episode 7. November 27, 2011.

"Judge, Jury, Executioner." Season 2. Episode 11. March 4, 2012.

"Sick." Season 3. Episode 2. October 21, 2012.

"Walk with Me." Season 3. Episode 3. October 28, 2012.

"When the Dead Come Knocking." Season 3. Episode 7. November 25, 2012.

Warm Bodies. Dir. Jonathan Levine. Summit Entertainment, 2013. Film.

White Zombie. Dir. Victor Halperin. United Artists, 1932. Film.

"Woods." Bon Iver. *Blood Bank* (EP). Jagjaguwar, 2009. Track 4. MP3.

The X Files. "Hollywood, A.D." Fox. Season 7. Episode 19. April 30, 2000. Television.

Young Frankenstein. Dir. Mel Brooks. 20th Century Fox, 1974. Film.

"Zombie." Fela Kuti (and Afrika '70). *Zombie.* Celluloid Records, 1977. Track 1. LP.

"Zombie Dance." The Cramps. *Songs the Lord Taught Us.* Illegal Records, 1979. Side 2. Track 2. LP.

Zombie Gunship. Limbic Software, 2011. Phone app.

Zombie Safe House Competition: Rules & Program. http://zombiesafehouse .wordpress.com/rules-program. Accessed September 12, 2012. Web.

Zombie Strippers. Dir. Jay Lee. Stage 6 Films, 2008. Film.

Zombieland. Dir. Ruben Fleisher. Relativity Media, 2006. Film.

Zombie Print

Beckett, Samuel. *Endgame.* New York: Grove, 1994. Print.

Birkin, Charles. "Ballet Negre." In *Zombie!: Stories of the Walking Dead.* Ed. Peter Haining. London: W. H. Allen, 1985. 189–208. Print.

Brooks, Max. *World War Z: An Oral History of the Zombie War.* New York: Three Rivers Press, 2006. Print.

———. *The Zombie Survival Guide: Complete Protection from the Living Dead.* New York: Broadway Press, 2003. Print.

Browne, S. G. *Breathers: A Zombie's Lament.* New York: Broadway Books, 2009. Print.

Chabon, Michael. *The Amazing Adventures of Kavalier & Clay.* New York: Random House, 2000. Print.

Connolly, John. "The New Lazarus." *The New Dead: A Zombie Anthology.* Ed. Christopher Golden. New York: St. Martin's Press, 2010. 1–8. Print.

Defoe, Daniel. *A Journal of the Plague Year.* 1722. New York: W. W. Norton, 1992. Print.

Grahame-Smith, Seth, and Jane Austen. *Pride and Prejudice and Zombies.* Philadelphia: Quirk Books, 2009. Print.

Haining, Peter, ed. *Zombie!: Stories of the Walking Dead.* London: W. H. Allen, 1985. Print.

Hanakuma, Yusaku. *Tokyo Zombie.* Trans. Ryan Sands. San Francisco: Last Gasp, 2008. Print.

Hutter, G. W. "Salt is not for Slaves." *Zombie!: Stories of the Walking Dead.* Ed. Peter Haining. London: W. H. Allen, 1985. 39–53. Print.

Ichiba, Daisuke. *Grossesse nerveuse.* Archères: United Dead Artists, 2009. Print.

"In the Shadow of the Golem." *The Incredible Hulk.* #134. December 1970. Print.

Khan, Ali S. "Preparedness 101: Zombie Apocalypse." Office of Public Health Preparedness and Response. Centers for Disease Control and Prevention. http://blogs.cdc.gov/publichealthmatters/2011/05/preparedness-101-zombie -apocalypse. Accessed November 8, 2013. Web.

Kirkman, Robert. *The Walking Dead.* #71. Berkeley: Skybound Comics, 2010. Print.

Kirkman, Robert, and Tony Moore. "Days Gone Bye." *The Walking Dead.* Vol. 1. Berkeley: Image, 2010. Print.

Lovecraft, H. P. *H. P. Lovecraft: Tales.* New York: Library Classics of the United States, 2005. Print.

Ma, Roger. *Zombie Combat Manual: A Guide for Fighting the Living Dead.* New York: Berkley Trade, 2010. Print.

Marcus, Ben. *The Flame Alphabet.* New York: Alfred A. Knopf, 2012. Print.

Marion, Isaac. *Warm Bodies: A Novel.* New York: Atria, 2011. Print.

Matheson, Richard. *I Am Legend*. 1954. New York: Tor Books, 2007. Print.

Poe, Edgar Allan. "The Facts in the Case of M. Valdemar." 1845. *The Works of the Late Edgar Allan Poe*. Vol. 1. Ed. Rufus W. Griswold et al. New York: Redfield, 1853, 1856. 121–30. Print.

Reed, Ishmael. *Mumbo Jumbo*. New York: Viking, 1972. Print.

Roberson, Chris, and Michael Allred. *iZOMBIE*. Vertigo, 2010–12. Print.

Romero, George A., and John A. Russo. *Night of the Living Dead*. Draft Script. 1968. http://wdjoyner.org/zombies/romero-etal_night-of-the-living-dead_script-1968.pdf. Accessed June 10, 2013. Web.

Shelley, Mary. *Frankenstein; or, The Modern Prometheus*. 1818. New York: W. W. Norton, 2012. Print.

Shepherd, Matthew, and Roy Boney, Jr. *Dead Eyes Open*. San Jose: SLG Publishing, 2008. Print.

Stoker, Bram. *Dracula*. Eds. Nina Auerbach and David J. Skal. New York: W. W. Norton, 1997. Print.

Tarantino, Quentin. Screenplay for *From Dusk till Dawn*. Daily Script. http://www.dailyscript.com/scripts/from_dusk_till_dawk.html. Accessed January 15, 2013. Web.

Wachowski, Larry, and Andy Wachowski. *Doc Frankenstein*. Burlyman Entertainment, 2004-present. Print.

Wallace, Inez. "I Walked with a Zombie." *Zombie!: Stories of the Walking Dead*. Ed. Peter Haining. London: W. H. Allen, 1985. 95–102. Print.

Whitehead, Colson. *Zone One*. New York: Doubleday, 2011. Print.

Zombie Theory and Scholarship

Abaci, Uygar. "Kant's Justified Dismissal of Artistic Sublimity." *Journal of Aesthetics and Art Criticism* 66.3 (2008): 237–51. Print.

Abbiss, Chris, and Paul Laursen. "Describing and Understanding Pacing Strategies during Athletic Competition." *Sports Medicine* 38 (2008): 239–52. Print.

Ackerman, Hans-W., and Jeanine Gauthier. "The Ways and Nature of the Zombi." *Journal of American Folklore* 104.414 (1991): 466–94. Print.

Agamben, Giorgio. *Homo Sacer: Sovereign Power and Bare Life.* Trans. Danielle Heller-Roazen. Palo Alto, CA: Stanford University Press, 1998. Print.

———. *Remnants of Auschwitz: The Witness and the Archive.* Trans. Daniel Heller-Roazen. New York: Zone Books, 2002. Print.

Ahmed, Sara. *The Cultural Politics of Emotion.* New York: Routledge, 2004. Print.

———. "Happy Objects." *The Affect Theory Reader.* Ed. Melissa Gregg and Gregory J. Seigworth. Durham, NC: Duke University Press, 2010. 29–51. Print.

Alpers, Paul. *What Is Pastoral?* Chicago: University of Chicago Press, 1997. Print.

Allowing Natural Death. http://allowingnaturaldeath.org/sources. Accessed January 9, 2013. Web.

Annas, Julia, and Jonathan Barnes. *The Modes of Scepticism: Ancient Texts and Modern Interpretations.* Cambridge, UK: Cambridge University Press, 1985. Print.

Auerbach, Nina. *Our Vampires, Ourselves.* Chicago: University of Chicago Press, 1995. Print.

Austin, John. *So Now You're a Zombie: A Handbook for the Newly Undead.* Chicago: Chicago Review Press, 2010. Print.

Austin, John L. *How to Do Things with Words.* Cambridge, MA: Harvard University Press, 1962. Print.

Badiou, Alain. *Pocket Pantheon: Figures of Postwar Philosophy.* Trans. David Macey. London: Verso, 2009. *Print.*

Bady, Aaron. "The MOOC Moment and the End of Reform." *The New Inquiry.* http://thenewinquiry.com/blogs/zunguzungu/the-mooc-moment-and-the-end-of-reform. Accessed May 15, 2013. Web.

Bakhtin, M. M. "Forms of Time and Chronotope in the Novel." *The Dialogic Imagination: Four Essays.* Austin: University of Texas Press, 1982. Print.

Barthes, Roland. "Outcomes of the Text." *The Rustle of Language.* Trans. Richard Howard. New York: Hill and Wang, 1986. 238–49. Print.

———. *Roland Barthes by Roland Barthes.* Trans. Richard Howard. New York: Hill and Wang, 1977. Print.

———. "Textual Analysis of a Tale by Edgar Allen Poe." *Poe Studies* 10 (1977): 1–12. Print.

Baudrillard, Jean. *The Intelligence of Evil or the Lucidity Pact.* Trans. Chris Turner. Oxford, UK: Berg Publishers, 2005. Print.

Beck, Ulrich. *Risk Society: Towards a New Modernity.* London: Sage, 1992. Print.

Beck, Ulrich, and Elisabeth Beck-Gernscheim. *Individualization: Institutionalized Individualism and Its Social and Political Consequences.* London: Sage, 2001. Print.

Beddoes, Thomas Lovell. *Selected Poems.* Manchester, UK: Carcanet Press Ltd., 1976. Print.

Benjamin, Walter. *Gesammelte Schriften.* Bd. VII-2. Eds. Rolf Tiedemann and Hermann Schweppenhäuser. Frankfurt a. Main: Suhrkamp Verlag, 1991. Print.

———. "Über Sprache überhaupt und über die Sprache des Menschen." *Frühe Arbeiten zur Bildungs- und Kulturkritik* VII-2. Frankfurt a. Main: Suhrkamp Verlag, 1977. 785–90. Print.

Bennett, Jane. *Vibrant Matter: A Political Ecology of Things.* Durham, NC: Duke University Press, 2010. Print.

Berman, Sigal Yael Edan, and Mohammad Jamshidi. "A Foraging Group of Autonomous, Mobile Robots-Implementation of Hierarchical Fuzzy Behavior-Based Control." *The 21st IEEE Convention of the Electrical and Electronic Engineers in Israel* (2000): 285–88. Print.

Bergson, Henri. "Laughter." *Comedy.* Ed. Wylie Sypher. Baltimore: Johns Hopkins University Press, 1980. 59–190. Print.

Berry, Jeff. *Beachbum Berry's Sippin' Safari: In Search of the Great "Lost" Tropical Drinks . . . and the People behind Them.* San Jose: Club Tiki Press, 2007. Print.

———. *Beachbum Berry Remixed: A Gallery of Tiki Drinks.* San Jose: Club Tiki Press, 2010. Print.

Berry, Jessica. *Nietzsche and the Ancient Skeptical Tradition.* New York: Oxford University Press, 2011. Print.

Bishop, Kyle. *American Zombie Gothic: The Rise and Fall (and Rise) of the Walking Dead in Popular Culture.* Jefferson, NC: McFarland, 2010. Print.

———. "Dead Man Still Walking: Explaining the Zombie Renaissance." *Journal of Popular Film and Television* 37 (April 2009): 16–25. Print.

———. "The Sub-Altern Monster: Imperialist Hegemony and the Cinematic Voodoo Zombie." *Journal of American Culture* 31.2 (2008): 141–52. Print.

Blackburn, Simon. *Truth: A Guide.* Oxford, UK: Oxford University Press, 2005. Print.

Bogost, Ian. *Alien Phenomenology; or, What It's Like to Be a Thing.* Minneapolis: University of Minnesota Press, 2012. Print.

Boluk, Stephanie, and Wylie Lenz. "Introduction: Generation Z, the Age of Apocalypse." *Generation Zombie: Essays on the Living Dead in Modern Culture.* Ed. Stephanie Boluk and Wylie Lenz. Jefferson, NC: McFarland, 2011. 1–17. Print.

Booker, M. Keith. *Monsters, Mushroom Clouds, and the Cold War: American Science Fiction and the Roots of Postmodernism, 1946–1964.* Westport, CT: Greenwood Press, 2001. Print.

Botting, Fred. "A-ffect-less: Zombie-Horror-Shock." *English Language Notes* 48.1 (2010): 177–90. Print.

Bourdieu, Pierre. *Distinction: A Social Critique of the Judgment of Taste.* Cambridge, MA: Harvard University Press, 1984. Print.

Braitenberg, Valentino. *Vehicles: Experiments in Synthetic Psychology.* Cambridge: MIT Press, 1986. Print.

Brecht, Bertolt. "Alienation Effects in Chinese Acting" (1936). *Brecht on Theatre.* Ed. John Willett. New York: Hill and Wang, 1964. 90–99. Print.

Brodesser-Akner, Taffy. "I Can't Think of Anything Less Funny than Dying in a Zombie Attack." *New York Times Magazine.* June 23, 2013, 20. Print.

Browning, Barbara. *Infectious Rhythm: Metaphors of Contagion and the Spread of African Culture.* New York: Routledge, 1998. Print.

Budick, Sanford. *Kant and Milton.* Cambridge, MA: Harvard University Press, 2010. Print.

Cameron, Ed. "The Voice against the Voice: Vodou, Psychoanalysis, and Zora Neale Hurston." *Women Writers: A Zine* (August 2008). http://www .womenwriters.net/aug08/cameron.htm. Accessed May 1, 2013. Web.

Cameron, Ron. *Acting Skills for Life*. Toronto: Dundurn, 1999. Print.

Campbell, Andy. "Zombie Apocalypse: CDC Denies Existence of Zombies Despite Cannibal Incidents." *Huffington Post*. June 1, 2012. http://www .huffingtonpost.com. Accessed December 29, 2012. Web.

Campbell, Timothy. *Improper Life: Technology and Biopolitics from Heidegger to Agamben*. Minneapolis: University of Minnesota Press, 2011. Print.

Canavan, Gerry. "'We *are* the Walking Dead': Race, Time, and Survival in Zombie Narrative." *Extrapolation* 51.3 (2010): 431–53. Print.

Cantor, C., and J. Price. "Traumatic Entrapment, Appeasement and Complex Post-Traumatic Stress Disorder: Evolutionary Perspectives of Hostage Reactions, Domestic Abuse and the Stockholm Syndrome." *Australian and New Zealand Journal of Psychiatry*. 41.5 (2007): 377–84. Print.

Carroll, Noël. "Horror and Humor." *Journal of Aesthetics and Art Criticism* 57.2 (1999): 145–60. Print.

———. "The Nature of Horror." *Journal of Aesthetics and Art Criticism* 46.1 (1987): 51–59. Print.

———. "Why Horror?" *Arguing about Art*. Ed. Alex Neill and Aaron Ridley. London: Routledge, 2001. 275–93. Print.

Cavell, Stanley. *The Claim of Reason: Wittgenstein, Skepticism, Morality, and Tragedy*. Oxford, UK: Clarendon Press, 1979. Print.

———. *Disowning Knowledge in Six Plays of Shakespeare*. Cambridge, UK: Cambridge University Press, 1987. Print.

———. *In Quest of the Ordinary: Lines of Skepticism and Romanticism*. Chicago: University of Chicago Press, 1988. Print.

Chalmers, David. *The Conscious Mind: In Search of a Fundamental Theory*. Oxford, UK: Oxford University Press, 1996. Print.

———. "Facing Up to the Problem of Consciousness." *Journal of Consciousness Studies* 2.3 (1995): 200–19. Print.

Chamberlain, Franc, Carl Lavery, and Ralph Yarrow. "Steps towards an Ecology of Performance." *University of Bucharest Review* (Literary and Cultural Studies Series) 14.1 (2012): 6–38. Print.

Chandler, Raymond. "Introduction to 'The Simple Art of Murder.'" 1950. *Later Novels and Other Writings.* New York: Library of America, 1995. 1016–19. Print.

Clausewitz, Carl von. *On War.* Trans. J. J. Graham. London: N. Trübner, 1873. Print.

Cohen, Jeffrey Jerome. "Monster Culture (Seven Theses)." *Monster Theory: Reading Culture.* Ed. Jeffrey Jerome Cohen. Minneapolis: University of Minnesota Press, 1996. 3–25. Print.

Coley, Rob, and Dean Lockwood. *Cloud Time: The Inception of the Future.* Alresford, Hants, UK: Zero Books, 2012. Print.

Comaroff, Jean, and John Comaroff. "Alien-Nation: Zombies, Immigrants, and Millennial Capitalism." *South Atlantic Quarterly* 101.4 (2002): 779–805. Print.

Comentale, Edward P. *Sweet Air: Modernism, Regionalism, and American Popular Song.* Urbana: University of Illinois Press, 2013. Print.

Condit, Jon. "Clark, Eugene (Land of the Dead)." Interview. *Dread Central.* August 18, 2005. http://www.dreadcentral.com/interviews/clark-eugene -land-dead#axzz2k47EP3qZ. Accessed May 22, 2013. Web.

Corbett, John. *Extended Play: Sounding Off from John Cage to Dr. Funkenstein.* Durham, NC: Duke University Press, 2004. Print.

Craddock, Harry. *The Savoy Cocktail Book.* 1930. London: Pavilion Books. 1999. Print.

Critchley, Simon. *Book of Dead Philosophers.* New York: Vintage, 2009. Print.

Crowther, Paul. *The Kantian Sublime: From Morality to Art.* Oxford, UK: Oxford University Press, 1989. Print.

"Culturomics." *The Cultural Observatory.* Harvard University. http://www .culturomics.org/cultural-observatory-at-harvard. Accessed December 12, 2012. Web.

Cummings, E. E. "pity this busy monster, manunkind." *100 Selected Poems.* New York: Grove, 1994. 89. Print.

Curtis, Wayne. *And a Bottle of Rum: A History of the New World in Ten Cocktails.* New York: Three Rivers Press, 2007. Print.

D'Angelo, Antonio, Jun Ota, and Enrico Pagello. "How Intelligent Behavior Can Emerge from a Group of Roboticles Moving Around." *Proceedings of the 2003 IEEE/RSJ International Conference on Intelligent Robots and Systems.* 2.27 (October 31, 2003): 1733–38. Print.

Danion, Frederic, Elodie Varrain, Mireille Bonnard, and Jean Pailhous. "Stride Variability in Human Gait: The Effect of Stride Frequency and Stride Length." *Gait and Posture* 18 (2003): 69–77. Print.

Dargis, Manohla. "Filmmakers Who Become Their Own Zombie Movie." Review of *Diary of the Dead. New York Times.* February 15, 2008. http://movies.nytimes.com/2008/02/15/movies/15dead.html?_r=0. Accessed May 22, 2013. Web.

Davis, Wade. *The Serpent and the Rainbow: A Harvard Scientist's Astonishing Journey into the Secret Societies of Haitian Voodoo, Zombis, and Magic.* New York: Simon & Schuster, 1985. Print.

De Man, Paul. "Phenomenality and Materiality in Kant." *The Textual Sublime: Deconstruction and Its Differences.* Ed. Gary Aylesworth and Hugh Silverman. Albany: SUNY Press, 1990. 87–109. Print.

Debord, Guy. *The Society of the Spectacle.* 1967. New York: Zone Books, 1995. Print.

Debray, Régis. *Media Manifestos.* Trans. Eric Rauth. London: Verso, 1996. Print.

DeGroff, Dale. *The Essential Cocktail: The Art of Mixing Perfect Drinks.* New York: Clarkson Potter, 2008. Print.

Deleuze, Gilles, and Félix Guattari. *Anti-Oedipus: Capitalism and Schizophrenia.* New York: Continuum, 2004. Print.

———. *A Thousand Plateaus: Capitalism and Schizophrenia.* Trans. Brian Massumi. Minneapolis: University of Minnesota Press, 1987. Print.

Dennett, Daniel. "The Unimagined Preposterousness of Zombies." *Journal of Consciousness Studies* 2:4 (1995): 322–26. Print.

Derrida, Jacques. *Archive Fever: A Freudian Impression.* Trans. Eric Prenowitz. Chicago: University of Chicago Press, 1996. Print.

———. *The Beast and the Sovereign,* Vol. 2. Trans. Geoffrey Bennington. Chicago: University of Chicago Press, 2011. Print.

———. "Le cinéma et ses fantômes." *Cahiers du cinéma* 556 (April 2001): 74–85. Print.

———. "Faith and Knowledge: The Two Sources of 'Religion' at the Limits of Reason Alone." *Religion.* Trans. Samuel Weber. Ed. Jacques Derrida and Gianni Vattimo. Stanford, CA: Stanford University Press, 1998. 1–78. Print.

———. *Rogues: Two Essays on Reason.* Stanford, CA: Stanford University Press, 2005. Print.

———. *Specters of Marx: The State of the Debt, the Work of Mourning, and the New International.* New York: Routledge, 1994. Print.

———. *Speech and Phenomena, and Other Essays on Husserl's Theory of Signs.* Trans. David B. Allison. Evanston, IL: Northwestern University Press, 1973. Print.

———. "Trace et archive, image et art." Remarks made June 25, 2002. http://www.jacquesderrida.com.ar/frances/trace_archive.htm. Accessed July 15, 2013. Web.

Derrida, Jacques, Jürgen Habermas, and Giovana Borradori. *Philosophy in a Time of Terror: Dialogues with Jürgen Habermas and Jacques Derrida.* Chicago: University of Chicago Press, 2003. Print.

Descartes, René. *Meditations on First Philosophy.* Trans. Michael Moriarty. Oxford, UK: Oxford University Press, 2008. Print.

Deuze, Mark. *Media Life.* Cambridge, UK: Polity Press, 2012. Print.

Diamond, Jared. *Collapse: How Societies Choose to Fail or Succeed.* New York: Penguin, 2011. Print.

———. "What's Your Consumption Factor?" *New York Times.* Opinion section. January 2, 2008. http://www.nytimes.com. Accessed December 29, 2012. Web.

Dishman, Rod. "Overview." *Exercise Adherence: Its Impact on Public Health.* Ed. R. Dishman. Champaign, IL: Human Kinetics, 1988. 1–9. Print.

Dolar, Mladen. *A Voice and Nothing More.* Cambridge: MIT Press, 2006. Print.

Dubreuil, Laurent. "Leaving Politics: Bios, Zōē, Life." *Diacritics* 36.2 (2006): 83–98. Print.

Duffy, Patrick Gavin. *The Official Mixer's Manual.* 1940. New York: Blue Ribbon Book, 1983. Print.

Duménil, Gérard, and Dominique Lévy. *The Crisis of Neoliberalism.* Cambridge, MA: Harvard University Press, 2011. Print.

Durand-Bush, N., and John Salmela. "The Development of Talent in Sport." *The Handbook of Sport Psychology.* 2nd ed. Ed. R. N. Singer, H. A. Hausenblas, and C. Janelle. New York: Wiley, 2001. 269–89. Print.

Durkheim, Emilé. *On Suicide.* 1897. London: Penguin Books, 2006. Print.

Ebert, Roger. Review of *Night of the Living Dead. Chicago Sun-Times.* January 5, 1969. http://www.rogerebert.com/reviews/the-night-of-the-living-dead-1967. Accessed May 22, 2013. Web.

Ehrlich, Paul. *The Population Bomb.* New York: Ballantine Books, 1968. Print.

Embury, David. *The Fine Art of Mixing Drinks.* 1948. New York: Mud Puddle Books, 2009. Print.

Emery, Amy Fass. "The Zombie In/As the Text: Zora Neale Hurston's *Tell My Horse.*" *African American Review* 39.3 (2005): 327–36. Print.

Esposito, Roberto. *Bios: Biopolitics and Philosophy.* Minneapolis: University of Minnesota Press, 2008. Print.

———. *Immunitas: The Protection and Negation of Life.* Cambridge, UK: Polity Press, 2011. Print.

Felten, Eric. *How's Your Drink?: Cocktails, Culture, and the Art of Drinking Well.* Chicago: Surrey Books, 2007. Print.

Fisher, Mark. *Capitalist Realism: Is There No Alternative?* Alresford, Hants, UK: Zero Books, 2009. Print.

Flores, Edmundo. "Issues of Land Reform." *Journal of Political Economy* 78.4 (1970): 890–905. Print.

Foucault, Michel. *The Birth of Biopolitics: Lectures at the ColleĀge de France, 1977–78.* Basingstoke: Palgrave Macmillan, 2008. Print.

———. *History of Sexuality,* Vol. 1. Trans. Robert Hurley. New York: Vintage Books, 1980. Print.

———. "Lives of Infamous Men." *The Essential Foucault*. Ed. Paul Rabinow and Nikolas Rose. New York: New Press, 2003. 279–93. Print.

———. *Security, Territory, Population: Lectures at the ColleÃge de France, 1977–78*. Basingstoke: Palgrave Macmillan, 2007. Print.

———. *Society Must Be Defended: Lectures at the ColleÃge de France, 1975–76*. New York: Picador Press, 2003. Print.

Frankfurt, Harry G. *On Bullshit*. Princeton, NJ: Princeton University Press, 2005. Print.

Freud, Sigmund. *The Freud Reader*. Ed. Peter Gay. New York: W. W. Norton, 1989. Print.

———. *The Standard Edition of the Complete Psychological Works of Sigmund Freud*. Gen. ed. James Strachey. London: Hogarth Press and the Institute of Psychoanalysis. 1956–74. Print.

———. *The Uncanny*. Trans. David McLintock. New York: Penguin Books, 2003. Print.

Fukuyama, Francis. *The End of History and the Last Man*. New York: Free Press, 1992. Print.

Gadamer, Hans-Georg. *Truth and Method*. New York: Continuum, 1999. Print.

Gibson, John, and Simona Bertacco. "Skepticism and the Idea of an Other." *Stanley Cavell and Literary Studies: Consequences of Skepticism*. Ed. Richard Eldridge and Bernard Rhie. New York: Continuum, 2011. Print.

Gill, Rosalind. *Gender and the Media*. Cambridge, UK: Polity Press, 2007. Print.

Gladwin, Alix. "Interview: Rick Genest." *Planet Notion*. http://www.planetnotion.com/2012/12/19/interview-rick-genest. Accessed May 1, 2013. Web.

Glissant, Edouard. *Caribbean Discourse: Selected Essays*. Trans. Michael J. Dash. Charlottesville: University Press of Virginia, 1999. Print.

Goldsmith, Kenneth. *Uncreative Writing: Managing Language in the Digital Age*. New York: Columbia University Press, 2011. Print.

Goodman, Steve. *Sonic Warfare: Sound, Affect, and the Ecology of Fear*. Cambridge: MIT Press, 2010. Print.

"Google Books." Wikipedia. http://en.wikipedia.org/wiki/Google_Books. Accessed January 23, 2013. Web.

"Google Ngram Viewer." Google. http://books.google.com/ngrams. Accessed December 12, 2012. Web.

Grahame-Smith, Seth. *How to Survive a Horror Movie: All the Skills to Dodge the Kills.* Philadelphia: Quirk Books, 2007. Print.

Gregg, Melissa. *Cultural Studies' Affective Voices.* New York: Palgrave Macmillan, 2006. Print.

Guyer, Paul. *Kant and the Experience of Freedom: Essays on Aesthetics and Morality.* Cambridge, UK: Cambridge University Press, 1993. Print.

Hägglund, Martin. "The Arche-Materiality of Time: Deconstruction, Evolution, and Speculative Materialism." *Theory after "Theory."* Ed. Derek Attridge and Jane Elliott. New York: Routledge, 2011. 265–77. Print.

———. *Radical Atheism: Derrida and the Time of Life.* Stanford, CA: Stanford University Press, 2008. Print.

Haigh, Ted. *Vintage Spirits and Forgotten Cocktails: From the Alamagoozlum to the Zombie and Beyond.* Beverly, MA: Quarry Books, 2009. Print.

Hahn, Patrick D. "Dead Man Walking: Wade Davis and the Secret of the Zombie Poison." *Biology Online.* http://www.biology-online.org/articles /dead_man_walking.html. Accessed May 1, 2013. Web.

Hall, Cameron, Arturo Figuero, Bo Fernhall, and Jill Kanaley. "Energy Expenditure of Walking and Running: Comparison with Prediction Equations." *Medicine and Science in Sports and Exercise* 36 (2004): 2128–34. Print.

Hall, Stuart. "Encoding/Decoding." *Culture, Media, Language: Working Papers in Cultural Studies, 1972–79.* Ed. Stuart Hall, Dorothy Hobson, Andrew Lowe, and Paul Willis. London: Hutchinson, 1980. Print.

Hammer, Espen. *Stanley Cavell: Skepticism, Subjectivity, and the Ordinary.* Oxford, UK: Polity, 2002. Print.

Harman, Graham. *Weird Realism: Lovecraft and Philosophy.* Alresford, Hants, UK: Zero Books, 2012. Print.

Harper, Stephen. "Zombies, Malls, and the Consumerism Debate: George Romero's *Dawn of the Dead." Americana: The Journal of Popular Culture* 1.2 (2002). http://www.americanpopularculture.com/journal/articles /fall_2002/harper.htm. Accessed November 12, 2013. Web.

Harvey, David. *Justice, Nature & the Geography of Difference.* London: Blackwell, 1996. Print.

———. *Rebel Cities: From the Right to the City to the Urban Revolution.* London: Verso, 2012. Print.

Haub, Carl. "How Many People Have Ever Lived on Earth?" *Population Reference Bureau.* October 2011. http://www.prb.org/Articles/2002 /HowManyPeopleHaveEverLivedonEarth.aspx. Accessed May 30, 2013. Web.

Hebdige, Dick. *Subculture: The Meaning of Style.* New York: Routledge, 1979. Print.

Heidegger. Martin. *Being and Time.* Trans. John Macquarrie and Edward Robinson. New York: Harper, 1962. Print.

Hockett, Charles Francis. "The Origin of Speech." *Scientific American* 203 (1960): 88–111. Print.

Holland, Owen, and Chris Melhuish. "Stigmergy, Self-Organization, and Sorting in Collective Robotics." *Artificial Life* 5 (1999): 173–202. Print.

The Holy Bible. King James Version. New York: American Bible Society, 1999. Print.

Hospice Patients Alliance. "New Designation for Allowing a Natural Death ('A.N.D.') Would Eliminate Confusion and Suffering When Patients Are Resuscitated against Their Wishes." http://www.hospicepatients.org/and .html. Accessed January 9, 2013. Web.

Huber, Zahra. "Zombie Bullets in High Demand Following Flesh-Eating Attacks." *CBS Detroit.* June 7, 2012. http://detroit.cbslocal.com. Accessed December 29, 2012. Web.

Hurston, Zora Neale. *Tell My Horse: Voodoo and Life in Haiti and Jamaica.* New York: Harper Perennial Modern Classics, 2009. Print.

International Necronautical Society. "New York Declaration on Inauthenticity (Delivered by INS General Secretary Tom McCarthy and INS Chief

Philosopher Simon Critchley at The Drawing Center, New York, 25th September 2007)." http://www.canopycanopycanopy.com/static/images/1 /ins/sfinsnydeclaration.pdf. Accessed May 1, 2012. Web.

Isenberg, Arnold. "Critical Communication." *Philosophical Review* 58.4 (1949): 330–44. Print.

Jameson, Fredric. *The Political Unconscious: Narrative as a Socially Symbolic Act.* Ithaca, NY: Cornell University Press, 1981. Print.

——. *Postmodernism; or, The Cultural Logic of Late Capitalism.* Durham, NC: Duke University Press, 1991. Print.

Johnson, Ian. "China's Great Uprooting: Moving 250 Million into Cities," *International New York Times* online, June 15, 2013. http://www.nytimes .com/2013/06/16/world/asia/chinas-great-uprooting-moving-250-million -into-cities.html. Accessed November 8, 2013. Web.

Joseph, Jennifer. "Interview with Joe Giles of 'The Walking Dead.'" December 29, 2011. http://jenniferxjoseph.com/jxj/2011/12/29/interview-with-joe-giles -of-the-walking-dead. Accessed December 18, 2013. Web.

Kant, Immanuel. *Critique of Pure Reason.* 1781. Cambridge, UK: Cambridge University Press, 1998. Print.

Kaplan, Aryeh. *Sefer Yetzirah: The Book of Creation.* Boston: Weiser Books, 1997. Print.

Kelleter, Frank. "*The Wire* and Its Readers." *The Wire: Race, Class, and Genre.* Ed. Liam Kennedy and Stephen Shapiro. Ann Arbor: University of Michigan Press, 2012. 33–70. Print.

Keren, Gad, Yoram Epstein, Abraham Magazanik, and Ezra Sohar. "The Energy Cost of Walking and Running with and without a Backpack." *European Journal of Applied Physiology* 46 (1981): 317–24. Print.

Keys, Ancel, Josef Brožek, Austin Henshel, Olaf Mickelsen, and Henry Longstreet Taylor. *The Biology of Human Starvation.* Minneapolis: University of Minnesota Press, 1950. Print.

Kinsey, Jean D. "The New Food Economy: Consumers, Farms, Pharms, and Science." *American Journal of Agricultural Economics* 83.5 (2001): 1113–30. Print.

Kitsantas, Anastasia, and Barry Zimmerman. "Comparing Self-Regulatory Processes among Novice, Non-expert, and Expert Volleyball Players: A Microanalytic Study." *Journal of Applied Sport Psychology* 14 (2002): 91–105. Print.

Klosterman, Chuck. "My Zombie, Myself: Why Modern Life Feels Rather Undead." *New York Times*. New York Edition. December 5, 2010. AR1. Print.

Knox, Crissy, and John Vereb. "Allow Natural Death: A More Humane Approach to Discussing End-of-Life Directives." *Journal of Emergency Nursing* 32.6 (2005): 560–61. Print.

Koethe, John. *Scepticism, Knowledge, and Forms of Reasoning.* Ithaca, NY: Cornell University Press, 2005. Print.

Kroker, Arthur, Marilouise Kroker, and David Cook. *Panic Encyclopedia: The Definitive Guide to the Postmodern Scene.* New York: St. Martin's Press, 1989. Print.

Kuo, Arthur, D. "A Simple Model of Bipedal Walking Predicts the Preferred Speed-step Length Relationship." *Journal of Biomedical Engineering* 123 (June 2001) 264–69. Print.

Kristeva, Julia. *Powers of Horror: An Essay on Abjection.* Trans. Leon S. Roudiez. New York: Columbia University Press, 1982. Print.

Kuhl, Patricia K. "Early Language Acquisition: Cracking the Speech Code." *Neuroscience* 5 (2004): 831–43. Print.

Lacan, Jacques. *The Four Fundamental Concepts of Psycho-analysis.* Trans. Alan Sheridan. London: W. W. Norton, 1977. Print.

Landecker, Hannah. "Food as Exposure: Nutritional Epigenetics and the New Metabolism." *BioSocieties* 6.2 (2011): 167–94. Print.

Landesman, Charles. *Skepticism: The Central Issues.* Oxford, UK: Blackwell, 2002. Print.

Laplanche, Jean. *Life and Death in Psychoanalysis.* Trans. Jeffrey Mehlman. Baltimore: Johns Hopkins University Press, 1970. Print.

Larkin, Philip. *The Whitsun Weddings.* Faber & Faber, 1964. Print.

Larkin, William S. "Res Corporealis: Persons, Bodies, and Zombies." *The Undead and Philosophy: Chicken Soup for the Soulless.* Ed. Richard Greene and K. Silem Mohammad. Chicago: Open Court, 2006. 15–26. Print.

Larsen, Lars Bang. "Zombies of Immaterial Labor: The Modern Monster and the Death of Death." *e-flux* 15 (April 2010). www.e-flux.com/journal. Accessed May 22, 2013. Web.

Lauro, Sarah Juliet. "Playing Dead: Zombies Invade Performance Art . . . and Your Neighbourhood." *Better Off Dead: The Evolution of the Zombie as Post-Human.* Ed. Deborah Christie and Sarah Juliet Lauro. Bronx, NY: Fordham University Press, 2011. 205–30. Print.

Lauro, Sarah Juliet, and Karen Embry. "A Zombie Manifesto: The Nonhuman Condition in the Era of Advanced Capitalism." *Boundary* 2 (Spring 2008): 85–108. Print.

Lazzarato, Maurizio. "From Biopower to Biopolitics." *Pli* 13.1 (2002): 100–12. Print.

Lea, Suzanne Goodney. "Modern Zombie Makers: Enacting the Ancient Impulse to Control and Possess Another." *Zombies Are Us: Essays on the Humanity of the Walking Dead.* Ed. Christopher M. Moreman and Cory James Rushton. Jefferson, NC: McFarland, 2011. 62–75. Print.

Legg, Stephen, and Arabinda Mahanty. "Energy Cost of Backpacking in Heavy Boots." *Ergonomics* 29 (1986): 433–38. Print.

Levi, Primo. *Se Questo É Un Uomo.* [If This Is a Man] 2nd ed. Torino: Einaudi, 1963. Print.

Levinas, Emmanuel. *Humanism of the Other.* Trans. Nidra Poller. Urbana: University of Illinois Press, 2003. Print.

———. *Otherwise Than Being or Beyond Essence.* Trans. Alfonso Lingis. Pittsburgh: Duquesne University Press, 1998. Print.

Lieberman, Daniel, and Dennis Bramble. "The Evolution of Marathon Running: Capabilities in Humans." *Sports Medicine* 37 (2007): 288–90. Print.

Loertscher, Laura, Darcy A. Reed, Michael P. Bannon, and Paul S. Mueller. "Cardiopulmonary Resuscitation and Do-Not-Resuscitate Orders: A Guide for Clinicians." *American Journal of Medicine* 123.1 (2010): 4–9. Print.

"Long-term Population History." *Wolfram|alpha*. http://www.wolframalpha
.com. Accessed May 30, 2013. Web.

Loudermilk, A. "Eating 'Dawn' in the Dark: Zombie Desire and Commodified
Identity in George A. Romero's 'Dawn of the Dead.'" *Journal of Consumer
Culture* 3.1 (2003): 83–108. Print.

Lowenstein, Adam. "Living Dead: Fearful Attractions of Film." *Representations*
110 (Spring 2010): 105–28. Print.

Lynskey, Dorian. *33 Revolutions Per Minute: A History of Protest Songs, From
Billie Holiday to Green Day.* New York: HarperCollins, 2011. Print.

Lyotard, Jean-François. *The Inhuman: Reflection on Time.* Palo Alto, CA:
Stanford University Press, 1988. Print.

Mader, Sharon. "Reviving the Dead in Southwestern PA: Zombie Capitalism,
the Non-Class and the Decline of the US Steel Industry." *Axes to Grind:
Re-Imagining the Horrific in Visual Media and Culture.* Ed. Harmony Wu.
Spectator 22.2 (2002): 69–77. Print.

Mahoney, Phillip. "Mass Psychology and the Analysis of the Zombie: From
Suggestion to Contagion." *Generation Zombie: Essays on the Living Dead
in Modern Culture.* Ed. Stephanie Boluk and Wylie Lenz. Jefferson, NC:
McFarland, 2011. 113–29. Print.

Malatesta, Davide, David Simar, Yves Dauvilliers, Robin Candau, Helmi Ben
Saad, Christian Préfaut, and Corrinne Caillaud. "Aerobic Determinants of
the Decline in Preferred Walking Speed in Healthy, Active 65- and 80-Year-
Olds." *Pflügers Archiv European Journal of Physiology* 447 (2003): 915–21. Print.

Malthus, Thomas Robert. *An Essay on the Principle of Population,* Vol. 2. London,
1806. Print.

Marcus, Greil. *Lipstick Traces: A Secret History of the Twentieth Century.*
Cambridge, MA: Harvard University Press, 1990. Print.

Mars, Louis P. "The Story of Zombie in Haiti." *Man: A Record of Anthropological
Science* 45.22 (March-April 1945): 38–40. Print.

Marsh, Leslie, and Christine Onof. "Stigmergic Epistemology, Stigmergic
Cognition." *Cognitive Systems Research* 9 (2008): 136–49. Print.

Martinez, Michael. "Tests in Cannibalism Case: Zombie-like Attacker Used Pot, Not 'Bath Salts.'" *CNN*. June 27, 2012. http://www.cnn.com/2012/06/27 /us/florida-cannibal-attack. Accessed May 1, 2012. Web.

Marx, Karl. *Grundrisse: Foundations of the Critique of Political Economy*. Harmondsworth, UK: Penguin Books, 1973. Print.

May, Jeff. "Zombie Geographies and the Undead City." *Social & Cultural Geography* 11.3 (2010): 285–98. Print.

McBride, Mary Margaret. Interview with Zora Neale Hurston on Zombies. January 25, 1943. http://www.youtube.com/watch?v=YmKPjh5RX6c. Accessed May 23, 2013. Web.

McCarthy, Tom. "Zombie Attack! Flesh-Eating Blitz Strikes Nation's Crime Headlines." *Guardian*. US News Blog. June 21, 2012. http://www.guardian .co.uk/world/us-news-blog/. *Accessed December 29, 2012. Web.*

McConnell, Mariana. Interview with George A. Romero. February 14, 2008. *Cinema Blend*. http://www.cinemablend.com/new/Interview-George-A -Romero-On-Diary-Of-The-Dead-7818.html. Accessed January 20, 2013.Web.

McGurl, Mark. "The Zombie Renaissance." *n + 1* 9 (April 26, 2012). http:// nplusonemag.com/the-zombie-renaissance-r-n. Accessed May 5, 2013. Web.

McLuhan, Marshall. *Understanding Media: The Extensions of Man*.2nd ed. New York: Signet, 1964. Print.

Meadows, Donnella, et al. *Limits to Growth: The 30-Year Update*. White River Junction, VT: Chelsea Green, 2004. Print.

Meehan, Jim. *The PDT Cocktail Book: The Complete Bartender's Guide from the Celebrated Speakeasy*. New York: Sterling Epicure, 2011. Print.

Meeusen, Romain, Martine Duclos, Carl Foster, Andrew Fry, Michael Gleeson, David Nieman, John Raglin, Gerard Rietjens, Jürgan Steinacker, and Axel Urhausen. "Prevention, Diagnosis, and Treatment of the Overtraining Syndrome." *Medicine and Science in Sports and Exercise* 45 (2013): 186–205. Print.

Meinrenken, Jens. "Eine jüdische Geschichte der Superhelden-Comics." *Helden, Freaks und Superrabbis: Die Juedische Farbe des Comics*. Ed. Marget

Kampmeyer-Käding and Cilly Kugelmann. Berlin: Jüdisches Museum Berlin, 2010. Print.

Metzl, Jonathan, and Anna Kirkland, eds. *Against Health: How Health Became the New Morality.* New York: New York University Press, 2010. Print.

Michel, Jean-Baptiste, Yuan Kui Shen, Aviva Presser Aiden, Adrian Veres, Matthew K. Gray, William Brockman, The Google Books Team, Joseph P. Pickett, Dale Hoiberg, Dan Clancy, Peter Norvig, Jon Orwant, Steven Pinker, Martin A. Nowak, and Erez Lieberman Aiden. "Quantitative Analysis of Culture Using Millions of Digitized Books." *Science* (Published online ahead of print, December 16, 2010). http://pinker.wjh.harvard.edu/articles/papers/Michel%20et%20al%20Quantitative%20analysis%20of%20culture%20Science%202011.pdf. Accessed November 12, 2013. Web.

Middleton, Richard. "'Last Night a DJ Saved My Life': Avians, Cyborgs, and Siren Bodies in the Era of Phonographic Technology." *Radical Musicology* 1 (2006). http://www.radical-musicology.org.uk/2006/Middleton.htm. Accessed December 1, 2013. Web.

Midrash Rabbah. Genesis I. Trans. Rabbi H. Freedman and Maurice Simon. London: Soncino Press, 1939. Print.

Mockus, Steve, and Travis Millard. *How to Speak Zombie: A Guide for the Living.* San Francisco: Chronicle Books, 2010. Print.

Mol, Annemarie, and John Law. "Embodied Action, Enacted Bodies: The Example of Hypoglycemia." *Body & Society* 10.2–3 (2004): 43–62. Available at http://bod.sagepub.com/content/10/2–3/43.abstract. Accessed November 13, 2013. Web.

Moreman, Christopher M. "Dharma of the Living Dead: A Meditation on the Meaning of the Hollywood Zombie." *Studies in Religion/Sciences Religieuses* 39.2 (2010): 263–81. Print.

Morgan, Michael L. *Discovering Levinas.* Cambridge, UK: Cambridge University Press, 2007. Print.

Morgan, William. "Prescription of Physical Activity: A Paradigm Shift." *Quest* 53 (2001): 366–82. Print.

Murphy, David P. *Zombies for Zombies: Advice and Etiquette for the Living Dead.* Naperville, IL: Sourcebooks, 2009. Print.

Murray, Noel. Interview with George Romero. AV Club. February 12, 2008. http://www.avclub.com/articles/george-romero,14198. Accessed January 20, 2013. Web.

Naas, Michael. *The End of the World, and Other Teachable Moments from Jacques Derrida's Final Seminar.* Bronx, NY: Fordham University Press, 2014. (forthcoming) Print.

Nealon, Jeffrey T. *Foucault beyond Foucault: Power and Its Intensification since 1984.*Stanford, CA: Stanford University Press, 2007. Print.

Nestle, Marion. *Food Politics: How the Food Industry Influences Nutrition and Health.* Berkeley: University of California Press, 2007. Print.

Newbury, Michael. "Fast Zombie/Slow Zombie: Food Writing, Horror Movies, and Agribusiness Apocalypse." *American Literary History* 24.1 (2012): 87–114. Print.

Newitz, Annalee. *Pretend We're Dead: Capitalist Monsters in American Pop Culture.* Durham, NC: Duke University Press, 2006. Print.

Ngai, Sianne. *Ugly Feelings.* Cambridge, MA: Harvard University Press, 2005. Print.

Nietzsche, Friedrich. *Beyond Good and Evil: Prelude to a Philosophy of the Future.* Trans. Walter Kaufmann. New York: Vintage, 1987. Print.

———. *The Gay Science.* 1882/1887. Cambridge, UK: Cambridge University Press, 2001. Print.

———. *On the Genealogy of Morals.* Ed. Walter Arnold Kaufmann. New York: Vintage Books, 1989. Print.

Noakes, Timothy, Alan St Clair Gibson, and Estelle Lambert. "From Catastrophe to Complexity: A Novel Model of Integrative Central Neural Regulation of Effort and Fatigue during Exercise in Humans: Summary and Conclusions." *British Journal of Sports Medicine* 39 (2005): 120–24. Print.

O'Connor, Brian. *Adorno.* Abingdon, UK: Routledge, 2013. Print.

Ollman, B. "Putting Dialectics to Work: The Process of Abstraction in Marx's Method." *Rethinking Marxism* 3.1 (1990): 26–74. Print.

Onstad, Katrina. "Horror Auteur Is Unfinished with the Undead." *New York Times.* February 10, 2008. http://www.nytimes.com/2008/02/10 /movies/10onst.html. Accessed May 22, 2013. Web.

Pacific Islands Monthly 16 (October 4, 1945): 49. Google Books. Accessed May 30, 2013. Web.

Paik, Peter Y. "The Gnostic Zombie and the State of Nature: On Robert Kirkman's *The Walking Dead*." Unpublished paper. 2011. Available at SSRN: http://ssrn.com/abstract=1912203. Accessed May 1, 2013. Web.

Pawlick, Thomas. *The End of Food: How the Food Industry is Destroying Our Food Supply and What We Can Do about It.* Fort Lee, NJ: Barricade, 2006. Print.

Peake, Bryce. "He Is Dead, and He Is Continuing to Die: Feminist Psycho-Semiotic Reflection on Men's Embodiment of Metaphor in a Toronto Zombie Walk." *Journal of Contemporary Anthropology* 1.1 (2010): 51–71. Print.

Perloff, Marjorie. *Unoriginal Genius: Poetry by Other Means in the New Century.* Chicago: University of Chicago Press, 2010. Print.

Phelan, Peggy. "'Just Want to Say': Performance and Literature, Jackson and Poirier." *PMLA* 125.4 (2010): 942–47. Print.

Pollan, Michael. *The Omnivore's Dilemma: A Natural History of Four Meals.* New York: Penguin Books, 2009. Print.

Putnam, Hilary. "Philosophy as the Education of Grownups: Stanley Cavell and Skepticism." *Reading Cavell.* Ed. Alice Crary and Sanford Shieh. New York: Routledge, 2006. 119–31. Print.

Raglin, John. "The Psychology of the Marathoner: Of One Mind and Many." *Sports Medicine* 37 (2007): 404–407. Print.

Raglin, John, and Yuri Hanin. "Competitive Anxiety." *Emotion in Sports.* Ed. Y. L. Hanin. Champaign, IL: Human Kinetics, 2000. 93–111. Print.

Rank, Otto. *Beyond Psychology.* New York: Dover, 1958. Print.

———. *The Double.* 1914. Trans. Harry Tucker Jr. Chapel Hill: University of North Carolina Press, 1971. Print.

Reimer, Raziel, and Amir Shapiro. "Biomechanical Energy Harvesting from Human Motion: Theory, State of the Art, Design Guidelines, and Future Directions." *Journal of NeuroEngineering and Rehabilitation* 8 (2011): 22. Print.

Ricoeur, Paul. *The Symbolism of Evil*. Boston: Beacon Press, 1967. Print.

Robles, Frances. "Homeless Victim of Cannibal Attack: Stranger 'Just Ripped Me to Ribbons.'" *Miami Herald*. August 8, 2012. http://www.miamiherald .com/. *Accessed December 29, 2012. Web.*

Rodman, Peter, and Henry McHenry. "Bioenergetics and the Origin of Hominid Bipedalism." *American Journal of Physical Anthropology*. 52 (1980): 103–106. Print.

Romero, George A., Adam Swica, and Michael Doherty. "Feature Commentary." *George A. Romero's Diary of the Dead*. Directed by George A. Romero. Santa Monica: Dimension Extreme, 2008. DVD.

Rosenberg, Harold. *The De-definition of Art: Action Art to Pop to Earthworks*. Chicago: University of Chicago Press, 1982. Print.

Russell, Jamie. *Book of the Dead: The Complete History of Zombie Cinema*. Surrey, UK: Fab Press, 2005. Print.

Rutherford, Jonathan. "Zombie Categories: An Interview with Ulrich Beck." *Individualization: Institutionalized Individualism and Its Social and Political Consequences*. Ulrich Beck and Elisabeth Beck-Gernscheim. London: Sage, 2001. 202–13. Print.

Sahlins, Marshall. *Stone Age Economics*. Hawthorne, NY: De Gruyter, 1972. Print.

Sanders, James. *Celluloid Skyline: New York and the Movies*. New York: Alfred A. Knopf, 2002. Print.

Sartre, Jean-Paul. "Preface to Frantz Fanon's 'Wretched of the Earth,'" *The Wretched of the Earth*. Trans. Richard Philcox. New York: Grove Press, 2004. xliii–lxii. Print.

Savage, Jon. *England's Dreaming: Anarchy, Sex Pistols, Punk Rock, and Beyond*. Rev. ed. New York: St. Martin's/Griffin, 2001. Print.

Schlosser, Eric. *Fast Food Nation: The Dark Side of an All American Meal*. New York: Harper, 2005. Print.

Schmitt, Carl. *Political Theology: Four Chapters on the Concept of Sovereignty*. Trans. George Schwab. Chicago: University of Chicago Press, 2006. Print.

Scholem, Gershom G. *On the Kabbalah and Its Symbolism*. Trans. Ralph Manheim. New York: Schocken Books, 1965. Print.

Seabrook, William. *The Magic Island*. New York: Paragon House, 1989. Print.

Serres, Michel. *Malfeasance: Appropriation through Pollution?* Palo Alto, CA: Stanford University Press, 2010. Print.

Shapiro, Stephen. "Transvaal, Transylvania: *Dracula*'s World-System and Gothic Periodicity." *Gothic Studies* 10.1 (2008): 29–47. Print.

Shaviro, Steve. "Capitalist Monsters." *Historical Materialism* 10.4 (2002): 281–90. Print.

Shaw, Steven. "Jason Rekulak Interview." *AskMen*. October 16, 2009. http://www.askmen.com/celebs/interview_300/352_jason-rekulak-interview.html. Accessed May 1, 2013. Web.

Shieh, Sanford. "The Truth of Skepticism." *Reading Cavell*. Ed. Alice Crary and Sanford Shieh. New York: Routledge, 2006. 131–65. Print.

Simmel, Georg. "The Metropolis and Mental Life." *The Blackwell City Reader*. Ed. Gary Bridge and Sophie Watson. Malden, MA: Blackwell, 2002. 11–19. Print.

Sjoberg, Laura, and Caron E. Gentry. "Reduced to Bad Sex: Narratives of Violent Women From the Bible to the War on Terror." *International Relations* 22.1 (2008): 5–23. Print.

Skal, David J. *The Monster Show: A Cultural History of Horror*. New York: Faber & Faber, 2001. Print.

Sloterdijk, Peter. *Critique of Cynical Reason*. Minneapolis: University of Minnesota Press, 1988. Print.

Smith, Vicki, and Tamara Lush. "Zombie Apocalypse: After Gory Incidents, Zombie Talk Grows." *Huffington Post*. June 3, 2012. http://www.huffingtonpost.com. *Accessed December 29, 2012. Web*.

Soja, Edward W. "Beyond *Postmetropolis*." *Urban Geography* 32.4 (2011): 451–69. Print.

———. "Six Discourses on the Postmetropolis." *The Blackwell City Reader*. Eds. Gary Bridge, and Sophie Watson. Malden, MA: Blackwell, 2002. Print.

Sontag, Susan. *Illness as Metaphor and Aids and Its Metaphors.* New York: Picador, 1989. Print.

Speth, James Gustave. *The Bridge at the End of the World: Capitalism, the Environment, and Crossing from Crisis to Sustainability.* New Haven, CT: Yale University Press, 2009. Print.

Spievak, Louis. *The Barbecue Chef.* Los Angeles: L. A. Spievak Corp., 1950. Print.

Spinoza, Benedict de. *A Spinoza Reader: The Ethics and Other Works.* Trans. Edwin Curley. Princeton, NJ: Princeton University Press, 1994. Print.

Stanislavski, Konstantin. *An Actor's Work on a Role.* Trans. Jean Benedetti. New York: Routledge, 2008. Print.

Strawson, Galen. *Selves: An Essay in Revisionary Metaphysics.* Oxford, UK: Oxford University Press, 2009. Print.

Strong, Marilee. *A Bright Red Scream: Self-Mutilation and the Language of Pain.* New York: Viking, 1998. Print.

Stroud, Barry. *The Significance of Philosophical Scepticism.* Oxford, UK: Oxford University Press, 1984. Print.

Suskind, Ron. "Faith, Certainty, and the Presidency of George W. Bush." *New York Times Magazine.* October 17, 2004. http://www.nytimes.com/2004/10/17/magazine/17BUSH.html?_r=0. Accessed January 15, 2013. Web.

Szasz, Thomas. *The Myth of Mental Illness: Foundations of a Theory of Personal Conduct.* New York: Harper & Row, 1974. Print.

Tanney, Julia. "On the Conceptual, Psychological, and Moral Status of Zombies, Swamp-Beings, and Other 'Behaviourally Indistinguishable' Creatures." *Philosophy and Phenomenological Research* 69.1 (2004): 173–86. Print.

Taussig, Michael. *Mimesis and Alterity: A Particular History of the Senses.* New York: Routledge, 1993. Print.

Terkel, Studs. *The Good War: An Oral History of World War II.* New York: Pantheon, 1984. Print.

Tesarz, Jonas, Alexander Schuster, Mechthild Hartmann, Andreas Gerhardt, and Wolfgang Eich. "Pain Perception in Athletes Compared to Normally

Active Controls: A Systematic Review with Meta-Analysis." *Pain* 153 (2012): 1253–62. Print.

Thacker, Eugene. *After Life*. Chicago: University of Chicago Press, 2010. Print.

———. "After Life: Swarms, Demons and the Antinomies if Immanence." *Theory after "Theory."* Ed. Jane Eliott and Derek Attridge. New York: Routledge Press, 2011. 181–93. Print.

———. *In the Dust of This Planet: Horror of Philosophy,* Vol. 1. Alresford, Hants, UK: Zero Books, 2011. Print.

———. "Three Questions on Demonology." *Hideous Gnosis: Black Theory Symposium 1.* Ed. Nicola Masciandaro. CreateSpace Independent Publishing Platform, 2010. 179–220. Print.

Thiel, Udo. *The Early Modern Subject: Self-Consciousness and Personal Identity from Descartes to Hume.* Oxford, UK: Oxford University Press, 2011. Print.

Thorsrud, Harald. *Ancient Scepticism.* Berkeley: University of California Press, 2009. Print.

Tocqueville, Alexis de. *Democracy in America.* 1835/1840. New York: Library of America, 2004. Print.

Toohey, Paul. "American Story: Rise of a Real-Life Zombie." *Adalaidenow.* www.adelaidenow.com.au/ipad/american-story-rise-of-the-real-zombie /story-fn6bqpju-1226212263604. Accessed May 1, 2013. Web.

Toronto Zombie Walk. "FAQs." http://torontozombiewalk.ca/faqs. Accessed December 1, 2012. Web.

Trefzer, Annette. "Possessing the Self: Caribbean Identity in Zora Neale Hurston's *Tell My Horse.*" *African-American Review* 34.2 (2000): 299–312. Print.

Van Dine, S. S. [Willard Huntington Wright]. "Twenty Rules for Writing Detective Stories." *American Magazine* (Sept. 1928). Reprt. in *The Art of the Mystery Story.* Ed. Howard Haycraft. New York: Grosset and Dunlap, 1947. 189–90. Print.

Virgil. *The Eclogues.* Trans. Guy Lee. New York: Penguin Books, 1984. Print.

Warner, Marina. *Fantastic Metamorphoses, Other Worlds.* Oxford, UK: Oxford University Press, 2002. Print.

———. *Phantasmagoria: Spirit Visions, Metaphors, and Media into the Twenty-first Century.* New York: Oxford University Press, 2006. Print.

Webb, Jen, and Sam Byrnard. "Some Kind of Virus: The Zombie as Body and as Trope." *Body and Society* 14.2 (2008): 83–98. Print.

Weheliye, Alexander G. *Phonographies: Grooves in Sonic Afro-Modernity.* Durham, NC: Duke University Press, 2005. Print.

Weber, Samuel. *Mass Mediauras: Form, Technics, Media.* Palo Alto, CA: Stanford University Press, 1996. Print.

Wertsch, James V. "Vygotsky's Two Minds on the Nature of Meaning." *Vygotskian Perspectives on Literary Research. Constructing Meaning through Collaborative Inquiry.* Ed. Carol D. Lee and Peter Smagorinsky. Cambridge, UK: Cambridge University Press, 2000. 19–31. Print.

Wierzbicka, Anna. *Semantics, Culture, and Cognition: Universal Human Concepts in Culture-Specific Configurations.* Oxford, UK: Oxford University Press, 1992. Print.

Williams, Evan Calder. *Combined and Uneven Apocalypse.* Winchester, UK: Zero Books, 2011. Print.

Williams, Michael. "The Metaphysics of Doubt." *Essays on Descartes' Meditations.* Ed. Amélie Rorty. Berkeley: University of California Press, 1986. 117–40. Print.

Williams, Raymond. *The Country and the City.* Nottingham, UK: Spokesman Books, 2011. Print.

———. *Culture and Society: 1780–1950.* New York: Columbia University Press, 1983. Print.

———. *The English Novel from Dickens to Lawrence.* Oxford, UK: Oxford University Press, 1970. Print.

Winnubst, Shannon. "Vampires, Anxieties, and Dreams: Race and Sex in the Contemporary United States." *Hypatia* 18.3 (2003): 1–20. Print.

Wittgenstein, Ludwig. *Philosophical Investigations.* Ed. P.M.S. Hacker and Joachim Schulte. Rev. 4th ed. Malden, MA: Wiley-Blackwell, 2009. Print.

Wolfe, Cary. *Philosophy and Animal Life.* New York: Columbia University Press, 2008. Print.

———. *What Is Posthumanism?* Minneapolis: University of Minnesota Press, 2010. Print.

Wondrich, David. *Imbibe! From Absinthe Cocktail to Whiskey Smash: A Salute in Stories and Drinks to "Professor" Jerry Thomas, Pioneer of the American Bar.* New York: Perigee, 2007. Print.

———. *Punch: The Delights (and Dangers) of the Flowing Bowl.* New York: Perigee, 2010. Print.

Wood, Robin. *Hollywood from Vietnam to Reagan . . . and Beyond.* 1986. Rev. ed. New York: Columbia University Press, 2003. Print.

———. "An Introduction to the American Horror Film." *Planks of Reason: Essays on the Horror Film.* Ed. Barry Keith. London: Scarecrow Press, 1984. 164–200. Print.

Wright, Bradford W. *Comic Book Nation: The Transformation of Youth Culture in America.* Baltimore: Johns Hopkins University Press, 2001. Print.

Wright, Richard. *Uncle Tom's Children.* New York: Harper Perennial, 2008. Print.

Yuval-Davis, Nira, "Gender, the Nationalist Imagination, War, and Peace." *Sites of Violence: Gender and Conflict Zones.* Ed. Wenona Giles and Jennifer Hyndman. Berkeley: University of California Press, 2004. 170–89. Print.

Žižek, Slavoj. *Looking Awry: An Introduction to Jacques Lacan through Popular Culture.* Cambridge: MIT Press, 1991. Print.

———. "Occupy Wall Street: What Is to Be Done Next?" *Guardian.* April 24, 2012. http://www.theguardian.com/commentisfree/cifamerica/2012/apr/24/occupy-wall-street-what-is-to-be-done-next. Accessed August 15, 2012. Web.

———. *The Sublime Object of Ideology.* 1989. New York: Verso, 2009. Print.

———. *Violence: Six Sideways Reflections.* New York: Picador, 2008. Print.

———. *Welcome to the Desert of the Real!: Five Essays on September 11 and Related Dates.* London: Verso, 2002. Print.

"Z-Max." Hornady Manufacturing Company. http://www.hornady.com/store/Z-MAX-Bullets. Accessed December 10, 2012. Web.

"zombie, n." *OED Online* (March 2013). http://www.oed.com/view/Entry/232982?redirectedFrom=zombie. Accessed May 13, 2013. Web.

"Zombie School: Inside the Walking Dead." From *The Walking Dead*. AMC.
 http://www.amctv.com/the-walking-dead/videos/inside-the-walking-dead
 -zombie-school. *Accessed December 29, 2012. Web.*
"Zombie vs. Ghoul." Google Ngram Viewer. http://books.google.com/ngrams.
 Accessed December 12, 2012. Web.
"Zombie Zowie, Hollywood Night Life Weird and Wonderful." *Winnipeg Free
 Press.* October 28, 1938. Print.

Contributors

Erik Bohman is a PhD candidate in the English Department at Indiana University. He currently works on phenomenology, narrative theory, and the twentieth- and twenty-first-century novel.

Edward P. Comentale is Professor of English at Indiana University. He is author of *Modernism, Cultural Production, and the British Avant-Garde* (2004) and *Sweet Air: Modernism, Regionalism, and American Popular Song* (2013). He is co-editor of several collections, including *Ian Fleming and James Bond: The Cultural Politics of 007* (2005); *T. E. Hulme and the Question of Modernism* (2006); and, with Aaron Jaffe, *The Year's Work in Lebowski Studies* (2009).

Jonathan P. Eburne is Associate Professor of Comparative Literature and English at Pennsylvania State University. He is the author of *Surrealism and the Art of Crime* (2008) and editor, with Jeremy Braddock, of *Paris, Capital of the Black Atlantic* (2013). He is co-editor of the "Refiguring Modernism" series at Penn State University Press and is currently completing a book titled *Outsider Theory*.

John Gibson is Associate Professor of Philosophy at the University of Louisville. He is the author of *Fiction and the Weave of Life* (2007) and editor of (with Noël Carroll) *Narrative, Emotion, and Insight* (2012);

(with Luca Pocci and Wolfgang Huemer) *A Sense of the World: Essays on Fiction, Narrative, and Knowledge* (2007); and (with Wolfgang Huemer) *The Literary Wittgenstein* (2004). He is currently at work on a book titled *Poetry, Metaphor, and Nonsense;* editing *The Philosophy of Poetry* for Oxford University Press; and editing, with Noël Carroll, *The Routledge Companion to Philosophy of Literature.*

Dan Hassler-Forest resides in the Netherlands, where his lifelong addiction to film, television, and books currently finds a welcome outlet in his position as assistant professor of English Literature at the University of Amsterdam. In his work he struggles to align his passion for pop culture with his dedication to radical Marxism, the results of which are published from time to time in international journals and edited collections. His own books include the monograph *Capitalist Superheroes: Caped Crusaders in the Neoliberal Age* (2012) and a collection of essays on comics and graphic literature.

Aaron Jaffe is Professor of English at the University of Louisville. He is author of *Modernism and the Culture of Celebrity* (2005) and *The Way Things Go: An Essay on the Matter of Second Modernism* (2014). With Edward P. Comentale, he edits the Year's Work, a book series in cultural theory from Indiana University Press.

Seth Morton is a PhD student at Rice University. His work looks at modernist and contemporary theories of technology and literature. He has published articles on experimental literature and archives.

Jeffrey T. Nealon is Liberal Arts Research Professor of English and Philosophy at Pennsylvania State University. He is author of *Foucault beyond Foucault: Power and Its Intensifications since 1984* (2008);

Post-Modernism; or, The Cultural Logic of Just-In-Time Capitalism (2012); and (with Susan Searls Giroux) *The Theory Toolbox* (2003).

Jack Raglin is Professor of Kinesiology in the School of Public Health at Indiana University. His research examines the interaction of biological and psychological variables in sport and exercise. Jack's most recent publication is titled "Crawling to the Finish Line: Why Do Some Endurance Runners Collapse?" (2013).

Andrea Ruthven has a predoctoral research grant with the Centre Dona i Literatura at the Universitat de Barcelona, where she is currently finishing her dissertation. Her interests include action heroines, their bodies and violence, and the monsters they battle and the worlds they live in. She has recently co-edited the volume *Women as Angel, Women as Evil: Interrogating the Boundaries* (2012).

Atia Sattar is Provost's Postdoctoral Scholar in the Humanities at the University of Southern California in the Department of Comparative Literature. Her research examines the relationship between aesthetics and scientific inquiry from the nineteenth century to the present. She has published articles in the journals *Isis* and *Configurations* and is currently working on her book *Visceral Aesthetics*.

Stephen Schneider is Assistant Professor of English at the University of Louisville. His essays have appeared in *College English, College Composition and Communication,* and *Technical Communication Quarterly.* His first book, *You Can't Padlock an Idea: Rhetorical Education at the Highlander Folk School, 1932–1961,* is forthcoming.

Stephen Shapiro teaches in the Department of English and Comparative Literary Studies at the University of Warwick. Author of *The Culture and Commerce of the Early American Novel: Reading the Atlantic World-System* (2009) and (with Anne Schwan) of *How to Read Foucault's* Discipline and Punish (2011), he is currently working on *From Gothic to God: Paranormal Capitalism and Evangelical America.*

Tatjana Soldat-Jaffe is Associate Professor of Linguistics in the Humanities Program at the University of Louisville. Her areas of expertise include sociolinguistics, language and ideology, and Yiddish studies. She is the author of *Twenty-first-Century Yiddishism: Language, Identity, and the New Jewish Studies* (2012) and is currently working on minority language planning and policies in Europe.

Stephen Watt is Provost Professor of English and Adjunct Professor of Theatre and Drama at Indiana University. He is author, most recently, of *Beckett and Contemporary Irish Writing* (2009), awarded the Robert Rhodes Prize from the American Conference for Irish Studies, and (with Cary Nelson) of *Office Hours* (2004) and *Academic Keywords: A Devil's Dictionary for Higher Education* (1999). He is completing a book-length manuscript tentatively titled "Irish Schlemiels: American Drama, Performance, and the Irish-Jewish Unconscious."

Index

music, 310; "Monster" horizon of violence, 15; sonic contagion, 294, 310; zombies as rhythmic opacity, 301, 306–307, 310. *See also* dance; performance

Narcisse, Clairvius, 25, 32, *36,* 37

"New Lazarus, The" (2010, short story), 26–27

Newbury, Michael, 268–70

Ngai, Sianne, 66, 79–81

Nietzsche, Friedrich, 111, 422

Night of the Living Dead (1968): absence of cultural coding in, 166; Ben as post-humanist protagonist, 305–306, 322, 336; civil rights as theme, 119, 184; enclosed spaces in, 135; Johnny as celebrity zombie, 25; logic of the mass in, 159–61; Matheson influence on, 120–21; meaningful noise in, 374–75; narrative framework, 130; as paradigmatic film, 342–43; pastoralism and, 10–11; post–World War II America as theme, 52–54, *53,* 163, 189n13, 199; representation as survival in, 12; systemic violence in, 164–65, 190n15; temporal slippage in, 14–15; treatment of media in, 160–65, *162,* 169–70, 180, 186–87, 189nn10–14; universal infection in, *333,* 334; zombie literature innovations in, 99; zombie research in, 55–56, 110–11

Night of the Living Dead (1990), 113

9/11 World Trade Center attack, 66, 321

novels: colonial subjectivity in, 128; drink as character component, 463n5; genre novels as mediators of experience, 204; genre play in *Pride and Prejudice and Zombies,* 346–47, 352; narrative voicing in, 216; penny dreadful and dime novel literature, 391, 393, 398; popular novel, 352; project-based production of, 409–411; sensitive zombies in romance novels, 21. *See also particular novels*

Occupy Wall Street, 146–47

Omega Man, The (1971), 120, 129–30, 148n3

otherness: abject undead as, 341; absence of language and, 362, 365; absence of personhood, 64–65; biopolitics and, 331–32; city-country dialectic and, 127; demographic fearmongering and, 104; eradication of difference and, 28–29, 122, 135; H-zombie ostracism, 37; Nietzschean "pathos of distance" and, 422–23; restoration of difference in *Zombie Survival Guide,* 140–41; urban social boundaries and, 120; zombies as stigmatized sickness, 22–23. *See also* humans

Otto; or, Up with Dead People (2008), 22, 25

panic culture, 4–6, *5*

pastoralism, 9–13, *11, 12,* 312–13, 429–30

peak zombie, 1–2, 8

Peake, Bryce, 251–53, 256–57

penny dreadful literature, 391, 393, 398

performance: CEBU dancing prisoners and, 308–309; ironic participation, 405–406; as political resistance, 256–60; systemic performance, 262–63; zombie advice literature, 248–49, 393–94, *395;*

education in, 355–56, 358, 359n5;
heteronormative desire in, 346, 351–52,
356–58; postfeminist slayer body in,
341–42, 344, *349, 353*–55; postfeminist
violence in, 347–52, 359n6, 360n7;
publication of, 409–411, *410*; treatment
of canonical literature, 207–208; zombie
apocalypse in, 344

prisons, 308–309

psychoanalysis: drive vs. desire in,
72–75, 226n9, 227, 274, 343–44; focus
on undying in, 2–3; monsters as
repression and, 84; revenance and
return theme, 400; sexual disgust in,
88n11; sexuality/hunger analogy, 63–64,
73–74; traumatic memory in, 67. *See also*
psychology; sexuality; uncanny, the

psychology: allegories of historical
trauma, 15, 67, 150, 465–66; civility in
zombie research, 54–55; commodity
fetishism, 207, 460–63; fan world
"strategy of containment," 205; hunger-
desire analogy, 63–64, 73–74; non-
disciplinary biopower and, 467–70,
473nn2–3; political consciousness,
143–44; psychical drive as zombie
trait, 72–75, 226n9, 227, 274, 343–44;
psychoanalysis and the undead, 2–4;
zombie consciousness, 34, 252–53;
zombie mental characteristics, 229–31;
zombie nostalgia, 277. *See also* morality;
physiology; psychoanalysis; sensitive
zombies; society

pulp literature, 94–95, *95*, 114n3

punk movement, 40–41, *41*, 294

P-zombies (philosophical zombies), 34,
42–43, 359n2

race. *See* African diaspora; slavery

Rank, Otto, 68, 87n7

real-life zombies, 31–32; cannibal zombies,
38–39, 240, 272–74; celebrity zombies,
25; serial killers and, 37–38; virophilia
and, 274. *See also* humans; H-zombies

[•REC] (2007), 7, 72, 149n6

receivers, 104–105

recording technology: auto-tuning, 312;
cut/groove as cultural code, 299–301,
306, 310; disembodiment of the voice
and, 297–98; Internet as digital undead,
8; phonographic subjectivity, 300–301;
recorded abjection in *[•REC]*, 7;
technological reproduction and, 397–98

Reed, Ishmael, 310, 389, 400–401

Rekulak, Jason, 409–411, 415n6

religion: Biblical zombies, 25–26, *27*,
57n5; demonic zombies in *[•REC]*, 72;
immortality vs. survival in, 336–38;
legend of the golem, 362, *364*, 365, 368,
379, 380–82, 388nn4–5; performative
language in scripture, 382–83; "proper
burial" and, 73, 88n8. *See also* morality

Resident Evil (1996–2012, video game), 9,
136

Return of the Living Dead (1985), 19–20, 25,
110–12

Revenant, The (2009), 133

Rico the Zombie, 25, 32, 41–44, *43*

Ricoeur, Paul, 70–71

risk management, 339n7

73–74; ironic "gay plague" zombies, 22; sexual disgust, 88n11; vampire defilement/purification, 70–71

Shakespeare, William, 73, 76

Shaun of the Dead (2004): abject mouth in, 70; anticonsumerism in, 151; drive vs. desire in, 76; Ed as celebrity zombie, 25; enclosed and fortress spaces in, 135; ironic self-awareness in, 405–406; posthuman future in, 406–407; return of the repressed in, 84–85; urban zombies as theme, 133; zombie humor in, 20–21, 207, 370–71, 435n2; zombie sentience in, 217

Shelley, Mary, 28–29, 96, 108

Shepherd, Matthew, 22–23

Simmel, Georg, 132, 134

Singing Detective, The (1986), 208

Sjoberg, Laura, 348

Skal, David J., 301–302

slashers, 73

slavery: colonialist discourse and, 118, 278–79, 281–83, 399; critical exegesis in *I Walked with a Zombie*, 284–87; Dahmer defense and, 38; dancing zombies and, 294; Davis zombie accounts, 37; domesticated/slave zombies, 84–85, 199–200, 343; enslaved sexual zombies, 69–70, 76, 85–87; in H. P. Lovecraft, 95–96; Hurston zombie accounts, 33; Nietzschean "pathos of distance" and, 422; revolutionary deathliness of the colonized, 289–90; Romero zombies and, 21, 199–200, 343; rum association

with, 448; Seabrook zombie accounts, 32–33. *See also* African diaspora; Caribbean zombies; colonialism/ postcolonialism

Sloterdijk, Peter, 315–16, 319

smartphone apps, 6

So Now You're a Zombie (2010, book), 248–49, 393–94, 395

society: biopolitics and, 323–24, 328–29, 331–32; composite body in Spinoza, 307–308; cooperative/social behaviors, 227, 230–33, 254–56, 326; Marxist levels of social analysis, 201; socially framing narratives, 195–98; swarm, 231, 256, 326, 329–30, 335–36; urban social boundaries, 120; zombie categories, 391–93, 398, 401–402; zombie community in *Land of the Dead*, 376. *See also* psychology

Soja, Edward W., 117, 120, 133–34, 143

Sontag, Susan, 6

Sophocles, 73

spatiality: city-country dialectic, 118–19, 123–24, 126–27, 131–34; claustrophobic space, 92, 96, 134, 149n6; disruption of privatized urban space, 148; domestic fortress spaces, 120–23, 131, 135–37, 136, 148n3, 323; enclosed spaces, 119–20, 135, 333; horizons, 89–93, 104–105; infrastructural collapse landscapes, 18–19, 133; music covers as reterritorialization, 313; naturalized urban human landscape, 130, 133; spatialization of narrative, 119–20,